CANON® EOS® 6D MARK II

GUIDE TO DIGITAL SLR PHOTOGRAPHY

David D. Busch

rockynook

David Busch's Canon[®] EOS[®] 6D Mark II Guide to Digital SLR Photography David D. Busch

Project Manager: Jenny Davidson

Series Technical Editor: Michael D. Sullivan

Layout: Bill Hartman

Cover Design: Mike Tanamachi Indexer: Valerie Haynes Perry Proofreader: Mike Beady

ISBN: 978-1-68198-334-9

1st Edition (1st printing, December 2017)

© 2018 David D. Busch

All images © David D. Busch unless otherwise noted

Rocky Nook, Inc. 1010 B Street, Suite 350 San Rafael, CA 94901 USA www.rockynook.com

Distributed in the U.S. by Ingram Publisher Services Distributed in the UK and Europe by Publishers Group UK

Library of Congress Control Number: 2017947936

All rights reserved. No part of the material protected by this copyright notice may be reproduced or utilized in any form, electronic or mechanical, including photocopying, recording, or by any information storage and retrieval system, without written permission of the publisher.

Many of the designations in this book used by manufacturers and sellers to distinguish their products are claimed as trademarks of their respective companies. Where those designations appear in this book, and Rocky Nook was aware of a trademark claim, the designations have been printed in caps or initial caps. All product names and services identified throughout this book are used in editorial fashion only and for the benefit of such companies with no intention of infringement of the trademark. They are not intended to convey endorsement or other affiliation with this book.

While reasonable care has been exercised in the preparation of this book, the publisher and author assume no responsibility for errors or omissions, or for damages resulting from the use of the information contained herein or from the use of the discs or programs that may accompany it.

This book is printed on acid-free paper.

Printed in Korea

Acknowledgments

Thanks to everyone at Rocky Nook, including Scott Cowlin, managing director and publisher, for the freedom to let me explore the amazing capabilities of the Canon EOS 6D Mark II. I couldn't do it without my veteran production team, including project manager, Jenny Davidson, and series technical editor, Mike Sullivan. Also thanks to Bill Hartman, layout; Valerie Hayes Perry, indexing; Mike Beady, proofreading; Mike Tanamachi, cover design; and my agent, Carole Jelen, who has the amazing ability to keep both publishers and authors happy.

About the Author

With more than two million books in print, **David D. Busch** is the world's #1 bestselling camera guide author, and the originator of popular series like *David Busch's Pro Secrets*, *David Busch's Compact Field Guides*, and *David Busch's Quick Snap Guides*. He has written more than 50 hugely successful guidebooks for Canon and other digital SLR models, including the all-time #1 bestsellers for several different cameras, additional user guides for other camera models, as well as many popular books devoted to dSLRs, including *Mastering Digital SLR Photography, Fourth Edition* and *Digital SLR Pro Secrets*. As a roving photojournalist for more than 20 years, he illustrated his books, magazine articles, and newspaper reports with award-winning images. He's operated his own commercial studio, suffocated in formal dress while shooting weddings, and shot sports for a daily newspaper and an upstate New York college. His photos and articles have appeared in *Rangefinder, Professional Photographer*, the late, lamented *Popular Photography*, and hundreds of other publications. He's also reviewed dozens of digital cameras for CNet and other CBS publications.

When About.com named its top five books on Beginning Digital Photography, debuting at the #1 and #2 slots were Busch's *Digital Photography All-In-One Desk Reference for Dummies* and *Mastering Digital Photography*. He has had as many as 18 books listed in the Top 100 of Amazon.com's Digital Photography Bestseller list—simultaneously! Busch's 250-plus other books published since 1983 include bestsellers like *Digital SLR Cameras and Photography for Dummies*.

Busch is a member of the Cleveland Photographic Society (www.clevelandphoto.org), which has operated continuously since 1887. Visit his website at http://www.canonguides.com.

Contents

Preface	xvi
Introduction	xvii
Chapter 1	
Canon EOS 6D Mark II Quick Start	1
First Things First	1
Initial Setup	4
Power Options	5
Final Steps	6
Setting the Time and Date	10
Selecting a Shooting Mode	12
Semi-Auto/Manual Modes	
Basic Zone Modes	14
Special Scene Modes	14
Choosing a Metering Mode	15
Choosing a Focus Mode	16
Selecting a Focus Point	17
Using the Self-Timer	19
Taking a Picture	20
Reviewing the Images You've Taken	21
Cruising through Index Views	22
Therefore Dhates to Vour Computer	23

Chapter 2	
Canon EOS 6D Mark II Roadmap	25
Front View	
The Canon EOS 6D Mark II's Business End	
Using the Electronic Level	
Going Topside	36
LCD Panel Readouts	
Lens Components	
Looking Inside the Viewfinder	41
Underneath Your EOS 6D Mark II	
Mastering the Touch Screen	43
Chapter 3	
Recommended Settings	47
Changing Default Settings	47
Resetting the Canon 6D Mark II	
Recommended Default Changes	50
Charter 4	
Chapter 4	
Nailing the Right Exposure	55
Getting a Handle on Exposure	55
How the 6D Mark II Calculates Exposure	
Correctly Exposed	61
Overexposed	
Underexposed	
Choosing a Metering Method	
Choosing an Exposure Method	67
Aperture-Priority	68
Shutter-Priority	
Program AE Mode	
Scene Intelligent Auto	
Manual Exposure	74

Adjusting Exposure with ISO Settings	76
Dealing with Visual Noise	78
Making EV Changes	79
Bracketing Parameters	81
Bracketing Auto Cancel	82
Bracketing Sequence	82
Number of Exposures	83
Increment Between Exposures	83
Creating a Bracketed Set	84
Working with HDR	86
Using HDR Mode	87
Bracketing and Merge to HDR	90
Fixing Exposures with Histograms	93
Tonal Range	94
Histograms and Contrast	96
Understanding Histograms	97
Basic Zone Modes	101
Making Changes in Basic Zone Modes	
Chapter 5	
	107
How Focus Works	
Contrast Detection	
Phase Detection	
Dual Pixel CMOS AF	
Cross-Type Focus Point	
Focus Modes	116
Adding Circles of Confusion	117
Your Autofocus Mode Options	118
One-Shot AF	
AI Servo AF	
AI Focus AF	
Manual Focus	120

Selecting an AF Area Selection Mode	120
AF with Color Tracking	123
Autofocus Custom Functions	123
C.Fn II-1: Tracking Sensitivity	124
C.Fn II-2: Accelerate/Decelerate Tracking	125
C.Fn II-3: AF Point Auto Switching	125
C.Fn II-4: AI Servo 1st Image Priority	125
C.Fn II-5: AI Servo 2nd Image Priority	126
C.Fn II-6: AF-Assist Beam Firing	127
C.Fn II-7: Lens Drive when AF Impossible	127
C.Fn II-8: Select AF Area Selection Mode	128
C.Fn II-9: AF Area Selection Method	128
C.Fn II-10: Orientation Linked AF Point	128
C.Fn II-11: Initial AF Point, Auto Selection, AI Servo AF	129
C.Fn II-12: Auto AF Point Selection	130
C.Fn II-13: AF Point Selection Movement	130
C.Fn II-14: AF Point Display During Focus	131
C.Fn II-15: VF Display Illumination	131
C.Fn II-16: AF Microadjustment	132
Fine-Tuning the Autofocus of Your Lenses	132
Lens Tune-Up	134
Back-Button Focus	138
Activating Back-Button Focus	140
Chapter 6	
Advanced Techniques, Wi-Fi, and GPS	141
Continuous Shooting	141
More Exposure Options	143
A Tiny Slice of Time	143
Working with Short Exposures	144
Long Exposures	147
Three Ways to Take Long Exposures	
Working with Long Exposures	148

Delayed Exposures Self-Timer Self-Timer Interval/Time Lapse Photography	150
Introducing Wi-Fi	151
General Wi-Fi Guidelines	
Using Wi-Fi, Bluetooth, and NFC	
Enabling Wi-Fi	156
Connecting to a Camera with Wi-Fi	
Connecting to Connect Station with Wi-Fi/NFC	
Using the EOS Utility with Wi-Fi	
Connecting to a Printer with Wi-Fi	
Connecting to Web Services	161
Connecting to a Wi-Fi Access Point	
Connecting to Your Smartphone or Tablet	
Geotagging	163
Chapter 7 Choosing Your Lens Arsenal	169
Buy Now, Expand Later	171
What Lenses Can You Use?	
EF vs. EF-S	174
	4
Ingredients of Canon's Alphanumeric Soup	
More Interesting Optics	178
More Interesting Optics	

Chapter 9

Electronic Flash Basics	193
How Electronic Flash Works	
Ghost Images	
Avoiding Sync Speed Problems	
Determining Exposure	
Guide Numbers	
Getting Started with Electronic Flash	
Flash Exposure Compensation and FE Lock	
Flash Range	
External Speedlite Control	
Flash Firing	
E-TTL II Meter	
Flash Sync Speed in Av Mode	
Flash Function Settings	
Flash C.Fn Settings	
Clear Settings	
Using Flash Settings	
When to Disable Flash Firing	
More on Flash Modes	
Using External Electronic Flash	
Speedlite 600EX-RT/600EX II-RT	
Speedlite 580EX II	
Speedlite 430EX III-RT	
Speedlite 320EX	
Speedlite 270EX II	
Close-Up Lites	

Chapter 10	
Working with Wireless Flash	225
Wireless Evolution	
Elements of Wireless Flash	226
Flash Combinations	
Controlling Flash Units	
Why Use Wireless Flash?	228
Key Wireless Concepts	229
Which Flashes Can Be Operated Wirelessly?	230
Setting Up a Master Flash or Controller	232
Using a Speedlite as an Optical Master	232
Using the ST-E2 Transmitter as Master	233
Using the Speedlite 600EX-RT/600EX II-RT as Radio Master	235
Using the Speedlite 430EX III-RT as Radio Master	
Using the ST-E3-RT as Radio Master	236
Setting Up a Slave Flash	236
Choosing a Channel	237
Working with Groups	238
Ratio Control	240
Chapter 11	
	243
Anatomy of the 6D Mark II's Menus	243
Shooting Menu Options	245
Image Quality	251
Image Review	251
Release Shutter without Card	251
Lens Aberration Correction	
Lens Electronic Manual Focus	
External Speedlite Control	256
Exposure Compensation/Automatic Exposure Bracketing	2.59
ISO Speed Settings	
Auto Lighting Optimizer	
White Balance	
Custom White Balance	266

White Balance Shift/Bracketing	267
Color Space	
Picture Style	
Long Exposure Noise Reduction	280
High ISO Speed Noise Reduction	
Highlight Tone Priority	
Dust Delete Data	284
Multiple Exposure	
HDR Mode	
Interval Timer	
Bulb Timer	289
Anti-Flicker Shooting	290
Mirror Lockup	
Aspect Ratio	
Live View Shooting	292
C1 12	
Chapter 12	
Chapter 12 Customizing with the Playback and Set-up Menus	293
Customizing with the Playback and Set-up Menus	293
Customizing with the Playback and Set-up Menus Playback Menu Options	293
Customizing with the Playback and Set-up Menus Playback Menu Options. Protect Images.	293
Customizing with the Playback and Set-up Menus Playback Menu Options. Protect Images. Rotate Image.	293
Customizing with the Playback and Set-up Menus Playback Menu Options. Protect Images Rotate Image Erase Images	293 294 295 296
Customizing with the Playback and Set-up Menus Playback Menu Options. Protect Images. Rotate Image Erase Images. Print Order.	293 294 295 296
Customizing with the Playback and Set-up Menus Playback Menu Options. Protect Images Rotate Image Erase Images Print Order. Photobook Set-up.	293 294 295 296 297 300
Customizing with the Playback and Set-up Menus Playback Menu Options. Protect Images. Rotate Image. Erase Images. Print Order. Photobook Set-up. RAW Image Processing.	293 294 295 296 297 300 300
Customizing with the Playback and Set-up Menus Playback Menu Options. Protect Images. Rotate Image Erase Images. Print Order. Photobook Set-up. RAW Image Processing. Cropping	293 294 295 296 300 300 302
Customizing with the Playback and Set-up Menus Playback Menu Options. Protect Images Rotate Image Erase Images Print Order. Photobook Set-up. RAW Image Processing. Cropping Resize.	293 294 295 296 300 302 303
Customizing with the Playback and Set-up Menus Playback Menu Options. Protect Images Rotate Image Erase Images Print Order. Photobook Set-up. RAW Image Processing. Cropping Resize. Rating	293 294 295 296 300 302 303 303
Customizing with the Playback and Set-up Menus Playback Menu Options. Protect Images Rotate Image Erase Images Print Order. Photobook Set-up. RAW Image Processing. Cropping Resize. Rating Slide Show	293 294 295 296 300 302 303 304 305
Customizing with the Playback and Set-up Menus Playback Menu Options. Protect Images Rotate Image Erase Images Print Order. Photobook Set-up. RAW Image Processing. Cropping Resize. Rating Slide Show Set Image Search Conditions	293 294 295 296 300 302 303 304 305 306
Customizing with the Playback and Set-up Menus Playback Menu Options. Protect Images Rotate Image Erase Images Print Order. Photobook Set-up. RAW Image Processing. Cropping Resize. Rating Slide Show Set Image Search Conditions Image Jump with Main Dial.	293 294 295 296 300 302 303 304 305 306
Customizing with the Playback and Set-up Menus Playback Menu Options. Protect Images Rotate Image Erase Images Print Order. Photobook Set-up. RAW Image Processing. Cropping Resize. Rating Slide Show Set Image Search Conditions Image Jump with Main Dial Highlight Alert.	293 294 295 296 300 302 303 304 305 305 306
Customizing with the Playback and Set-up Menus Playback Menu Options. Protect Images Rotate Image Erase Images Print Order. Photobook Set-up. RAW Image Processing. Cropping Resize. Rating Slide Show Set Image Search Conditions Image Jump with Main Dial Highlight Alert AF Point Disp.	
Customizing with the Playback and Set-up Menus Playback Menu Options. Protect Images Rotate Image Erase Images Print Order. Photobook Set-up. RAW Image Processing. Cropping Resize. Rating Slide Show Set Image Search Conditions Image Jump with Main Dial. Highlight Alert. AF Point Disp. Playback Grid	293 294 295 296 300 302 303 304 305 306 307 308 308
Customizing with the Playback and Set-up Menus Playback Menu Options. Protect Images Rotate Image Erase Images Print Order. Photobook Set-up. RAW Image Processing. Cropping Resize. Rating Slide Show Set Image Search Conditions Image Jump with Main Dial. Highlight Alert. AF Point Disp. Playback Grid Histogram Disp.	293 294 295 296 300 302 303 304 305 306 307 308 308 308
Customizing with the Playback and Set-up Menus Playback Menu Options. Protect Images Rotate Image Erase Images Print Order. Photobook Set-up. RAW Image Processing. Cropping Resize. Rating Slide Show Set Image Search Conditions Image Jump with Main Dial. Highlight Alert. AF Point Disp. Playback Grid	

Set-up Menu Options	310
Select Folder	310
File Numbering	
Auto Rotate	
Format Card	
Eye-Fi Settings	314
Wireless Communication Settings	
Auto Power Off	
LCD Brightness	
LCD Off/On Button	
Date/Time/Zone	
Language	
Viewfinder Display	318
GPS Settings	
Video System	
Mode Guide	
Feature Guide	
Help Text Size	
Touch Control	
Beep	
Battery Info	322
Sensor Cleaning	
INFO. Button Display Options	325
Multi Function Lock	326
Custom Shooting Mode (C1, C2)	326
Clear All Camera Settings	330
Copyright Information	
Manual/Software URL	
Certification Logo Display	
Firmware	

Chapter	13

The Custom Functions and My Menus	333
Custom Function 1 (C.Fn I): Exposure	
Exposure Level Increments	
ISO Speed Setting Increments	336
Bracketing Auto Cancel	
Bracketing Sequence	
Number of Bracketed Shots	337
Safety Shift	
Exposure Comp. Auto Cancel	
Exposure Metering Mode, AE Locked After Focus	339
Custom Function 3 (C.Fn III): Operation/Others	340
Warnings in Viewfinder	340
Dial Direction During Tv/Av	341
Retract Lens on Power Off	341
Custom Controls	341
Clear All Custom Func. (C.Fn)	343
My Menu	343
Chapter 14 Using Live View	347
Shooting Menu Options	
AF Method	
Touch Shutter	
Metering Timer	
Grid Display	
Exposure Simulation	
Silent LV Shooting	
Shooting in Live View	351
Changing the Live View Display	353
Quick Control	355
Focusing in Live View	355
Selecting an AF Method	356
Focus Operation	360
Using the Touch Shutter	

Shooting Movies	362
Movie Shooting Menus	362
Movie Shooting 1	362
Movie Shooting 2	
Movie Shooting 3	
Movie Shooting 4	
Movie Shooting 5	
Exposure Options	
Formats, Compression, Resolution, and Frame Rates	
Quick Control	
Video Snapshots	
Shooting HDR Movies	
Playback and Editing	
Chambon 15	
T' C Cl D M	381
Tips for Shooting Better Movies	
Tips for Shooting Better Movies Plan Ahead	381
Plan Ahead	381
Tips for Shooting Better Movies Plan Ahead Depth-of-Field and Video Zooming and Video	381382
Tips for Shooting Better Movies Plan Ahead Depth-of-Field and Video Zooming and Video Keeping Things Stable and on the Level	381 381 382 383
Tips for Shooting Better Movies Plan Ahead Depth-of-Field and Video Zooming and Video Keeping Things Stable and on the Level Shooting Script	
Tips for Shooting Better Movies Plan Ahead. Depth-of-Field and Video. Zooming and Video. Keeping Things Stable and on the Level. Shooting Script. Storyboards.	
Tips for Shooting Better Movies Plan Ahead. Depth-of-Field and Video. Zooming and Video. Keeping Things Stable and on the Level. Shooting Script. Storyboards. Storytelling in Video.	
Tips for Shooting Better Movies Plan Ahead. Depth-of-Field and Video. Zooming and Video. Keeping Things Stable and on the Level. Shooting Script. Storyboards. Storytelling in Video. Composition.	
Tips for Shooting Better Movies Plan Ahead. Depth-of-Field and Video. Zooming and Video. Keeping Things Stable and on the Level. Shooting Script. Storyboards. Storytelling in Video.	

Preface

You don't want good pictures from your new Canon EOS 6D Mark II—you demand *outstanding* photos. After all, this camera is one of the most versatile and affordable full-frame cameras that Canon has ever introduced. It boasts 26 megapixels of resolution, blazing-fast autofocus, built-in GPS, and wireless communications with other cameras, smartphones and tablets, or your computer. It has cool features, including time-lapse photography, full high-definition movie shooting, a touch screen that allows you to make many settings with a tap of the LCD, and an amazing wireless flash capability.

What you need is a guide that explains the purpose and function of the 6D Mark II's basic controls, how you should use them, and *why*. Ideally, there should be information about file formats, resolution, exposure, and other special autofocus modes available, but you'd prefer to read about those topics only after you've had the chance to go out and take a few hundred great pictures with your new camera. Why isn't there a book that summarizes the most important information in its first two or three chapters, with lots of illustrations showing what your results will look like when you use this setting or that?

Now there is such a book. If you want a quick introduction to the 6D Mark II's focus controls, wireless flash synchronization options, how to choose lenses, or which exposure modes are best, this book is for you. If you can't decide on what basic settings to use with your camera because you can't figure out how changing ISO or white balance or focus defaults will affect your pictures, you need this guide.

Introduction

Canon makes haste slowly, especially in the case of its most popular advanced camera, which, in its latest iteration is dubbed the Canon EOS 6D Mark II. The original Mark I was introduced in September 2012 and remained as the Canon affordable full-frame workhorse for roughly five years. It's safe to say that the new Mark II is one of the most eagerly anticipated upgrades Canon has ever introduced, and this camera does not disappoint. Resolution has been boosted from 20 megapixels to a whopping 26 megapixels, while retaining the excellent high ISO performance (now expandable to the equivalent of ISO 102,400) that Canon is known for. A useful touch screen has been added, making it easy to "type" in comments, while accelerating many menu functions and allowing the photographer to select a focus point (or take a picture) in live view with a quick tap. Thanks to a Dual Pixel CMOS sensor, the 6D Mark II can continuously autofocus using accurate phase detection in live view.

Once you've confirmed that you made a wise purchase decision, the question comes up, *how do I* use this thing? All those cool features can be mind-numbing to learn, if all you have as a guide is the manual furnished with the camera. Help is on the way. I sincerely believe that this book is your best bet for learning how to use your new camera, and for learning how to use it well.

David Busch's Canon EOS 6D Mark II Guide to Digital SLR Photography is aimed at both Canon and dSLR veterans as well as newcomers to digital photography and digital SLRs. Both groups can be overwhelmed by the options the 6D Mark II offers, while underwhelmed by the explanations they receive in their user's manual. The manuals are great if you already know what you don't know, and you can find an answer somewhere in a booklet arranged by menu listings and written by a camera vendor employee who last threw together instructions on how to operate a camcorder.

Who Am I?

After spending years as the world's most successful unknown author, I've become slightly less obscure in the past few years, thanks to a horde of camera guidebooks and other photographically oriented tomes. You may have seen my photography articles in leading photographic magazines but, first, and foremost, I'm a photojournalist and made my living in the field until I began devoting most of my time to writing books.

Although I love writing, I'm happiest when I'm out taking pictures, which is why I invariably spend several days each week photographing landscapes, people, close-up subjects, and other things. I spend a month or two each year traveling to events, such as Native American "powwows," Civil War re-enactments, county fairs, ballet, and sports (baseball, basketball, football, and soccer are favorites). I once spent a fruitful October in Salamanca, Spain. I went there to shoot photographs of the people, landscapes, and monuments that I've grown to love, with about five hours a day set aside for study at a *colegio* located in an ancient monastery in the old part of the city, just steps from the cathedral. I can offer you my personal advice on how to take photos under a variety of conditions because I've had to meet those challenges myself on an ongoing basis.

Like all my digital photography books, this one was written by someone with an incurable photography bug. My first Canon SLR was a now-obscure model called the Pellix back in the 1960s, and I've used a variety of newer models since then. I've worked as a sports photographer for an Ohio newspaper and for an upstate New York college. I've operated my own commercial studio and photo lab, cranking out product shots on demand and then printing a few hundred glossy $8 \times 10s$ on a tight deadline for a press kit. I've served as a photo-posing instructor for a modeling agency. People have actually paid me to shoot their weddings and immortalize them with portraits. I even prepared press kits and articles on photography as a PR consultant for a large Rochester, NY company, that formerly dominated the industry.

Like you, I love photography for its own merits, and I view technology as just another tool to help me get the images I see in my mind's eye. But, also like you, I had to master this technology before I could apply it to my work. This book is the result of what I've learned, and I hope it will help you master your 6D Mark II digital SLR, too.

In closing, I'd like to ask a special favor: let me know what you think of this book. If you have any recommendations about how I can make it better, visit my website at www.canonguides.com, click on the E-Mail Me tab, and send your comments, suggestions on topics that should be explained in more detail, or, especially, any typos. (The latter will be compiled on the Errata page you'll also find on my website.) I really value your ideas, and appreciate it when you take the time to tell me what you think! Some of the content of the book you hold in your hands came from suggestions I received from readers like yourself. If you found this book especially useful, tell others about it. Visit http://www.amazon.com/dp/1681983346 and leave a positive review. Your feedback is what spurs me to make each one of these books better than the last. Thanks!

Canon EOS 6D Mark II Quick Start

Whether you've already taken a dozen or twelve hundred photos with your new camera, you'll want to take a more considered approach to operating your Canon EOS 6D Mark II. If you need a quick start, this chapter is designed to get your camera fired up and ready for shooting as quickly as possible. Because I realize that some of you may already have experience with advanced Canon cameras, including the previous Mark I, each of the major sections in this chapter will begin with a brief description of what is covered in that section, so you can easily jump ahead to the next if you are in a hurry to get started.

First Things First

This section helps get you oriented with all the things that come in the box with your Canon EOS 6D Mark II, including what they do. I'll also describe some optional equipment you might want to have. If you want to get started immediately, skim through this section and jump ahead to "Initial Setup" later in this chapter.

The Canon EOS 6D Mark II comes in an impressive box containing the essentials you need to get started. The first thing to do is carefully unpack the camera and double-check the contents with the checklist on one end of the box. It's better to know *now* that the video cable you *thought* was included, isn't provided by Canon.

At a minimum, the box should have the following:

- Canon EOS 6D Mark II digital camera. It almost goes without saying that you should check out the camera immediately, making sure the color LCD on the back isn't scratched or cracked, the memory card and battery doors open properly, and, when a charged battery is inserted and lens mounted, the camera powers up and reports for duty. Out-of-the-box defects like these are rare, but they can happen. It's probably more common that your dealer played with the camera or, perhaps, it was a customer return. That's why it's best to buy your 6D Mark II from a retailer you trust to supply a factory-fresh camera.
- Battery Pack LP-E6N. You'll need to charge this 7.2V, 1865mAh (milliampere hour) battery before using it. I'll offer instructions later in this chapter. It should be furnished with a protective cover, which should always be mounted on the battery when it is not inside the camera, to avoid shorting out the contacts.
- Battery Charger LC-E6/LC-E6E. One of these chargers, described in the next section, is required to vitalize the LP-E6N battery.
- Eyecup Eg. This will already be attached to the camera viewfinder, but it can be removed and replaced with other eyepiece accessories, such as a magnifier.
- Wide strap. Canon provides you with a "steal me" neck strap emblazoned with your camera model. It's not very adjustable, and, while useful for showing off to your friends exactly which nifty new camera you bought, it's probably not your best option.
 - My recommendation: I never attach the Canon strap to my cameras, and instead opt for a more serviceable strap from companies like UPstrap (www.upstrap-pro.com), which has a non-slip pad that offers reassuring traction and eliminates the contortions we sometimes go through to keep the camera from slipping off our shoulder. I prefer that type to holsters and sliding straps that attach to the tripod socket. Dangling cameras are not my thing.
- RF-3 body cap. The body cap keeps dust from infiltrating your camera when a lens is not mounted. Always carry a body cap (and rear lens cap). When not in use, the body cap/rear lens cap nest together for compact storage.
- User's manuals. Canon still provides a printed manual with the 6D Mark II, a miniature guidebook that is deceptively thick, and which provides only basic information. It's a multilanguage book, and with only 210 pages of information about the 6D Mark II in English, and an additional 44 pages on wireless communication. The remainder duplicates the same information in French and Spanish. Canon provides information on downloading more complete documentation for the camera and lenses in PDF format from the web site for your country. Even if you have my book, you'll probably want to check the printed guide from time to time, if only to check the actual nomenclature for some obscure accessory, or to double-check an error code. The PDF file is 610 pages in length.
- Warranty and registration card. Don't lose these! You can register your Canon 6D Mark II by mail, although you don't really need to in order to keep your warranty in force, but you may need the information in this paperwork (plus the purchase receipt/invoice from your retailer) should you require Canon service support.

There are a few things Canon classifies as optional accessories, even though you (and I) might consider some of them essential. Here's a list of what you *don't* get in the box, but might want to think about as an impending purchase. I'll list them roughly in the order of importance:

- **Memory card.** You'll need to purchase an SD/SDHC/SDXC memory card, if you don't already have one. The 6D Mark II supports UHS-I speeds.
 - My recommendation: For a 26.1-megapixel camera, you really need an SD memory card that's a minimum of 16GB in size, and a 32GB, 64GB, or larger card would be much better. In general, you don't need to spend the extra cash for a fast UHS-II memory card, as the 6D Mark II supports only UHS-I speeds. However, if you happen to own a USB 3.0 memory card reader that does support UHS-II transfer, you can save a bit of time offloading your memory card to your computer. You don't even need to decipher the card's label to tell whether you have a UHS-I or UHS-II card. Flip it over; the UHS-II type has an extra row of contacts located above the ones on the edge of the card.
- Extra LP-E6N/LP-E6 battery. Even though you might get 500 to nearly 1,200 shots from a single battery, it's easy to exceed that figure in a few hours of shooting sports at 6.5 fps. Batteries can unexpectedly fail, too, or simply lose their charge from sitting around unused for a week or two.
 - My recommendation: Buy an extra (I own four, in total), keep it charged, and free your mind from worry. While the latest LP-E6N version is best, if you're upgrading from a previous model that uses the original LP-E6 batteries and have a spare or two, you can use them as well.
- EOS Digital Solution Disc CD. The disc contains useful software, including Digital Photo Pro Professional, EOS Utility, Lens Registration Tool, Web Service Registration Tool, Sample Music, and the Picture Style Editor. It's no longer supplied with the camera.
 - My recommendation: Canon still offers what it calls EOS Digital Solution Disk Software as a download. However, despite the name, you're retrieving only the software (not a disc) in a self-installing format. You may have to supply your camera's serial number for access. The Canon support site for your country will also allow you to download and install the individual programs found on the "disc."
- Interface Cable IFC-400PCU. You can use this 1.5-meter/4.9-foot cable to transfer photos from the camera to your computer (not recommended), to upload and download settings between the camera and your computer (highly recommended), and to operate your camera remotely using the Canon software. Canon has recently stopped supplying this cable in the box with the camera.
 - My recommendation: I don't recommend using the cable to transfer images. Direct transfer uses a lot of battery power, and is potentially slower.

■ Add-on Speedlite. Like most pro cameras, the Canon 6D Mark II does not include a built-in electronic flash, so you'll need an off-camera Speedlite such as the Canon 600EX II-RT, which was designed especially for cameras in this class.

My recommendation: Your add-on flash can function as the main illumination for your photo, or softened and used to fill in shadows. If you do much flash photography at all, consider a Speedlite as an important accessory. For the most flexibility when lighting your subject, you'll need *two* flash units: one on the camera to be used as a master, and one off-camera flash triggered wirelessly as a slave. Canon also offers the ST-E2 and ST-E3-RT transmitter/triggers, which can serve as masters.

■ AC Adapter Kit ACK-E6. This device is used with a *DC coupler*, the DR-E6, that replaces the LP-E6N battery and powers the Canon 6D Mark II from AC current.

My recommendation: There are several typical situations where this capability can come in handy: when you're cleaning the sensor manually and want to totally eliminate the possibility that a lack of juice will cause the fragile shutter and mirror to spring to life during the process; when indoors shooting tabletop photos, portraits, class pictures, and so forth for hours on end; when using your 6D Mark II for remote shooting as well as time-lapse photography; for extensive review of images on your television; or for file transfer to your computer. These all use prodigious amounts of power, which can be provided by this AC adapter.

- Angle Finder C right-angle viewer. This handy accessory fastens in place of the standard rubber eyecup and provides a 90-degree view for framing and composing your image at right angles to the original viewfinder, useful for low-level (or high-level) shooting. (Or, maybe, shooting around corners!)
- HDMI cable HTC-100. You'll need this optional cable if you want to connect your camera directly to an HDTV for viewing your images. Because standard-definition television sets are on the way out, Canon no longer supports the Stereo AV Cable AVC-DC400ST, which could be used with previous cameras to connect to an analog television through the set's yellow RCA video jack and red/white RCA audio jacks.

My recommendation: If you don't want to spring for the Canon HTC-100 cable, a standard HDMI mini C cable works fine.

Initial Setup

Most 6D Mark II owners can skip this section, which describes basic setup steps. I'm including it at the request of ambitious photo buffs who have upgraded to this advanced camera after switching from another brand or an entry-level model.

The initial setup of your Canon EOS 6D Mark II is fast and easy. Basically, you just need to charge the battery, attach a lens, insert a memory card, and make a few settings.

Power Options

Your Canon EOS 6D Mark II is a sophisticated hunk of machinery and electronics, but it needs a charged battery to function, so rejuvenating the LP-E6N lithium-ion battery pack furnished with the camera should be your first step. A fully charged power source should be good for approximately 1,200 shots, based on standard tests defined by the Camera & Imaging Products Association (CIPA) document DC-002. The figure was arrived at based on a fully charged battery and no use of live view or movie settings.

All rechargeable batteries undergo some degree of self-discharge just sitting idle in the camera or in the original packaging. Lithium-ion power packs of this type typically lose a small amount of their charge every day, even when the camera isn't turned on. The small amount of juice used to provide the "skeleton" outline on the top-panel monochrome LCD when the 6D Mark II is turned off isn't the culprit; Li-ion cells lose their power through a chemical reaction that continues when the camera is switched off. So, it's very likely that the battery purchased with your camera is at least partially pooped out, so you'll want to revive it before going out for some serious shooting.

Several additional battery chargers are available for the Canon EOS 6D Mark II. The included compact LC-E6 is the charger that most 6D Mark II owners end up using. Purchasing one of the optional charging devices offers more than some additional features: You gain a spare that can keep your camera running until you can replace your primary power rejuvenator. I like to have an extra charger in case my original charger breaks, or when I want to charge more than one battery at a time. (That's often the case if your using the BG-E21 grip.) Here's a list of your power options:

- LC-E6. The standard charger for the 6D Mark II (and also compatible with earlier cameras that use the LC-E6 or LC-E6N batteries), this one is the most convenient, because of its compact size and built-in wall plug prongs that connect directly into your power strip or wall socket and require no cord. (See Figure 1.1, left.)
- LC-E6E. This is similar to the LC-E6, and also charges a single battery, but requires a cord. That can be advantageous in certain situations. For example, if your power outlet is behind a desk or in some other semi-inaccessible location, the cord can be plugged in and routed so the charger itself sits on your desk or another more convenient spot. The cord is standard and works with many different chargers and devices (including the power supply for my laptop), so I purchased several of them and leave them plugged into the wall in various locations. I can connect my 6D Mark II's charger, my laptop computer's charger, and several other electronic components to one of these cords without needing to crawl around behind the furniture. The cord draws no power when it's not plugged into a charger. Unhook the charger from the cord when you're not actively rejuvenating your batteries.
- Car Battery Cable CBC-E6. It includes the charger (plug into your vehicle's lighter or accessory socket). The vehicle battery option allows you to keep shooting when in remote locations that lack AC power.

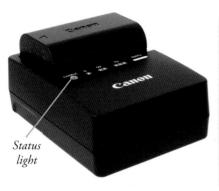

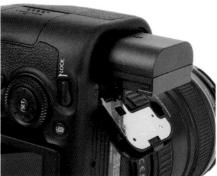

Figure 1.1
The flashing status light indicates that the battery is being charged (left). Insert the battery in the camera; it only fits one way (right).

- Battery Grip BG-E21. This accessory holds one or two LC-E6N batteries. You can potentially double your shooting capacity, while adding an additional shutter release, Main Dial, AE lock/FE lock, and AF point selection controls for vertically oriented shooting.
- AC Adapter Kit ACK-E6. As I mentioned earlier, this device allows you to operate your EOS 6D Mark II directly from AC power, with no battery required. Studio photographers need this capability because they often snap off hundreds of pictures for hours on end and want constant, reliable power. The camera is probably plugged into a flash sync cord (or radio device), and the studio flash are plugged into power packs or AC power, so the extra tether to this adapter is no big deal in that environment. You also might want to use the AC adapter when viewing images on a TV connected to your 6D Mark II, shooting video, or when shooting remote or time-lapse photos.

Charging the Battery

When the battery is inserted into the LC-E6 charger properly (it's impossible to insert it incorrectly), a Charge light begins flashing. It flashes on and off until the battery reaches a 50 percent charge, then blinks in two-flash cycles between 50 and 75 percent charged, and in a three-flash sequence until the battery is 90 percent charged, usually within about 90 minutes. You should allow the charger to continue for about 60 minutes more, until the status lamp glows green steadily, to ensure a full charge. When the battery is charged, flip the lever on the bottom of the camera and slide in the battery (see Figure 1.1, right). To remove the battery from the camera, press the white retaining button.

Final Steps

Your Canon EOS 6D Mark II is almost ready to fire up and shoot. You'll need to select and mount a lens, adjust the viewfinder for your vision, and insert a memory card. Each of these steps is easy, and if you've used a previous EOS model, you already know exactly what to do. I'm going to provide a little extra detail for those of you who are new to the Canon or digital SLR worlds.

EF-S LENSES NOT WELCOME

If you've used any of Canon's non-full-frame cameras with the 1.6X crop factor (more on that in Chapter 7), you may have worked with the EF-S lenses that can be mounted on those models. They feature a square white alignment indicator on the barrel, which mates with a similar indicator on the camera lens mount. These EF-S lenses *cannot* be used with the 6D Mark II; the rear lens elements extend back into the camera body too far, and would strike the mirror. You can't use EF-S lenses on any of Canon's full-frame cameras, nor on earlier 1.3X crop models or 1.6X crop models prior to the EOS 20D, such as the EOS 10D.

Mounting the Lens

As you'll see, my recommended lens mounting procedure emphasizes protecting your equipment from accidental damage, and minimizing the intrusion of dust. If your 6D Mark II has no lens attached, select the lens you want to use and loosen (but do not remove) the rear lens cap. I generally place the lens I am planning to mount vertically in a slot in my camera bag, where it's protected from mishaps, but ready to pick up quickly. By loosening the rear lens cap, you'll be able to lift it off the back of the lens at the last instant, so the rear element of the lens is covered until then.

After that, remove the body cap by rotating the cap toward the shutter release button. You should always mount the body cap when there is no lens on the camera, because it helps keep dust out of the interior of the camera, where it can settle on the mirror, focusing screen, interior mirror box, and potentially find its way past the shutter onto the sensor. (While the 6D Mark II's sensor cleaning mechanism works fine, the less dust it has to contend with, the better.) The body cap also protects the vulnerable mirror from damage caused by intruding objects (including your fingers, if you're not cautious).

Once the body cap has been removed, remove the rear lens cap from the lens, set it aside, and then mount the lens on the camera by matching the raised red alignment indicator on the lens barrel with the red dot on the camera's lens mount. Rotate the lens away from the shutter release until it seats securely. Set the focus mode switch on the lens to AF (autofocus). If the lens hood is bayoneted on the lens in the reversed position (which makes the lens/hood combination more compact for transport), twist it off and remount with the edge facing outward. A lens hood protects the front of the lens from accidental bumps, stray fingerprints, and reduces flare caused by extraneous light arriving at the front element of the lens from outside the picture area.

Adjusting Diopter Correction

Those of us with less than perfect eyesight can often benefit from a little optical correction in the viewfinder. Your contact lenses or glasses may provide all the correction you need, but if you are a glasses wearer and want to use the EOS 6D Mark II without your glasses, you can take advantage of the camera's built-in diopter adjustment, which can be varied from -3 to +1 correction. Press the shutter release halfway to illuminate the indicators in the viewfinder, then rotate the diopter

adjustment control next to the viewfinder (see Figure 1.2) while looking through the viewfinder until the indicators appear sharp. Technically, you should make the dioptric adjustment using the image frame itself, but the virtual position of the indicators is close enough, and usually easier to focus on.

If the available correction is insufficient, Canon offers 10 different Dioptric Adjustment Lens Series E correction lenses for the viewfinder window. If more than one person uses your 6D Mark II, and each requires a different diopter setting, you can save a little time by noting the number of clicks and direction (clockwise to increase the diopter power; counterclockwise to decrease the diopter value) required to change from one user to the other.

Inserting a Memory Card

You can't take photos without a memory card inserted in your EOS 6D Mark II (although there is a Release Shutter Without Card entry in the Shooting 1 menu that enables/disables shutter release functions when a memory card is absent—covered in Chapter 11). So, your final step will be to insert a memory card. Slide the door on the right side of the body toward the back of the camera to release the cover, and then open it. (You should only remove the memory card when the camera is switched off, but the 6D Mark II will remind you if the door is opened while the camera is still writing photos to the memory card.)

Insert the memory card into the slot with the label facing the back of the camera, as shown in Figure 1.3, oriented so the edge with the double row of tiny holes (on the CF card) or gold contacts (on the SD card) go into the slot first. Close the door, and your preflight checklist is done! (I'm going to assume you remember to remove the lens cap when you're ready to take a picture!) When you want to remove the memory card later, press down on the SD card to make the memory card pop out.

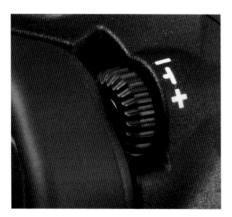

Figure 1.2 Viewfinder diopter correction from –3 to +1 can be dialed in.

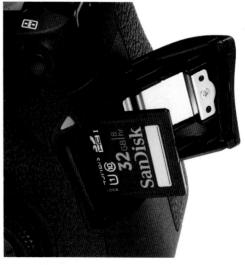

Figure 1.3 Insert the memory card in the slot with the label facing the back of the camera.

Formatting a Memory Card

There are three ways to create a blank memory card for your 6D Mark II, and two of them are at least partially wrong. Here are your options, both correct and incorrect:

- Transfer (move) files to your computer. When you transfer (rather than copy) all the image files to your computer from the memory card (either using a direct cable transfer or with a card reader, as described later in this chapter), the old image files are erased from the card, leaving the card blank. Theoretically. This method does *not* remove files that you've labeled as Protected (choosing the Protect images function in the Playback menu) nor does it identify and lock out parts of your memory card that have become corrupted or unusable since the last time you formatted the card. Therefore, I recommend always formatting the card, rather than simply moving the image files, each time you want to make a blank card. The only exception is when you *want* to leave the protected/unerased images on the card for awhile longer, say, to share with friends, family, and colleagues.
- (Don't) Format in your computer. With the memory card inserted in a card reader or card slot in your computer, you can use Windows or Mac OS to reformat the memory card. Don't! The operating system won't necessarily arrange the structure of the card the way the 6D Mark II likes to see it (in computer terms, an incorrect *file system* may be installed). The only way to ensure that the card has been properly formatted for your camera is to perform the format in the camera itself. The only exception to this rule is when you have a seriously corrupted memory card that your camera refuses to format. Sometimes it is possible to revive such a corrupted card by allowing the operating system to reformat it first, then trying again in the camera.
- Setup menu format. To use the recommended method to format a memory card, press the MENU button, rotate the Main Dial (located on top of the camera, just behind the shutter release button), choose the Set-up 1 menu (which is represented by a wrench icon), use the Quick Control Dial (that round wheel to the right of the LCD) to navigate to the last entry, Format, and press the SET button in the center of the dial to access the Format screen. Press the SET button and the screen shown in Figure 1.4 appears. If you want to perform an extrathorough low-level format on the card, press the Trash button (on the bottom-right edge of the back of the camera) to insert a check mark in the box. Then select OK and press SET one final time to begin the format process.

HOW MANY SHOTS REMAINING?

Don't be daunted by the camera's apparent inability to tell you how many shots you have left on the top-panel monochrome LCD. The counter on the control panel shows only 1999 shots remaining, maximum, even though your memory card has much more capacity remaining. It is easy to exceed that number with today's high-capacity memory cards. Fortunately, the 6D Mark II can indicate up to 9999 images remaining on rear LCD monitor, so even if you're using a huge card and shooting in the smallest JPEG size (S3), your shots remaining count will overflow that display only rarely.

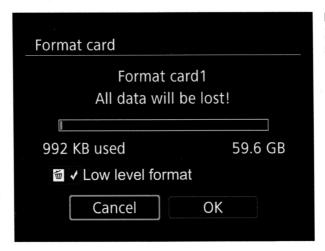

Figure 1.4 Formatting a memory card.

Setting the Time and Date

The first time you use the Canon EOS 6D Mark II, it may ask you to enter the time and date. (This information may have been set by someone checking out your camera on your behalf prior to sale.) Just follow these steps:

- 1. Press the MENU button, located in the upper-left corner of the back of the 6D Mark II.
- 2. Rotate the Main Dial (near the shutter release button on top of the camera) until the Set-up 2 menu is highlighted. It's marked by a wrench and the message SET UP2, as shown at left in Figure 1.5.
- 3. Rotate the Quick Control Dial (QCD) to move the highlighting down to the Date/Time entry.

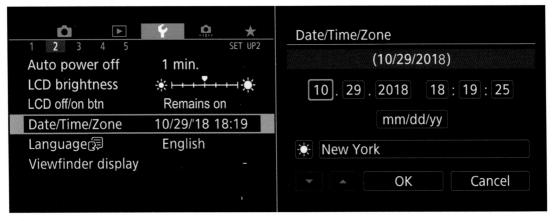

Figure 1.5 Choose the Date/Time entry from the Set-up 2 menu and set the parameters.

- 4. Press the SET button in the center of the QCD to access the Date/Time/Zone setting screen, shown at right in Figure 1.5. (The location of the Main Dial and QCD are shown at left and right [respectively] in Figure 1.6.)
- 5. Rotate the QCD to select the value you want to change. When the gold box highlights the month, day, year, hour, minute, or second format you want to adjust, press the SET button to activate that value. A pair of up/down pointing triangles appears above the value.
- 6. Rotate the Quick Control Dial to adjust the value up or down. Press the SET button to confirm the value you've entered.
- 7. Repeat steps 5 and 6 for each of the other values you want to change. The date format can be switched from the default mm/dd/yy to yy/mm/dd or dd/mm/yy. You can activate/deactivate Daylight Saving Time, and select a Time Zone.
- 8. When finished, rotate the QCD to select either OK (if you're satisfied with your changes) or Cancel (if you'd like to return to the Set-up 2 menu screen without making any changes). Press SET to confirm your choice.
- 9. When finished setting the date and time, press the MENU button to exit.

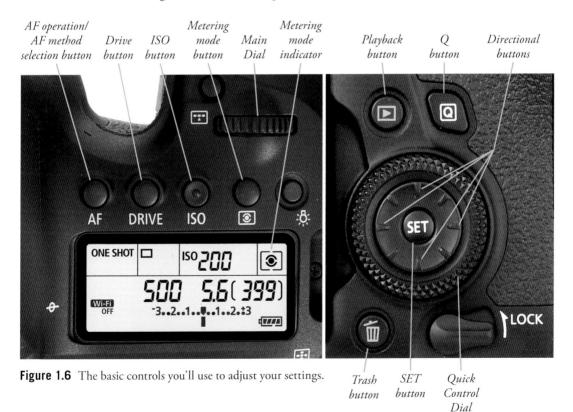

REACH OUT AND TOUCH SOMETHING

Your Canon EOS.6D Mark II has a touch-sensitive screen that is useful for navigating menus, selecting focus points, and other functions. In many cases, you can use the buttons and dials and the touch screen almost interchangeably, but for this Quick Start chapter I'm going to stick to using the physical controls instead of the touch controls. There are two reasons for that. First, it's important you become comfortable using the buttons and dials, because for many functions they are faster, sometimes easier, and work reliably even when your fingers are "encumbered" (say, while you're wearing gloves). In addition, this introductory chapter is intended primarily for those new to the Canon pro world, and I think it's a good idea to give equal weight to the "quick" and "start" of the chapter title. I'll explain how to use the touch screen in Chapter 2.

Selecting a Shooting Mode

The following sections show you how to choose semi-automatic, automatic shooting, or exposure modes; select a metering mode (which tells the camera what portions of the frame to evaluate for exposure); and set the basic autofocus functions.

Now it's time to fire up your EOS 6D Mark II and take some photos. The easy part is turning on the power—that OFF/ON switch on the top-left shoulder of the camera, nestled next to the Mode Dial (see Figure 1.7). Turn on the camera, and, if you mounted a lens and inserted a fresh battery and memory card, you're ready to begin. You'll need to select a shooting mode, metering mode, and focus mode.

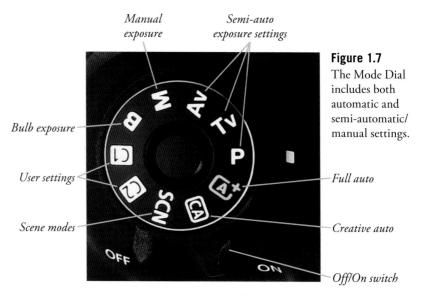

You can choose a shooting method from the Mode Dial located on the top-left edge of the 6D Mark II. To rotate the dial, you must press the button in the center to release the dial lock. The camera has one fully automatic mode called Scene Intelligent Auto, which makes virtually all the decisions for you (except when to press the shutter). The Mode Dial also has a SCN position for selecting Scene modes suitable for typical types of subjects (such as Sports or Landscapes), and Creative Auto, which does allow changing some parameters.

The 6D Mark II also has five *semi-automatic/manual* modes (what Canon calls Creative Zone modes), including Program, Shutter-priority, Aperture-priority, Manual, and Bulb, which allow you to provide input over the exposure and settings the camera uses. There are also two camera user settings (Custom shooting modes) that can be used to store specific groups of camera settings, which you can then recall quickly by spinning the Mode Dial to C1 or C2. You'll find a complete description of fully automatic and semi-automatic/manual modes in Chapter 4, as well as Custom shooting modes in Chapter 13.

Turn your camera on by flipping the power switch to ON. Next, you need to select which shooting mode to use. If you're very new to digital photography, you might want to set the camera to Auto (the green frame on the Mode Dial) or P (Program mode) and start snapping away. These modes will make all the appropriate settings for you for many shooting situations.

Semi-Auto/Manual Modes

Here is a list of the five Creative Zone modes available from the Mode Dial. I'll provide additional information about Special Scene and Creative Auto modes shortly.

- P (Program). This semi-automatic mode allows the 6D Mark II to select the basic exposure settings, but you can still override the camera's choices to fine-tune your image.
- **Tv** (**Shutter-priority**). This mode (Tv stands for *time value*) is useful when you want to use a particular shutter speed to stop action or produce creative blur effects. The 6D Mark II will select the appropriate f/stop for you.
- **Av** (**Aperture-priority**). Choose when you want to use a particular lens opening, especially to control sharpness or how much of your image is in focus. The 6D Mark II will select the appropriate shutter speed for you. Av stands for *aperture value*.
- M (Manual). Select when you want full control over the shutter speed and lens opening, either for creative effects or because you are using a studio flash or other flash unit not compatible with the 6D Mark II's automatic flash metering.
- **B** (Bulb). Choose this mode and the shutter will remain open as long as you hold down the release button. It is useful for making exposures of indeterminate length (say, you want to capture some fireworks, and leave the shutter open until a burst appears, then release the shutter after a few seconds when the light trails have been captured). The B setting can also be used to produce exposures longer than the 30 seconds (maximum) the 6D Mark II can take automatically.

Basic Zone Modes

Here is a list of two of the Basic Zone modes available from the Mode Dial. I'll provide additional information about Special Scene modes next.

- Scene Intelligent Auto/Full Auto. In this mode, marked with a green A+ icon, the EOS 6D Mark II makes all the exposure decisions for you.
- Creative Auto. This Creative Auto mode is basically the same as the Full Auto option, but allows you to change the brightness and other parameters of the image. The 6D Mark II still makes most of the decisions for you, but you can make some simple adjustments using the Creative Auto setting screen that appears when you press the Quick Control button (located on the back of the camera to the right of the LCD monitor). You can find instructions for using this mode and the other shooting modes in Chapter 4.

Special Scene Modes

With the dial in the SCN position, you can select any of 12 Special Scene modes. When the screen appears, you can press the Q button (located on the right back panel of the camera, just above the Quick Control dial and shown earlier in Figure 1.6) to continue to a screen with your options listed in a vertical column. Use the up/down arrows to highlight the scene mode you want to work with, and choose SET. I'll show you how to make the small set of adjustments allowed when working with Special Scene modes in Chapter 4.

- **Portrait.** Use this mode when you're taking a portrait of a subject standing relatively close to the camera and want to de-emphasize the background, maximize sharpness, and produce flattering skin tones.
- **Group photo.** Provides settings that help ensure everyone in a group shot is in acceptably sharp focus.
- Landscape. Select this mode when you want extra sharpness and rich colors of distant scenes.
- **Sports.** Use this mode to freeze fast-moving subjects.
- **Kids.** Produces pleasant skin tones, with bright colors and a fast-enough shutter speed to allow sharp pictures of rampaging children.
- Panning. Chooses a slow shutter speed so you can pan the camera to follow action, producing a (relatively) sharp subject against a blurred background.
- **Close-up.** This mode is helpful when you are shooting close-up pictures of a subject from about one foot away or less.
- **Food.** Gives you bright and vivid colors, to make your food look more appetizing than it probably was in real life. Shooting pictures of your food has become almost mandatory when dining out, thanks to Instagram.
- Candlelight. Preserves the warm, pleasant colors found in subjects illuminated by candlelight. The built-in flash is disabled, but if you have an external Speedlite connected and powered up, it will fire anyway and spoil your picture. Turn it off!

- **Night Portrait.** Choose this mode when you want to illuminate a subject in the foreground with flash, but still allow the background to be exposed properly by the available light. Be prepared to use a tripod or an image-stabilized (IS) lens to reduce the effects of camera shake. (You'll find more about IS and camera shake in Chapter 10.)
- Handheld Night Scene. The 6D Mark II takes four continuous shots and combines them to produce a well-exposed image with reduced camera shake.
- HDR Backlight Control. The 6D Mark II takes three continuous shots at different exposures and combines them to produce a single image with improved detail in the highlights and shadows.

Choosing a Metering Mode

Metering mode is the next setting you'll want to make. Note that for this and the settings that follow, the 6D Mark II must be set to one of the semi-automatic and manual modes and *not* to Scene Intelligent Auto or a Scene mode. Among the four metering modes I'll describe next, the default Evaluative metering is probably the best choice as you get to know your camera. To change metering modes, press the Metering button (seen in Figure 1.6, which also shows the Main Dial and other controls). The screen shown in Figure 1.8 appears for about six seconds, waiting for your input.

GETTING INFO

If the expected screen does not appear on the LCD monitor, press the INFO. button several times until it is shown. One of the most frequent queries I get from new users asks why, when they follow the directions in my book, the illustrated screen isn't shown. In virtually all cases, it's because the photographer has turned off the LCD display using the INFO. button on the back of the camera to the left of the viewfinder.

Figure 1.8

Metering modes
(left to right):
Evaluative, Partial,
Spot, Centerweighted.

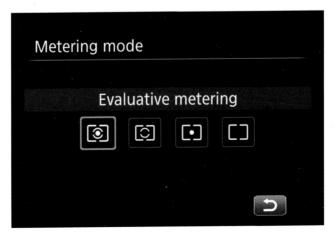

Spin the Main Dial to cycle among the following choices:

- Evaluative metering. The standard metering mode; the 6D Mark II attempts to intelligently classify your image and choose the best exposure based on readings from a 7,500-pixel exposure sensor in the viewfinder that detects RGB (red/green/blue) and infrared illumination levels within a 63-zone metering area.
- Partial metering. Exposure is based on a central spot, roughly 6.5 percent of the image area.
- **Spot metering.** Exposure is calculated from a smaller central spot, about 3.2 percent of the image area, located in the center of the frame.
- Center-weighted averaging metering. The 6D Mark II meters the entire scene, but gives the most emphasis to the central area of the frame.

You'll find a detailed description of each of these modes in Chapter 4.

Choosing a Focus Mode

You can easily switch between automatic and manual focus by moving the AF/MF switch on the lens mounted on your camera. However, if you're using a semi-automatic shooting mode, you'll still need to choose an appropriate focus mode. (You can read more on selecting focus parameters in Chapter 5.)

To set the focus mode, press what Canon calls the AF Operation/AF Method Selection button on the top panel of the camera and marked with an AF label (AF Operation and AF Method Selection are the same thing). The screen shown in Figure 1.9 appears on the LCD monitor. If you spin the Main Dial within about six seconds after the screen appears, you can select one of the three AF methods from the AF Operation screen.

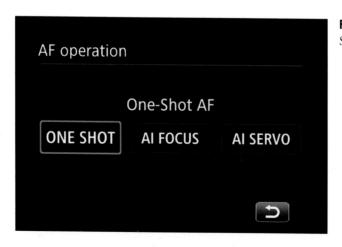

Figure 1.9Set autofocus mode.

The three choices are as follows:

- One-Shot. This mode, sometimes called *single autofocus*, locks in a focus point when the shutter button is pressed down halfway, and the focus confirmation light glows in the viewfinder. The focus will remain locked until you release the button or take the picture. If the camera is unable to achieve sharp focus, the focus confirmation light will blink. This mode is best when your subject is relatively motionless.
- AI Servo. This mode, sometimes called *continuous autofocus*, sets focus when you partially depress the shutter button, but continues to monitor the frame and refocuses if the camera or subject is moved. This is a useful mode for photographing sports and moving subjects.
- AI Focus. In this mode, the 6D Mark II switches between One-Shot and AI Servo as appropriate. That is, it locks in a focus point when you partially depress the shutter button (One-Shot mode), but switches automatically to AI Servo if the subject begins to move. This mode is handy when photographing a subject, such as a child at quiet play, which might move unexpectedly.

Selecting a Focus Point

The Canon EOS 6D Mark II uses up to 45 different focus points to calculate correct focus. In Full Auto mode, the focus point is selected automatically by the camera. In the other semi-automatic modes, you can allow the camera to select the focus point automatically, or you can specify which focus point should be used.

Your camera has five different ways of specifying the method that will be used to choose which focus points are selected by the camera automatically, or by the user manually. The choices can vary, depending on the lens mounted on the camera. (I'll cover these in detail in Chapters 5 and 12.) Your options are as follows:

- Single-point Spot AF (Manual Selection). Allows you to manually select a single, reduced-size AF point.
- Single-point AF (Manual Selection). For manual selection of a single, slightly larger AF point.
- **Zone AF (Manual Selection of Zone).** AF points are segregated into nine zones, and you can select which zone to use.
- Large Zone AF (Manual Selection of Zone). AF points are segregated into three zones (the left, center, and right clusters of AF points), and you can select which zone to use.
- Automatic Selection AF. The camera selects one or more focus points automatically within the entire AF area, and highlights them in red in the viewfinder.

The 6D Mark II offers several ways of choosing the AF area selection mode. (I'll explain them all in Chapter 5.) The fastest way is to press the AF Area Selection button located on top of the camera (seen at left in Figure 1.10). Here's a quick how-to on choosing the AF area mode:

- 1. **Press the AF Area Selection button.** It's located just northwest of the Main Dial on top of the camera.
- 2. **Select AF selection method.** As you press the AF Area Selection button, the screen shown at right in Figure 1.10 appears and will remain for about six seconds if you take no further action. The highlighting will indicate which mode is selected. Note that the nomenclature that appears on the screen for the modes differs slightly from that used in the Canon manual (and which I've used in the bullet points above). A similar indicator, without the text labels, appears in the viewfinder frame. You might want to use that to change modes while the 6D Mark II is up to your eye, after you've learned what each mode does. The AF method mode is also shown on the top-surface LCD panel.
- 3. **Press the AF Area Selection button several times.** Each press will cycle to the next selection method, and then wrap around to the first again.

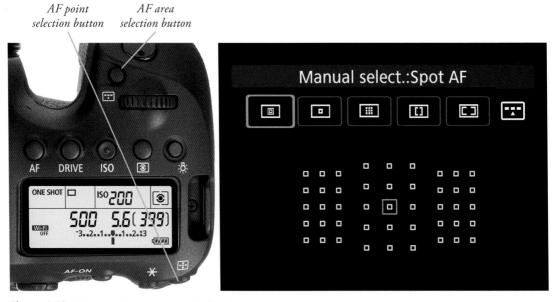

Figure 1.10 Choose AF selection method and points or zone.

Once you've chosen your AF method mode, there are several ways to set the focus point in any of the four manual selection modes:

- Press the AF point selection button. Don't confuse this button, located on the back of the camera, with the AF Area Selection button near the Main Dial. The screen shown at right earlier in Figure 1.10 appears.
- In Single Point AF or Single Point Spot mode, use the Main Dial to move the selected point, left or right in the array, and the Quick Control Dial to move the point up or down.
- In Zone AF mode, use the directional buttons to move the zones up, down, left, or right. The QCD and Main Dial both cycle the zones around within the 45-point area.
- In Large Zone AF mode, the left/right directional buttons, QCD, and Main Dial move the zones from left to right only.
- In Automatic Selection AF mode, the point(s) are chosen by the camera, and can't be manually specified.

SIX-SECOND RULE

Many informational and settings screens, such as the AF Point Selection screen, will be "live" for about 6 to 14 seconds after you've pressed the relevant button. I won't repeat that information for every setting in this book; if a screen vanishes, just press the appropriate button once more.

Using the Self-Timer

If you want to set a short delay before your picture is taken, you can use the self-timer. Press the DRIVE button (the screen shown earlier in Figure 1.9 will appear) and rotate the Quick Control Dial until one of the three the self-timer icons appear, as shown in the bottom row of Figure 1.11. From left to right, they are 10 Second Delay, 2 Second Delay, and 10 Second Delay plus Consecutive Shots. (When the last is highlighted, you can rotate the QCD to specify the number of pictures [from 2 to 10] to be taken after the self-timer elapses.)

Press the shutter release to lock focus and start the timer. The self-timer lamp will blink and the beeper will sound (unless you've silenced it in the menus) until the final two seconds, when the lamp remains on and the beeper beeps more rapidly.

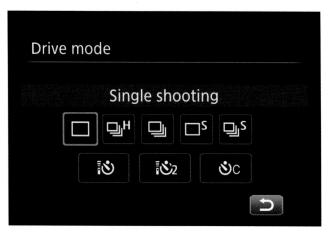

Figure 1.11Choose self-timer or other drive mode.

Taking a Picture

This final section of the chapter guides you through taking your first pictures, reviewing them on the LCD monitor, and transferring your shots to your computer.

Press the shutter release button halfway to lock in focus at the selected autofocus point for a few seconds. When the shutter button is in the half-depressed position, the exposure, calculated using the shooting mode you've selected, is also locked.

Press the button the rest of the way down to take a picture. At that instant, the mirror flips up out of the light path to the optical viewfinder (assuming you're not using Live View mode, discussed in Chapter 14), the shutter opens, the electronic flash (if attached and enabled) fires, and your 6D Mark II's sensor absorbs a burst of light to capture an exposure. In fractions of a moment, the shutter closes, the mirror flips back down restoring your view, and the image you've taken is escorted off the CMOS sensor chip very quickly into an in-camera store of memory called a buffer, and the EOS 6D Mark II is ready to take another photo. The buffer continues dumping your image onto the memory card as you keep snapping pictures without pause (at least until the buffer fills and you must wait for it to get ahead of your continuous shooting, or your memory card fills completely).

Reviewing the Images You've Taken

The Canon EOS 6D Mark II has a broad range of playback and image review options. Here are the basics, as shown in Figure 1.12. I'll explain more choices, such as rotating the image on review, in Chapter 2:

- **Display image.** Press the Playback button (marked with a blue right-pointing triangle on the right back panel of the 6D Mark II) to display the most recent image on the LCD monitor in full-screen single-image mode. If you last viewed your images using the thumbnail mode (described later in this list), the Index display appears instead.
- View additional images. Rotate the Quick Control Dial to review additional images, one at a time. Turn it counterclockwise to review images from most recent to oldest, or clockwise to start with the first image on the memory card and cycle forward to the newest. (You can also move among images using the touch screen, as I'll explain in Chapter 2.)
- Jump ahead or back. When you're using the single-image display (not zoomed or viewing reduced-size thumbnail images), you can zip through your shots more quickly to find a specific image. Just rotate the Main Dial to leap ahead or back 1, 10, or 100 images or another method, depending on the increment you've set using the last entry in the Playback 2 menu. I find the 6D Mark II's use of the Main Dial is faster. You can also jump ahead by screens of images, by

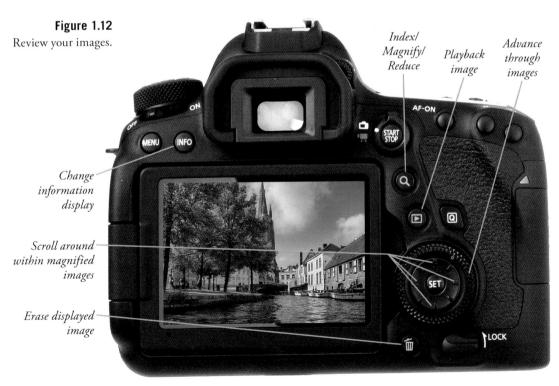

date, or by folder, and jump among movies, stills, or image "rating." (You can mark favorite images with one to four stars, as I'll explain when I show you how to select all these Playback options in Chapter 12.)

- **View image information.** Press the INFO. button repeatedly to cycle among overlays of basic image information, detailed shooting information, or no information at all.
- Zoom in on an image. When an image is displayed full-screen on your LCD, press the Magnify/Reduce button (located on the back right of the camera) and rotate the Main Dial to zoom in or out. Press the Playback button to exit magnified display. I'll show you how to specify how much magnification is applied (from 1.5X up to 10X is available) using the Playback 3 menu, in Chapter 12. Pinching and spreading two fingers on the touch screen can also be used to zoom in and out.
- Scroll around in a magnified image. Press the Magnify/Enlarge button, then use the directional buttons to scroll around within a magnified image.
- View thumbnail images. You can also rapidly move among a large number of images using the Index mode described in the section that follows this list.
- Access functions. While reviewing pictures in full-image view, you can press the Q button to produce a Quick Control screen that gives you access to many simple functions. You can protect or rate images, resize them, change the jumping method, rotate them, perform RAW image processing, enable or disable highlight alerts, and activate/deactivate AF point display. When the Quick Control screen is visible, use the multi-controller joystick to select the function to perform.

Cruising through Index Views

You can navigate quickly among thumbnails representing a series of images using the 6D Mark II's Index mode. Here are your basic options.

- Display thumbnails. Press the Playback button to display an image on the color LCD monitor. If you last viewed your images using Index mode, an array of images appears automatically (see Figure 1.13). If an image pops up full-screen in single-image mode, press the Magnify/Reduce button once. Then, you can switch between 4, 9, 36, 100, and back to single-image view by rotating the Main Dial counterclockwise. A few clicks will take you from magnified view to the four-image index view (and continuing to rotate counterclockwise will produce fewer/larger index images), while clockwise switches to fewer index images and back to single-image mode.
- Navigate within a screen of index images. In Index mode, use the QCD or multi-controller directional buttons to move the highlight box around within the current Index display screen.
- Check image. When an image you want to examine more closely is highlighted, press the SET button until the single-image version appears full-screen on your LCD.

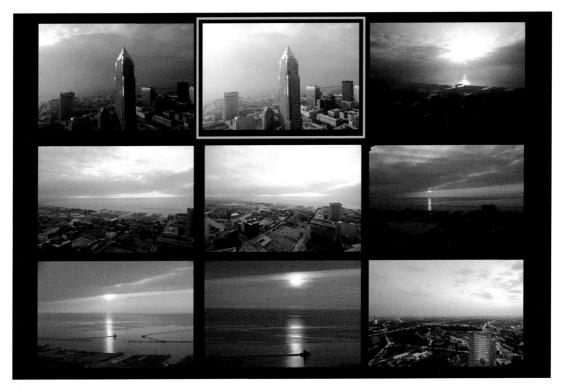

Figure 1.13 Review thumbnails of 4, 9, 36, or 100 images using Index review.

Transferring Photos to Your Computer

The final step in your picture-taking session will be to transfer the photos you've taken to your computer for printing, further review, or image editing. Your 6D Mark II allows you to print directly to PictBridge-compatible printers and to create print orders right in the camera.

For now, you'll probably want to transfer your images either by using a cable transfer from the camera to the computer or by removing the memory card from the 6D Mark II and transferring the images with a card reader. The latter option is generally the best, because it's usually much faster and doesn't deplete the battery of your camera. However, you can use a cable transfer when you have the cable and a computer, but no card reader (perhaps you're using the computer of a friend or colleague, or at an Internet café).

To transfer images from the camera to a Mac or PC computer using the USB cable:

- 1. Turn off the camera.
- 2. Pry back the rubber cover that protects the EOS 6D Mark II's USB port, and plug an optional USB cable into the USB port. (See Figure 1.14.)

- 3. Connect the other end of the USB cable to a USB port on your computer.
- 4. Turn on the camera. Your installed software usually detects the camera and offers to transfer the pictures, or the camera appears on your desktop as a mass storage device, enabling you to drag and drop the files to your computer.

To transfer images from a memory card to the computer using a card reader:

- 1. Turn off the camera.
- 2. Slide open the memory card door, press the gray button, and press down on the SD card to pop it up for removal.
- 3. Insert the memory card into your memory card reader. Your installed software detects the files on the card and offers to transfer them. The card can also appear as a mass storage device on your desktop, which you can open and then drag and drop the files to your computer.

Canon EOS 6D Mark II Roadmap

While it might take some time to learn the position and function of each of the EOS 6D Mark II's controls, once you've mastered them the camera is remarkably easy to use. That's because dedicated buttons with only one or two functions each are much faster to access than the alternative—a maze of menus that must be navigated every time you want to use a feature. The advantage of menu systems—dating back to early computer user interfaces of the 1980s—is that they are easy to *learn*. The ironic disadvantage of menus is that they are clumsy to *use* because they require so many more steps.

NOTE

When I ask you to *press* or *tap* in this book, I mean you should press and release a button or tap the touch screen (described later). The 6D Mark II will then give you some time (6 to 16 seconds, depending on the function) to make an adjustment. When I am asking you to keep a button depressed while using another control, I'll say *hold*. For many functions, the camera's exposure meters must be active; just tap the shutter release button lightly to wake them up.

While your Canon manual includes a few black-and-white drawings impaled with dozens of labels, I prefer to give you a (hyphen-filled) up-close-and-personal, full-color, street-level roadmap with many different views and lots of explanation accompanying each zone of the camera. By the time you finish this chapter, you'll have a basic understanding of every control and what it does. I'm not going to delve into menu functions here—you'll find a discussion of your Set-up, Shooting, and Playback menu options in Chapters 11, 12, and 13. Everything here is devoted to the button pusher and dial twirler in you.

You'll also find this "roadmap" chapter a good guide to the rest of the book, as well. I'll try to provide as much detail here about the use of the main controls as I can, but some topics (such as autofocus and exposure) are too complex to address in depth right away. So, I'll point you to the relevant chapters that discuss things like set-up options, exposure, use of electronic flash, and working with lenses with the occasional cross-reference.

Front View

The front of the 6D Mark II is the face seen by your subjects as you snap away. For the photographer, though, the front is the surface your fingers curl around as you hold the camera, and there are only two buttons to press while shooting—the shutter release and depth-of-field button, plus the Main Dial. There are additional controls on the lens itself, plus the lens release button you'll use only when swapping optics. Figure 2.1 is a view of the front of the EOS 6D Mark II with the lens detached. The other main components you need to know about are as follows:

- Shutter release button. Angled on top of the hand grip is the shutter release button. Press this button down halfway to lock exposure and focus (in One-Shot mode and AI Focus with non-moving subjects). Press all the way to take the picture. Tapping the shutter release when the camera has turned off the autoexposure and autofocus mechanisms reactivates both. When a review image is displayed on the back-panel color LCD, tapping this button removes the image from the display and reactivates the autoexposure and autofocus mechanisms.
- Main Dial. This dial is used to change shooting settings. When settings are available in pairs (such as shutter speed/aperture), this dial will be used to make one type of setting, such as shutter speed, while the Quick Control Dial (on the back of the camera) will be used to make the other, such as aperture setting.
- **Remote control sensor.** This infrared sensor detects the invisible flash of a Canon remote control, like the RC-6.
- **Self-timer lamp.** When using the self-timer, this lamp also flashes to mark the countdown until the photo is taken. (You can turn off the lamp if you don't want it.)
- DC coupler cord access cover. This cover, on the inside edge of the hand grip, opens to allow the DC power cable to connect to the 6D Mark II through the battery compartment.

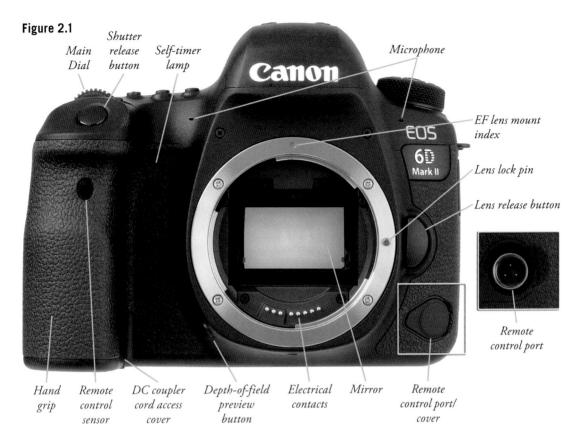

- Hand grip. This provides a comfortable hand-hold, and also contains the 6D Mark II's battery.
- Lens release button. Press and hold this button to unlock the lens so you can rotate the lens to remove it from the camera.
- Lens lock pin. This pin on the lens flange retracts when the release button is held down to unlock the lens.
- **Depth-of-field preview button.** This button, adjacent to the lens mount, stops down the lens to the taking aperture so you can see in the viewfinder how much of the image is in focus. The view grows dimmer as the aperture is reduced.
- EF lens mount index. Line up this dot with the raised red dot on the barrel of your EF lens to align the lens as you mount it on the camera. If your lens has a raised white square instead, it's an EF-S lens and cannot be mounted on the 6D Mark II!
- Mirror. The partially silvered mirror reflects light up to the optical viewfinder, and allows some light to pass downward to the autofocus sensor.

- **Electrical contacts.** These contacts connect to matching points on the lens to allow the camera and lens to communicate electronically.
- **Microphone.** The 6D Mark II has only a monophonic microphone. To record stereo sound, you'll need to plug in an external mic, as described later.
- Remote control port/cover. The remote control port cover protects the remote control port (shown in the inset). You can connect a variety of devices to this three-pin port, including the RS-80N3 remote switch, TC80N3 timer/remote controller, or LC-5 wireless controller.

You'll find more controls on the side of the 6D Mark II, shown in Figure 2.2. In the illustration, you can see the Mode Dial on top, and the rubber cover on the side that protects the camera's USB, TV, HDMI, external flash, and remote-control ports. The main buttons shown include:

- Lens mounting index mark. Line up this raised dot on an EF lens with the red dot on the lens flange to align the lens as you mount it on the camera. As I noted, non-compatible EF-S lenses have a raised white square indicator instead.
- Port covers (not shown). The 6D Mark II's ports are behind these two rubber covers, which I've removed from view in Figure 2.2 through the magic of Photoshop.
- Digital/USB port. Plug in an optional 4.3-foot Canon Interface Cable IFC-400PCU or generic USB mini-B cable to this digital port and connect the other end to a USB port in your computer to transfer photos, or to your PictBridge-compatible printer to output hard copies. The optional 6.2-foot IFC-200U or 15.4-foot IFC-500U II interface cable can be purchased if you need a longer link-up. The port can be used with the Wireless File Transmitter WFT-E7 II and GPS Receiver GP-E2.
- HDMI Out port. You need to buy an accessory cable to connect your 6D Mark II to an HDMI-compatible television, video recorder, or other device, as one to fit this port is not provided with the camera. If you have a high-definition television, it's worth the expenditure to be able to view your camera's output in all its glory. Canon's HDMI cable HTC-100, and other Type C HDMI cables are compatible.
- External microphone In port. Connect an external stereo microphone with a 3.5mm stereo mini-plug here to bypass the internal microphone when recording sound.
- NFC mark. Tap your smart device here to make a wireless connection using Near Field Communications, as described in Chapter 6.
- **Neck strap mount.** Attach your neck strap here, and to the matching mount on the opposite edge of the camera.
- Autofocus/Manual focus lens/Image stabilizer switches. Canon autofocus lenses have a switch to allow changing between automatic focus and manual focus, and, in the case of IS lenses, another switch to turn image stabilization on and off.

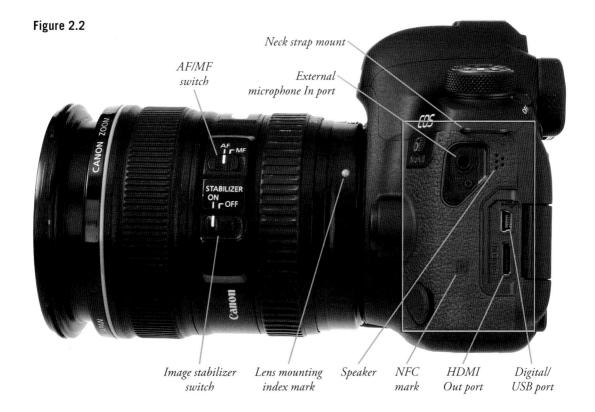

The Canon EOS 6D Mark II's Business End

The back panel of the EOS 6D Mark II (see Figure 2.3) bristles with more than a dozen different controls, buttons, and knobs. That might seem like a lot of controls to learn, but you'll find, as I noted earlier, that it's a lot easier to press a dedicated button and spin a dial than to jump to a menu every time you want to change a setting. On the left side of the camera, you'll find the following buttons and components:

- Viewfinder eyepiece with eyecup. You can frame your composition by peering into the viewfinder. It's surrounded by a soft rubber eyecup/frame that seals out extraneous light when pressing your eye tightly up to the viewfinder, and it also protects your eyeglass lenses (if worn) from scratching. It can be removed and replaced by the cap attached to your neck strap when you use the camera on a tripod, to ensure that light coming from the back of the camera doesn't venture inside and possibly affect the exposure reading.
- LCD monitor. This upgraded 3.0-inch, 1,040,000-dot full-color liquid crystal display presents your menus, review images, and live previews as you make adjustments, shoot, and evaluate your images. Although often referred to as just the *LCD*, the official name is *LCD monitor*,

because the monochrome panel on top of the 6D Mark II is called the *LCD panel*. In Chapter 13, I'll show you how to adjust the LCD monitor's brightness and color balance.

One major change Canon made for the Mark II version of this camera was the introduction of a touch screen. I'll explain how to use the touch screen at the end of this chapter.

- MENU button. Summons/exits the menu displayed on the rear LCD monitor of the 6D Mark II. When you're working with submenus, this button also serves to exit a submenu and return to the main menu.
- **INFO. button.** This button has different functions, depending on whether you are taking still photos, working in live view or movie shooting modes, reviewing images in Playback mode, or working with menus.

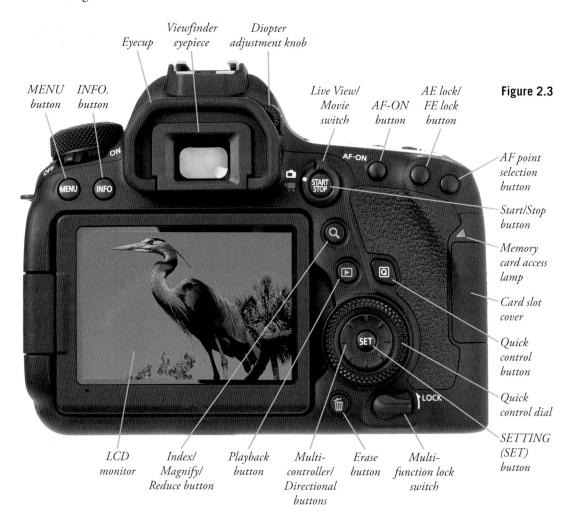

The INFO. button has three sets of functions, depending on mode:

■ Still shooting mode. While composing images through the optical viewfinder, the INFO. button cycles among the Electronic Level (shown later in the chapter in Figure 2.13, left, next to its viewfinder counterpart), Shooting Functions/Quick Control screen (Figure 2.4), and a blank screen. When you press the Q button while Shooting Functions are displayed, the camera switches to Quick Control mode, and the functions surrounded by gray boxes can be adjusted.

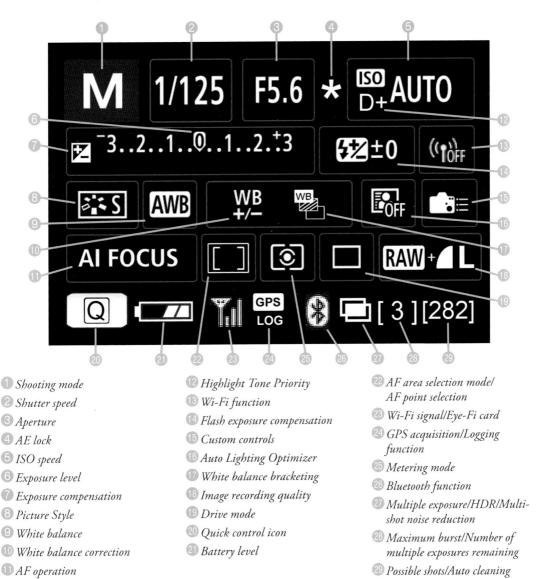

Figure 2.4 Shooting Information/Quick Control screen.

- Change to Live View/Movie shooting mode. When pressed repeatedly while using Live View or Movie mode, the INFO. button cycles among a slightly different set of informational screens, with basic shooting information, additional information, an information screen with histogram, and a screen with only framing information displayed (there is no "blank" screen). I'll show you those screens, and how to use them, in Chapter 14, which describes how to use Live View mode and shoot video clips with your EOS 6D Mark II.
- Playback mode. In Playback mode, while reviewing images, pressing the INFO. button cycles among three displays of the image: a single-frame version of the image, a similar view with basic information about the shot arrayed at the top and bottom of the frame (see Figure 2.5), and a detailed display with a thumbnail of the image with additional shooting information. You can scroll down this screen using the multi-controller directional buttons to view additional details shown in Figures 2.6–2.12.

Figure 2.5 Basic Playback information screen.

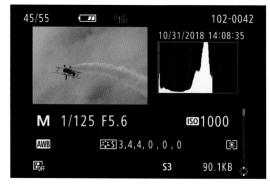

Figure 2.6 Basic Shooting information and brightness histogram.

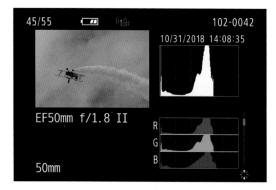

Figure 2.7 RGB histogram and lens information.

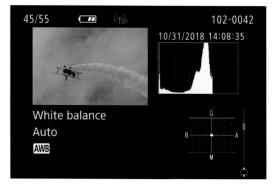

Figure 2.8 White balance data.

Figure 2.9 Picture Style sharpness information.

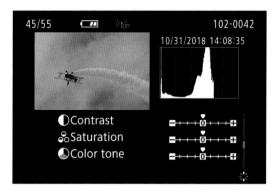

Figure 2.10 Picture Style, Saturation, and Contrast information.

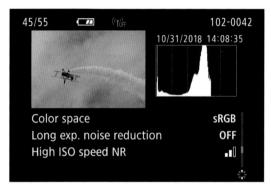

Figure 2.11 Color Space and Noise Reduction data.

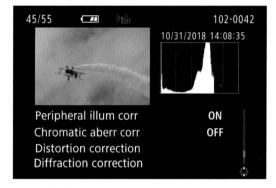

Figure 2.12 Lens correction information.

On the right side of the 6D Mark II, you'll find these buttons, dials, and switches, shown earlier in Figure 2.3:

- Index/Magnify/Reduce button. During Playback, zooms in to magnify image, and zooms out to full screen and index views.
- Playback button. Displays the last picture taken. Thereafter, you can move back and forth among the available images by rotating the Quick Control Dial, to advance or reverse one image at a time, or the Main Dial, to jump forward or back using the jump method described in the discussion of the Playback menu in Chapter 13. To quit playback, press this button again. The 6D Mark II also exits Playback mode automatically when you press the shutter button (so you'll never be prevented from taking a picture on the spur of the moment because you happened to be viewing an image).

- Erase button. Press to erase the image shown on the LCD. A menu will pop up displaying Cancel and Erase choices. Rotate the Quick Control Dial to select one of these actions; then press the SET button to activate your choice.
- **Diopter adjustment knob.** Rotate this knob to adjust the diopter correction for your eyesight.
- Live View/Movie switch. Flip to switch between Live View and Movie modes.
- **Start/Stop button.** Press once to begin live view or movie capture, and again to exit.
- Multi-controller/directional buttons. This joypad-like button, nestled within the Quick Control Dial, can be shifted up, down, side to side, and diagonally for a total of eight directions, or pressed. It can be used for several functions, including AF point selection, scrolling around a magnified image, trimming a photo, or setting white balance correction.
- AF-ON button. Press this button to activate the autofocus system without needing to partially depress the shutter release. This control, used with other buttons, allows you to lock exposure and focus separately. Lock exposure by pressing the shutter release halfway, or by pressing the AE Lock button; autofocus by pressing the shutter release halfway, or by pressing the AF-ON button. Functions of this button will be explained in more detail in Chapter 5.
- AE/FE (autoexposure/flash exposure) lock. In Shooting mode, it locks the exposure or external flash exposure that the camera sets when you partially depress the shutter button. The exposure lock indication (*) appears in the viewfinder. If you want to recalculate exposure with the shutter button still partially depressed, press the * button again. The exposure will be unlocked when you release the shutter button or take the picture. To retain the exposure lock for subsequent photos, keep the * button pressed while shooting.
 - When using external flash, pressing the * button fires an extra pre-flash when you partially depress the shutter button that allows the unit to calculate and lock exposure prior to taking the picture.
- **AF point selection button.** In Shooting mode, this button activates autofocus point selection. (See Chapter 5 for information on setting autofocus/exposure point selection.)
- **Memory card access lamp.** When lit or blinking, this lamp indicates that the Compact Flash card is being accessed.
- Quick Control (Q) button. Press this button to produce the Quick Control screen, which gives you access to many features when in Shooting mode. When you're reviewing images in Playback, a different Quick Control screen pops up that allows you to protect or rate images, change jump method, resize, or perform other functions.
- Quick Control Dial (QCD). Used to select shooting options, such as f/stop or exposure compensation value, or to navigate through menus. It also serves as an alternate controller for some functions set with other controls, such as AF point.

- **SETTING button.** This button (usually abbreviated as SET button) selects a highlighted setting or menu option.
- Multi-function lock switch. Rotated upward, it prevents the Main Dial, QCD, and multi-controller or a tap on the touch screen from changing a setting. If you try to use one of these locked controls, an L warning will be displayed in the optical viewfinder and the LCD panel; in the Shooting Settings display, Lock will be shown. You can select which of the four are locked out using the Multi Function Lock entry in the Set-up 4 menu. Choose any combination of one, two, three, or all four controls to freeze with this lock switch.

Using the Electronic Level

The electronic level readout includes indicators that show the amount of front/back tilt of the camera and horizontal rotation (along the axis passing through the center of the lens). The outer ring shows the amount of horizontal rotation; the inner circle shows front/back tilt, shown in one-degree increments. When the bar turns from red to green, the camera is level.

The 6D Mark II has three different modes for this feature. The INFO. button produces the electronic level on the LCD monitor in both still shooting and live view modes, and in movie mode before you start capturing video. (The level cannot be displayed while shooting movies.) You must activate the still and live view/movie electronic levels separately. The Set-up 4 menu has an INFO. Button Display Options entry for still photography, and a counterpart called INFO. Button LV Display Options when you're using live view. Each has slightly different options for the INFO. button, as I'll explain in Chapter 12.

You can also view a slightly different leveling display in the optical viewfinder, using a display at the top of the frame like the one shown in Figure 2.13, right. The horizontal axis shows horizontal rotation from plus/minus 1 to 7 degrees, and the vertical axis displays front-back tilt from plus/minus 4 degrees. When either exceeds 7 or 4 degrees (respectively) the arrow-head flashes in the viewfinder. You must activate the viewfinder level using the Viewfinder Display's Electronic Level entry.

Figure 2.13 Electronic levels for LCD monitor (left) and viewfinder (right).

USING THE QUICK CONTROL SCREEN

You can activate the Quick Control screen (shown earlier in Figure 2.4) by pressing the Q button located just below the multi-controller, to the right of the color LCD monitor. Then, use the multi-controller directional buttons to highlight one of the settings in the screen.

You can't change the exposure mode; instead rotate the Mode Dial to one of the Basic Zone or Creative Zone modes other than Scene Intelligent Auto. The choices you can select change, depending on the position of the Mode Dial.

Once you've highlighted a setting, you can change it by rotating either the Main Dial or Quick Control Dial. You can then move the highlighting to a different setting using the multi-controller, if you want to make multiple changes. Press the Q button a second time to lock in the settings and exit the Quick Control screen. You can also press the SET button to make your changes for each setting using a screen display.

Going Topside

The top surface of the Canon EOS 6D Mark II has its own set of frequently accessed controls. The three of them just forward of the status LCD panel have dual functions and are marked with hyphenated labels. Press the relevant button (you don't need to hold it down) and then rotate the Main Dial to choose the left function of the pair, such as metering mode, autofocus, or ISO, and the Quick Control Dial to select the right function, such as white balance, drive mode, or flash exposure compensation. The settings you make will be indicated in the LCD status panel, which is described in the section that follows this one. The key controls, shown in Figure 2.14, are as follows:

- **AF area selection button.** This button can be used to change the autofocus area selection mode (as described in Chapter 5).
- Mode Dial lock release. Hold down the Mode Dial lock release and rotate this dial to switch among exposure modes, and to choose one of the camera user settings (C1 or C2). You'll find these modes and options described in more detail in Chapter 13 (where I show you how to register your settings in the C1/C2 "slots").
- On/Off switch. No surprises here: powers your camera on and off.
- Sensor focal plane. Precision macro and scientific photography sometimes requires knowing exactly where the focal plane of the sensor is. The symbol on the side of the pentaprism marks that plane.
- Hot shoe/Flash sync contacts. Slide an electronic flash into this multi-purpose accessory shoe when you need an external Speedlite. A dedicated flash unit, like those from Canon, can use the multiple contact points shown to communicate exposure, zoom setting, white balance information, and other data between the flash and the camera. There's more on using electronic flash in Chapters 9 and 10.

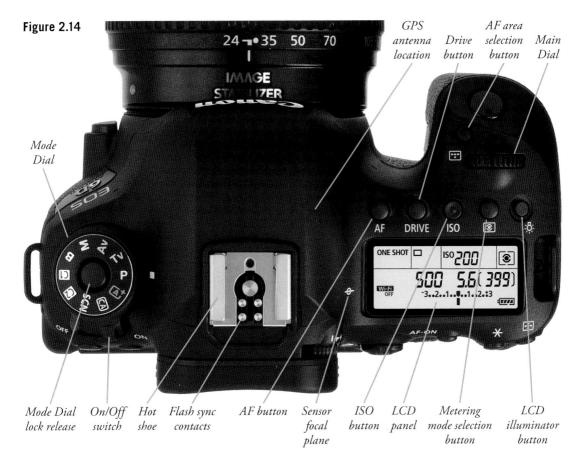

- **AF button.** Press once and then rotate the Main Dial to change between One-Shot, AI Focus, and AI Servo autofocus modes (you'll find more about those modes in Chapter 5).
- **Drive button.** Drive mode settings include single shooting, high-speed continuous (up to 6.5 fps), low-speed continuous (up to 3.0 fps), silent single, silent continuous, self-timer 10 sec./ remote, self-timer 2 sec./remote and self-timer continuous (specify from 2 to 10 exposures after the 10-second delay). Each is selected by holding down the button and rotating the Main Dial.
- **ISO button.** Press and rotate the Main Dial to choose an ISO setting. You'll find more about ISO options in Chapter 4, and flash EV settings in Chapter 9.
- Metering mode selection button. Rotate the Main Dial after pressing this button to change between Evaluative, Partial, Spot, or Center-weighted metering.
- LCD illuminator button. Press this button to turn on the amber LCD panel lamp that backlights the LCD status panel for about six seconds, or to turn it off if illuminated. The lamp will remain lit beyond the six-second period if you are using the Mode Dial or other shooting control.

- LCD panel. The monochrome LCD panel provides information about the status of your camera and its settings, including exposure mode, number of pictures remaining, battery status, and many other settings. I'll illustrate all these in the next section.
- Main Dial. This dial is used to make many shooting settings. When settings come in pairs (such as shutter speed/aperture in Manual shooting mode), the Main Dial is used for one (for example, shutter speed), while the Quick Control Dial is used for the other (aperture). When an image is on the screen during playback, this dial also specifies the leaps that skip a particular number of images during playback of the shots you've already taken. Jumps can be 1 image, 10 images, 100 images, jump by date, or jump by screen (that is, by screens of thumbnails when using Index mode), date, or folder. (Jump method is selected in the Playback 2 menu, as described in Chapter 13.) This dial is also used to move among tabs when the MENU button has been pressed, and is used within some menus (in conjunction with the Quick Control Dial) to change pairs of settings.
- **GPS antenna location.** This is the approximate location of the antenna for the 6D Mark II's built-in GPS feature, which I'll tell you about in Chapter 6.

LCD Panel Readouts

The top panel of the EOS 6D Mark II (see Figure 2.15) contains an amber-colored (when backlit) monochrome LCD readout that displays status information about most of the shooting settings. All the information segments available are shown in Figure 2.16. I've color-coded the display to make it easier to differentiate them; the information does *not* appear in color on the actual 6D Mark II. Many of the information items are mutually exclusive (that is, in the AF operation area at upper left, only one of the possible settings illustrated will appear).

Some of the items on the status LCD also appear in the viewfinder, such as the shutter speed and aperture (pictured in blue in Figure 2.16), and the exposure level (in yellow at the bottom).

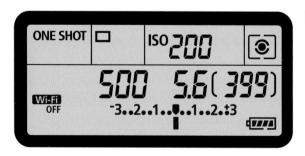

Figure 2.15

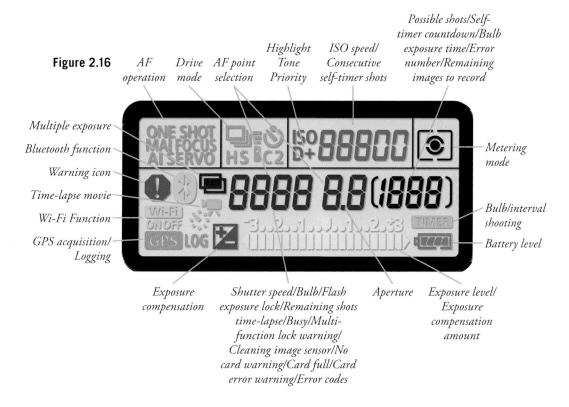

Lens Components

The typical lens, like the one shown in Figure 2.17, has most of these common features:

- **Filter thread.** Lenses have a thread on the front for attaching filters and other add-ons. Some also use this thread for attaching a lens hood (you screw on the filter first, and then attach the hood to the screw thread on the front of the filter).
- **Lens hood bayonet mount.** This is used to mount the lens hood for lenses that don't use screwmount hoods (the majority).
- **Zoom ring.** Turn this ring to change the zoom setting.
- Zoom scale. These markings on the lens show the current focal length selected.
- Focus ring. This is the ring you turn when you manually focus the lens.
- Focus scale. This is a readout that rotates in unison with the lens's focus mechanism to show the distance at which the lens has been focused. It's a useful indicator for double-checking autofocus, roughly evaluating depth-of-field, and for setting manual focus guesstimates.
- Autofocus/Manual focus switch. Allows you to change from automatic focus to manual focus.

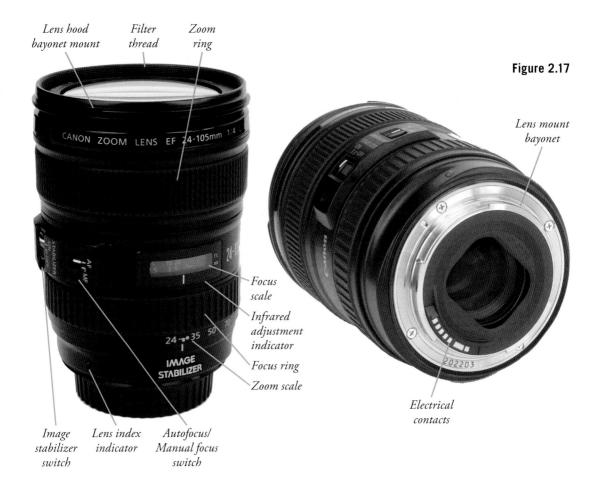

- Image stabilizer switch. Lenses with IS include a separate switch for adjusting the stabilization feature.
- Infrared adjustment indicator. If you're shooting infrared photos (with a suitable visible light cut-off filter), you should know that IR illumination focuses at a different point from ordinary light. If you want the most accurate focus and you're using a lens with IR indicators, the focus point should be adjusted from the white line on the lens barrel to the red line representing your current zoom setting. With the 24-105mm lens shown, indicators are provided for 24mm, 35mm, and 50mm focal lengths. The focus difference diminishes as focal length increases; from 50-105mm you can "guestimate" the correct adjustment, or ignore it altogether. In many cases, depth-of-field (when using f/stops of f/8 or smaller) may take care of the disparity.
- Electrical contacts. The gold contacts on the rear of the lens mate with the contacts on the camera body, allowing the lens and camera to communicate electronically.
- Lens mount bayonet. This is the component used to mount the lens on the camera.
- Lens index indicator. Line up this mark with the corresponding mark on the lens mount.

Looking Inside the Viewfinder

Much of the important shooting status information is shown inside the viewfinder of the EOS 6D Mark II. As with the status LCD up on top, not all this information will be shown at any one time. Figure 2.18 shows what you can expect to see. In addition to the information shown, the viewfinder also can display brackets indicating the currently active autofocus zone and lines that show the frame area when using the optional 1:1 and 16:9 (movie) aspect ratios (which can be selected in the Shooting 4 menu, as described in Chapter 11).

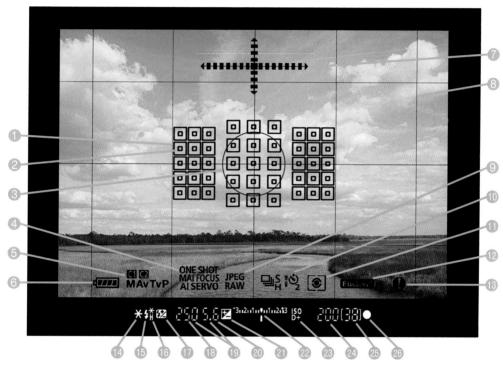

- AF point
- Spot AF point
- Spot metering circle
- AF operation
- Shooting mode
- 6 Battery level
- Telectronic level
- 3 Grid
- ¶

 IPEG/RAW
- Drive mode
- Metering mode

Figure 2.18

- Plicker detection
- [®] Warning icon
- 14 AE lock/AE bracketing in progress
- Flash ready/Improper flash exposure lock warning
- 1 FE lock/Flash exposure bracketing in progress/High-speed
- ### Flash exposure compensation
- ® Shutter speed/Bulb/Flash exposure lock/Busy/Multifunction lock/No card/Card full/ Card error/Error codes

- 19 AF point selection
- Aperture
- Exposure compensation
- Exposure level indicator
- 3 Highlight tone priority
- ② ISO speed/Consecutive self-timer shots
- (3) Maximum burst/Remaining multiple exposures
- Tocus indicator

Underneath Your EOS 6D Mark II

There's not a lot going on with the bottom panel of your EOS 6D Mark II. You'll find a tripod socket, which secures the camera to a tripod, and is also used to lock on the optional BG-E20 battery grip, which provides more juice to run your camera to take more exposures with a single charge. It also adds a vertically oriented shutter release, Main Dial, AE lock/FE lock, and AF point selection controls for easier vertical shooting. To mount the grip, slide the battery door latch to open the door, then push down on the small pin that projects from the hinge. That will let you remove the battery door. Then slide the grip into the battery cavity, aligning the pin on the grip with the small hole on the other side of the tripod socket. Tighten the grip's tripod socket screw to lock the grip onto the bottom of your 6D Mark II. Figure 2.19 shows the underside view of the camera

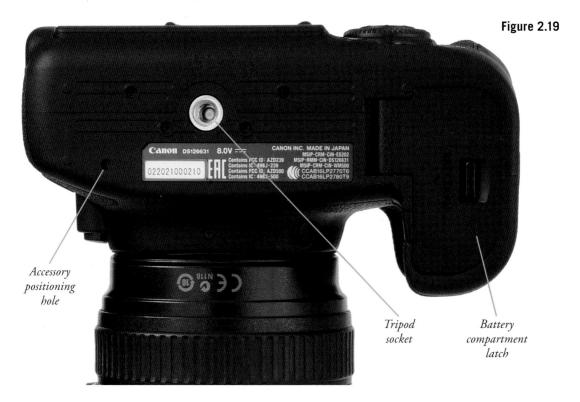

Mastering the Touch Screen

Touch screens are finally making the migration from consumer cameras and smartphones to highend cameras like the 6D Mark II. This section will show you how to activate/deactivate it, and how to use its functions. Using the touch screen, you can perform many routine operations, including menu navigation/selection functions by tapping the screen. For many veteran shooters, touch-friendly tasks are no quicker than the button/dial procedures we are used to, and can even be more awkward for those with large fingers or who need/want to wear gloves.

Some menu entries work better with the touch screen (which can be activated/deactivated and sensitivity set to Standard or Sensitive in the Set-up 4 menu) than others. You'll have to try them to see which are convenient for you. You can adjust sliders with a fingertip to set ISO, make exposure or flash exposure compensation adjustments, and just slide your finger around the White Balance Shift/Amber-Blue/Green-Magenta grid to set color bias to your heart's content. It's also very fast to press one of the top-panel direct access buttons (AF, DRIVE, ISO, or Metering Mode) and then immediately tap the option you want on the screen. Most will love the touch screen, but will pick and choose exactly how they prefer to use it.

TIP: YOUR CHOICE

Throughout this book, I may not explicitly say "tap the screen, or use the button, or visit the menu" for every single operation. Given the large number of how-to entries in this book, that would require unnecessarily long descriptions and extra verbiage. I'm going to assume that once you master the touch screen using the information in this section, you'll make your own choice and use whichever method you prefer. I'll generally stick to using the physical controls that we're all accustomed to. But, unless I specifically say to use the touch screen or physical controls, assume I mean you can use either one.

When a main menu, adjustment screen, or the Quick Control menu is displayed, you will often elect to use the touch screen to make your changes. Optionally, you can resort to the physical controls that provide the equivalent functions, including the available buttons and navigational buttons. However, I think that once you become familiar with the speed with which the touch screen allows you to make these adjustments, you'll be reluctant to go back to the "old" way of doing things.

The 6D Mark II's touch screen is *capacitive* rather than *resistive*, making it more like the current generation of smartphones than earlier computer touch-sensitive screens. The difference is that your camera's LCD responds to the electrical changes that result from *contact* rather than the force of *pressure* on the screen itself. That means that the screen can interpret your touches and taps in more

44

complex ways. It "knows" when you're using two fingers instead of one, and can react to multitouch actions and gestures, such as swiping (to scroll in any direction), and pinching/spreading of fingers to zoom in and out. Since you probably have been using a smartphone for a while, these actions have become ingrained enough to be considered intuitive. Virtually every main and secondary function or menu operation can be accessed from the touch screen. However, if you want to continue using the buttons and dials, the 6D Mark II retains that method of operation.

Here's what you need to know to get started:

- **Tap to select.** Tap (touch the LCD screen briefly) to select an item, including a menu heading or icon. Any item you can tap will have a frame or box around it. Figure 2.20, left, shows the taps needed to select a menu tab and specific entry within that menu and then make your adjustments on the screen that appears. On settings screens, tappable items will have a box around them.
- **Drag/swipe to select.** Many functions can be selected by touching the screen and then sliding your finger to the right or left until the item you want is highlighted. For example, instead of tapping, you can slide horizontally along the main menu's tabs to choose any Shooting, Playback, Set-up, Custom, or My Menu tab. Or, you can swipe along the tab *numbers* underneath the main tabs to quickly move among individual screens. However, you can't slide vertically to choose an individual menu entry; tap the desired entry instead. The swiping motion is represented by the arrows in Figure 2.20, left.
- **Tap to choose an option.** When you reach the adjustment screen, you can tap to select an option quickly, as seen in Figure 2.20, right. Note that in this case, you can only choose the option (Month), and you still need to rotate the Main Dial to increment the value.

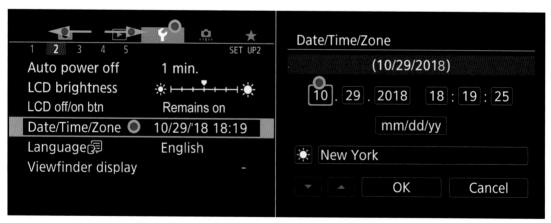

Figure 2.20 Select a menu tab and entry (left) and change settings (right).

- **Drag/swipe to adjust scales.** Screens that contain a sliding scale can be adjusted by dragging. In Figure 2.21, left, the arrows show how you can drag along the exposure compensation scale to make adjustments. You can also tap the minus/plus buttons, and exit by tapping the return arrow at lower right. Even when you are using the touch screen, you can still opt for the Main Dial or QCD to make your changes. Note that some scales, such as the LCD brightness scale in Figure 2.21, right, don't respond to dragging. Instead, tap on the scale's fixed-size intervals.
- Drag/swipe to scroll among single images. In Playback single-image mode, as you review your images, you can drag your finger left and right to advance from one image to another, much as you might do with a smartphone or tablet computer. Use one finger to scroll one image at a time, and two to jump using the image jump method you've chosen in the Playback 2 menu, as described in Chapter 12. The arrows at the bottom of Figure 2.22, left, represent this function.

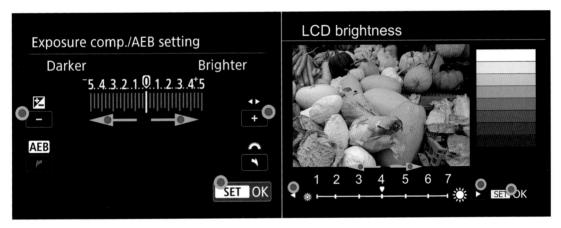

Figure 2.21 Use sliding scales or tap icons to make adjustments.

Figure 2.22 In Playback, pinch or spread fingers to magnify or reduce images, and swipe/drag to move/jump among them.

- **Drag to scroll among thumbnails.** When viewing thumbnails, you can drag through the thumbnail screen to quickly move among sets of index images, as represented in Figure 2.22, right.
- Pinch/spread to reduce/enlarge. During playback, you can use two fingers to "pinch" the screen to reduce/shrink the image, from, say, single image to index view. Tap on a thumbnail to view it full size. Spread those two fingers apart to enlarge an image, to zoom in from, say, a nine-image index array to the four-image display, then to single image. If you continue spreading, you can magnify the image up to about 10X. Tap the return icon to resume single-image display. (See the arrows in the top half of Figure 2.22, left.)
- Fine-tune touch features. As I'll explain in Chapter 12, you can enable or disable touch operation and change sensitivity from Standard to Sensitive in the Set-up 4 menu under the Touch Control entry. The click sound the touch feature makes can be turned on or off using the Beep setting in the Set-up 4 menu.
- Avoid "protective" sheets, moisture, and sharp implements. The LCD uses capacitive technology to sense your touch, rather than pressure sensitivity. LCD protectors or moisture can interfere with the touch functions, and styluses or sharp objects (such as pens) won't produce the desired results. I have, in fact, used "skins" on my 6D Mark II's LCD with good results (even though the screen is quite rugged and really doesn't need protection from scratches), but there is no guarantee that all such protectors will work for you.

As I noted, the choice of whether to use the traditional buttons or touch screen is up to you. I've found that with some screens, the controls are too close together to be easily manipulated with my wide fingers. The touch screen can be especially dangerous when working with some functions, such as card formatting. In screens where the icons are large and few in number, such as the screen used to adjust LCD brightness, touch control works just fine. Easiest of all is touch operation during Playback. It's a no-brainer to swipe your finger from side to side to scroll among images and pinch/spread to zoom out and in.

Recommended Settings

This chapter is purely optional, especially for those who are new to an advanced Canon at the 6D Mark II's level, who should skip it entirely for now, and return when they've gained some experience with this full-featured camera. This section is for the benefit of those who want to know *now* some of the most common changes I recommend to the default settings of your 6D Mark II. Canon has excellent reasons for using these settings as a default; I have better reasons for changing them.

Changing Default Settings

Even if this is your first experience with a Canon digital SLR, you can easily make a few changes to the default settings that I'm going to recommend, and then take your time learning *why* I suggest these changes when they're explained in the more detailed chapters of this book. I'm not going to provide step-by-step instructions for changing settings here; I'll give you an overview of how to make any setting adjustment, and leave you to navigate through the fairly intuitive 6D Mark II menu system to make the changes yourself. Or, you can jump ahead to Chapters 11 to 13 for more detailed instructions on a particular setting.

Resetting the Canon 6D Mark II

If you want to change from the factory default values, you might think that it would be a good idea to make sure that the Canon 6D Mark II is set to the factory defaults in the first place. After all, even a brand-new camera might have had its settings changed at the retailer, or during a demo. Most of the time, however, you'll prefer to use the Clear All Camera Settings option in the Set-up 5 menu, which returns most settings (other than Custom Functions) to their default values. The tables that follow show the settings defaults after using the Clear All Camera Settings menu option.

Table 3.1 Shooting Settings Defaults						
Option	Default Setting	Option	Default Setting			
AF operation	One-Shot AF	HDR mode	Disable			
AF area selection mode	Automatic selec-	Interval timer	Disable			
	tion AF	Bulb timer	Disable			
Lens electronic manual	Disable after	Anti-flicker	Disable			
focus	One-Shot AF	Mirror lockup	Disable			
Metering mode	Evaluative	Viewfinder display				
ISO		Electronic level	Hide			
ISO speed	Auto	Grid display	Hide			
ISO speed range	Min: 100	Show in viewfinder	Only flicker			
	Max: 40,000		detection			
Auto	Min: 100	Custom Functions	Unchanged			
	Max: 12,800	External Speedlite contr	rol			
Minimum shutter	Auto	Flash firing	Enable			
speed for Auto		E-TTL II flash	Evaluative flash			
Drive mode	Single Shooting	metering	metering			
Exposure comp./AEB	Canceled	Flash sync speed in	Auto			
Flash exposure comp.	Canceled	Av mode				
Multiple exposure	Disable					

Table 3.2 Image Recording Settings Defaults						
Option	Default Setting	Option	Default Setting			
Image quality	Large	Custom White balance	Canceled			
Aspect ratio	3:2	White balance shift	Canceled			
Picture Style	Auto	White balance	Canceled			
Auto lighting optimizer	Standard	bracketing				
Lens aberration correction	ı	Color space	sRGB			
Peripheral illumina- tion correction	Enable	Long exposure noise reduction	Disable			
Chromatic aberration correction	Enable	High ISO speed NR Highlight tone priority	Standard Disable			
Distortion correction	Disable	File numbering	Continuous			
Diffraction correction	Enable	Dust Delete Data	Erased			
White balance	Auto (Ambience priority)	2 det Detect Data				

Table 3.3 Camera Settings Defaults					
Option	Default Setting	Option	Default Setting		
Image review time	2 sec.	Language	Unchanged		
Release shutter without	Enable	GPS	Disable		
card		Video system	Unchanged		
Image jump with dial	10 images	Shooting mode guide	Enable		
Highlight alert	Disable	Feature guide	Enable		
AF point display	Disable	Help text size	Small		
Playback grid	Off	Touch control	Standard		
Histogram display	Brightness	Веер	Enable		
Magnification	2x (from center)	Auto cleaning	Enable		
(Approximate)		INFO. button display	Select both		
Control over HDMI	Disable	options			
Vertical image auto	Camera/	INFO. button live	Unchanged		
rotation	Computer	view display options			
Wi-Fi	Disable	Multi function lock	QCD only		
Bluetooth function	Disable	Custom shooting	Unchanged		
Auto power off	1 min.	mode			
LCD brightness	4 (Center)	Copyright information	Unchanged		
LCD off/on button	Remains on	Configure: My Menu	Unchanged		
Date/Time/Zone	Unchanged	Menu display	Normal		

Table 3.4 Live View Shooting Settings Defaults							
Option Default Setting Option Default Setting							
Live View Shooting	Enable	Grid display	Off				
AF operation	One-Shot AF	Aspect ratio	3:2				
AF Method	Face+Tracking	Exposure simulation	Enable				
Touch shutter	Disable	Silent LV shooting	Mode 1				
Metering timer	8 sec.						

Table 3.5 Movie Settings Defaults					
Option	Default Setting	Option	Default Setting		
Movie recording size	NTSC: 1920 × 1080 29.96.5 fps PAL: 1920 × 1080 25.00 fps	Movie Servo AF speed When active AF speed Metering timer	Always on 0 (Standard) 8 sec.		
Sound recording Wind filter Attenuator Movie ISO speed settings ISO speed ISO speed range ISO Auto Time-lapse ISO Auto Movie Servo AF speed AF method Movie Servo AF track sensitivity	Auto Auto Disable Auto Min: 100 Max: 25,600 Max: 25,600 Max: 12,800 Enable Face+Tracking 0 (Standard)	Grid display Shutter button function Video snapshot Time-lapse movie Movie digital IS Remote control shooting	Hide Half press: Metering+AF Fully press: No function Disable Disable Disable Disable		

Recommended Default Changes

Although I won't be explaining how to use the Canon 6D Mark II's menu system in detail until Chapters 11 to 13, you can make some simple changes now. These general instructions will serve you to make any of the setting changes I recommend next. It's likely that experienced photographers won't need the settings charts that follow, but I'm including some basic recommendations for those who want some guidance in shooting particular types of subjects. You'll find specific types for functions like autofocus and other features later in this book.

The 6D Mark II divides its menu entries into "tabbed" sections—Shooting, Playback, Set-up, Custom Functions, and My Menu. The available pages for each can vary, depending on your shooting mode, as I'll explain in Chapter 11.

To access menus, tap the MENU button. Use the Main Dial to move from menu to menu, and the Quick Control Dial to highlight a particular menu entry. Press the SET button to select a menu item. You can also navigate with the multi-controller directional buttons or use the touch screen. When you've highlighted the menu item you want to work with, press the SET button to select it. The current settings for the other menu items in the list will be hidden, and a list of options for the selected menu item (or a submenu screen) will appear. Or, you may be shown a separate settings

screen for that entry. Within the menu choices, you can scroll up or down with the Quick Control Dial; press SET to select the choice you've made; and press the MENU button again to exit.

Once you've made changes for a specific type of shooting, you should store each set of parameters in one of the Custom Shooting mode user slots, C1 or C2, in the Custom Function 4 menu, as explained in Chapter 13. Here are some recommended settings to consider. Note that these tables don't correspond to entire menus; I'm listing only the settings that need attention. If a particular parameter is not listed, you can use a setting of your choice.

AUTOFOCUS TABLES

I have recommended settings for each of these types of photographs for most of the 6D Mark II's autofocus settings as well. Your AF adjustments (fortunately!) are not changed when you do a basic camera reset, as they reside in the Custom Functions II menu (which I describe in Chapter 13). Because there are several variations for my AF recommendations, I'm saving those tables for Chapter 5, which I devote solely to explaining the nuances of autofocus.

Table 3.6 Default, All Purpose, Sports: Outdoors, Sports: Indoors						
	Default	All Purpose	Sports: Outdoors	Sports: Indoors		
SETTINGS						
Exposure Mode	Your choice	Your choice	Tv	Tv		
Autofocus Mode	One-Shot	AI Focus	AI Servo	AI Servo		
Drive Mode	Single Shooting	Single Shooting	Continuous	Continuous		
			Shooting	Shooting		
SHOOTING MENU	S					
Beep	Enable	Enable	Enable	Enable		
Image Review	2 sec.	2 sec.	Off	Off		
Metering Mode	Evaluative	Evaluative	Evaluative	Evaluative		
Color Space	sRGB	sRGB sRGB		sRGB		
Picture Style	Auto	Auto	Standard	Standard		
ISO Speed	Auto	Auto	800-3200	800-3200		
ISO Speed Range	100-40000	100-12800	200-3200	200-12800		
Auto ISO Range	100-12800	100-6400	200-6400	400-12800		
ISO Auto Minimum	Auto	Auto	1/250	1/250		
Shutter Speed						

Table 3.6 Default, All Purpose, Sports: Outdoors, Sports: Indoors (continued)								
Default All Purpose Sports: Outdoors Sports: In								
SHOOTING MENU	SHOOTING MENUS (continued)							
Long Exposure NR	Disable	Disable	Disable	Disable				
High ISO speed NR	Standard	Standard	Standard	Standard				
Highlight Tone	Disable	Disable	Disable	Disable				
Priority								
SET-UP MENUS								
Auto Power Off	1 minute	30 sec.	Off	Off				
LCD Brightness	Auto	Medium	Medium	Medium				

Table 3.7 Stage Performances, Long Exposure, HDR, Portrait					
	Stage Performances	Long Exposure	HDR	Portrait	
SETTINGS					
Exposure Mode	Your choice	Manual/ Your choice	One-Shot	One-Shot	
Autofocus Mode	One-Shot	AI Focus	AI Servo	AI Servo	
Drive Mode	Continuous Shooting	Single Shooting	Continuous Shooting	Continuous Shooting	
SHOOTING MEN	US				
Beep	Disable	Enable	Enable	Enable	
Image Review	Off	Off	Off	2 sec.	
Metering Mode	Spot	Center- weighted	Evaluative	Center- weighted	
Color Space	Adobe RGB	Adobe RGB	Adobe RGB	Adobe RGB	
Picture Style	User—Reduce contrast, add sharpening	Neutral	Standard	Portrait	
ISO Speed	800-3200	800-3200	Auto	Auto	
ISO Speed Range	100-40000	100-12800	200-3200	200-1600	
Auto ISO Range	100-12800	100-6400	200-6400	100-3200	

Table 3.7 Stage Performances, Long Exposure, HDR, Portrait (continued)						
	Stage Performances	Long Exposure	HDR	Portrait		
SHOOTING MENU	S (continued)					
ISO Auto Minimum Shutter Speed	Auto	Auto	1/250	1/250		
Long Exposure NR	Disable	Disable	Disable	Disable		
High ISO Speed NR	Standard	Standard	Standard	Standard		
Highlight Tone Priority	Disable	Disable	Disable	Disable		
SET-UP MENUS						
Auto Power Off	1 minute	Disable	Disable	Disable		
LCD Brightness	Dimmer	Dimmer	Medium	Medium		

Table 3.8 Studio Flash, Landscape, Macro, Travel, E-Mail						
	Studio Flash	Landscape	Macro	Travel	E-mail	
SETTINGS						
Exposure Mode	Manual	Av	Tv	Tv	Av	
Autofocus Mode	One-Shot	One-Shot	Manual	One-Shot	One Shot	
Drive Mode	Single Shooting	Single Shooting	Single Shooting	Single Shooting	Single Shooting	
SHOOTING MEN	US					
Beep	Disable	Enable	Enable	Enable	Enable	
Image Review	2 sec.	2 sec.	2 sec.	2 sec.	2 sec.	
Metering Mode	Evaluative	Evaluative	Spot	Evaluative	Evaluative	
Color Space	Adobe RGB	Adobe RGB	Adobe RGB	Adobe RGB	Adobe RGB	
Picture Style	User— Reduce con- trast, add sharpening	Landscape	Auto	Landscape	Auto	
ISO Speed	100-400	100-1600	100-1600	Auto	Auto	
ISO Speed Range	100-40000	100-12800	200-3200	200-1600	100-3200	
Auto ISO Range	100-12800	100-6400	200-6400	100-3200	100-6400	

Table 3.8 Studio Flash, Landscape, Macro, Travel, E-Mail (continued)						
	Studio Flash	Landscape	Macro	Travel	E-mail	
SHOOTING MENU	US (continued)					
ISO Auto	Auto	Auto	1/250	1/250	Auto	
Minimum Shutter						
Speed						
Long Exposure NR	Disable	Disable	Disable	Disable	Disable	
High ISO Speed	Standard	Standard	Standard	Standard	Standard	
NR						
Highlight Tone	Disable	Enable	Disable	Enable	Enable	
Priority					9	
SET-UP MENUS						
Auto Power Off	Off	Off	Off	30 sec.	30 sec.	
LCD Brightness	Medium	Medium	Medium	Medium	Medium	

Nailing the Right Exposure

This chapter shows you the fundamentals of exposure, so you'll be better equipped to override the 6D Mark II's default settings when you want to, or need to. After all, correct exposure is one of the foundations of good photography, along with accurate focus and sharpness, appropriate color balance, freedom from unwanted noise and excessive contrast, as well as pleasing composition.

The 6D Mark II gives you a great deal of control over all of these, although composition is entirely up to you. You must still frame the photograph to create an interesting arrangement of subject matter, but all the other parameters are basic functions of the camera. You can let your 6D Mark II set them for you automatically, you can fine-tune how the camera applies its automatic settings, or you can make them yourself, manually. The amount of control you have over exposure, sensitivity (ISO settings), color balance, focus, and image parameters like sharpness and contrast make the 6D Mark II a versatile tool for creating images.

In the next few pages, I'm going to give you a grounding in one of those foundations, and explain the basics of exposure, either as an introduction or as a refresher course, depending on your current level of expertise. When you finish this chapter, you'll understand most of what you need to know to take well-exposed photographs creatively in a broad range of situations with the EOS 6D Mark II.

Getting a Handle on Exposure

This section explains the fundamental concepts that go into creating an exposure. If you already know about the role of f/stops, shutter speeds, and sensor sensitivity in determining an exposure, you might want to skip to the next section, which explains how the 6D Mark II calculates exposure.

In the most basic sense, exposure is all about light. Correct exposure provides the range of tones and colors you need to create the desired image. Poor exposure can cloak important details in shadow, or wash them out in glare-filled featureless expanses of white. However, getting the perfect exposure requires some intelligence—either that built into the camera or the smarts in your head—because digital sensors can't capture all the tones we can see. If the range of tones in an image is extensive, embracing both inky black shadows and bright highlights, we often must settle for an exposure that renders most of those tones—but not all—in a way that best suits the photo we want to produce.

As the owner of a 6D Mark II, you're probably aware of the traditional "exposure triangle" of aperture (quantity of light and light passed by the lens), shutter speed (the amount of time the shutter is open), and the ISO sensitivity of the sensor—all working proportionately and reciprocally to produce an exposure. The trio is itself affected by the amount of illumination that is available. So, if you double the amount of light, increase the aperture by one stop, make the shutter speed twice as long, or boost the ISO setting 2X, you'll get twice as much exposure. Similarly, you can increase any of these factors while decreasing one of the others by a similar amount to keep the same exposure.

Working with any of the three controls involves trade-offs. Larger f/stops provide less depth-of-field, while smaller f/stops increase depth-of-field (and potentially at the same time can *decrease* sharpness through a phenomenon called *diffraction*). Shorter shutter speeds do a better job of reducing the effects of camera/subject motion, while longer shutter speeds make that motion blur more likely. Higher ISO settings increase the amount of visual noise and artifacts in your image, while lower ISO settings reduce the effects of noise. (See Figure 4.1.)

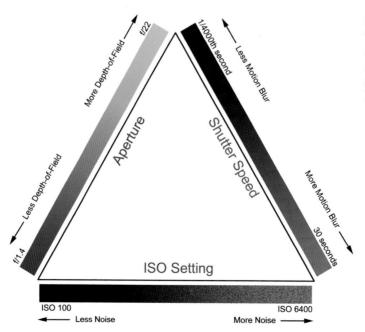

Figure 4.1
The traditional exposure triangle includes aperture, shutter speed, and ISO sensitivity.

Exposure determines the look, feel, and tone of an image, in more ways than one. Incorrect exposure can impair even the best-composed image by cloaking important tones in darkness, or by washing them out so they become featureless to the eye. On the other hand, correct exposure brings out the detail in the areas you want to picture, and provides the range of tones and colors you need to create the desired image. However, getting the perfect exposure can be tricky, because digital sensors can't capture all the tones we can see. If the range of tones in an image is extensive, embracing both inky black shadows and bright highlights, the sensor may not be able to capture them all. Sometimes, we must settle for an exposure that renders most of those tones—but not all—in a way that best suits the photo we want to produce. You'll often need to make choices about which details are important, and which are not, so that you can grab the tones that truly matter in your image. That's part of the creativity you bring to bear in realizing your photographic vision.

For example, look at two bracketed exposures presented at top in Figure 4.2, of Église Sainte-Marie, Nova Scotia. At 190 feet, it is one of the tallest wooden structures in North America. For the image at upper left, the highlights (chiefly the brightest parts of the church) are well exposed, but everything else in the shot is seriously underexposed. The version on the upper right, taken an instant later with the tripod-mounted camera, shows detail in the shadow areas of the building, but the highlights are completely washed out. The camera's sensor simply can't capture detail in both dark areas and bright areas in a single shot.

With digital camera sensors, it's tricky to capture detail in both highlights and shadows in a single image, because the number of tones, the *dynamic range* of the sensor, is limited. The solution, in this case, was to resort to a technique called High Dynamic Range (HDR) photography, in which the two exposures from Figure 4.2 were combined in an image editor such as Photoshop, or a specialized HDR tool like Photomatix (two versions from about \$40 to \$100 from www.hdrsoft.com). The resulting shot is shown at bottom in Figure 4.2. I'll explain more about HDR photography later in this chapter. For now, though, I'm going to concentrate on showing you how to get the best exposures possible without resorting to such tools, using only the features of your 6D Mark II.

To understand exposure, you need to understand the six aspects of light that combine to produce an image. Start with a light source—the sun, an interior lamp, or the glow from a campfire—and trace its path to your camera, through the lens, and finally to the sensor that captures the illumination. Here's a brief review of the things within our control that affect exposure.

■ Light at its source. Our eyes and our cameras—film or digital—are most sensitive to that portion of the electromagnetic spectrum we call *visible light*. That light has several important aspects that are relevant to photography, such as color and harshness (which is determined primarily by the apparent size of the light source as it illuminates a subject). But, in terms of exposure, the important attribute of a light source is its *intensity*. We may have direct control over intensity, which might be the case with an interior light that can be brightened or dimmed. Or, we might have only indirect control over intensity, as with sunlight, which can be made to appear dimmer by introducing translucent light-absorbing or reflective materials in its path.

Figure 4.2 The image is exposed for the highlights, losing shadow detail (upper left). At upper right, the exposure captures detail in the shadows, but the background highlights are washed out. Combining the two exposures produces the best compromise image (bottom).

- **Light's duration.** We tend to think of most light sources as continuous. But, as you'll learn in Chapter 9, the duration of light can change quickly enough to modify the exposure, as when the main illumination in a photograph comes from an intermittent source, such as an electronic flash.
- Light reflected, transmitted, or emitted. Once light is produced by its source, either continuously or in a brief burst, we can see and photograph objects by the light that is reflected from our subjects toward the camera lens; transmitted (say, from translucent objects that are lit from behind); or emitted (by a candle or television screen). When more or less light reaches the lens from the subject, we need to adjust the exposure. This part of the equation is under our control to the extent we can increase the amount of light falling on or passing through the subject (by adding extra light sources or using reflectors), or by pumping up the light that's emitted (by increasing the brightness of the glowing object).
- **Light passed by the lens.** Not all the illumination that reaches the front of the lens makes it all the way through. Filters can remove some of the light before it enters the lens. Inside the lens barrel is a variable-sized diaphragm that dilates and contracts to vary the size of the aperture and control the amount of light that enters the lens. You, or the 6D Mark II's autoexposure system, can control exposure by varying the size of the aperture. The relative size of the aperture is called the *flstop*.
- Light passing through the shutter. Once light passes through the lens, the amount of time the sensor receives it is determined by the 6D Mark II's shutter, which can remain open for as long as 30 seconds (or even longer if you use the Bulb setting) or as briefly as 1/4,000th second.
- Light captured by the sensor. Not all the light falling onto the sensor is captured. If the number of photons reaching a particular photosite doesn't pass a set threshold, no information is recorded. Similarly, if too much light illuminates a pixel in the sensor, then the excess isn't recorded or, worse, spills over to contaminate adjacent pixels. We can modify the minimum and maximum number of pixels that contribute to image detail by adjusting the ISO setting. At higher ISOs, the incoming light is amplified to boost the effective sensitivity of the sensor.

These factors all work proportionately and reciprocally to produce an exposure. That is, if you double the amount of light that's available, increase the aperture by one stop, make the shutter speed twice as long, or boost the ISO setting 2X, you'll get twice as much exposure. Similarly, you can increase any of these factors while decreasing one of the others by a similar amount to keep the same exposure.

F/STOPS AND SHUTTER SPEEDS

If you're *really* new to more advanced cameras (and I realize that many soon-to-be-ambitious photographers do purchase the 6D Mark II as their first digital SLR), you might need to know that the lens aperture, or f/stop, is a ratio, much like a fraction, which is why f/2 is larger than f/4, just as 1/2 is larger than 1/4. However, f/2 is actually *four times* as large as f/4. (If you remember your high school geometry, you'll know that to double the area of a circle, you multiply its diameter by the square root of two: 1.4.)

Lenses are usually marked with intermediate f/stops that represent a size that's twice as much/half as much as the previous aperture. So, a lens might be marked f/2, f/2.8, f/4, f/5.6, f/8, f/11, f/16, f/22, with each larger number representing an aperture that admits half as much light as the one before. Shutter speeds are actual fractions (of a second), but the numerator is omitted, so that 60, 125, 250, 500, 1,000, and so forth represent 1/60th, 1/125th, 1/250th, 1/500th, and 1/1,000th second. To avoid confusion, Canon uses quotation marks to signify longer exposures: 2", 2"5, 4", and so forth representing 2.0-, 2.5-, and 4.0-second exposures, respectively.

Most commonly, exposure settings are made using the aperture and shutter speed, followed by adjusting the ISO sensitivity if it's not possible to get the preferred exposure; that is, the one that uses the "best" f/stop or shutter speed for the depth-of-field (range of sharp focus) or action stopping we want (produced by short shutter speeds, as I'll explain later). Table 4.1 shows equivalent exposure settings using various shutter speeds and f/stops.

When the 6D Mark II is set for P (Program) mode, the metering system selects the correct exposure for you automatically, but you can change quickly to an equivalent exposure for one shot only (not a series of images) by locking the current exposure, and then spinning the Main Dial until the desired equivalent exposure combination is displayed. You can use this standard Program Shift feature more easily if you remember that you need to rotate the dial toward the left when you want to increase the amount of depth-of-field or use a slower shutter speed; rotate to the right when you want to reduce the depth-of-field or use a faster shutter speed. The need for more/less DOF and slower/faster shutter speed are the primary reasons you'd want to use Program Shift. I'll explain Program mode exposure shifting options in more detail later in this chapter.

Table 4.1 Equivalent Exposures				
Shutter Speed	f/stop	Shutter Speed	f/stop	
1/30th second	f/22	1/500th second	f/5.6	
1/60th second	f/16	1/1,000th second	f/4	
1/125th second	f/11	1/2,000th second	f/2.8	
1/250th second	f/8	1/4,000th second	f/2	

In Aperture-priority (Av) and Shutter-priority (Tv) modes, you can change to an equivalent exposure using a different combination of shutter speed and aperture, but only by either adjusting the aperture in Aperture-priority mode (the camera then chooses the shutter speed) or shutter speed in Shutter-priority mode (the camera then selects the aperture). I'll cover all these exposure modes and their differences later in the chapter.

How the 6D Mark II Calculates Exposure

When using the optical viewfinder, your 6D Mark II calculates exposure by measuring the light that passes through the lens and is bounced up by the mirror toward a 7,560-pixel exposure sensor that's also sensitive to infrared illumination. This RGB-IR metering sensor is located near the focusing surface. (Note: In live view, the sensor image is used instead to calculate exposure, as I'll explain later.) Light is evaluated using a pattern you can select (more on that later) and based on the assumption that each area being measured reflects about the same amount of light as a neutral gray card that reflects a "middle" gray of about 12 to 18 percent reflectance. (The photographic "gray cards" you buy at a camera store have an 18 percent gray tone, which does represent middle gray; however, your camera is calibrated to interpret a somewhat darker 12 percent gray; I'll explain more about this later.) That "average" 12 to 18 percent gray assumption is necessary, because different subjects reflect different amounts of light. In a photo containing, say, a white cat and a dark gray cat, the white cat might reflect five times as much light as the gray cat. An exposure based on the white cat will cause the gray cat to appear to be black, while an exposure based only on the gray cat will make the white cat appear washed out.

This is more easily understood if you look at some photos of subjects that are dark (they reflect little light), those that have predominantly middle tones, and subjects that are highly reflective. The next figure shows a simplified scale with a middle gray 18 percent tone, plus black and white patches, along with a human figure (not a cat) to illustrate how different exposure measurements actually do affect an exposure.

Correctly Exposed

The image shown in Figure 4.3, left, represents how a photograph might appear if you inserted the patches shown at bottom left into the scene, and then calculated exposure by measuring the light reflecting from the middle gray patch, which, for the sake of illustration, we'll assume reflects approximately 12 to 18 percent of the light that strikes it. The gray patch also happens to be similar in reflectance to the background behind the subject. The exposure meter in the 6D Mark II sees an object that it thinks is a middle gray, calculates an exposure based on that, and the patch in the center of the strip is rendered at its proper tonal value. Best of all, because the resulting exposure is correct, the black patch at left and white patch at right are rendered properly as well.

Figure 4.3 Left: Exposure calculated based on the middle-gray tone in the center of the card, the black and white patches are rendered accurately, too. Center: Exposure calculated based on the black square, the black patch looks gray, the gray patch appears to be a light gray, and the white square is seriously overexposed. Right: When exposure is calculated based on the white patch on the right, the photo is underexposed.

When you're shooting pictures with your 6D Mark II, and the meter happens to base its exposure on a subject that averages that "ideal" middle gray, you'll end up with similar (accurate) results. The camera's exposure algorithms are concocted to ensure this kind of result as often as possible, barring any unusual subjects (that is, those that are backlit, or have uneven illumination). The 6D Mark II has four different metering modes (described in the next section), each of which is equipped to handle certain types of unusual subjects, as I'll outline.

Overexposed

Figure 4.3, center, shows what would happen if the exposure were calculated based on metering the leftmost, black patch, which is roughly the same tonal value of the darkest areas of the subject's hair. The light meter sees less light reflecting from the black square than it would see from a gray middletone subject, and so figures, "Aha! I need to add exposure to brighten this subject up to a middle gray!" That lightens the "black" patch, so it now appears to be gray.

But now the patch in the middle that was *originally* middle gray is overexposed and becomes light gray. And the white square at right is now seriously overexposed and loses detail in the highlights, which have become a featureless white. Our human subject is similarly overexposed.

Underexposed

The third possibility in this simplified scenario is that the light meter might measure the illumination bouncing off the white patch, which roughly corresponds to the subject's blouse, and try to render *that* tone as a middle gray. A lot of light is reflected by the white square, so the exposure is

reduced, bringing that patch closer to a middle gray tone. The patches that were originally gray and black are now rendered too dark. Clearly, measuring the gray card—or a substitute that reflects about the same amount of light—is the only way to ensure that the exposure is precisely correct. (See Figure 4.3, right.)

As you can see, the ideal way to measure exposure is to meter from a subject that reflects 12 to 18 percent of the light that reaches it. If you want the most precise exposure calculations, the solution is to use a stand-in, such as the evenly illuminated gray card I mentioned earlier. But, because the standard Kodak gray card reflects 18 percent of the light that reaches it and, as I said, your camera is calibrated for a somewhat darker 12 percent tone, you would need to add about one-half stop *more* exposure than the value metered from the card.

In some very bright scenes (like a snowy landscape or a lava field), you won't have a mid-tone to meter. Another substitute for a gray card is the palm of a human hand (the backside of the hand is too variable). But a human palm, regardless of ethnic group, is even brighter than a standard gray card, so instead of one-half stop more exposure, you need to add one additional stop. That is, if your meter reading is 1/500th of a second at f/11, use 1/500th second at f/8 or 1/250th second at f/11 instead. (Both exposures are equivalent.)

Or, you might want to resort to using an evenly illuminated gray card mentioned earlier. Small versions are available that can be tucked in a camera bag. Place it in your frame near your main subject, facing the camera, and with the exact same even illumination falling on it that is falling on your subject. Then, use the Spot metering function (described in the next section) to calculate exposure.

But, the standard Kodak gray card reflects 18 percent of the light while, as I noted, your camera is calibrated for a somewhat darker 12 percent tone. If you insisted on getting a perfect exposure, you would need to add about one-half stop more exposure than the value provided by taking the light meter reading from the card. Of course, in most situations, it's not necessary to do this. Your camera's light meter will do a good job of calculating the right exposure, especially if you use the exposure tips in the next section. But, I felt that explaining exactly what is going on during exposure calculation would help you understand how your 6D Mark II's metering system works.

EXTERNAL METERS CAN BE CALIBRATED

The light meters built into your 6D Mark II are calibrated at the factory. But if you use a handheld incident or reflective light meter, you *can* calibrate it, using the instructions supplied with your meter. Because a handheld meter, of both the reflective and incident type, *can* be calibrated to the 18 percent gray standard (or any other value you choose), my rant about the myth of the 18 percent gray card doesn't apply.

ORIGIN OF THE 18 PERCENT MYTH

Why are so many photographers under the impression that camera light meters are calibrated to the 18 percent "standard," rather than the true value, which may be 12 to 14 percent, depending on the vendor? You'll find this misinformation in an alarming number of places. I've seen the 18 percent myth taught in camera classes; I've found it in books, and even been given this wrong information from the technical staff of camera vendors. (They should know better—the same vendors' engineers who design and calibrate the cameras have the right figure.)

The most common explanation is that during a revision of Kodak's instructions for its gray cards in the 1970s, the advice to open up an extra half stop was omitted, and a whole generation of shooters grew up thinking that a measurement off a gray card could be used as-is. The proviso returned to the instructions by 1987, it's said, but by then it was too late. Next to me is a (c)2006 version of the instructions for KODAK Gray Cards, Publication R-27Q (still available in authorized versions from non-Kodak sources). The current directions read (with a bit of paraphrasing from me in italics):

- For subjects of normal reflectance increase the indicated exposure by 1/2 stop.
- For light subjects use the indicated exposure; for very light subjects, decrease the exposure by 1/2 stop. (*That is, you're measuring a subject that's lighter than middle gray.*)
- If the subject is dark to very dark, increase the indicated exposure by 1 to 1-1/2 stops. (You're shooting a dark subject.)

Choosing a Metering Method

To calculate exposure automatically, you need to tell the 6D Mark II where in the frame to measure the light (this is called the *metering method*) and what controls should be used (aperture, shutter speed, or both) to set the exposure. That's called *exposure mode*, and includes Program (P), Shutter-priority (Tv), Aperture-priority (Av), or Manual (M) options, plus Scene Intelligent Auto and Creative Auto. I'll explain all these next.

But first, I'm going to introduce you to the four metering methods. You can select any of the four if you're working with P, Tv, Av, or M exposure modes; if you're using Scene Intelligent Auto or Creative Auto, Evaluative metering is selected automatically and cannot be changed.

Choose a metering mode by pressing the Metering mode button on the top panel, and using the Main Dial until the icon for the mode you want appears in the status LCD. You can also select the metering mode by pressing the Q button and navigating to the metering mode icon in the center of the bottom row of the Quick Control screen.

Then, choose your mode:

■ **Evaluative.** The 6D Mark II slices up the frame into 63 different zones, shown as yellow rectangles at left in Figure 4.4. (Don't confuse these zones with the 45 *autofocus* zones; they are different.) Within those exposure zones are the 7,560 RGB-IR light-sensitive pixels of the exposure sensor.

The exposure zones used are linked to the autofocus system such that as the camera evaluates the measurements, it gives extra emphasis to the metering zones that indicate sharp focus. From this data, it makes an educated guess about what kind of picture you're taking, based on examination of thousands of different real-world photos in the camera's database. For example, if the top sections of a picture are much lighter than the bottom portions, the algorithm can assume that the scene is a landscape photo with lots of sky. This mode is the best all-purpose metering method for most pictures. I'll explain how to choose an autofocus/exposure zone later in this chapter. See Figure 4.4, right, for an example of a scene that can be easily interpreted by the Evaluative metering mode.

Figure 4.4 Evaluative metering uses 63 zones (left) and 7,560 exposure sensors, and is effective for evenly lit scenes (right).

LOCKING EXPOSURE

By default, the 6D Mark II will lock exposure when the shutter release is pressed halfway, immediately after autofocus is locked in when using One-Shot AF with Evaluative metering. If you don't want to lock exposure with this half-press in One-Shot mode, you can disable it using C.Fn 1-8, as I'll describe in Chapter 13.

Of course, focus can change when using AI Focus or AI Servo (if your subject moves or you reframe the image), so exposure is *not* locked when the shutter release is pressed halfway while using Evaluative metering. Instead, exposure is not locked until the moment of exposure or until you press the AE/FE Lock button (marked with an asterisk symbol on the back of the camera) or a user-defined AE lock button.

- Partial. This is a *faux* spot mode, using roughly 6.1 percent of the image area to calculate exposure, which, as you can see at left in Figure 4.5, is a rather large spot, represented by the larger cyan circle. The status LCD icon is shown in the upper-left corner. Use this mode if the background is much brighter or darker than the subject, as in Figure 4.5, right. In Partial metering mode (as well as Spot and Center-weighted averaging), exposure is locked only when the picture is taken, or the AE/FE lock button is pressed. (A half-press of the shutter release does not lock exposure.) Exposure is set using the center AF point.
- **Spot.** This mode confines the reading to a limited area in the center of the viewfinder, as shown at left in Figure 4.6, making up only 1.3 percent of the image. This mode is useful when you want to base exposure on a small area in the frame, such as the gray portions of the structure in Figure 4.6, right. If that area is in the center of the frame, so much the better. If not, you'll have to make your meter reading and then lock exposure by pressing the shutter release halfway, or by pressing the AE lock (*) button. Note that spot metering is *not* linked to the focus point; the center point is always used.
- Center-weighted averaging. In this mode, the exposure meter emphasizes a zone in the center of the frame to calculate exposure, as shown at left in Figure 4.7, on the theory that, for most pictures, the main subject will be located in the center. Center-weighting works best for portraits, architectural photos, and other pictures in which the most important subject is located in the middle of the frame, as in Figure 4.7, right. As the name suggests, the light reading is weighted toward the central portion, but information is also used from the rest of the frame. If your main subject is surrounded by very bright or very dark areas, the exposure might not be exactly right. However, this scheme works well in many situations if you don't want to use one of the other modes. Lock exposure with the AE/FE lock button. As with Partial and Spot, the exposure is not linked to the focus point; the center point is used.

Figure 4.5 Partial metering uses a center spot that's roughly 6.5 percent of the frame area (left), and is excellent for images with the most important areas in the center (right).

Figure 4.6 Spot metering calculates exposure based on a center spot that's only 3.2 percent of the image area (left), and allows measuring specific areas, such as the gray portions of the structure (right).

Figure 4.7 Center-weighted metering calculates exposure based on the full frame, but emphasizes the center area (left). Exposure for the image on right was calculated from the large area in the center of the frame, with less emphasis on the darker surroundings.

Choosing an Exposure Method

You'll find four methods for choosing the appropriate shutter speed and aperture: Program (P), Shutter-priority (Tv), Aperture-priority (Av), and Manual (M). To select one of these modes, just press the Mode Dial lock release button and spin the Mode Dial (located at the top-left side of the camera) to choose the method you want to use.

Your choice of which exposure method is best for a given shooting situation will depend on things like your need for lots of (or less) depth-of-field, a desire to freeze action or allow motion blur, or how much noise you find acceptable in an image. (Remember that exposure triangle at the beginning of the chapter.) Each of the 6D Mark II's exposure methods emphasizes one of those aspects of image capture or another. This section introduces you to all of them.

In Scene Intelligent Auto mode, the 6D Mark II selects an appropriate ISO sensitivity setting, color (white) balance, Picture Style, color space, noise reduction features, and use of the Auto Lighting Optimizer. Use the Scene Intelligent Auto exposure mode when you hand your camera to a friend to take a picture (say, of you standing in front of the Eiffel Tower), and want to be sure they won't accidentally change any settings. In Creative Auto mode, which I'll describe later in this chapter, you can specify some parameters (including AF point selection and Drive mode), but none of them directly relate to exposure.

Aperture-Priority

In Av mode, you specify the lens opening used, and the 6D Mark II selects the shutter speed. Aperture-priority is especially good when you want to use a particular lens opening to achieve a desired effect. Perhaps you'd like to use the smallest f/stop possible to maximize depth-of-field in a close-up picture. Or, you might want to use a large f/stop to throw everything except your main subject out of focus, as in Figure 4.8. Maybe you'd just like to "lock in" a particular f/stop smaller than the maximum aperture because it's the sharpest available aperture with that lens. Or, you might prefer to use, say, f/2.8 on a lens with a maximum aperture of f/1.4, because you want the best compromise between speed and sharpness.

Aperture-priority can even be used to specify a *range* of shutter speeds you want to use under varying lighting conditions, which seems almost contradictory. But think about it. You're shooting a soccer game outdoors with a telephoto lens and want a relatively high shutter speed, but you don't care if the speed changes a little should the sun duck behind a cloud. Set your 6D Mark II to Av, and adjust the aperture until a shutter speed of, say, 1/1,000th second is selected at your current ISO setting. (In bright sunlight at ISO 400, that aperture is likely to be around f/11.) Then, go ahead and shoot, knowing that your 6D Mark II will maintain that f/11 aperture (for sufficient DOF as the soccer players move about the field), but will drop down to 1/750th or 1/500th second if necessary should the lighting change a little.

If the shutter speed in the viewfinder or on the Shooting Settings screen is blinking, that indicates that the 6D Mark II is unable to select an appropriate shutter speed at the selected aperture and the current ISO setting. To correct overexposure, select a smaller aperture (if available) or choose a lower ISO sensitivity. Fix underexposure conditions by choosing a larger aperture (if possible) or a higher ISO setting.

That's the major pitfall of using Av: you might select an f/stop that is too small or too large to allow an optimal exposure with the available shutter speeds. For example, if you choose f/2.8 as your aperture and the illumination is quite bright (say, at the beach or in snow), even your camera's fastest shutter speed might not be able to cut down the amount of light reaching the sensor to provide the right exposure. Or, if you select f/8 in a dimly lit room, you might find yourself shooting with a very slow shutter speed that can cause blurring from subject movement or camera shake. Aperture-priority is best used by those with a bit of experience in choosing settings. Many seasoned photographers leave their 6D Mark II set on Av all the time.

Figure 4.8 Use Aperture-priority to "lock in" a large f/stop when you want to blur the background.

When to use Aperture-priority:

- General landscape photography. The 6D Mark II is a great camera for landscape photography, of course, because its 26MP of resolution allows making huge, gorgeous prints, as well as smaller prints that are filled with eye-popping detail. Aperture-priority is a good tool for ensuring that your landscape is sharp from foreground to infinity, if you select an f/stop that provides maximum depth-of-field.
 - If you use Av mode and select an aperture like f/11 or f/16, it's your responsibility to make sure the shutter speed selected is fast enough to avoid losing detail to camera shake, or that the 6D Mark II is mounted on a tripod. One thing that new landscape photographers fail to account for is the movement of distant leaves and tree branches. When seeking the ultimate in sharpness, go ahead and use Aperture-priority, but boost ISO sensitivity a bit, if necessary, to provide a sufficiently fast shutter speed, whether shooting hand-held or with a tripod.
- Specific landscape situations. Aperture-priority is also useful when you have no objection to using a long shutter speed, or, particularly, want the 6D Mark II to select one. Waterfalls are a perfect example. You can use Av mode, set your camera to ISO 100, use a small f/stop, and let the camera select a longer shutter speed that will allow the water to blur as it flows. Indeed, you might need to use a neutral-density filter to get a sufficiently long shutter speed. But Aperture-priority mode is a good start.
- Portrait photography. Portraits are the most common applications of selective focus. A medium-large aperture (say, f/5.6 or f/8) with a longer lens/zoom setting (in the 85mm-135mm range) will allow the background behind your portrait subject to blur. A *very* large aperture (I frequently shoot wide open with my 85mm f/1.2 lens) lets you apply selective focus to your subject's *face*. With a three-quarters view of your subject, as long as their eyes are sharp, it's okay if the far ear or their hair is out of focus.
- When you want to ensure optimal sharpness. All lenses have an aperture or two at which they perform best, providing the level of sharpness you expect from a camera with the resolution of the 6D Mark II. That's usually about two stops down from wide open, and thus will vary depending on the maximum aperture of the lens. My 85mm f/1.2 is good wide open, but it's even sharper at f/2.8 or f/4; I shoot my 70-200mm f/2.8 wide open at concerts, but, if I can use f/4 instead, I'll get better results. Aperture-priority allows me to use each lens at its very best f/stop.
- Close-up/Macro photography. Depth-of-field is typically very shallow when shooting macro photos, and you'll want to choose your f/stop carefully. Perhaps you need the smallest aperture you can get away with to maximize DOF. Or, you might want to use a wider stop to emphasize your subject, as I did with the photo of the bird in Figure 4.8. Av mode comes in very useful when shooting close-up pictures. Because macro work is frequently done with the 6D Mark II mounted on a tripod, and your close-up subjects, if not living creatures, may not be moving much, a longer shutter speed isn't a problem. Av mode can be your preferred choice.

Shutter-Priority

Shutter-priority (Tv) is the inverse of Aperture-priority: you choose the shutter speed you'd like to use, and the camera's metering system selects the appropriate f/stop. Perhaps you're shooting action photos and you want to use the absolute fastest shutter speed available with your camera; in other cases, you might want to use a slow shutter speed to add some blur to a sports image that would be mundane if the action were completely frozen. Motor sports and track-and-field events particularly lend themselves to creative use of slower speeds, as you can see in Figure 4.9. Shutter-priority mode gives you some control over how much action-freezing capability your digital camera brings to bear in a particular situation.

You'll also encounter the same problem as with Aperture-priority when you select a shutter speed that's too long or too short for correct exposure under some conditions. I've shot outdoor soccer games on sunny Fall evenings and used Shutter-priority mode to lock in a 1/1,000th second shutter speed, which triggered the blinking warning, even with the lens wide open.

Like Av mode, it's possible to choose an inappropriate shutter speed. If that's the case, the maximum aperture of your lens (to indicate underexposure) or the minimum aperture (to indicate overexposure) will blink. To fix, select a longer shutter speed or higher ISO setting (for underexposure), or a faster shutter speed/lower ISO setting (for overexposure).

Figure 4.9 Lock the shutter at a slow speed to introduce a little blur into an action shot, seen here in this panned image of a base runner.

When to use Shutter-priority:

- To reduce blur from subject motion. Set the shutter speed of the 6D Mark II to a higher value to reduce the amount of blur from subjects that are moving. The exact speed will vary depending on how fast your subject is moving and how much blur is acceptable. You might want to freeze a basketball player in mid-dunk with a 1/1,000th second shutter speed, or use 1/250th second to allow the spinning wheels of a motocross racer to blur a tiny bit to add the feeling of motion.
- **To add blur from subject motion.** There are times when you want a subject to blur, say, when shooting waterfalls with the camera set for a one- or two-second exposure in Shutter-priority mode.
- To add blur from camera motion when *you* are moving. Say you're panning to follow a pair of relay runners. You might want to use Shutter-priority mode and set the 6D Mark II for 1/60th second, so that the background will blur as you pan with the runners. The shutter speed will be fast enough to provide a sharp image of the athletes.
- To reduce blur from camera motion when *you* are moving. In other situations, the camera may be in motion, say, because you're shooting from a moving train or auto, and you want to minimize the amount of blur caused by the motion of the camera. Shutter-priority is a good choice here, too.
- Landscape photography hand-held. If you can't use a tripod for your landscape shots, you'll still probably want the sharpest image possible. Shutter-priority can allow you to specify a shutter speed that's fast enough to reduce or eliminate the effects of camera shake. Just make sure that your ISO setting is high enough that the 6D Mark II will select an aperture with sufficient depth-of-field, too.
- Concerts, stage performances. I shoot a lot of concerts with my 70-200mm f/2.8 lens, and have discovered that, when image stabilization is taken into account, a shutter speed of 1/180th second is fast enough to eliminate blur from hand-holding the 6D Mark II with this lens, and also to avoid blur from the movement of all but the most energetic performers. I use Shutter-priority and set the ISO so the camera will select an aperture in the f/4-5.6 range.

Program AE Mode

Program mode (P) uses the 6D Mark II's built-in smarts to select the correct f/stop and shutter speed using a database of picture information that tells it which combination of shutter speed and aperture will work best for a particular photo. If the correct exposure cannot be achieved at the current ISO setting, the shutter speed or aperture indicator in the viewfinder will blink, indicating under- or overexposure. You can then boost or reduce the ISO to increase or decrease sensitivity.

The 6D Mark II's recommended exposure can be overridden if you want. Use the EV setting feature (described later, because it also applies to Tv and Av modes) to add or subtract exposure from the

metered value. And, as I mentioned earlier in this chapter, you can change from the recommended setting to an equivalent setting (as shown in Table 4.1) that produces the same exposure, but using a different combination of f/stop and shutter speed. To accomplish this:

- 1. Press the shutter release halfway to lock in the current base exposure, or press the AE Lock button (*) on the back of the camera (in which case the * indicator will illuminate in the view-finder to show that the exposure has been locked).
- 2. If the camera cannot select an appropriate exposure:
 - **Underexposure.** To compensate, you must either use a higher ISO setting or provide additional illumination, such as electronic flash.
 - Overexposure. You can usually compensate for this by reducing the ISO speed to a lower setting. Your scene must be *very* bright indeed to trigger overexposure at a shutter speed of 1/4,000th second and ISO 100, the lowest sensitivity setting. But if you're photographing, say, a blast furnace, and still have an overexposure situation, you can resort to a neutral-density filter or find some way to reduce the amount of illumination.
- 3. Once an exposure is set, you can spin the Main Dial to change to a different combination of settings. Rotate left to select a longer shutter speed/smaller aperture, or to the right to choose a faster shutter speed/larger aperture.

Note: Your adjustment remains in force for a *single* exposure; if you want to change from the recommended settings for the next exposure, you'll need to repeat those steps.

When to use Program mode priority:

- When you're in a hurry to get a grab shot. The 6D Mark II will do a pretty good job of calculating an appropriate exposure for you, without any input from you.
- When you hand your camera to a novice. Set the 6D Mark II to P, hand the camera to your friend, relative, or trustworthy stranger you meet in front of the Eiffel Tower, point to the shutter release button and viewfinder, and say, "Look through here, and press this button."
- When no special shutter speed or aperture settings are needed. If your subject doesn't require special anti- or pro-blur techniques, and depth-of-field or selective focus aren't important, use P as a general-purpose setting. You can still make adjustments to increase/decrease depth-of-field or add/reduce motion blur with a minimum of fuss.

Scene Intelligent Auto

On first consideration, including an exposure mode with no user options might seem counterintuitive on a camera as advanced as the 6D Mark II, because it essentially transforms a sophisticated pro/enthusiast camera into a point-and-click snapshooter. Delve deeper, and you'll discover that there is method in Canon's madness, and that Scene Intelligent Auto is a lot more than a less versatile version of Program mode. The key is the *Intelligent* part of the mode's nomenclature.

With P mode, only the shutter speed and aperture are determined by the camera. You can change the metering mode, autofocus mode, white balance, and virtually all other settings. In Scene Intelligent Auto mode, the 6D Mark II will analyze your scene, even to the extent of evaluating whether your subject is static or moving, and then intelligently choose optimum settings without any input from you. Its choices include:

- **ISO speed.** The camera will choose an ISO sensitivity automatically.
- Picture Style. The A (automatic) Picture Style is active, and the camera will choose appropriate settings. Note that if you have made changes to the Auto Picture Style (I'll show you how to do that in Chapter 11), they will be ignored in Scene Intelligent Auto.
- White balance. White balance is set automatically and cannot be changed.
- Auto Lighting Optimizer. Always active in Scene Intelligent Auto mode.
- Color space. Forced to sRGB.
- **Autofocus.** AI Focus AF is always used, and AF area selection modes cannot be specified. AF point selection is always automatic, and the AF-assist beam activated.
- Metering mode. Evaluative metering is always used.

Things that you can choose in Scene Intelligent Auto mode include:

- Manual focus. Manual focus can be chosen by toggling the AF/MF switch on the lens to Manual.
- **AF point selection mode.** You can select any of the five point selection modes, as described in Chapter 1, and further explained in Chapter 5.
- **Drive mode.** You use the Quick Control screen or Drive mode button to choose from single shooting, high-/low-speed continuous shooting, silent single shooting, silent continuous shooting, and 10 sec./2 sec. and continuous self-timer modes.

Some shooting options are available from the truncated three-tab menu system offered in Scene Intelligent Auto mode. I'll explain all menu entries for all exposure modes in Chapters 11 to 13.

Manual Exposure

Part of being an experienced photographer comes from knowing when to rely on your 6D Mark II's automation (including Scene Intelligent Auto or P mode), when to go semi-automatic (with Tv or Av), and when to set exposure manually (using M). Some photographers actually prefer to set their exposure manually most of the time, as the 6D Mark II will be happy to provide an indication of when its metering system judges your settings provide the proper exposure, using the analog exposure scale at the bottom of the viewfinder and on the status LCD.

Manual exposure can come in handy in some situations. You might be taking a silhouette photo and find that none of the exposure modes or EV correction features give you exactly the effect you want. For example, when I shot the ballet dancer in Figure 4.10 in front of a mostly dark background highlighted by an illuminated curtain off to the right, there was no way any of my 6D Mark II's exposure modes would be able to interpret the scene the way I wanted to shoot it, even with Spot metering, which didn't have a narrow enough field-of-view from my position. So, I took a couple test exposures, and set the exposure manually using the exact shutter speed and f/stop I needed. You might be working in a studio environment using multiple flash units. The additional flash are triggered by slave devices (gadgets that set off the flash when they sense the light from another flash, or, perhaps from a radio or infrared remote control). Your camera's exposure meter doesn't compensate for the extra illumination, and can't interpret the flash exposure at all, so you need to set the aperture manually.

Because, depending on your proclivities, you might not need to set exposure manually very often, you should still make sure you understand how it works. Fortunately, the 6D Mark II makes setting exposure manually very easy. Just set the Mode Dial to M, turn the Main Dial to set the shutter speed, and rotate the QCD to adjust the aperture. Press the shutter release halfway or press the AE Lock button, and the exposure scale in the viewfinder shows you how far your chosen setting diverges from the metered exposure.

Figure 4.10 Manual exposure allows selecting both f/stop and shutter speed, especially useful when you're experimenting, as with this shot of ballet dancers.

When to use Manual exposure:

- When working in the studio. If you're working in a studio environment, you generally have total control over the lighting and can set exposure exactly as you want. The last thing you need is for the 6D Mark II to interpret the scene and make adjustments of its own. Use M and the shutter speed, aperture, and (as long as you don't use ISO-Auto) ISO setting are totally up to you.
- When using non-dedicated flash. External Canon-dedicated flash units are cool, but if you're working with a non-compatible flash unit, particularly studio flash plugged into a PC/X sync adapter mounted on the hot shoe, the camera has no clue about the intensity of the flash, so you'll have to dial in the appropriate aperture manually.
- If you're using a hand-held light meter. The appropriate aperture, both for flash exposures and shots taken under continuous lighting, can be determined by a hand-held light meter, flash meter, or combo meter that measures both kinds of illumination. With an external meter, you can measure highlights, shadows, backgrounds, or additional subjects separately, and use Manual exposure to make your settings.
- When you want to outsmart the metering system. Your 6D Mark II's metering system is "trained" to react to unusual lighting situations, such as backlighting, extra-bright illumination, or low-key images with murky shadows. In many cases, it can counter these "problems" and produce a well-exposed image. But what if you don't want a well-exposed image? Manual exposure allows you to produce silhouettes in backlit situations, wash out all the middle tones to produce a luminous look, or underexpose to create a moody or ominous dark-toned photograph.

Adjusting Exposure with ISO Settings

Another way of adjusting exposures is by changing the ISO sensitivity setting. Sometimes photographers forget about this option, because the common practice is to set the ISO once for a particular shooting session (say, at ISO 100 or 200 for bright sunlight outdoors, or ISO 800 when shooting indoors) and then forget about it. ISOs higher than ISO 100 or 200 are seen as "bad" or "necessary evils." However, changing the ISO is a valid way of adjusting exposure settings, particularly with the Canon EOS 6D Mark II, which produces good results at ISO settings that create grainy, unusable pictures with some other camera models.

Indeed, I find myself using ISO adjustment as a convenient alternate way of adding or subtracting EV when shooting in Manual mode, and as a quick way of choosing equivalent exposures when in Auto or semi-automatic modes. For example, I've selected a Manual exposure with both f/stop and shutter speed suitable for my image using, say, ISO 200. I can change the exposure in one-third-stop increments by pressing the ISO button on top of the camera, and spinning the Main Dial one click

at a time. The difference in image quality/noise at the base setting of ISO 200 is negligible if I dial in ISO 100 to reduce exposure a little, or change to ISO 400 to increase exposure. I keep my preferred f/stop and shutter speed, but still adjust the exposure.

Or, perhaps, I am using Tv mode and the metered exposure at ISO 200 is 1/500th second at f/11. If I decide on the spur of the moment I'd rather use 1/500th second at f/8, I can press the ISO button and spin the Main Dial to switch to ISO 100. Of course, it's a good idea to monitor your ISO changes, so you don't end up at ISO 1600 accidentally. ISO settings can, of course, also be used to boost or reduce sensitivity in particular shooting situations.

When not using Scene Intelligent Auto (which sets ISO automatically), the 6D Mark II can set ISO speeds manually for stills. (In video mode, Auto ISO must be used in all modes except Manual exposure.) The ISO Speed Settings entry in the Shooting 2 menu allows you to specify what speeds are available and how they are used:

- **ISO Speed.** This scale allows you to choose from the enabled ISO speeds, plus Auto, using a sliding scale that can be adjusted using the QCD, multi-controller directional buttons, or the touch screen. Pressing the INFO. button when the scale is visible activates Auto.
- ISO Speed Range (for Stills). You can specify the minimum and maximum ISO sensitivity available, from ISO 100 to 40000, plus "expanded" settings of L (ISO 50 equivalent) and H1 (ISO 51200)/H2 (ISO 102400). Note that the expanded settings may produce unacceptable grain and/or contrast.
 - I find myself using this feature frequently to keep me from accidentally switching to a setting I'd rather not use (or need to avoid). For example, at concerts I may switch from ISO 1600 to 6400 as the lighting changes, and I set those two values as my minimum or maximum. Outdoors in daylight, I might prefer to lock out ISO values lower than ISO 100 or higher than ISO 800.
- Auto Range. This is the equivalent "safety net" for Auto ISO operation. You can set the minimum no lower than ISO 100 and the maximum to ISO 12800, and no further. Use this to apply your own "smarts" to the Auto ISO setting.
- Minimum Shutter Speed. You can choose whether to allow the 6D Mark II to select the slowest shutter speed used before Auto ISO kicks in. The idea here is that you'll probably want to boost ISO sooner if you're using a long lens with P and Av modes (in which the camera selects the shutter speed). If you specify, for example, a minimum shutter speed of 1/250th second, if P or Av mode needs a slower shutter speed for the proper exposure, it will boost ISO instead, within the range you've specified with Auto Range.

This setting has two modes. In Auto mode, the camera decides when the shutter speed is too low. You can fine-tune this by choosing Slower or Faster on the scale (–3 to +3) that appears. Or, you can manually select the "trigger" shutter speed, from 1 second to 1/4,000th second.

By default, both the exposure level increments (size of shutter speed or f/stop changes) are in 1/3-stop jumps. In the C.Fn I-1 and C.Fn I-2 menus (described in Chapter 13), you can set exposure level increments to 1/3 or 1/2 stops, and ISO changes to 1/3- or 1-stop increments. The larger 1-stop step for ISO allows rapid switching through ISO 100, 200, 400, 800, and so forth.

Table 4.2 shows the available ISO settings for each shooting mode, both with and without flash. The ISO speed range depends, of course, on the minimum and maximum values you enable.

Table 4.2 Available ISO Auto Settings			
Shooting Mode	ISO—No Flash	ISO—Flash	
Scene modes	Depends on SCN used	Depends on SCN used	
Scene Intelligent Auto/Creative Auto	ISO 100-ISO 12800	ISO 100-ISO 1600	
Tv/Av/P/M	ISO 100-ISO 40000	ISO 100-ISO 1600	
Bulb	ISO 400	ISO 400 (Lower settings may be used with fill flash to avoid overexposure)	

Tip

Find yourself locked out of ISO settings lower than 200 or higher than 32000? You've probably set Highlight Tone Priority to Enable in the Shooting 3 menu, as described in Chapter 11.

Dealing with Visual Noise

Visual image noise is that random grainy effect that some like to use as a special effect, but which, most of the time, is objectionable because it robs your image of detail even as it adds that "interesting" texture. Noise is caused by two different phenomena: high ISO settings and long exposures.

High ISO noise commonly first appears when you raise your camera's sensitivity setting above ISO 3200. With Canon cameras, which are renown for their good ISO noise characteristics, noise is usually fairly noticeable at ISO 6400 and above. At the H1 and H2 settings (ISO 51200 and 102400 equivalents), noise is usually quite bothersome. This kind of noise appears as a result of the amplification needed to increase the sensitivity of the sensor. Because your sensor has twice as many green pixels as red and blue pixels, such noise is typically worse in areas that have red, blue, and magenta tones, because the green signals don't have to be amplified as much to produce detail. While higher ISOs do pull details out of dark areas, they also amplify non-signal information randomly, creating noise.

A similar noisy phenomenon occurs during long time exposures, which allow more photons to reach the sensor, increasing your ability to capture a picture under low-light conditions. However, the longer exposures also increase the likelihood that some pixels will register random phantom photons, often because the longer an imager is "hot," the warmer it gets, and that heat can be mistaken for photons. There's also a special kind of noise called fixed-pattern noise, produced by the design of CMOS sensors like the one in the 6D Mark II.

You might still want to apply the optional long exposure noise reduction that can be activated in the Shooting 3 menu. This type of noise reduction involves the 6D Mark II taking a second, blank exposure, and comparing the random pixels in that image with the photograph you just took. Pixels that coincide in the two represent noise and can safely be suppressed. This noise reduction system, called *dark frame subtraction*, effectively doubles the amount of time required to take a picture, and is used only for exposures longer than one second. Noise reduction can reduce the amount of detail in your picture, as some image information may be removed along with the noise. So, you might want to use this feature with moderation. Some types of images don't require noise reduction, because the grainy pattern tends to blend into the overall scene.

To activate your 6D Mark II's high ISO and long exposure noise reduction features, go to the Shooting 3 menu, as explained further in Chapter 11. You can also apply noise reduction to a lesser extent using Photoshop or Canon Digital Photo Professional (or, DPP, which is necessary for working with Dual Pixel RAW images in any case), and when converting RAW files to some other format, using your favorite RAW converter, or an industrial-strength product like Noise Ninja (www.picturecode.com) to wipe out noise after you've already taken the picture.

Making EV Changes

Sometimes you'll want more or less exposure than indicated by the 6D Mark II's metering system. Perhaps you want to underexpose to create a silhouette effect, or overexpose to produce a high-key look. It's easy to use the 6D Mark II's exposure compensation system to override the exposure recommendations, available in any non-automatic mode except Manual. There are three ways to make exposure value (EV) changes with the 6D Mark II.

■ Viewfinder/Quick Control Dial. When looking through the optical viewfinder, you can add/subtract exposure compensation ±3 stops by tapping the shutter release halfway (you don't have to hold it down) and then rotating the Quick Control Dial. Turn clockwise to add exposure, or counter-clockwise to reduce exposure. The exposure scale at the bottom of the screen and in the top-panel monochrome LCD will indicate the amount of exposure compensation you've dialed in. (See Figure 4.11, top.) The EV +/− symbol appears to the left of the exposure scale when compensation has been made, and disappears when you zero out your change and return to the metered exposure.

- Quick Control screen. Press the Q button and use the multi-controller to select the exposure scale. Then rotate the QCD. Rotate clockwise to add exposure, or counter-clockwise to reduce exposure. (As always, you can use the touch screen to access these controls.) The exposure scale on the screen will indicate the amount of exposure compensation and display the EV icon. (See Figure 4.11, bottom.)
- Shooting 2 menu. Press the MENU button and rotate the Main Dial to select the Shooting 2 menu. Then rotate the QCD or use the directional buttons to highlight the Expo. Comp/AEB entry. Press SET to access the screen shown in Figure 4.12. Then rotate the QCD or slide a finger across the scale to select the amount of exposure compensation. The screen has helpful labels (Darker on the left and Brighter on the right) to make sure you're adding/subtracting when you really want to.

Note that this method has two advantages: you can choose up to five stops of exposure compensation (rather than just three with the first two methods), and you can specify automatic exposure bracketing from this screen just by rotating the Main Dial. I'll explain bracketing in more detail next.

Figure 4.11 When you set exposure compensation with the Quick Control Dial, the amount of adjustment is shown in the viewfinder and top-panel monochrome LCD (top). You can also use the Quick Control screen (bottom).

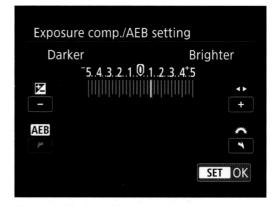

Figure 4.12 A wider range of exposure compensation adjustments (up to five stops) can be made using the Expo. Comp/AEB entry in the Shooting 2 menu.

Bracketing Parameters

Bracketing is a method for shooting several consecutive exposures using different settings, as a way of improving the odds that one will be exactly right. Before digital cameras took over the universe, it was common to bracket exposures, shooting, say, a series of three photos at 1/125th second, but varying the f/stop from f/8 to f/11 to f/16. In practice, smaller than whole-stop increments were used for greater precision. Plus, it was just as common to keep the same aperture and vary the shutter speed, although in the days before electronic shutters, film cameras often had only whole-increment shutter speeds available. Figure 4.13 shows a typical bracketed series.

Today, cameras like the 6D Mark II can bracket exposures much more precisely, and bracket white balance as well (using the WB Shift/Bkt entry found in the Shooting 2 menu and described in Chapter 11). While WB bracketing is sometimes used when getting color absolutely correct in the camera is important, autoexposure bracketing (AEB) is used much more often. When this feature is activated, the 6D Mark II takes a series of shots, all at a different exposure value—one at the standard exposure, and the others with more or less exposure. (See Figure 4.14.) In Av mode, the shutter speed will change, whereas in Tv mode, the aperture speed will change. The next sections will explain the parameters you can select.

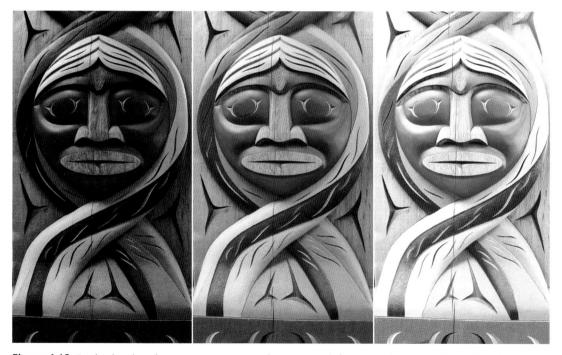

Figure 4.13 In this bracketed series, you can see underexposure (left), metered exposure (center), and overexposure (right).

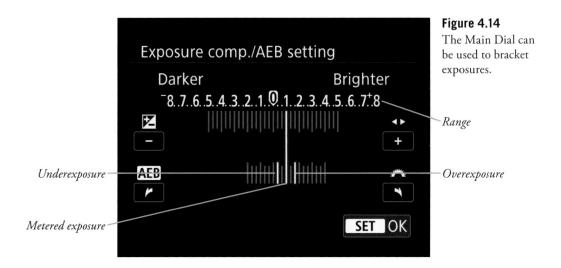

Bracketing Auto Cancel

The first parameter to set is found in the Custom Functions menu as C.Fn I-3, Bracketing Auto Cancel. When you activate bracketing (in the Shooting 2 menu), the 6D Mark II continues to shoot bracketed exposures until you manually turn the bracket feature off, assuming you have this setting disabled. That's a good thing. If you're out shooting a series of bracketed exposures (especially for HDR), it's convenient to have your bracket setting be "sticky" and still be active even if you turn your camera off. Some shooters like to bracket virtually *everything* and leave bracketing on routinely.

However, much of the time you'll want to turn bracketing off, and you may not want to visit the Shooting 2 menu to deactivate it manually. Set Bracketing Auto Cancel to Enable, and bracketing is cancelled when you turn the 6D Mark II off, change lenses, use the flash, or change memory cards. When this setting is set to Disable, bracketing remains in effect until you manually turn it off or use the flash. The flash still cancels bracketing, but your settings are retained.

Bracketing Sequence

Also in the Custom Function menu, you'll find C.Fn I-4, Bracketing Sequence, which allows you to specify the order in which the autoexposure bracketing series are exposed. Your choice will depend both on personal preference, and what you intend to do with the bracketed shots.

The options include:

- 0 +: The exposure sequence is standard exposure, decreased exposure, increased exposure. With this default value, your base exposure will be captured and saved first on your memory card, followed by the progressively reduced exposure images, then the shots with increased exposure. You might prefer this order if you expect your standard exposure will be the preferred image and arranged first in the queue of each bracket set, and want the alternate exposures to follow.
- - 0 +: The sequence is decreased exposure, standard exposure, increased exposure. This order is the most logical to use if you're shooting with the intention to combine images using HDR (high dynamic range) techniques in your image editor or HDR utility. The final bracketed array is stored on your memory card starting with the most underexposed shot, and progressing to the best exposed, and then on to the overexposures. That makes it easy to use all of your bracketed shots in the HDR sequence, or to select only some of them to combine.
- + 0 –: This sequence is the inverse of the last one, progressing from increased exposure to standard exposure and decreased exposure. You might prefer this order if you expect to see your best exposures on the plus side of the exposure sequence, and want them to be displayed first.

Number of Exposures

The final bracketing entry in the Custom Function menu is C.Fn I-5, Number of Bracketed Shots, where you can elect to bracket 2, 3, 5, or 7 shots:

- 2 shots. The 6D Mark II will capture one image at the *base* or standard exposure (which can be the metered exposure, or one that's more or less than the metered exposure, as I'll explain shortly). It then takes one additional shot that provides either *more* or *less* exposure relative to that "base" image. Rotate the QCD to the right to specify more exposure for the second shot, or to the left to specify less exposure. The *amount* of additional/less exposure is determined by the increment you select. (Read on! I'll tie all the parameters together in an upcoming section.)
- 3, 5, 7 shots. The camera captures one image at the base exposure, and then two, four, or six shots bracketed around that exposure, respectively. That translates to one over/one under at the 3-shot setting, two over/two under at the 5-shot setting, and three over/three under when using the 7-shot option.

Increment Between Exposures

You can choose the size of the jump between each of the bracketed exposures. To do that, you'll need to visit the Expo. Comp/AEB entry in the Shooting 2 menu. There, you can select from plus/minus 1/3 to 3 full stops in 1/3-stop increments, by rotating the Main Dial. The next section provides instructions for producing a bracketed set.

Creating a Bracketed Set

Using autoexposure bracketing is trickier than it needs to be, but has been made more flexible than with some earlier models. With the 6D Mark II you are not limited to only three exposures (as I noted, up to seven shots can be taken), and you can choose to bracket only overexposures or underexposures—a very useful improvement! Just follow these steps:

- Specify number of exposures and sequence. Choose the number of bracketed exposures you
 want and the sequence in which they will be shot in the Custom Function menu, as described
 earlier.
- 2. **Activate the Expo. Comp./AEB screen.** Press the MENU button and navigate to the Shooting 2 menu, where you'll find the Expo. Comp./AEB option. Press SET to select this entry.
- 3. **Set the bracket range/increment.** Rotate the Main Dial to spread out or contract the three bars to include the desired range and exposure increment you want to use. The wider the spread, the larger the increment and the larger the range of bracketed shots you'll end up with. The Main Dial will allow you to set the bracket range to up to three stops on either side of the standard (middle) exposure.

For example, in Figure 4.15 (top), the red highlighted bars are separated from the center bar by a full f/stop, so the bracketing will produce one image at one stop *less* than the zero point (the large center bar), one at the zero point, and one at one stop more than that. Figure 4.15 (bottom) shows the bars more widely separated, for a bracketed set three stops under and three stops over the midpoint, or standard/base exposure.

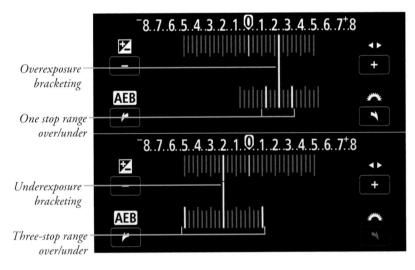

Figure 4.15
Use the Quick
Control Dial to bias
the bracketing
toward more or less
exposure, and the
Main Dial to set the
bracket range.

4. **Adjust zero point/standard exposure.** By default, the bracketing is zeroed around the center of the scale, which represents the correct exposure as metered by the 6D Mark II. But you might want to have your three bracketed shots *all* biased toward overexposure or underexposure. Perhaps you feel that the metered exposure will be too dark or too light, and you want the bracketed shots to lean in the other direction. Use the Quick Control Dial to move the bracket spread toward one end of the scale or the other. Figure 4.15 (top) shows the bracketing biased toward overexposure, while in Figure 4.15 (bottom), the zero point is clustered around underexposure. (Actually, the exposure bar at left will be five stops under the metered exposure, the center bar two stops under, and the right bar ends up one stop over the metered value.)

NON-BRACKETING IS EXPOSURE COMPENSATION

When the three bracket indicators aren't separated, using the QCD simply, in effect, adds or subtracts exposure compensation. You'll be shooting a "bracketed" set of one picture, with the zero point placed at the portion of the scale you indicated. Until you rotate the Main Dial to separate the three bracket indicators by at least one indicator, this screen just supplies EV adjustment. Also, keep in mind that the increments shown will be either 1/3 stop or 1/2 stop, depending on how you've set Exposure Level Increments in the Custom Function 1 menu.

- 5. **Confirm your choice.** Press the SET button to enter the settings.
- 6. **Take your photo sequence.** Press the shutter release to start capturing the bracketed sequence. The drive mode you select will determine when they are taken:
 - **Single shooting/Silent single shooting.** Press the shutter release one time for each exposure in the sequence.
 - High-speed continuous/Low-speed continuous/Silent continuous. You can hold down the shutter release and all the shots in the sequence will be exposed. The 6D Mark II stops shooting when the series is complete.
 - 10 sec./2 sec. self-timer modes. After the appropriate delay, all the shots in the sequence will be taken.
 - Self-timer continuous. If you should happen to want to take a clutch of bracketed sets, one after another, you can set the drive mode to Self-timer continuous and specify 2 to 10 exposures. After the delay has elapsed, the 6D Mark II will expose each bracketed set one after another. It's hard to visualize a need for this, but you might want to do it if your subject was moving, or changing facial expressions and you wanted to bracket each separately.
- 7. **Monitor your shots.** As the images are captured, three indicators will appear on the exposure scale in the viewfinder, with one of them flashing for each bracketed photo, showing when the base exposure, underexposure, and overexposure are taken.

8. **Turn bracketing off when done.** Bracketing remains in effect when the set is taken so you can continue shooting bracketed exposures until you use the electronic flash, turn off the camera, or return to the menu to cancel bracketing.

NOTE

AEB is disabled when you're using flash, Multi Shot Noise Reduction, taking long time exposures with the Bulb setting, or have enabled the Auto Lighting Optimizer in the Shooting 2 menu (in which case the optimizer would probably override and nullify bracketing).

Working with HDR

High dynamic range (HDR) photography is quite the rage these days, and entire books have been written on the subject. It's not really a new technique—film photographers have been combining multiple exposures for ages to produce a single image of, say, an interior room while maintaining detail in the scene visible through the windows.

Suppose you wanted to photograph a dimly lit room that had a bright window showing an outdoors scene. Proper exposure for the room might be on the order of 1/60th second at f/2.8 at ISO 200, while the outdoors scene probably would require f/11 at 1/400th second. That's almost a 7 EV step difference (approximately 7 f/stops) and effectively beyond the dynamic range of any digital camera, including the 6D Mark II.

Until camera sensors gain much higher dynamic ranges (which may not be as far into the distant future as we think), special tricks like Auto Lighting Optimizer and HDR photography will remain basic tools. With the 6D Mark II, you can create in-camera HDR exposures, or shoot HDR the old-fashioned way—with separate bracketed exposures that are later combined in a tool like Photomatix or Adobe's Merge to HDR Pro image-editing feature. I'm going to show you how to use both.

The 6D Mark II's in-camera HDR feature is simple, flexible, and surprisingly effective in creating high dynamic range images. It's also remarkably easy to use. Although it combines only three images to create a single HDR photograph, and while it's not always as good as the manual HDR method I'll describe in the section after this one, it's a *lot* faster.

Figure 4.16 shows you a typical situation in which you might want to use this setting, a brightly lit building with lots of detail in both shadows and highlights. HDR allows combining the detail from multiple images—not just the three shown at left, but as many as you want, if you combine them manually (as I'll show you later). However, a quickie solution is to use the 6D Mark II's HDR mode, described next. It captures three consecutive images and then merges them as a JPEG image that preserves both highlight and shadow detail.

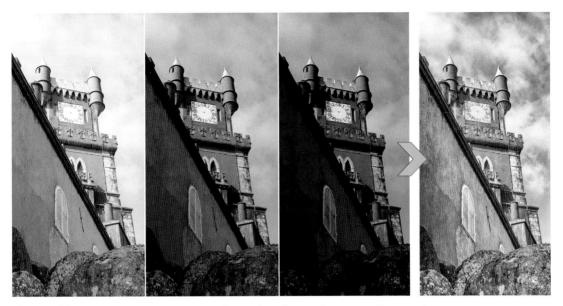

Figure 4.16 Three different exposures can be combined to produce one well-exposed image.

Using HDR Mode

Here are some tips for using this feature:

- Use a tripod if possible. Because there may be some camera movement between the continuous shots, you'll get better results if you mount the 6D Mark II on a tripod.
- Moving objects may produce ghosts. In this case, there may be some *subject* motion between shots, producing "ghost" effects.
- Misalignment. If you *don't* use a tripod, when Auto Image Align is activated, this mode does a good job of realigning your multiple images when they are merged. However, it can't do a perfect job, particularly with repetitive patterns that are difficult for the camera's "brains" to sort out. Some misalignment is possible.
- **Shutter speeds vary.** The camera brackets by adjusting the shutter speed within the increment range selected, *even if you're using Tv or M modes and have specified a shutter speed.*
- Unwanted cropping. Because the processor needs to be able to shift each individual image slightly in any (or all) of four directions in Auto Align mode (described next), it needs to crop the image slightly to trim out any non-image areas that result. Your final image will be slightly smaller than one shot in other modes.
- Weird colors. Some types of lighting, including fluorescent and LED illumination, "cycle" many times a second, and colors can vary between shots. You may not even notice this when single shooting, but it becomes more obvious when using any continuous shooting mode, including HDR mode. The combined images may have strange color effects.

- Can't use any RAW mode, or expanded ISO settings. Your image will be recorded as a Large JPEG only, and HDR is disabled with expanded ISO settings (L, H1, or H2). Only settings from ISO 100 to 40000 can be used. Auto Lighting Optimizer, Distortion Correction, and Highlight Tone Priority settings are disabled/ignored.
- The process takes time. Forget about firing off a large number of HDR shots in a row. After the 6D Mark II captures its three images, it takes a few seconds to process them and save your final image. Be patient.

You can locate HDR Mode in the Shooting 3 menu, where you can access the screen shown in Figure 4.17.

This menu has four separate entries:

- Adjust Dynamic Range. There are five choices in this entry. Select Disable HDR to turn HDR completely off. The others select the number of stops of dynamic range improvement the HDR feature will provide. Choose Auto to allow the 6D Mark II to examine your scene and select an appropriate EV range. As you gain experience you might want to select the range yourself, in order to achieve a particular look. You can choose plus/minus 1, 2, or 3 EV.
- Effect. If you've worked with HDR utilities (such as Photomatix) in the past, you know that various parameters can be adjusted while combining HDR images to produce various effects. These include the amount of color saturation (the "richness" of the hues); the boldness of the edge transitions between portions of the image (producing mild to distinct outlines); brightness of the resulting image; and contrast/tone. Various combinations of these settings produce what can only be called special effects. Select from what Canon terms Natural, Art Standard, Art Vivid, Art Bold, or Art Embossed. Note that these effects are added to the settings of any Picture Style currently in use.

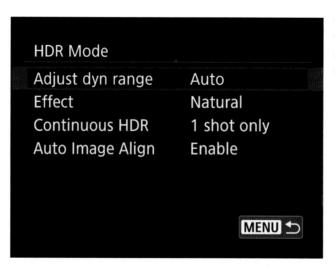

Figure 4.17
The HDR Mode menu has four entries.

- Continuous HDR. Choose 1 Shot Only if you plan to take just a single HDR exposure and want the feature disabled automatically thereafter, or Every Shot to continue using HDR mode for all subsequent exposures until you turn it off.
- Auto Image Align. HDR images are ideally produced with the camera on a tripod, in order to reduce the ghosting effects from a series of pictures that each aren't perfectly aligned with the other. You can choose Enable to have the camera attempt to align all three HDR exposures, or select Disable when using a tripod. The success of the automatic alignment will vary, depending on the shutter speed used (higher is better), and the amount of camera movement (less is better!).

SPECIAL HDR EFFECTS

The Effect parameters generate five different special effects (see Figure 4.18):

- Natural. Provides the most useful range of highlight and shadow details.
- Art Standard. Offers a great deal of highlight and shadow detail, but with lower overall contrast and outlines accentuated, making the image look more like a painting. Saturation, bold outline, and brightness are adjusted to the default levels, and tonal range is lower in contrast.
- **Art Vivid.** Similar to Art Standard, but saturation is boosted to produce richer colors, and the bold outlines are not as strong, producing a poster-like effect.
- Art Bold. Even higher saturation than Art Vivid, with emphasized edge transitions, producing what Canon calls an "oil painting" effect.
- Art Embossed. Reduces saturation, darker tones, and lower contrast, and gives the image a faded, aged look. The edge transitions are brighter or darker to emphasize them.

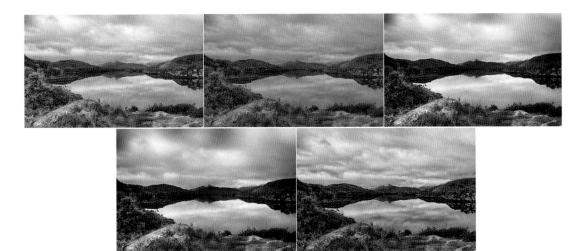

Figure 4.18 Top row (left to right): Natural, Art Standard, Art Vivid; bottom row: Art Bold, Art Embossed.

Bracketing and Merge to HDR

HDR (high dynamic range) photography was, for awhile, an incredibly popular fad. There are even entire books that do nothing but tell you how to shoot HDR images. Everywhere you looked there were overprocessed, garish HDR images that had little relationship to reality. I've been able to resist the temptation to overdo my landscape and travel photography (unlike the deliberately awful example I created for Figure 4.19). The phony-looking skies, the unnatural halos that appear at the edges of some objects, and the weird textures are usually a giveaway. My rule of thumb is that, if you can tell it's HDR, it's been done wrong—unless your intent was to show off what HDR can do.

The technique does have its uses, especially if done subtly, or as a special effect. That's what I was looking for when I shot John Popper of Blues Traveler for Figure 4.20. I wanted an edgy, posterlike quality, and so applied HDR liberally, but with the hope that the effect might not be evident on first glance.

Figure 4.19 A deliberately overcooked HDR photo.

Although the 6D Mark II does have its built-in HDR feature, you can usually get much better, more tasteful results if you create your high dynamic range images manually. You can use a tool such as Photoshop's Merge to HDR Pro feature, a stand-alone HDR utility, or a third-party Photoshop plug-in.

When you're using Merge to HDR Pro in Adobe Photoshop (similar functions are available in other programs, including the Mac/PC utility Photomatix [www.hdrsoft.com; free to try, \$39–99 to buy, depending on the version you select]), you'd take and combine several pictures. As I mentioned earlier, one would be exposed for the shadows, one for the highlights, and perhaps one for the midtones. Then, you'd use the Merge to HDR command (or the equivalent in other software) to combine all of the images into one HDR image that integrates the well-exposed sections of each version. You can use the camera's bracketing feature to produce those images.

Figure 4.20 In this case, HDR added a desired posterlike effect.

The next steps show you how to combine the separate exposures into one merged high dynamic range image. The sample images at left in Figure 4.21 show the results you can get from a three-shot (manually) bracketed sequence. The images should be as identical as possible, except for exposure. So, as with HDR mode, it's a good idea to mount the 6D Mark II on a tripod, use a remote release, and take all the exposures at once. Just follow these steps:

- 1. **Set up the camera.** Mount the 6D Mark II on a tripod.
- 2. **Choose an f/stop and Av mode.** Select an aperture that will provide a correct exposure at your initial settings for the series of bracketed shots. *And then leave this adjustment alone!* You don't want the aperture to change for your series, as that would change the depth-of-field, and, subtly, the size of some elements of the image as they move more or less out of focus. You want the 6D Mark II to adjust exposure *only* using the shutter speed.
- 3. **Choose manual focus.** You don't want the focus to change between shots, so set the 6D Mark II to manual focus, and carefully focus your shot.
- 4. **Choose RAW exposures.** Set the camera to take RAW files, which will give you the widest range of tones in your images.
- 5. **Set up your bracketed set.** Use the instructions earlier in this chapter to set the number of bracketed images you take, and the increment between them. After you've created your first few manual HDR photos, you'll learn to judge what increment is best (larger isn't always better). However, the more shots you have to work with, the better your results can be.
- 6. **Take your photos.** With the camera in continuous shooting mode, press the button on the remote (or carefully press the shutter release or use the self-timer) and take the set of bracketed exposures.
- 7. **Continue with the Merge to HDR Pro steps listed next.** You can also use a different program, such as Photomatix, if you know how to use it.

Figure 4.21 Three bracketed photos should look like this (left). The finished image is shown at right.

The next steps show you how to combine the separate exposures into one merged high dynamic range image.

- 1. **Copy your images to your computer.** If you use an application to transfer the files to your computer, make sure it does not make any adjustments to brightness, contrast, or exposure. You want the real raw information for Merge to HDR Pro to work with.
- 2. Activate Merge to HDR Pro. Choose File > Automate > Merge to HDR Pro.
- 3. **Select the photos to be merged.** Use the Browse feature to locate and select your photos to be merged. You'll note a checkbox that can be used to automatically align the images if they were not taken with the camera mounted on a rock-steady support. This will adjust for any slight movement of the camera that might have occurred when you changed exposure settings.
- 4. **Choose parameters (optional).** The first time you use Merge to HDR Pro, you can let the program work with its default parameters. Once you've played with the feature a few times, you can read the Adobe help files and learn more about the options than I can present in this non-software-oriented camera guide.
- 5. Click OK. The merger begins.
- 6. **Save.** Once HDR merge has done its thing, save the file to your computer.

What if you don't have the opportunity, inclination, or skills to create several images at different exposures, as described? If you shoot in RAW format, you can still use Merge to HDR, working with a *single* original image file. What you do is import the image into Photoshop several times, using Adobe Camera Raw to create multiple copies of the file at different exposure levels.

For example, you'd create one copy that's too dark, so the shadows lose detail, but the highlights are preserved. Create another copy with the shadows intact and allow the highlights to wash out. Then, you can use Merge to HDR to combine the two and end up with a finished image that has the extended dynamic range you're looking for. (This concludes the image-editing portion of the chapter. We now return you to our alternate sponsor: photography.)

Fixing Exposures with Histograms

Your 6D Mark II's histograms are a simplified display represented by the numbers of pixels at each of 256 brightness levels (although the camera actually captures many more levels in its 14-bit image files). The resulting graph produces an interesting mountain range effect. The 6D Mark II lets you designate either an RGB version or brightness-only version of the histogram as your "main" histogram display, using the Histogram Display entry in the Playback 3 menu. Or, you can display both types at once by scrolling down in the main histogram display screen using the up/down directional buttons. Figure 4.22 shows the single default histogram you select (in this case the brightness version) at left, and displays both at right.

Figure 4.22 Shooting information display, with luminance histogram (left); Histogram display with luminance, red, green, and blue histograms (right).

The 6D Mark II also provides a "live" brightness histogram on the screen as you frame and shoot when using Live View mode. Although separate charts may be provided for brightness and the red, green, and blue channels, when you first start using histograms, you'll want to concentrate on the brightness histogram, which I'll discuss next.

As I said, each vertical line in the graph represents the number of pixels in the image for each brightness value, from 0 (black) on the left to 255 (white) on the right, although the resolution of the LCD monitor isn't sufficient to actually show each of the 256 lines. The vertical axis measures that number of pixels at each level.

Tonal Range

Histograms help you adjust the tonal range of an image, the span of dark to light tones, from a complete absence of brightness (black) to the brightest possible tone (white), and all the middle tones in between. Because all values for tones fall into a continuous spectrum between black and white, it's easiest to think of a photo's tonality in terms of a black-and-white or grayscale image, even though you're capturing tones in three separate color layers of red, green, and blue.

Because your images are digital, the tonal "spectrum" isn't really continuous: it's divided into discrete steps that represent the different tones that can be captured. Figure 4.23 may help you understand this concept. The gray steps shown range from 100 percent gray (black) at the left, to 0 percent gray (white) at the right, with 20 gray steps in all (plus white).

Along the bottom of the chart are the digital values from 0 to 255 recorded by your sensor for an image with 8 bits per channel. (8 bits of red, 8 bits of green, and 8 bits of blue equal a 24-bit, full-color image.) Any black captured would be represented by a value of 0, the brightest white by 255, and the midtones would be clustered around the 128 marker.

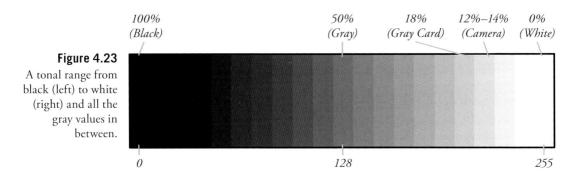

Grayscale images (which we call black-and-white photos) are easy to understand. Or, at least, that's what we think. When we look at a black-and-white image, we think we're seeing a continuous range of tones from black to white, and all the grays in between. But, that's not exactly true. The blackest black in any photo isn't a true black, because *some* light is always reflected from the surface of the print, and if viewed on a screen, the deepest black is only as dark as the least-reflective area a computer monitor can produce. The whitest white isn't a true white, either, because even the lightest areas of a print absorb some light (only a mirror reflects close to all the light that strikes it), and, when viewing on a computer monitor, the whites are limited by the brightness of the display's LCD or LED picture elements. Lacking darker blacks and brighter, whiter whites, that continuous set of tones doesn't cover the full grayscale tonal range.

The full scale of tones becomes useful when you have an image that has large expanses of shades that change gradually from one level to the next, such as areas of sky, water, or walls. Think of a picture taken of a group of campers around a campfire. Since the light from the fire is striking them directly in the face, there aren't many shadows on the campers' faces. All the tones that make up the *features* of the people around the fire are compressed into one end of the brightness spectrum—the lighter end.

Yet, there's more to this scene than faces. Behind the campers are trees, rocks, and perhaps a few animals that have emerged from the shadows to see what is going on. These are illuminated by the softer light that bounces off the surrounding surfaces. If your eyes become accustomed to the reduced illumination, you'll find that there is a wealth of detail in these shadow images.

This campfire scene would be a nightmare to reproduce faithfully under any circumstances. If you are an experienced photographer, you are probably already wincing at what is called a *high-contrast* lighting situation. Some photos may be high in contrast when there are fewer tones and they are all bunched up at limited points in the scale. In a low-contrast image, there are more tones, but they are spread out so widely that the image looks flat. Your digital camera can show you the relationship between these tones using a *histogram*.

Histograms and Contrast

Although histograms are most often used to fine-tune exposure, you can glean other information from them, such as the relative contrast of the image. Figure 4.24 (top) shows a histogram representing an image having normal contrast. In such an image, most of the pixels are spread across the image, with a healthy distribution of tones throughout the midtone section of the graph. That large peak at the right side of the graph represents all those light tones in the sky. A normal-contrast image you shoot may have less sky area, and less of a peak at the right side, but notice that very few pixels hug the right edge of the histogram, indicating that the lightest tones are not being clipped because they are off the chart.

With a lower-contrast image, like the one shown in Figure 4.24 (center), the basic shape of the previous histogram will remain recognizable, but gradually will be compressed together to cover a smaller area of the gray spectrum. The squished shape of the histogram is caused by all the grays in the original image being represented by a limited number of gray tones in a smaller range of the scale.

Instead of the darkest tones of the image reaching into the black end of the spectrum and the whitest tones extending to the lightest end, there is a small gap at either end. Consequently, the blackest areas of the scene are now represented by a light gray, and the whites by a somewhat lighter gray.

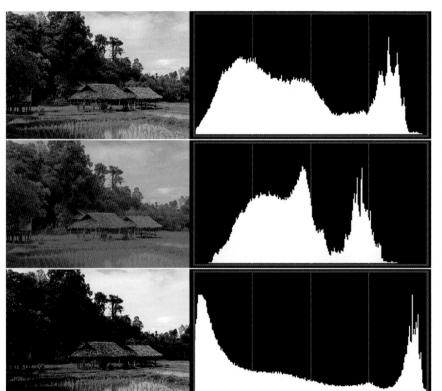

Figure 4.24

Top: The image has fairly normal contrast, even though there is a peak of light tones at the right side representing the sky. Center: The low-contrast image has all the tones squished into one section of the grayscale. Bottom: A high-contrast image produces a histogram in which the tones are spread out (bottom).

The overall contrast of the image is reduced. Because all the darker tones are actually a middle gray or lighter, the scene in this version of the photo appears lighter as well.

Going in the other direction, increasing the contrast of an image produces a histogram like the one shown in Figure 4.24 (bottom). In this case, the tonal range is now spread over the entire width of the chart, but, except for the bright sky (which you can see peaks at right), there is not much variation in the middle tones; the mountain "peaks" are not very high. When you stretch the grayscale in both directions like this, the darkest tones become darker (that may not be possible) and the lightest tones become lighter (ditto). In fact, shades that might have been gray before can change to black or white as they are moved toward either end of the scale.

The effect of increasing contrast may be to move some tones off either end of the scale altogether, while spreading the remaining grays over a smaller number of locations on the spectrum. That's exactly the case in the example shown. The number of possible tones is smaller and the image appears harsher.

Understanding Histograms

The important thing to remember when working with the histogram display in your 6D Mark II is that changing the exposure does *not* change the contrast of an image. The curves illustrated in the previous three examples remain exactly the same shape when you increase or decrease exposure. I repeat: The proportional distribution of grays shown in the histogram doesn't change when exposure changes; it is neither stretched nor compressed. However, the tones as a whole are moved toward one end of the scale or the other, depending on whether you're increasing or decreasing exposure. You'll be able to see that in some illustrations that follow.

So, as you reduce exposure, tones gradually move to the black end (and off the scale), while the reverse is true when you increase exposure. The contrast within the image is changed only to the extent that some of the tones can no longer be represented when they are moved off the scale.

To change the contrast of an image, you must do one of four things:

- Change the 6D Mark II's contrast setting using the menu system. You'll find these adjustments in your camera's Picture Styles, as explained in Chapter 11.
- Use your camera's tone "booster." The Highlight Tone Priority and Auto Lighting Optimizer features, described in Chapter 11, can also adjust contrast.
- Alter the contrast of the scene itself, for example, by using a fill light or reflectors to add illumination to shadows that are too dark.
- Attempt to adjust contrast in post-processing using your image editor or RAW file converter. You may use features such as Levels or Curves (in Photoshop, Photoshop Elements, and many other image editors), or work with HDR software to cherry-pick the best values in shadows and highlights from multiple images.

Of the four of these, the third—changing the contrast of the scene—is the most desirable, because attempting to fix contrast by fiddling with the tonal values is unlikely to be a perfect remedy. However, adding a little contrast can be successful because you can discard some tones to make the image more contrasty. However, the opposite is much more difficult. An overly contrasty image rarely can be fixed, because you can't add information that isn't there in the first place.

What you *can* do is adjust the exposure so that the tones *that are already present in the scene* are captured correctly. Figure 4.25 (top) shows the histogram for an image that is badly underexposed. You can guess from the shape of the histogram that many of the dark tones to the left of the graph have been clipped off. There's plenty of room on the right side for additional pixels to reside without having them become overexposed. So, you can increase the exposure (either by changing the f/stop or shutter speed, or by adding an EV value) to produce the corrected histogram shown in Figure 4.25 (center).

Conversely, if your histogram looks like the one shown in Figure 4.25 (bottom), with bright tones pushed off the right edge of the chart, you have an overexposed image, and you can correct it by reducing exposure. In addition to the histogram, the 6D Mark II has its Highlights feature, which shows areas that are overexposed with flashing tones (often called "blinkies") in the review screen.

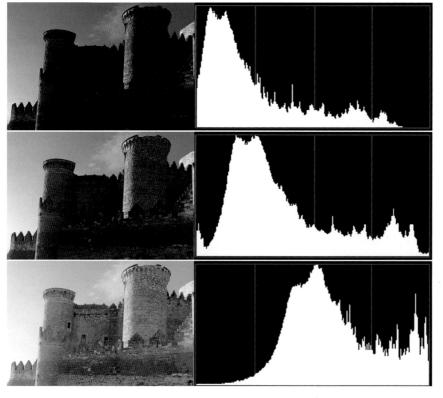

Figure 4.25
Top: A histogram of an underexposed image may look like this. Center: Adding exposure will produce a histogram like this one.
Bottom: A histogram of an overexposed image will show clipping at the right side.

Depending on the importance of this "clipped" detail, you can adjust exposure or leave it alone. For example, if all the dark-coded areas in the review are in a background that you care little about, you can forget about them and not change the exposure, but if such areas appear in facial details of your subject, you may want to make some adjustments.

A traditional technique for optimizing exposure is called "expose to the right," (ETTR) which involves adding exposure to push the histogram's curve toward the right side but not far enough to clip off highlights. The rationale for this method is that extra shadow detail will be produced with a minimum increase in noise, especially in the shadow areas. It's said that half of a digital sensor's response lies in the brightest areas of an image, and so require the least amount of amplification (which is one way to increase digital noise). ETTR can work, as long as you're able to capture a satisfactory amount of information in the shadows.

Exposing to the Right

It's easier to understand exposing to the right if you divide the histogram into fifths, as you see on the display used by the 6D Mark II. And, for the sake of simplicity and smaller numbers, with a 14-bit file like that produced with your camera's ordinary RAW file, the maximum number of tones that can be captured is 16,383. However, each fifth of the histogram does *not* encompass 3,277 tones (one-fifth of 16,384, rounded up).

Instead, the right-most fifth, the highlights, accounts for 8,192 different captured tones. Moving toward the left, the next fifth represents 4,096, followed by 2,048 levels, 1,024 levels, and, in the left-most section where the deepest shadows reside, only 512 different tones are captured. When processing your RAW file, there are only 512 tones to recover in the shadows (compared to the whopping 8,192 in the highlights), which is why boosting/amplifying them as you raise the ISO increases noise. (As I mentioned earlier, the effect is most noticeable in the red and blue channels; your sensor's Bayer array has twice as many green-sensitive pixels as red or blue.) (See Figure 4.26.)

Instead, you want to add exposure—as long as you don't push highlights off the right edge of the histogram—to brighten the shadows. Because there are 8,192 tones available in the highlights, even if the RAW image *looks* overexposed, it's possible to use your RAW converter's Exposure slider (such as the one found in Adobe Camera Raw) to bring back detail captured in that surplus of tones in the highlights. This procedure is the exact opposite of what was recommended for film of the transparency variety—it was fairly easy to retrieve detail from shadows by pumping more light through them when processing the image, while even small amounts of extra exposure blew out highlights. You'll often find that the range of tones in your image is so great that there is no way to keep your histogram from spilling over into the left and right edges, costing you both highlight and shadow detail. Exposing to the right may not work in such situations. A second school of thought recommends *reducing* exposure to bring back the highlights, or "exposing to the left." You would then attempt to recover shadow detail in an image editor, using tools like Adobe Camera Raw's Exposure slider. But remember, above all, that this procedure will also boost noise in the shadows, and so the technique should be used with caution. In most cases, exposing to the right is your best bet.

256 Shades of Gray (JPEG) 16383 Shades of Gray (14-bit RAW)

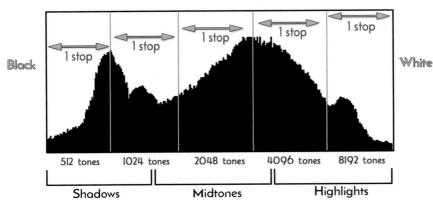

Figure 4.26 Most of the tones captured in an image reside on the right half of the histogram.

The more you work with histograms, the more useful they become. One of the first things that histogram veterans notice is that it's possible to overexpose one channel even if the overall exposure appears to be correct. For example, flower photographers soon discover that it's really, really difficult to get a good picture of a red rose. The exposure and luminance histogram may look okay—but there's no detail in the rose's petals. Looking at the RGB histograms can show why: the red channel is probably blown out. If you look at the red histogram, you'll probably see a peak at the right edge that indicates that highlight information has been lost. In fact, the green channel may be blown, too, and so the green parts of the flower also lack detail. Only the blue channel's histogram would typically be entirely contained within the boundaries of the chart, and, on first glance, the white luminance histogram at top of the column of graphs seems fairly normal.

Any of the primary channels, red, green, or blue, can blow out all by themselves, although bright reds seem to be the most common problem area. More difficult to diagnose are overexposed tones in one of the "in-between" hues on the color wheel. Overexposed yellows (which are very common) will be shown by blowouts in *both* the red and green channels. Too-bright cyans will manifest as excessive blue and green highlights, while overexposure in the red and blue channels reduces detail in magenta colors. As you gain experience, you'll be able to see exactly how anomalies in the RGB channels translate into poor highlights and murky shadows.

The only way to correct for color channel blowouts is to reduce exposure. As I mentioned earlier, you might want to consider filling in the shadows with additional light to keep them from becoming too dark when you decrease exposure. In practice, you'll want to monitor the red channel most closely, followed by the blue channel, and slightly decrease exposure to see if that helps. Because of the way our eyes perceive color, we are more sensitive to variations in green, so green channel blowouts are less of a problem, unless your main subject is heavily colored in that hue.

If you plan on photographing a frog hopping around on your front lawn, you'll want to be extra careful to preserve detail in the green channel, using bracketing or other exposure techniques outlined in this chapter.

While you can often recover poorly exposed photos in your image editor, your best bet is to arrive at the correct exposure in the camera, minimizing the tweaks that you have to make in post-processing.

Basic Zone Modes

One final tool in the 6D Mark II exposure repertoire is one that your camera offers little control over: Basic Zone modes. Your Canon Rebel 6D Mark II includes Basic Zone shooting modes that can automatically make all the basic settings needed for certain types of shooting situations, such as Portraits, Landscapes, Close-ups, Sports, or Night Portrait pictures. They are especially useful when you suddenly encounter a picture-taking opportunity and don't have time to decide exactly which Creative Zone mode you want to use. Instead, you can spin the Mode Dial to SCN, choose the appropriate Basic Zone mode, and fire away, knowing that, at least, you have a fighting chance of getting a good or usable photo.

Basic Zone modes are also helpful when you're just learning to use your 6D Mark II. Once you've mastered the operation of your camera, you'll probably prefer one of the Creative Zone modes that provide more control over shooting options. The Basic Zone scene modes may give you only a few options. However, when you select a mode you'll see a screen that shows you which of the settings you can change. I'll describe those options in the next section. For now, I'm going to tell you about each of the Basic Zone modes.

Here are the modes available from the Mode Dial:

- Scene Intelligent Auto. With the Auto setting, all the photographer has to do in this mode is press the shutter release button. Almost every other decision is made by the camera's electronics. Press the Q button and a screen appears that allows you to choose any of the Drive or AF Point Selection modes.
- Creative Auto. This mode is similar to Scene Intelligent Auto, except that in addition to Drive and AF Point Selection modes, you can choose an "Ambience" setting (which I'll describe shortly) and a "Background Blur" parameter, which simply chooses an f/stop to provide more or less depth-of-field.

With the Mode Dial rotated to the SCN position, you can select one of the Special Scene modes. When the scene selection screen appears (see Figure 4.27), press the Q button, highlight Choose Scene, press SET, and then rotate the Main Dial or QCD to scroll through a list of the available scene modes. Press Enter to confirm your choice and return to the screen that will display the other parameters you can adjust in that mode.

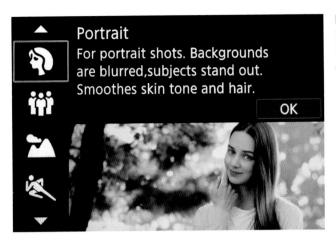

Figure 4.27
Rotate the Main
Dial or QCD to
select a Scene mode.

I'll describe the possible options shortly, after a quick overview of the available Scene modes:

- Portrait. This mode tends to use wider f/stops and faster shutter speeds, providing blurred backgrounds and images with no camera shake. If you hold down the shutter release, the 6D Mark II will take a continuous sequence of photos, which can be useful in capturing fleeting expressions in portrait situations. Skin tones and hair are portrayed in a softer, more flattering way.
- **Group photo.** Provides settings that help ensure everyone in a group shot is in acceptably sharp focus.
- Landscape. The 6D Mark II tries to use smaller f/stops for more depth-of-field, and boosts saturation slightly for richer colors. An attached and powered up external Speedlite will fire.
- **Sports.** In this mode, the 6D Mark II tries to use high shutter speeds to freeze action, switches to continuous shooting to allow taking a quick sequence of pictures with one press of the shutter release, and uses AI Servo AF to continually refocus as your subject moves around in the frame. You can find more information on autofocus options in Chapter 5.
- Kids. Applies continuous focusing to follow the movement of frenetic children, and continuous shooting to grab a continuous stream of still photos. Skin tones are adjusted to look vibrant and healthy. You can place the center AF point in the viewfinder over your main subject and press the shutter release halfway. The 6D Mark II will refocus as required to track the child's motion, and you'll hear a beep that indicates that refocusing is taking place. If the camera cannot achieve sharp focus, the focus confirmation indicator in the viewfinder will blink.
- Panning. Chooses a slow shutter speed so you can pan the camera to follow action, producing a (relatively) sharp subject against a blurred background.

- Close-Up. This mode is similar to the Portrait setting, with wider f/stops to isolate your close-up subjects, and high shutter speeds to eliminate the camera shake that's accentuated at close focusing distances. However, if you have your camera mounted on a tripod or are using an image-stabilized (IS) lens, you might want to use the Creative Zone Aperture-priority (Av) mode instead, so you can specify a smaller f/stop with additional depth-of-field.
- Food. Rich colors and higher contrast in this mode make your food pictures look vivid and appetizing.
- Candlelight. This mode retains the warm tones typically seen in photos illuminated by candlelight. The built-in flash is disabled, but if you have an external Speedlite connected and powered up, it will fire anyway and spoil your picture. Turn it off!
- **Night Portrait.** Combines flash with ambient light to produce an image that is mainly illuminated by the flash, but the background is exposed by the available light. This mode uses longer exposures, so a tripod, monopod, or IS lens is a must.
- Handheld Night Scene. The 6D Mark II takes four continuous shots and combines them to produce a well-exposed image with reduced camera shake.
- HDR Backlight Control. The 6D Mark II takes three continuous shots at different exposures and combines them to produce a single image with improved detail in the highlights and shadows.

Making Changes in Basic Zone Modes

I've previously described how to use the Quick Control screen when working with Creative Zone modes, to change many settings, such as ISO, shutter speed, aperture, and other parameters. When using Basic Zone modes, your options are different. In each case, you can activate the Quick Control screen by pressing the Quick Control button. Then, one of several different screens will appear on your LCD.

Scene Intelligent Auto

In Scene Intelligent Auto mode, press the Q button and choose Drive or AF Point Selection modes. The default Drive mode is Single Shooting, but you can also choose from High Speed Continuous Shooting, Low Speed Continuous Shooting, and 10-second, 2-second, or Continuous self-timers. Auto Selection AF is the default AF Point Selection mode, but you can press the AF Point Selection button to cycle among Spot AF, 1 Pt AF, Zone AF, and Large Zone. I'll explain each of these in more detail in Chapter 5.

Creative Auto Mode

When the Mode Dial is set to Creative Auto, a screen like the one shown in Figure 4.28 appears. It shows the current settings for CA. The elements in this screen:

- **Ambience.** Select ambience effects, plus Standard.
- Background blur. Allows you to increase/decrease the blurriness of the background of your images by adjusting the aperture and depth-of-field.
- **Drive mode.** You can select from any of the camera's Drive modes.
- **Informational display.** Shows battery and Wi-Fi status, image quality, and number of exposures remaining.
- **Q button.** Tap this icon on the touch screen to produce the Quick Control menu. You can also press the physical Q button located to the right of the LCD monitor.

You can proceed from the main screen to the Quick Control menu for Creative Auto by pressing/tapping the Q button or Q icon. You can then highlight Ambience, Background Blur, Drive Mode, or AF Point Selection to set those options. As you highlight each of the four, you can press the SET button to make an adjustment to that parameter.

- Ambience. Highlight Ambience and press SET and a list of Ambience-based options appear. Use the up/down controls to select the "ambience" setting you want. Ambience is a type of picture style that adjusts parameters like sharpness or color richness to produce a particular look.
 - Select from among: Standard, Vivid, Soft, Warm, Intense, Cool, Brighter, Darker, or Monochrome.
 - If you've chosen something other than Standard (which cannot be modified), a screen like the one in Figure 4.29 appears.
 - Highlight the parameter, and then rotate the Main Dial. Use the left/right directional buttons to change the effect to Low, Standard, or Strong. With the Monochrome ambience setting, however, your choices are Blue, B/W, and Sepia. Press the SET button to confirm and exit. In live view mode, the camera will simulate the effect your ambience setting will have on the finished image.
- Background Blur. When you highlight the Background Blur section, which is set to Off by default, you can rotate the Main Dial or use the left/right directional buttons to select blurred (the left side of the scale) or sharp (the right side). The 6D Mark II will try to use a larger f/stop to reduce depth-of-field and blur the background, or a smaller f/stop and increased depth-of-field to sharpen the background.
- **Drive Mode.** Highlight this setting, and press the SET button to pop up the adjustment screen. You can rotate the Main Dial to change among any of the various drive modes listed above Scene Intelligent Auto.

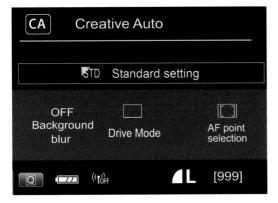

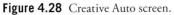

Figure 4.29 Adjusting ambience Vivid setting.

Table 4.3 Selecting Ambience		
Ambience Setting	Effect	
Standard	This is the customized set of parameters for each Basic Zone mode, each tailored specifically for Portrait, Landscape, Close-Up, Sports, or other mode.	
Vivid	Produces a look that is slightly sharper and with richer colors for the relevant Basic Zone mode.	
Soft	Reduced sharpness for adult portraits, flowers, children, and pets.	
Warm	Warmer, soft tones. An alternative setting for portraits and other subjects that you want to appear both soft and warm.	
Intense	Darker tones with increased contrast to emphasize your subject. This setting is great for portraits of men.	
Cool	Darker, cooler tones. Use with care on human subjects, which aren't always flattered by the icier look this setting can produce.	
Brighter	Overall lighter image with less contrast.	
Darker	Produces a darker image.	
Monochrome	Choose from black-and-white, sepia, or blue (cyanotype) toning.	

Scene Modes

When you select one of the Scene modes, your choices for all modes include Brightness, Drive Mode, and AF Point Selection. The Food/Candlelight modes allow adjusting color along a scale from cool to warm. The Panning scene mode, available with certain Canon lenses, also allows you to specify the strength of the effect. Unfortunately, at this writing, Canon has not made a list of the compatible lenses available. The manual says "See Canon Web Site" and the Canon web page describing the feature has a dead link that does not provide the promised list. With luck, Canon will fix this by the time this book is published.

Mastering the Mysteries of Autofocus

Capturing a compelling photograph involves a lot more than just correct exposure. The right tonal range, proper white balance, good color, and other factors all can help elevate your image from good to exceptional. But one of the most important and, sometimes, the most frustrating aspects of shooting with a highly automated—yet fully adjustable—camera like the EOS 6D Mark II is achieving sharp focus. Your camera has lots of AF controls and options, and new users and veterans alike can quickly become confused. In this chapter, I'm going to clear up the mysteries of autofocus and show you exactly how to use your 6D Mark II's AF features to their fullest. I'll even tell you when to abandon the autofocus system and turn to the ancient art of manual focus, too.

How Focus Works

This section describes the differences between contrast detection and phase detection autofocus, and details how linear and cross-type AF sensors work in the 6D Mark II's advanced focusing system. Even those who are familiar with these concepts should still read this section carefully, because Canon has made some revolutionary changes in AF with the introduction of its Dual Pixel CMOS AF sensor design in which every single pixel used for autofocus is split into two photodiodes that can be used to provide advanced autofocus features in Live View and Movie modes.

For most applications, autofocus is much faster and more convenient than manual focusing, which is problematic because our eyes and brains have poor memory for correct focus. That's why an eye doctor must shift back and forth between sets of lenses and ask "Does that look sharper—or was it sharper before?" in determining a correct prescription. Similarly, manual focusing involves jogging

the focus ring back and forth as you go from almost in focus, to sharp focus, to almost focused again. The little clockwise and counterclockwise arcs decrease in size until you've zeroed in on the point of correct focus. What you're looking for is the image with the most contrast between the edges of elements in the image.

The camera also looks for these contrast differences among pixels to determine relative sharpness. There are two ways that sharp focus is determined: phase detection and contrast detection. The camera also looks for these contrast differences among pixels to determine relative sharpness. To get the most from your camera, you really need to understand both. We'll start with the easier of the two: contrast detection.

Contrast Detection

Contrast detection is a slower mode and was used exclusively by Canon dSLRs in Live View and Movie modes until relatively recently, when, starting in 2012, Canon began adding a small number of special pixels to the sensor of some of its cameras, starting with the EOS Rebel T4i, with a Hybrid CMOS AF system which allowed a limited type of phase detection autofocus. By 2013, it replaced the hybrid autofocus image sensor with the new Dual Pixel CMOS AF that is now used by the Canon 6D Mark II. The dual pixel system goes much further, as I'll explain later in this chapter. To appreciate the innovation, you need to understand traditional contrast detection first.

The relatively slow contrast detection method was necessary because, to allow live viewing of the sensor image, the camera's mirror has to be flipped up out of the way so that the illumination from the lens can continue through the open shutter to the sensor. Your view through the viewfinder is obstructed, of course, and there is no partially silvered mirror to reflect some light down to the autofocus sensors. So, an alternate means of autofocus must be used in Live View, and that method is *contrast detection*.

Contrast detection is a bit easier to understand and is illustrated by Figure 5.1, which uses an extreme enlargement of a shot of some wood siding (actually, a 19th century outhouse). At top in the figure, the transitions between pixels are soft and blurred. When the image is brought into focus (bottom), the transitions are sharp and clear. Although this example is a bit exaggerated so you can see the results on the printed page, it's easy to understand that when maximum contrast in a subject is achieved, it can be deemed to be in sharp focus.

As I noted, contrast detection is used in Live View and Movie mode, even when Dual Pixel CMOS AF is also active. (In effect, you get two AF systems

Figure 5.1 Focus in contrast detection mode evaluates the increase in contrast in the edges of subjects, starting with a blurry image (top) and producing a sharp, contrasty image (bottom).

from one sensor.) Contrast detection works best and is very accurate with static subjects, but it is inherently slower and not well suited for tracking moving objects. Contrast detection works less well than phase detection in dim light, because its accuracy is determined by its ability to detect variations in brightness and contrast. You'll find that contrast detection works better with faster lenses, too, because larger lens openings admit more light that can be used by the sensor to measure contrast.

Phase Detection

Like all digital SLRs that use an optical viewfinder and mirror system to preview an image (that is, when not in Live View mode), the Canon EOS 6D Mark II calculates focus using what is called a *passive phase detection* system. It's passive in the sense that the ambient illumination in a scene (or that illumination augmented with a focus-assist beam) is used to determine correct focus.

Parts of the image from two opposite sides of the lens are directed down to the floor of the camera's mirror box, where an autofocus sensor array resides; the rest of the illumination from the lens bounces upward toward the optical viewfinder system and the autoexposure sensors. Figure 5.2 is a wildly over-simplified illustration that may help you visualize what is happening.

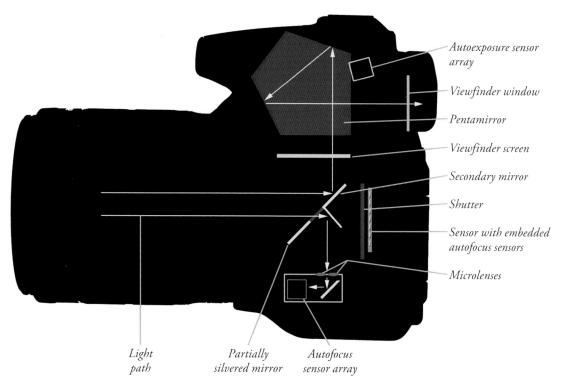

Figure 5.2 Part of the light is bounced downward to the autofocus sensor array, and split into two images, which are compared and aligned to create a sharply focused image.

SIMPLIFICATION MADE OVERLY SIMPLE

To reduce the complexity of the diagram, it doesn't show the actual path of the light passing through the lens, as it converges to the point of focus. That point is either the viewfinder screen when the mirror is down or the sensor plane when the mirror is flipped up and the shutter has opened. Nor does it show the path of the light directed to the autoexposure sensor. Only two of the pairs of autofocus microlenses are shown, and greatly enlarged so you can see their approximate position. All we're concerned about here is how light reaches the autofocus sensor.

As light emerges from the rear element of the lens, most of it is reflected upward toward the focusing screen, where the relative sharp focus (or lack of it) is displayed (and which can be used to evaluate manual focus). It then bounces off two more reflective surfaces in the pentaprism emerging at the optical viewfinder correctly oriented left/right and up/down. (The image emerges from the lens reversed.) Some of the illumination is directed to the autoexposure sensor at the top of the pentaprism housing.

A small portion of the illumination passes through the partially silvered center of the main mirror, and is directed downward to the autofocus sensor array, which includes 45 separate autofocus "detectors." Conceptually, these function as shown in Figure 5.3, another simplified illustration. The illumination arrives from opposite sides of the lens surface and is directed through separate microlenses, producing two half images. These images are compared with each other, much like

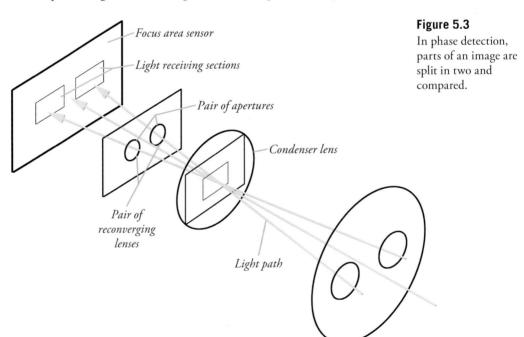

(actually, *exactly* like) a two-window rangefinder used in surveying, weaponry, and non-SLR cameras like the venerable Leica M film models.

When the image is out of focus—or out of phase—as in Figure 5.4 (top), the two halves, each representing a slightly different view from opposite sides of the lens, don't line up. Sharp focus is achieved when the images are "in phase," and aligned, as in Figure 5.4 (bottom).

As with any rangefinder-like function, accuracy is better when the "base length" between the two images is larger. (Think back to your high school trigonometry; you could calculate a distance more accurately when the separation between the two points where the angles were measured was greater.) For that reason, phase detection autofocus is more accurate with larger (wider) lens openings than with smaller lens openings, and may not work at all when the f/stop is smaller than f/5.6 or f/8. Obviously, the "opposite" edges of the lens opening are farther apart with a lens having an f/2.8 maximum aperture than with one that has a smaller, f/5.6 maximum f/stop, and the base line is much longer. The 6D Mark II can perform these comparisons and then move the lens elements directly to the point of correct focus very quickly, in milliseconds.

Unfortunately, while the 6D Mark II's focus system finds it easy to measure degrees of apparent focus at each of the focus points in the viewfinder, it doesn't really know with any certainty *which* object should be in sharpest focus. Is it the closest object? The subject in the center? Something lurking *behind* the closest subject? A person standing over at the side of the picture? Many of the techniques for using autofocus effectively involve telling the EOS 6D Mark II exactly what it should be focusing on, by choosing a focus zone or by allowing the camera to choose a focus zone for you. I'll address that topic shortly.

Figure 5.4
When the image is in focus, the two halves of the image align, as with a rangefinder.

Dual Pixel CMOS AF

So far, we've explored how the 6D Mark II autofocuses when using the optical viewfinder. A completely different AF system comes into play when you're capturing stills or movies in live view. Understanding contrast and phase detection helps you appreciate the innovation that is Canon's Dual Pixel CMOS AF system. Used in Live View mode while shooting stills and movies, it works much more quickly than the camera's more traditional contrast detection system alone.

An array of special pixels provides the same type of split-image rangefinder phase detection AF that is available when using the optical viewfinder. The most important aspect of the system is that it doesn't rob the camera of any imaging resolution. It would have been possible to place AF sensors between the pixels used to capture the image, but that would leave the sensor with less area with which to capture light. Keep in mind that CMOS sensors, unlike earlier CCD sensors, have more on-board circuitry which already consumes some of the light-gathering area. Microlenses are placed above each photosensitive site to focus incoming illumination on the sensor and to correct for the oblique angles from which some photons may approach the imager. (Older lenses, designed for film, are the worst offenders in terms of emitting light at severely oblique angles; newer "digital-friendly" lenses do a better job of directing photons onto the sensor plane with a less "slanted" approach.)

With the Dual Pixel CMOS AF system, the same photosites capture both image and autofocus information. Each pixel is divided into two photodiodes, facing left and right when the camera is held in horizontal orientation (or above and below each other in vertical orientation; either works fine for autofocus purposes). Each pair functions as a separate AF sensor, allowing a special integrated circuit to process the raw autofocus information before sending it on to the 6D Mark II's digital image processor, which handles both AF and image capture. For the latter, the information grabbed by *both* photodiodes is combined, so that the full photosensitive area of the sensor pixel is used to capture the image.

While traditional contrast detection frequently involves frustrating "hunting" as the camera continually readjusts the focus plane trying to find the position of maximum contrast, adding Dual Pixel CMOS AF phase detection allows the 6D Mark II to focus smoothly, which is important for speed, and essential when shooting movies (where all that hunting is unfortunately captured for posterity). Movie Servo AF tracking is improved, allowing shooting movies of subjects in motion. The system works with (at this writing) 103 different lenses, both current and previously available optics, and works especially well with lenses that have speedy USM or STM motors. I'll explain the 6D Mark II's AF operation in live view and movie shooting in more detail in Chapter 6.

Cross-Type Focus Point

Returning to the optical viewfinder's AF system, we're going to explore one special aspect next. So far, we've only looked at focus sensors that calculate focus in a single direction. Figure 5.5 (top left and right) illustrates a horizontally oriented linear focus sensor evaluating a subject that is made up, predominantly, of vertical lines. But what does such a sensor do when it encounters a subject that isn't conveniently aligned at right angles to the sensor array? You can see the problem in Figure 5.5

Figure 5.5
A horizontally oriented sensor handles vertical lines easily (top). A horizontal sensor has problems with subjects that have parallel horizontal lines (bottom left). A vertically oriented sensor is really needed for that type of subject (bottom right).

(bottom left), which pictures the same weathered wood siding rotated 90 degrees. The horizontal grain of the wood isn't divided as neatly by the split image, so focusing using phase detection is more difficult. The lines in the grain don't cross the AF sensor at right angles any more.

You can see the "solution" at bottom right in Figure 5.5, in the form of a vertical linear sensor, which does a better job of interpreting horizontal lines. By mixing both types in a focusing system, the vertical sensors could detect differences in horizontal lines, while the horizontal sensors took care of the vertical lines. Both varieties are equally adept at handling *diagonal* lines, which crossed each type of line sensor at a 45-degree angle.

However, a better solution is the use of a *cross-type* sensor, which is a merger of vertical and horizontal linear sensors, thus including sensitivity to horizontal, vertical, and lines at any diagonal angle. In lower light levels, with subjects that are moving, or with subjects that have no pattern and less contrast to begin with, the cross-type sensor not only works faster but can focus subjects that a horizontal- or vertical-only sensor can't handle at all.

In practice, these sensors consist of an *array* of lines and, in the 6D Mark II, none of them are strictly horizontal or vertical in orientation. Instead, the AF points are arranged as shown at left in

Figure 5.6, using what are called *cross-type* sensors that form a plus-sign shape. All 45 AF points in the 6D Mark II are potentially cross sensors (the number available will depend on the lens mounted on your camera—some AF points cannot function in cross mode with certain lenses, as I'll explain shortly). In cross sensor mode, such sensors are a merger of vertical and horizontal linear sensors, thus including sensitivity to horizontal, vertical, and lines at any diagonal angle. In lower light levels, with subjects that are moving, or with subjects that have no pattern and less contrast to begin with, the cross-type sensor not only works faster but can focus subjects that a horizontal- or vertical-only sensor can't handle at all.

Figure 5.6 Cross-type sensors can achieve sharp focus with horizontal, vertical, and diagonal lines (left). The center focus point (right) has additional diagonal sensors (in red) that function with lenses with an f/2.8 or larger maximum aperture.

These 45 AF sensors function with lenses that have a maximum aperture of f/5.6 or larger (remember that smaller numbers equal larger apertures; f/4 is larger than f/5.6, for example). So, if you're using a lens with an f/stop from, say, f/1.2 through f/5.6, all 45 AF points will function as cross-type sensors. (Some may function in cross mode with a few f/8 lenses.) If your maximum aperture is even larger—f/2.8 or greater—the *center* AF point will also use a pair of diagonal sensors, represented in red at right in Figure 5.6. Note that the baseline of these diagonal AF points is much larger than that of the green vertically/horizontally oriented sensors. Coupled with the larger baseline of lenses with, say, f/1.2 to f/2.8 maximum apertures, the center AF sensors are significantly more accurate than those at the other 44 locations in the frame.

Usable AF Points and Lens Groups

The 45 AF points in your camera all function as cross-type sensors with the majority of lenses that you are likely to own. However, if you are using certain slower lenses, or use a teleconverter to multiply your lens's focal length, some of the focus points revert to line sensor behavior, or may become totally unavailable for autofocus.

Canon makes sorting out how usable AF points are affected by your choice of lenses and lens+ extender combinations easy, by classifying them in groups, labeled A through H. Pages 145 to 152 of Canon's 6D Mark II manual lists the lenses available at the time the 6D Mark II was introduced,

and assigns a group to each. If you own lenses introduced in 2017 or later, I urge you to visit the Canon website for the definitive group for your particular optics.

The lens and lens/teleconverter combinations in the Group A and Group B categories allow all 45 AF points to function as cross-type sensors, with Group A entries enabling the dual-cross center focus point. With Group C and Group D lenses, some or all of the AF points at the left and right flanks of the center array revert to horizontal line sensitive behavior. With Group E and Group F lenses, the two groups of five points at the far left and right edges of the array are not available, and Group G lens combinations disable the upper and lower row of points, leaving only 27 usable AF points. Group G lenses allow only one cross-type point in the center of the array.

Figure 5.7 provides a quick reference to the function of each AF sensor within a given lens grouping. Dual cross, cross-type, horizontal, and vertical sensors are all represented. If an AF point is grayed out in a particular group, that sensor is not used and is not displayed as you shoot. When you press either AF point selection button, the disabled points will blink, while the enabled points will stay lit. Here's a more detailed listing of the AF point behaviors you can expect:

- **Group A.** Autofocusing with all 45 points is possible, so you can choose any of the AF area selection modes (described later in this chapter). However, with all lenses in this group, the center AF point functions as a high-precision dual cross sensor *if that lens has a maximum aperture of fl2.8 or larger*. The other 44 AF points are cross-type sensors. (See Figure 5.7, upper left.)
- **Group B.** This group of lens/lens+extender combinations is virtually identical in function to Group A, except that the center AF point serves as a conventional cross-type sensor, rather than a dual cross sensor. Autofocusing with all 45 points is possible. (See Figure 5.7, upper center.)

Group A	Group B	Group C
Group D	Group E	Group F
Group G	Group H	Dual cross sensor
		Cross sensor Vertical line sensitive Horizontal line sensitive

Figure 5.7 Dual cross, cross-type, horizontal, and vertical sensors.

- **Group C.** This group of lens/lens+extender combinations uses all 45 AF points, but the outermost 5 sensors on each side are sensitive only to horizontal lines, as you can see represented by orange lines in Figure 5.7, upper right.
- **Group D.** This fourth group uses all 45 AF points like the previous three, but only the 15 points in the center function as cross-type sensors. The outer sensors all are sensitive only to horizontal lines. (See Figure 5.7, center left.)
- **Group E.** Only 35 AF points are used with this group of lens/lens+extender combinations. The center 15 function as cross-type sensors, while two columns of sensors on either side of the center (20 in all) are sensitive only to horizontal lines. (See Figure 5.7 center.)
- **Group F.** Just 35 AF points are available with this next group of lens/lens+extender combinations. Only the 9 sensors at the very center are of the cross type. The rows above and below the center are sensitive to vertical lines, while the two columns on either side of the center are sensitive to horizontal lines. (See Figure 5.7, center right.)
- **Group G.** Only 27 AF points are available with this group. The nine center points function as cross-type sensors; the nine points to the left and nine to the right are sensitive to horizontal lines. The other points are disabled. (See Figure 5.7, lower left.)
- **Group H.** Only the center cross-type focus point can be used. (See Figure 5.7, bottom center.)

Focus Modes

Focus modes tell the camera *when* to evaluate and lock in focus. They don't determine *where* focus should be checked; that's the function of other autofocus features. Focus modes tell the camera whether to lock in focus once, say, when you press the shutter release halfway (or use some other control, such as the AF-ON button), or whether, once activated, the camera should continue tracking your subject and, if it's moving, adjust focus to follow it.

The 6D Mark II has three AF modes: One-Shot AF (also known as single autofocus), AI Servo (continuous autofocus), and AI Focus AF (which switches between the two as appropriate). I'll explain these in more detail later in this section. But first, some confusion...

MANUAL FOCUS

With manual focus activated by sliding the AF/MF switch on the lens, your 6D Mark II lets you set the focus yourself. There are some advantages and disadvantages to this approach. While your batteries will last longer in manual focus mode, it will take you longer to focus the camera for each photo, a process that can be difficult. Modern digital cameras, even dSLRs, depend so much on autofocus that the viewfinders are no longer designed for optimum manual focus. Pick up any film camera and you'll see a bigger, brighter viewfinder with a focusing system that's a joy to focus on manually.

Adding Circles of Confusion

You know that increased depth-of-field brings more of your subject into focus. But more depth-of-field also makes autofocusing (or manual focusing) more difficult because the contrast is lower between objects at different distances. This is an added factor *beyond* the rangefinder aspects of lens opening size in phase detection. An image that's dimmer is more difficult to focus with any type of focus system, phase detection, contrast detection, or manual focus.

So, focus with a 200mm lens (or zoom setting) may be easier in some respects than at a 28mm focal length (or zoom setting) because the longer lens has less apparent depth-of-field. By the same token, a lens with a maximum aperture of f/1.8 will be easier to autofocus (or manually focus) than one of the same focal length with an f/4 maximum aperture, because the f/4 lens has more depth-of-field and a dimmer view. That's yet another reason why lenses with a maximum aperture smaller than f/5.6 can give your 6D Mark II's autofocus system fits—increased depth-of-field joins forces with a dimmer image that's more difficult to focus using phase detection.

To make things even more complicated, many subjects aren't polite enough to remain still. They move around in the frame, so that even if the 6D Mark II is sharply focused on your main subject, it may change position and require refocusing. An intervening subject may pop into the frame and pass between you and the subject you meant to photograph. You (or the 6D Mark II) have to decide whether to lock focus on this new subject, or remain focused on the original subject. Finally, there are some kinds of subjects that are difficult to bring into sharp focus because they lack enough contrast to allow the 6D Mark II's AF system (or our eyes) to lock in. Blank walls, a clear blue sky, or other subject matter may make focusing difficult.

If you find all these focus factors confusing, you're on the right track. Focus is, in fact, measured using something called a *circle of confusion*. An ideal image consists of zillions of tiny little points, which, like all points, theoretically have no height or width. There is perfect contrast between the point and its surroundings. You can think of each point as a pinpoint of light in a darkened room. When a given point is out of focus, its edges decrease in contrast and it changes from a perfect point to a tiny disc with blurry edges (remember, blur is the lack of contrast between boundaries in an image). (See Figure 5.8.)

Figure 5.8 When a pinpoint of light (left) goes out of focus, its blurry edges form a circle of confusion (center and right).

If this blurry disc—the circle of confusion—is small enough, our eye still perceives it as a point. It's only when the disc grows large enough that we can see it as a blur rather than a sharp point that a given point is viewed as out of focus. You can see, then, that enlarging an image, either by displaying it larger on your computer monitor or by making a large print, also enlarges the size of each circle of confusion. Moving closer to the image does the same thing. So, parts of an image that may look perfectly sharp in a 5×7 —inch print viewed at arm's length, might appear blurry when blown up to 11×14 and examined at the same distance. Take a few steps back, however, and it may look sharp again.

To a lesser extent, the viewer also affects the apparent size of these circles of confusion. Some people see details better at a given distance and may perceive smaller circles of confusion than someone standing next to them. For the most part, however, such differences are small. Truly blurry images will look blurry to just about everyone under the same conditions.

Technically, there is just one plane within your picture area, parallel to the back of the camera (or sensor, in the case of a digital camera), that is in sharp focus. That's the plane in which the points of the image are rendered as precise points. At every other plane in front of or behind the focus plane, the points show up as discs that range from slightly blurry to extremely blurry until the out-of-focus areas become one large blur that de-emphasizes the background.

In practice, the discs in many of these planes will still be so small that we see them as points, and that's where we get depth-of-field. Depth-of-field is just the range of planes that include discs that we perceive as points rather than blurred splotches. The size of this range increases as the aperture is reduced in size and is allocated roughly one-third in front of the plane of sharpest focus, and two-thirds behind it. The range of sharp focus is always greater behind your subject than in front of it.

Your Autofocus Mode Options

To save battery power, unless Continuous Autofocus is activated, your 6D Mark II doesn't start to focus the lens until you partially depress the shutter release or AF-ON button. But, autofocus isn't some mindless beast out there snapping your pictures in and out of focus with no feedback from you after you press that button. There are several settings you can modify that return at least a modicum of control to you. Your first decision should be whether you set the 6D Mark II to One-Shot, AI Servo AF, or AI Focus AF. With the camera set for one of the Creative Zone modes, press the AF button on the top panel and use the Main Dial or QCD to select the focus mode you want (see Figure 5.9). Press SET to confirm your choice. (The AF/M switch on the lens must be set to AF before you can change autofocus mode.)

Figure 5.9
Press the AF button
and then rotate the
Main Dial or Quick
Control Dial until
the AF choice you
want is selected.

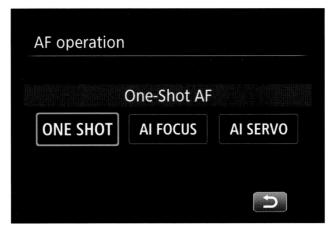

One-Shot AF

In this mode, also called *single autofocus*, focus is set once and remains at that setting until the button is fully depressed, taking the picture, or until you release the shutter button without taking a shot. For non-action photography, this setting is usually your best choice, as it minimizes out-of-focus pictures (at the expense of spontaneity). The drawback here is that you might not be able to take a picture at all while the camera is seeking focus; you're locked out until the autofocus mechanism is happy with the current setting. One-Shot AF/Single Autofocus is sometimes referred to as *focus priority* for that reason. Because of the small delay while the camera zeroes in on correct focus, you might experience slightly more shutter lag. This mode uses less battery power.

When sharp focus is achieved, the selected focus point will flash red in the viewfinder, and the focus confirmation light at the lower right will illuminate and remain lit as long as focus is maintained and you continue to hold down the shutter release. The exposure will be locked at the same time. By keeping the shutter button depressed halfway, you'll find you can reframe the image while retaining the focus (and exposure) that's been set. You can also use the AE Lock/FE Lock button to retain the exposure calculated from the center AF point while reframing.

Al Servo AF

This mode, also known as *continuous autofocus*, is the mode to use for sports and other fast-moving subjects. In this mode, once the shutter release is partially depressed, the camera sets the focus but continues to monitor the subject, so that if it moves or you move, the lens will be refocused to suit. Focus and exposure aren't really locked until you press the shutter release down all the way to take the picture. You'll often see continuous autofocus referred to as *release priority*. If you press the shutter release down all the way while the system is refining focus, the camera will go ahead and take a picture, even if the image is slightly out of focus. You'll find that AI Servo AF produces the least amount of shutter lag of any autofocus mode: press the button and the camera fires. It also uses the

most battery power, because the autofocus system operates as long as the shutter release button is partially depressed. With C.Fn II-4 and II-5 you can specify autofocus priority separately for the first and subsequent shots in a continuous sequence, giving priority to shooting speed, best focus, or equal weight, as explained later in this chapter.

AI Servo AF uses a technology called *predictive AF*, which allows the 6D Mark II to calculate the correct focus if the subject is moving toward or away from the camera at a constant rate. It uses either the automatically selected AF point or the point you select manually to set focus.

Al Focus AF

This setting is a combination of the first two. When selected, the camera focuses using One-Shot AF and locks in the focus setting. But, if the subject begins moving, it will switch automatically to AI Servo AF and change the focus to keep the subject sharp. AI Focus AF is a good choice when you're shooting a mixture of action pictures and less dynamic shots and want to use One-Shot AF when possible. The camera will default to that mode, yet switch automatically to AI Servo AF when it would be useful for subjects that might begin moving unexpectedly, such as children or pets.

Manual Focus

With manual focus activated by sliding the AF/MF switch on the lens, your 6D Mark II lets you set the focus yourself, both using the eye-level optical viewfinder and on the LCD monitor in Live View mode. There are some advantages and disadvantages to this approach. While your batteries will last longer in manual focus mode through the optical viewfinder, it will take you longer to focus the camera for each photo, a process that can be difficult. Modern digital cameras, even dSLRs, depend so much on autofocus that the viewfinders of models that have less than full-frame-sized sensors are no longer designed for optimum manual focus.

Selecting an AF Area Selection Mode

The Canon EOS 6D Mark II uses 45 different focus points to calculate correct focus. In any of the Basic Zone shooting modes, the focus point is selected automatically by the camera. In the Creative Zone modes, you can allow the camera to select the focus point automatically, or you can specify which focus point should be used. There are five AF Area Selection modes.

- **Single-point Spot AF (Manual Selection).** You can choose one small AF point for focus. The point is roughly the size of the inner square shown at top left in Figure 5.10.
- **Single-point AF (Manual Selection).** You can choose one AF point for focus from among those shown at top center in Figure 5.10.
- **Zone AF (Manual Zone Selection).** Select any of nine different focus zones, each with a 3 × 3-point array of nine points. At top right in the figure, the zone is centered in the middle of the array.

Figure 5.10 The three AF Area Selection modes are Single-point Spot AF (Manual Selection), upper left; Single-point AF (Manual Selection), upper center; Zone AF (Manual Zone Selection), upper right; Large Zone AF, lower left; and 45-point Automatic Selection AF, lower right.

- Large Zone AF (Manual Selection of Zone). You can choose the clusters of 15 focus points at left, right, or middle of the focus point array, as seen at lower left in Figure 5.10.
- 45-point Automatic Selection AF. The camera will choose the focus point for you from the entire AF area. This mode is always used in Basic Zone exposure modes. In One-Shot AF mode, pressing the shutter button halfway displays the AF points currently selected for calculating focus. In AI Servo AF mode, you can tell the 6D II which of the 45 points to use initially, although the camera can switch to a different point as appropriate if the subject moves. Use C.Fn II-11: Initial AF Pt AI Servo AF, as described later in this chapter.

To choose the AF Area, just follow these steps:

- 1. Make sure the lens AF/MF switch is set to AF.
- 2. Tap the shutter release to activate the focus system.
- 3. Press the AF Area Selection Mode button located northwest of the Main Dial. The current focus selection indicators will be highlighted in red in the viewfinder.
- 4. Continue pressing, if necessary, until the method you want is displayed in the viewfinder or LCD monitor, or shown on the top-surface control panel.

As explained later in this chapter, you can use C.Fn II-8 to limit the AF area selection modes available, and C.Fn II-9 to adjust the controls used to choose the selection mode. When choosing a focus point manually, the viewfinder indicator will display **SEL** [] (for Spot AF or Single-point selection) or [] **AF** (for the other three modes) at the bottom of the frame as you make your selection.

In the single-point manual selection mode, press the focus point selection button (in the upper-right corner of the back of the camera) or the focus point selection mode button. Then, use the directional buttons to move the active focus point around the frame. If you press SET, the AF center point will be selected. You can also rotate the Main Dial to move the focus point to the left or right within a row of focus sensors, and rotate the QCD to move up and down rows. In zone AF mode, rotating either the Main Dial or Quick Control Dial will switch from zone to zone in a loop. In large zone AF, the two dials move the zone left or right.

While automatic point selection works well and is often best for moving subjects, manual point selection can be quite useful when you have time to zero in on a subject. This mode is certainly your best choice when you want to focus precisely on a subject that is surrounded by fine detail, as shown in Figure 5.11. The heron was not moving and my camera and 400mm lens were mounted on a sturdy tripod, so it was easy to place the focus spot exactly where I wanted it. Keep in mind that the portion of the sensor used to autofocus is not precisely represented by the rectangle shown in the viewfinder, so if you're focusing on, say, the near eye of a portrait subject turned at a 45-degree angle with a wide aperture, you might end up focusing on the bridge of their nose instead. You'll want to keep the actual focus area in mind in situations where focus is that critical.

Figure 5.11 Manual point selection allowed focusing precisely on the heron, despite the surrounding detail.

AF with Color Tracking

When using Zone AF or Large Zone AF, the 6D Mark II's 7,560-pixel RGB+infrared exposure sensor mentioned in Chapter 4 can also be used to facilitate autofocus. The color information can recognize colors equivalent to skin tones, and thus enhance AF sensitivity when shooting still photos of human subjects. As I'll explain later in this chapter, you can activate this feature using C.Fn II-12. The default is 0: Enable, which tells the 6D Mark II to select AF points representing skin tones automatically. It works well in One-Shot mode to lock in focus; in AI Servo AF mode, focusing on humans is enhanced (if no skin tones are detected, the camera will focus on the nearest object). As AI Servo AF continues to refocus as required until the shutter release is pressed down all the way, the 6D Mark II continues to select focus points representing the colors of the subject first focused on. Under lighting conditions dim enough to trigger the AF-assist beam, color information is not used. If you select 1: Disable, AF points are selected without regard to color information. **Note:** This feature is disabled in Landscape, Panning, Close-up, Food, Candlelight, Night Portrait, and Night Scene modes.

Autofocus Custom Functions

Most of my detailed explanations of menus and their options will be covered in Chapters 11, 12, and 13, as readers have told me they prefer to have menu functions collected in a reference section of the book for easy access when they want my recommendations on how to make settings. However, the 6D Mark II's AF options make up such an integral part of understanding how autofocus works that I'm going to include their descriptions in this chapter. If you need a review of how to navigate menus, check out the beginning of Chapter 11.

The Custom Functions menu tab, which uses brown highlighting and an icon representing a camera with five marks under it, has only a single page, seen at left in Figure 5.12. It has four entries: C.Fn I: Exposure, C.Fn II: Autofocus, C.Fn III:Operation/Others, and Clear All Custom Func. I'll

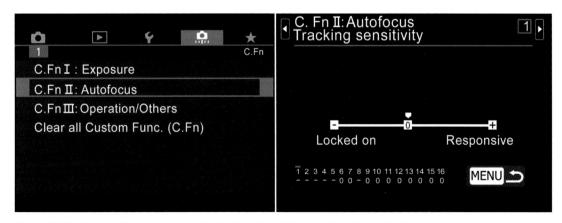

Figure 5.12 Custom Functions menu (left); Autofocus Tracking Sensitivity (right).

describe the C.Fn II: Autoexposure options in this chapter; you'll find the others discussed in Chapter 13.

Highlight C.Fn II: Autofocus, press SET, and a screen like the one shown in Figure 5.12, right, appears. The number of the currently selected Custom Function is indicated by a box in the upper right of the screen, and highlighted with a colored bar above its number in the strip of numbers at the bottom. For the Autofocus menu, there are 16 numbers in all, each representing a different AF Custom Function. Some Custom Functions use settings screens to make adjustments; those are indicated by horizontal bar symbols beneath their number (1–5 and 8 in this case). Other Custom Functions use numbered options, with the default values always assigned number zero. A non-default (non-zero) value that has been selected is colored cyan, so you can always tell at a glance what options are active with each of these 16 Custom Functions.

To adjust a Custom Function, highlight its number and press SET to view the adjustment screen. The figure shows the adjustment screen for Tracking Sensitivity. After you've made your adjustment, press MENU to confirm and exit. That's all there is to it. Each of the 16 Autofocus Custom Functions is described next.

C.Fn II-1: Tracking Sensitivity

Options: 0 (default) -1, -2, +1, +2

My preference: -2 for action when not shooting continuous; +2 for action at high frame rates

Tracking sensitivity determines how swiftly the AF system refocuses on a new subject that enters the focus area. Your choices range from -2 (Locked On) to +2 (Responsive), with 0 (balanced) as the default. Negative numbers allow you to retain focus on the original subject even if it briefly leaves the area covered by the focus points, making tracking easier. Positive numbers switch more quickly to a new subject.

Sometimes new subjects interject themselves in the frame temporarily. Perhaps you're shooting an architectural photo from across the street and a car passes in front of the camera. Or, at a football game, a referee dashes past just as a receiver is about to make a catch. This setting lets you specify how quickly the 6D Mark II reacts to these transient interruptions that would cause relatively large changes in focus before refocusing on the "new" subject matter. You can specify a long delay, so that the interloper is ignored, or a shorter delay, so that the camera immediately refocuses when a new subject moves into the frame.

A setting of –2 (Locked On) causes the 6D Mark II to ignore the intervening subject matter for a significant period of time. Use this setting when shooting subjects, such as sports, in which focus interruptions are likely to be frequent and significant. You can also choose a setting of +2 (Responsive) which tells the camera to wait only a moment before refocusing. Very high continuous frame rates may work better when you allow refocusing to take place rapidly, without a lock-on delay. Intermediate settings from –1 or +2 provide different amounts of delay. The middle value, 0, offers an intermediate delay before the camera refocuses on the new subject. It's often the best choice when

shooting sports in either of the continuous shooting modes, as the long delay can throw off autofocus accuracy at higher fps settings.

C.Fn II-2: Accelerate/Decelerate Tracking

Options: 0 (default), +1, +2

My preference: 0 for subjects moving steadily, +1 for subjects with sudden movements

This setting works hand-in-hand with Tracking Sensitivity. It determines how the AF system responds to sudden acceleration, deceleration, or stopping. Your choices are 0 (constant speed) to 2 (sudden changes). The default value works well for most subjects that aren't moving erratically, and I use that most of the time. For children, pets, and certain sports, I use a positive value to allow the camera to continue focusing on the subject even if they change speed or stop unexpectedly. The downside with the +2 settings is that the 6D Mark II becomes extremely sensitive to movement changes, which can make focusing become as erratic as your subject.

Some activities demand more sensitivity to speed changes than others. Motor racing or track and field, for example, involve more constant movement, and work well with the default setting. Sports like football or basketball might call for a +1 setting; manic children, excited pets, or athletes running toward you may call for a +2 setting.

C.Fn II-3: AF Point Auto Switching

Options: 0 (default), +1, +2

My preference: 0 for most subjects; +1 for fast-moving subjects

This setting determines how quickly the AF system changes from the current AF point to an adjacent one when the subject moves away from the current point, or an intervening object moves across the frame into the area interpreted by the current point. Your choices are 0 (slower point switching response) to 2 (faster response). This parameter operates in Auto Selection, Zone AF, and Large Zone AF area selection modes.

AF Point Auto Switching is the third of the three "tracking" parameters you can adjust. Use positive values if your subjects move quickly in any direction, including away from the camera, but avoid when using wide-angle lenses, as the extra depth-of-field can confuse the AF system.

C.Fn II-4: Al Servo 1st Image Priority

Options: Release priority, Equal priority (default), Focus priority

My preference: Release priority for sports, Equal priority for most other subjects

This setting determines the point at which the 6D Mark II locks in focus when you push the shutter button all the way down when taking a series of photographs. Remember that if you're using a small f/stop with extended depth-of-field, your chances of getting a shot with acceptable depth-of-field are improved at any of these settings.

Here are your options:

- Release priority. The shutter will fire immediately, even if sharp focus has not yet been achieved. Use this setting when getting the shot—any shot—is crucial, and a slightly out-of-focus image would be preferable to none at all. Whether you're a photojournalist or a proud parent snapping Baby's first steps, you'd probably prefer not to miss the shot because the camera is still fine-tuning focus. The 6D Mark II focuses so quickly that, unless your subject is low in contrast or otherwise problematic, release priority will probably give you a good shot nearly all the time. Remember that if you're using a small f/stop with extended depth-of-field, your chances of getting a shot with acceptable depth-of-field are improved even though you're using release priority.
- Equal priority. If focus is important to you, try out this balanced setting that will give the camera a little extra time—but not too much—and improve your chances of getting a precisely focused image without inordinate delay.
- Focus priority. Sometimes, accurate focus is all-important, and with a leisurely shooting pace you might not mind waiting an extra fraction of a second while the AF system "hunts" to achieve precise autofocus when faced with the occasional more difficult subject. I tend to use this setting for everything except action shots and birds-in-flight, because my speedy 6D Mark II usually doesn't introduce much of a delay as it autofocuses.

C.Fn II-5: Al Servo 2nd Image Priority

Options: Shooting speed priority, Equal priority (default), Focus priority

My preference: Shooting speed priority for sports, Equal priority for most other subjects

Most of us have an itchy trigger finger, so the first photograph in a series may not capture the decisive moment. When shooting bursts, the 6D Mark II can continue to fine-tune focus for the second and subsequent images in the series, using the priority you set here. The parameters are similar to those of the previous setting.

- Shooting speed priority. Since this is the second (or ongoing) shot, the shutter has already fired at least once, so this setting tells the camera to keep the same focus setting and continue capturing images. Note that you can select this option regardless of what parameter you've specified for the *first* shot. So, if you've chosen focus priority for the initial image, selecting this setting is a safe bet *if your subject is not moving* quickly enough to require additional focus fine-tuning. But if you selected release priority for the first image, using this setting may mean that the first and all subsequent images may be a little (or a lot) out of focus.
- Equal priority. This balanced setting allows you to express your trust that the 6D Mark II will provide a reasonable compromise between speed and focus for all images captured after the first.
- Focus priority. Selecting this option can slow down the continuous shooting speed of your camera, but will almost ensure getting a series of shots that are in optimum focus.

C.Fn II-6: AF-Assist Beam Firing

Options: Enable (default), Disable, IR AF assist beam only

My preference: IR AF assist beam only

This setting determines when bursts from an electronic flash are used to emit a pulse of light that helps provide enough contrast for the EOS 6D Mark II to focus on a subject. You can select Enable to use an attached Canon Speedlite to produce a focus assist beam. Use Disable to turn this feature off if you find it distracting. Keep in mind that if you select Enable and the Speedlite's own AF-Assist Beam Firing is set to Disable, the AF-assist beam will not be emitted (the flash's setting takes precedence).

- 0: Enable. The AF-assist light is emitted by the camera's external flash whenever light levels are too low for accurate focusing using the ambient light.
- 1: Disable. The AF-assist illumination is disabled. You might want to use this setting when shooting at concerts, weddings, or darkened locations where the light might prove distracting or discourteous.
- 2: IR AF Assist beam only. Some Canon flash units, such as the Speedlite 600EX-RT II, have a near-infrared pattern assist beam. Select this option to disable visible light flashes and activate only the less-obtrusive IR beam. Because AF assist is intrusive for the types of subjects I shoot, I prefer to use it only when an IR assist is available from my Speedlite.

C.Fn II-7: Lens Drive when AF Impossible

Options: Continue focus search (default); Stop focus search

My preference: Stop focus search

When a scene has little inherent contrast (say, a blank wall or the sky) or if there isn't enough illumination to allow determining contrast accurately (in low light levels, or with lenses having maximum apertures of less than f/5.6), a lens may be unable to achieve autofocus. Very long telephoto lenses suffer from this syndrome because their depth-of-field is so shallow that the correct point of focus may zip past during the AF process before the AF system has a chance to register it.

Use this setting to tell the 6D Mark II either to keep trying to focus if AF seems to be impossible or to stop seeking focus. Your choices are as follows:

- 0: Continue Focus Search. The 6D Mark II will keep trying to focus, even if the effort causes the lens to become grossly out of focus. Use this default setting if you'd prefer that the lens keep trying. Sometimes you can point the lens at an object with sufficient contrast at approximately the same distance to let the AF system lock on, then reframe your original subject with the hope that accurate focus will now be achieved.
- 1: Stop Focus Search. When this option is selected, the camera will stop trying to focus uselessly, allowing you to attempt to manually bring the subject into focus. This setting is best for very long telephoto lenses (around 400mm and up), because they encounter AF difficulties more than most lenses, and are less likely to benefit from extended "hunting."

C.Fn II-8: Select AF Area Selection Mode

Options: Manual Select: Spot AF, Manual Select: Single Point, Manual Select: Zone AF, Manual Select: Large Zone AF, Auto Selection AF

My preference: All options checked

When you access this entry, a screen with all five modes is displayed. Use the Quick Control Dial or directional buttons to highlight a mode you want to activate/deactivate and press SET. A check mark above the icon indicates that the mode will be available. Select OK to confirm your choices. To cycle among the modes you've checked, press the AF area selection button on the top of the camera or Main Dial (if selected as your control) until the mode you want to use is selected.

C.Fn II-9: AF Area Selection Method

Options: AF area selection button (default), Main Dial

My preference: AF area selection button

With this setting, you can customize the control used to switch from one AF area selection mode to another, perhaps making the selection easier or more intuitive for you, or (as is the default) making this process require the use of two controls so that it can't be done accidentally. Your choices are as follows:

- 0: AF Area Selection button. To change the AF area selection mode, you must *first* press *either* the AF area selection button (on top of the camera, near the Main Dial) *or* the AF point selection button (in the upper-right corner of the back of the camera to the immediate right of the * button), and *then* press the AF area selection button multiple times to switch selection modes.
- 1: Main Dial. When this option is chosen, you must first press the AF area selection button *or* AF point selection button and then rotate the Main Dial to change the AF area selection mode. This choice allows you to avoid repeatedly pressing the AF point selection button and use the Main Dial instead.

C.Fn II-10: Orientation Linked AF Point

Options: Same for both vertical and horizontal (default); Separate AF Points: Area+Point; Separate AF points: Point Only

My preference: Separate AF Points: Area+Point

If you have a preference for particular AF area selection modes and a manually selected AF point when composing vertical or horizontal pictures, you can specify that preference using this menu entry, by choosing Separate AF Points. Or, you can indicate that you want to use the same mode/point in all orientations (Same for Both Vert/Horiz).

If you'd like to differentiate, there are three different orientations to account for:

- **0: Same for both vertical and horizontal.** The AF area selection mode *and* the AF point or zone that you select manually are used for both vertical and horizontal images.
- 1: Separate AF points: Area+Point. This is my favorite mode. The AF area selection mode and AF point or zone that you select manually can be specified for one of three orientations. Each time you rotate the camera, both the AF area selection mode and the focus point you have most recently manually selected for that orientation will be selected. The recognized orientations include:
 - Camera held horizontally. This orientation assumes that the camera is positioned so the viewfinder/shutter release are on top.
 - Camera held vertically with the grip/shutter release at the top.
 - Camera held vertically with the grip/shutter release at the bottom.
- 2: Separate AF points: Point Only. The AF area mode remains the same *regardless of camera orientation*, but you can specify a different AF point in manual point selection modes for each of the three orientations described above. The specified point will remain in force even if you switch from one manual selection mode to another.

You might want to use this feature when you want to keep the same initial focus point when photographing certain subjects even if you happen to rotate the camera for certain shots. Perhaps you're shooting candid portraits or fashion, and you'd like the focus point to remain at the "top" of the frame at all times.

C.Fn II-11: Initial AF Point, Auto Selection, AI Servo AF

Options: Auto (default), Initial Auto Area AF Point Selected, Manual AF Point My preference: Auto

Do you feel that Auto Selection: 45 Pt. AF is *too* automated for you? If you'd like to regain a little control over this automated feature, this is the over-ride for you. You can manually specify the starting point that will be used in AI Servo (continuous autofocus) mode, or mandate that a point you had previously chosen in another AF area selection mode be used when you switch to 45 Pt. AF. If you're confused, this description of your options should clear things up:

- 0: Auto. This default value restores the fully automatic operation of the Auto Selection: 45 pt. AF mode. Use this when you trust your 6D Mark II to make the right selection. For the types of action photography I do, I end up with this setting most of the time. Specifying a start point for auto AF selection can prove distracting when trying to capture moving subjects.
- 1: Initial Auto Area AF Pt Selected. You can use the AF point selection controls to specify any one of the 45 AF points available. When AI Servo AF starts to focus in Auto Selection, it will first use the point you have chosen before seeking other points as the 6D Mark II evaluates

your scene. You could use this option when you know that your main subject will *probably* be located in a particular area of the frame (say, a racing car approaching from the left), but still want the camera to refocus as the subject moves. This helps reduce AF confusion from movement elsewhere in the frame that is not your main subject.

■ 2: Manual AF Point. If you switch to Auto Selection mode from Single Point Spot AF or Single Point AF when using AI Servo AF, the focus system will begin operation using the AF point you manually selected in either of these previous modes. This can be a convenient mode to use, because you can define a button to switch from another mode to Auto Selection, using a defined Custom Control under Metering and AF Start. I'll explain the use of Custom Controls in Chapter 13.

C.Fn II-12: Auto AF Point Selection

Options: Enable (default), Disable

My preference: Enable when shooting people or events

Your 6D Mark II can use color and facial recognition to identify and track subjects while autofocusing. The feature is processing-intensive, so autofocus takes a bit longer and maximum speed under continuous is limited. It can operate when the AF Area Selection mode is Zone AF, Large Zone AF, or 45 Point Automatic AF. Your choices are as follows:

- 0: Enable. The autofocus point is based on human faces, color information, and AF phase detection. This mode is most useful when working in AI Servo AF mode (continuous autofocus), because the 6D Mark II "remembers" the color at the first focus position, and then continues to refocus while tracking your subject using AF points that detect that same color. In One-Shot AF mode, the camera focuses just once, but can identify people more easily. This mode may take longer to achieve focus, and face detection may not occur if the face is small or dimly lit. If no skin tones are found, the camera will focus on the color of the area first focused on.
- 1: Disable. The autofocus point is selected using only AF data. Face information or color information is ignored.

C.Fn II-13: AF Point Selection Movement

Options: Stops at AF area edges (default), Continuous

My preference: Stops at AF area edges

This entry simply specifies whether manual focus point selection will stop at the edges of the AF point array, or whether it will wrap around, *Pac-Man* style, to continue at the opposite edge (left/right, or top/bottom). The edge-stop option is best if you use the points at the edges often and don't want to continue to the opposite side. If you want to move quickly around in the array and aren't worrying about overshooting, then 1: Continuous is the speedier choice.

C.Fn II-14: AF Point Display During Focus

Options: Selected (constant) (default), All (constant), Selected (pre-AF focused), Selected AF point (focused), Disable display

My preference: Selected (constant)

Your 6D Mark II can show you the AF points during shooting, and this entry provides four different options that control the conditions under which the points are displayed. The configuration is largely a matter of personal preference, reflecting when you like to see your focus points or if you find them distracting. The options are as follows:

- 0: Selected (constant). The selected AF point(s) (only) are always highlighted. I prefer to see my selected points while I am shooting.
- 1: All (constant). All 45 possible AF points are always shown.
- 2: Selected (pre-AF focused). Focus points are shown when selecting AF point(s); when the camera is ready to shoot, before AF operation; and when focus is achieved (except when using AI Servo AF).
- 3: Selected AF point (focused). Focus points are shown only when selecting AF point(s) or when focus is achieved (except when using AI Servo AF).
- **4: Disable display.** The selected AF point(s) will *not* be displayed, except if you've chosen Selected (constant).

C.Fn II-15: VF Display Illumination

Options: Auto (default), Enable, Disable

My preference: Auto. I can use the Q button if I need to, as described below.

You can elect to have the AF points and grid in the viewfinder highlighted in red when focus is achieved. Keep in mind that when you press the AF Selection button, the AF points will illuminate regardless of how you have this option set. You can select:

- 0: Auto. Points and grid illuminate when focus is achieved under low light only. When selected, you can also specify whether the AF point should also light up in red when you press the Q button while using AI Servo AF. This is especially useful for sports photography and other applications where you want to see the selected focus point. The option does not work if VF Illumination is set to Disable. If the viewfinder electronic level and viewfinder grid are enabled, they will also light up in red.
- 1: Enable. Points and grid are illuminated when focus is achieved at all times. The same Q button behavior described above is available.
- 2: Disable. Points and grid are never illuminated (except when the AF Selection button is pressed).

C.Fn II-16: AF Microadjustment

Options: Disable, Adjust all by same amount, Adjust by lens (default)

My preference: Adjust by lens

Caution! Use this control, which allows you to tweak the point of focus of individual lenses, with care. Well-intentioned, but inaccurate adjustments can turn slight focus problems into major ones. I'll cover this drastic correctional step in detail next.

Fine-Tuning the Autofocus of Your Lenses

I hope you never need to use AF Microadjustment because it is applied only when you find that a lens is not focusing properly. If the lens happens to focus a bit ahead or a bit behind the actual point of sharp focus, and it does that consistently, you can use the microadjustment feature to "calibrate" the lens's focus.

Why is the focus "off" for some lenses in the first place? There are lots of factors, including the age of the lens (an older lens may focus slightly differently), temperature effects on certain types of glass, humidity, and tolerances built into a lens's design that all add up to a slight misadjustment, even though the components themselves are, strictly speaking, within specs. A very slight variation in your lens's mount can cause focus to vary slightly. With any luck (if you can call it that), a lens that doesn't focus exactly right will at least be consistent. If a lens always focuses a bit behind the subject, the symptom is *back focus*. If it focuses in front of the subject, it's called *front focus*.

You're almost always better off sending such a lens in to Canon to have them make it right. But that's not always possible. Perhaps you need your lens recalibrated right now, or you purchased a used lens that is long out of warranty. If you want to do it yourself, the first thing to do is determine whether your lens has a back focus or front focus problem.

For a quick-and-dirty diagnosis (*not* a calibration; you'll use a different target for that), lay down a piece of graph paper on a flat surface, and place an object on the line at the middle, which will represent the point of focus (we hope). Then, shoot the target at an angle using your lens's widest aperture and the autofocus mode you want to test. Mount the camera on a tripod so you can get accurate, repeatable results.

If your camera/lens combination doesn't suffer from front or back focus, the point of sharpest focus will be the center line of the chart, as you can see in Figure 5.13. If you do have a problem, one of the other lines will be sharply focused instead. Should you discover that your lens consistently front or back focuses, it needs to be recalibrated. Unfortunately, it's only possible to calibrate a lens for a single focusing distance. So, if you use a lens (such as a macro lens) for close focusing, calibrate for that. If you use a lens primarily for middle distances, calibrate for that. Close-to-middle distances are most likely to cause focus problems, anyway, because as you get closer to infinity, small changes in focus are less likely to have an effect.

Figure 5.13 Correct focus (top), front focus (middle), and back focus (bottom).

Lens Tune-Up

The key tool you can use to fine-tune your lens is the AF Microadjustment entry, C.Fn II-16. You'll find the process easier to understand if you first run through this quick overview of the menu options:

- 0: Disable. Deactivates autofocus microadjustment. You might want to use this if you've mounted a different copy of a lens you've registered for adjustment. For example, a photojournalist might make an adjustment for his or her personal lens, and then need to borrow a different copy of the exact same lens from a friend or a department's equipment pool. The 6D Mark II can't tell the two lenses apart, so it's probably best to disable the microadjustment feature while using that "foreign" lens.
- 1: Adjust all by same amount. The same adjustment is applied to all your lenses. You'd use this if your camera, rather than just a lens or two, requires calibration. (In this case, I particularly recommend sending the camera back to Canon for repair.)
- 2: Adjust by lens. You can set an adjustment individually for up to 40 different lens combinations (lens+teleconverter combinations are registered separately). If you discover you don't care for the calibrations you make in certain situations (say, it works better for the lens you have mounted at middle distances, but is less successful at correcting close-up focus errors), or, as described above, are using a different copy of the exact same lens, you can deactivate the feature as you require. Adjustment values range from −20 to +20.

Evaluate Current Focus

The first step is to capture a baseline image that represents how the lens you want to fine-tune autofocuses at a particular distance. You'll often see advice for photographing a test chart with millimeter markings from an angle, and the suggestion that you autofocus on a particular point on the chart. Supposedly, the markings that actually *are* in focus will help you recalibrate your lens. The problem with this approach is that the information you get from photographing a test chart at an angle doesn't tell you what to do to make a precise correction. So, your lens back focuses three millimeters behind the target area on the chart. So what? Does that mean you change the value -3 increments? Or -15 increments? Angled targets are a "shortcut" that don't save you time.

Instead, you'll want to photograph a target that represents what you're trying to achieve: a plane of focus locked in by your lens that represents the actual plane of focus of your subject. For that, you'll need a flat target, mounted precisely perpendicular to the sensor plane of the camera. Then, you can take a photo, see if the plane of focus is correct, and if not, dial in a bit of fine-tuning in the AF Microadjustment menu, and shoot again. Lather, rinse, and repeat until the target is sharply focused.

You can use the focus target shown in Figure 5.14, or you can use a chart of your own, as long as it has contrasty areas that will be easily seen by the autofocus system, and without very small details that are likely to confuse the AF. Download your own copy of my chart from www.dslrguides.com/FocusChart.pdf. (The URL is case sensitive.) Then print out a copy on the

Figure 5.14 Use this focus test chart, or create one of your own.

largest paper your printer can handle. (I don't recommend just displaying the file on your monitor and focusing on that; it's unlikely you'll have the monitor screen lined up perfectly perpendicular to the camera sensor.) Then, follow these steps:

- 1. **Position the camera.** Place your camera on a sturdy tripod with a remote release attached, positioned at roughly eye-level at a distance from a wall that represents the distance you want to test for. Keep in mind that autofocus problems can be different at varying distances and lens focal lengths, and that you can enter only *one* correction value for a particular lens. So, choose a distance (close-up or mid range) and zoom setting with your shooting habits in mind.
- Set the autofocus mode. Choose the autofocus mode (One-Shot AF or AI Servo AF) you want to test. (Because AI Auto mode just alternates between the two, you don't need to test that mode.)
- 3. Level the camera (in an ideal world). If the wall happens to be perfectly perpendicular, you can use a bubble level, plumb bob, or other device of your choice to ensure that the camera is level to match. Many tripods and tripod heads have bubble levels built in. Avoid using the center column, if you can. When the camera is properly oriented, lock the legs and tripod head tightly.
- 4. **Level the camera (in the real world).** If your wall is not perfectly perpendicular, use this old trick. Tape a mirror to the wall, and then adjust the camera on the tripod so that when you look through the viewfinder at the mirror, you see directly into the reflection of the lens. Then, lock the tripod and remove the mirror.
- 5. **Mount the test chart.** Tape the test chart on the wall so it is centered in your camera's viewfinder.
- 6. **Photograph the test chart using AF.** Allow the camera to autofocus, and take a test photo, using the remote release to avoid shaking or moving the camera.
- 7. **Make an adjustment and rephotograph.** Make a fine-tuning adjustment (described next) and photograph the target again.
- 8. **Evaluate the image.** If you have the camera connected to your computer with a USB cable or through a Wi-Fi connection, so much the better. You can view the image after it's transferred to your computer. Otherwise, *carefully* open the camera card door and slip the memory card out and copy the images to your computer.
- 9. **Evaluate focus.** Which image is sharpest? That's the setting you need to use for this lens. If your initial range doesn't provide the correction you need, repeat the steps between -20 and +20 until you find the best fine-tuning.

Make Adjustments

Making the adjustments is simple. From the AF Microadjustment entry, C.Fn II-16, select AF Microadjustment, and choose from Adjust All By Same Amount, Adjust By Lens, or Disable.

- Adjust All By Same Amount. Use this if all your lenses appear to front focus or back focus all the time, and consistently. Highlight the entry and press the SET button. You can clear current adjustment settings by pressing the Trash button. Or, press the Q button to produce a screen with a scale from −20 to +20. (See Figure 5.15.) Use the Quick Control Dial to choose a value, and press SET to confirm.
- **Adjust By Lens.** Follow these steps:
 - 1. **Highlight Adjust By Lens and press the Q button.** A screen like the one shown in Figure 5.16 will appear. For a prime lens, there will be only a single adjustment scale; for a zoom lens, there will be one scale for W (wide angle) and one for T (telephoto) focal lengths.
 - 2. **Press the INFO. button.** The Review/Edit lens information screen appears. It shows the name of the currently mounted lens and a 10-digit serial number (or 0000000000 if the number cannot be obtained). Note that while the 6D Mark II can differentiate among various lenses, it "sees" all copies of the exact same lens as identical. If you own two copies of the same 50mm f/1.4 lens, the identical adjustment will be applied to both.
 - 3. **If the serial number is obtained,** you can select OK to move on to the next step. If you need to edit the serial number, you can use the QCD to highlight any digit, then press SET to edit that digit. Rotate the QCD to increase or decrease the value of the digit. Select OK when finished.

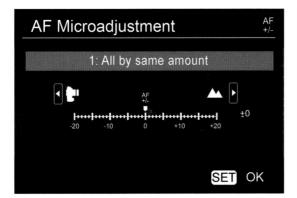

Figure 5.15 Adjustments toward the left move the focus plane closer to the camera; adjustments to the right move it farther away.

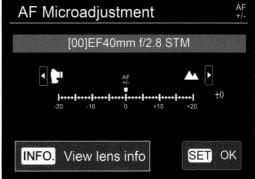

Figure 5.16 Press the INFO. button to view information about the lens mounted on the camera.

- 4. **Select the scale.** Then rotate the QCD to adjust between –20 and +20 (no letters required). Moving the indicator to the right moves the focus point to the rear of the standard point of focus. Adjusting to the left moves the focus point to a position in front of the default focus point.
- 5. **Press SET to confirm your changes.** The 6D Mark II has enough memory to store values for 40 different lenses or lens+tele-extender combinations (handy!). If you want to register more than 40 lenses, select a lens with an adjustment that can be deleted, mount it on the camera, and reset its adjustment to 0. That will free up a slot for a different lens.

NOTE

The –20/+20 increments are not fixed values: they are based on the amount of depth-of-field available with the lens at its widest aperture. Canon states that each increment represents one-eighth of the available depth-of-field at the focal length being adjusted. That means that the increments are not only very fine, but produce different amounts of adjustment based on whether you are tweaking a wide-angle or telephoto focal length.

Back-Button Focus

Once you've been using your camera for a while, you'll invariably encounter the terms back focus and back-button focus, and wonder if they are good things or bad things. Actually, they are two different things, and are often confused with each other. Back focus is a bad thing, and occurs when a particular lens consistently autofocuses on a plane that's behind your desired subject. This malady may be found in some of your lenses, or all your optics may be free of the defect. The good news is that if the problem lies in a lens (rather than a camera misadjustment that applies to all your lenses), it can be fixed. I'll show you how to do that using the AF Microadjustment feature later in this chapter.

Back-button focus, on the other hand, is a tool you can use to separate two functions that are commonly locked together—exposure and autofocus—so that you can lock in exposure while allowing focus to be attained at a later point, or vice versa. It's a *good* thing, although using back-button focus effectively may require you to unlearn some habits and acquire new ways of coordinating the action of your fingers.

As you have learned, the default behavior of your Canon 6D Mark II is to set both exposure and focus (when AF is active) when you press the shutter release down halfway. When using One-Shot mode, that's that: both exposure and focus are locked and will not change until you release the shutter button, or press it all the way down to take a picture and then release it for the next shot. In

AI Servo mode, exposure is locked and focus is set when you press the shutter release halfway, but the camera will continue to refocus if your subject moves for as long as you hold down the shutter button halfway. Focus isn't locked until you press the button down all the way to take the picture. In AI Focus AF mode, the camera will start out in One-Shot mode, but switch to AI Servo AF if your subject begins moving.

What back-button focus does is *decouple* or separate the two actions. You can retain the exposure lock feature when the shutter is pressed halfway, but assign autofocus *start* and/or autofocus *lock* to a different button. So, in practice, you can press the shutter button halfway, locking exposure, and reframe the image if you like (perhaps you're photographing a backlit subject and want to lock in exposure on the foreground, and then reframe to include a very bright background as well).

But, in this same scenario, you *don't* want autofocus locked at the same time. Indeed, you may not want to start AF until you're good and ready, say, at a sports venue as you wait for a ballplayer to streak into view in your viewfinder. With back-button focus, you can lock exposure on the spot where you expect the athlete to be, and activate AF at the moment your subject appears. The 6D Mark II gives you a great deal of flexibility, both in the choice of which button to use for AF, and the behavior of that button. You can *start* autofocus, *lock* autofocus at a button press, or *lock it while holding the button*. That's where the learning of new habits and mind-finger coordination comes in. You need to learn which back-button focus techniques work for you, and when to use them.

Back-button focus lets you avoid the need to switch from One-Shot to AI Servo AF when your subject begins moving unexpectedly. Nor do you need to use AI Focus AF mode and *hope* the camera switches from One-Shot to AI Servo appropriately. You retain complete control. It's great for sports photography when you want to activate autofocus precisely based on the action in front of you. It also works for static shots. You can press and release your designated focus button, and then take a series of shots using the same focus point. Focus will not change until you once again press your defined back button.

Want to focus on a spot that doesn't reside under one of the camera's 45 focus areas? Use back-button focus to zero in focus on that location, then reframe. Focus will not change. Don't want to miss an important shot at a wedding or a photojournalism assignment? With back-button focus, you can focus first, and wait until the decisive moment to press the shutter release and take your picture. The 6D Mark II will respond immediately and not bother with refocusing at all.

Back-button focus can also save battery power. Ordinarily, your IS lens will begin adjusting for camera shake as soon as you begin focusing. Constantly refocusing can consume a lot of power. With back-button focus, the IS isn't switched on until you decide to autofocus on your subject.

Activating Back-Button Focus

You'll find the tool for enabling back-button focus in the Custom Functions menu, under C.Fn III: Operation/Others, as seen at left in Figure 5.17. Just follow these steps to activate back-button focus.

- Access Custom Functions. Press the MENU button and use the Main Dial to navigate to the Custom Function menu, located between the Set-up (wrench icon) and My Menu (star icon) tabs.
- Select Custom Controls. Highlight the C.Fn III: Operation/Others entry and press SET.
 Then press the left/right directional buttons to select C.Fn III-4 Custom Controls, as seen at right in Figure 5.17. Press SET again.
- 3. **Choose Shutter Button function.** Highlight the top entry, "Shutter Butt. Half-Press" and press SET.
- 4. **Set Shutter Button to metering only.** A screen will appear with three choices (from left to right): Metering and AF Start; Metering Start; and AE lock (* button is pressed). The default value is Metering and AF Start, which you want to uncouple. Select Metering Start instead, and press SET to confirm.
- 5. **Set AF-ON button to activate autofocus.** You'll be returned to the Custom Controls menu. Scroll down to the second entry, AF-ON Button, and press SET. Select Metering and AF Start (if it's not already selected; it's the default value). Press SET to confirm.
- 6. Exit. Press the MENU button twice to exit (or just tap the shutter release button).
- 7. **Use back-button focus.** Henceforth, press the shutter release halfway to meter, and all the way to take a picture, and press the AF-ON button to activate autofocus.

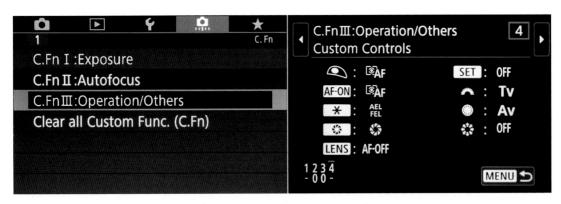

Figure 5.17 Set back-button focus using the C.Fn III-4, Custom Controls entry.

Advanced Techniques, Wi-Fi, and GPS

You can happily spend your entire shooting career using the techniques and features already explained in this book. Great exposures, sharp pictures, and creative compositions are all you really need to produce great shot after great shot. But, those with enough interest in getting the most out of their Canon EOS 6D Mark II who buy this book probably will be interested in going beyond those basics to explore some of the more advanced techniques and capabilities of the camera. Capturing the briefest instant of time, transforming common scenes into the unusual with lengthy time exposures, and working with new tools like GPS and Wi-Fi are all tempting avenues for exploration. So, in this chapter, I'm going to offer longer discussions of some of the more advanced techniques and capabilities that I like to put to work.

Continuous Shooting

The 6D Mark II's "motor drive" capabilities are, in many ways, much superior to what we used to get with film cameras, which could chew up a 36-exposure roll of film in a few seconds, even at a leisurely 3 frames per second. Your camera can shoot at up to 6.5 fps under ideal conditions, and with fast 64GB or larger memory cards, you can capture images for a long, long time before using up all the space on your digital "film."

To use the 6D Mark II's continuous shooting mode, press the DRIVE button and rotate the Main Dial to select High-speed continuous (up to 6.5 frames per second), Low-speed continuous (3 fps), or Silent continuous shooting (3 fps). Alternatively, you can press the Q button to pop up the Quick Control screen and select the drive mode icon, located in the bottom row of icons.

Figure 6.1 Continuous shooting allows you to capture an entire sequence of exciting moments as they unfold.

When you partially depress the shutter button, the viewfinder will display a number representing the maximum number of shots you can take at the current quality settings. (If your battery is low, this figure will be lower.) The display shows a maximum of 99 shots remaining; it's possible that the camera can take more than that, so the 99 will remain lit until the actual number remaining drops below that value. When the internal buffer is full, a "buSY" indicator will be shown. Generally speaking, you can expect to take roughly 150 shots in a single burst when shooting Large, Medium, and all Small image sizes and compression ratios. The lone exception is with a Large JPEG Fine image and standard speed SD card; you may be limited to about 110 frames before the buffer fills. (Canon does not specify the exact speed of its "benchmark" Secure Digital standard/high-speed cards.)

Continuous shooting can be affected by the speed with which your 6D Mark II is able to focus. So, in AI Servo AF mode, the frames-per-second rate may be lower. Lenses that inherently focus more slowly (see Chapter 7 for information on the various types of autofocus motors built into Canon lenses), and scenes that are poorly lit can also affect the frame rate.

When the 6D Mark II's internal buffer fills, the camera will stop capturing images until enough pictures have been written to the memory card to allow shooting to resume. As you might expect, the number of continuous shots you can fire off before that happens varies with the format you choose and the write speed of your card.

The reason the size of your bursts is limited by the buffer is that continuous images are first shuttled into the 6D Mark II's internal memory, then doled out to the memory card as quickly as they can be written to the card. Technically, the 6D Mark II takes the RAW data received from the digital image processor and converts it to the output format you've selected—either JPG or CR2 (RAW) or both—and deposits it in the buffer ready to store on the card.

This internal "smart" buffer can suck up photos much more quickly than the memory card and, indeed, some memory cards are significantly faster or slower than others. You'll get the best results when using a shutter speed of 1/500th second, the widest opening of the lens, One-Shot autofocus,

and when image stabilization is turned off. However, when One-Shot AF is active, the 6D Mark II will focus only once at the beginning of the sequence, and then use that focus setting for the rest of the shots in the burst. If your subject is moving, you can use AI Servo AF instead, at a slightly slower continuous frame rate.

Setting High ISO Speed Noise Reduction to High also limits the length of your continuous burst. You'll also see a decrease if lens aberration correction is active, or you have the camera set to do white balance bracketing. (In such cases, the 6D Mark II stores multiple copies of each image snapped, slowing down the burst rate.) Anti-flicker shooting and use of RAW or RAW+JPEG formats also reduce the continuous shooting speed. While you can use flash in continuous mode, the camera will wait for the flash to recycle between shots, slowing down the continuous shooting rate. In Live View mode, if you use Servo AF, the maximum shooting speed is likely to be no more than 4.3 frames per second.

More Exposure Options

In Chapter 4, you learned techniques for getting the *right* exposure, but I haven't explained all your exposure options just yet. You'll want to know about the *kind* of exposure settings that are available to you with the Canon EOS 6D Mark II. There are options that let you control when the exposure is made, or even how to make an exposure that's out of the ordinary in terms of length (time or bulb exposures). The sections that follow explain your camera's special exposure features, and even discuss a few it does not have (and why it doesn't).

A Tiny Slice of Time

Exposures that seem impossibly brief can reveal a world we didn't know existed. In the 1930s, Dr. Harold Edgerton, a professor of electrical engineering at MIT, pioneered high-speed photography using a repeating electronic flash unit he patented called the *stroboscope*. As the inventor of the electronic flash, he popularized its use to freeze objects in motion, and you've probably seen his photographs of bullets piercing balloons and drops of milk forming a coronet-shaped splash. Electronic flash freezes action by virtue of its extremely short duration—as brief as 1/50,000th second or less. You can read more about using electronic flash to stop action in Chapter 9.

Of course, the 6D Mark II is fully capable of immobilizing all but the fastest movement using only its shutter speeds, which range all the way up to 1/4,000th second. Indeed, you'll rarely have need for such a brief shutter speed in ordinary shooting. If you wanted to use an aperture of f/2.8 at ISO 100 outdoors in bright sunlight, for some reason, a shutter speed of 1/4,000th second would more than do the job. You'd need a faster shutter speed only if you moved the ISO setting to a higher sensitivity (but why would you do that?). Under less than full sunlight, 1/4,000th second is more than fast enough for any conditions you're likely to encounter.

Most sports action can be frozen at 1/2,000th second or slower, and for many sports a slower shutter speed is preferable—for example, to allow the wheels of a racing automobile or motorcycle, or the propeller on a classic aircraft to blur realistically.

But if you want to do some exotic action-freezing photography without resorting to electronic flash, the 6D Mark II's top shutter speed is at your disposal. Here are some things to think about when exploring this type of high-speed photography:

- You'll need a lot of light. High shutter speeds cut very fine slices of time and sharply reduce the amount of illumination that reaches your sensor. To use 1/4,000th second at an aperture of f/6.3, you'd need an ISO setting of 800—even in full daylight. To use an f/stop smaller than f/6.3 or an ISO setting lower than 800, you'd need *more* light than full daylight provides. (That's why electronic flash units work so well for high-speed photography when used as the sole illumination; they provide both the effect of a brief shutter speed and the high levels of illumination needed.)
- Don't combine high shutter speeds with electronic flash. You might be tempted to use an electronic flash with a high shutter speed. Perhaps you want to stop some action in daylight with a brief shutter speed and use electronic flash only as supplemental illumination to fill in the shadows. Unfortunately, under most conditions you can't use flash in subdued illumination with your 6D Mark II at any shutter speed faster than 1/180th second. That's the fastest speed at which the camera's focal plane shutter is fully open: at shorter speeds, the "slit" comes into play, so that the flash will expose only the small portion of the sensor exposed by the slit during its duration. (Check out "Avoiding Sync Speed Problems" in Chapter 9 if you want to see how you can use shutter speeds shorter than 1/180th second with certain Canon Speedlites, albeit at much-reduced effective power levels.)

Working with Short Exposures

You can have a lot of fun exploring the kinds of pictures you can take using very brief exposure times, whether you decide to take advantage of the action-stopping capabilities of your built-in or external electronic flash or work with the Canon EOS 6D Mark II's faster shutter speeds. Here are a few ideas to get you started:

■ Take revealing images. Fast shutter speeds can help you reveal the real subject behind the façade, by freezing constant motion to capture an enlightening moment in time. Legendary fashion/portrait photographer Philippe Halsman used leaping photos of famous people, such as the Duke and Duchess of Windsor, Richard Nixon, and Salvador Dali to illuminate their real selves. Halsman said, "When you ask a person to jump, his attention is mostly directed toward the act of jumping and the mask falls so that the real person appears." Try some high-speed portraits of people you know in motion to see how they appear when concentrating on something other than the portrait. (See Figure 6.2.)

- Create unreal images. High-speed photography can also produce photographs that show your subjects in ways that are quite unreal. A helicopter in mid-air with its rotors frozen makes for an unusual picture. Figure 6.3 shows a pair of pictures. At top, a shutter speed of 1/1,000th second virtually stopped the rotation of the chopper's rotors, while the bottom image, shot at 1/200th second, provides a more realistic view of the blurry blades as they appeared to the eye.
- Capture unseen perspectives. Some things are *never* seen in real life, except when viewed in a stop-action photograph. Edgerton's balloon bursts were only a starting point. Freeze a hummingbird in flight for a view of wings that never seem to stop. Or, capture the splashes as liquid falls into a bowl, as shown in Figure 6.4. No electronic flash was required for this image (and wouldn't have illuminated the water in the bowl as evenly). Instead, a clutch of high-intensity lamps and an ISO setting of 1600 allowed the EOS 6D Mark II to capture this image at 1/2,000th second.

Figure 6.2 When your subjects leap, the real person inside emerges.

Figure 6.3 Top: the chopper's blades are frozen at 1/1,000th second; bottom: a more realistic blurry rendition at 1/200th second shutter speed.

Figure 6.4
A large amount of artificial illumination and an ISO 1600 sensitivity setting allowed capturing this shot at 1/2,000th second without use of an electronic flash.

■ Vanquish camera shake and gain new angles. Here's an idea that's so obvious it isn't always explored to its fullest extent. A high enough shutter speed can free you from the tyranny of a tripod, making it easier to capture new angles, or to shoot quickly while moving around, especially with longer lenses. I tend to use a monopod or tripod for almost everything when I'm not using an image-stabilized lens, and I end up missing some shots because of a reluctance to adjust my camera support to get a higher, lower, or different angle. If you have enough light and can use an f/stop wide enough to permit a high shutter speed, you'll find a new freedom to choose your shots. I have a favored 500mm lens that I use for sports and wildlife photography, almost invariably with a tripod, as I don't find the "reciprocal of the focal length" rule particularly helpful in most cases. (I would not hand-hold this hefty lens at its 500mm setting with a 1/500th second shutter speed under most circumstances.) However, at 1/2,000th second or faster, and with a sufficiently high ISO setting (I recommend ISO 800-1600) to allow such a speed, it's entirely possible for a steady hand to use this lens without a tripod or monopod's extra support, and I've found that my whole approach to shooting animals and other elusive subjects changes in high-speed mode. Selective focus allows dramatically isolating my prey wide open at f/6.3, too.

Long Exposures

Longer exposures are a doorway into another world, showing us how even familiar scenes can look much different when photographed over periods measured in seconds. At night, long exposures produce streaks of light from moving, illuminated subjects like automobiles or amusement park rides. Extra-long exposures of seemingly pitch-dark subjects can reveal interesting views using light levels barely bright enough to see by. At any time of day, including daytime (in which case you'll often need the help of neutral-density filters, which reduce the amount of light passing through the lens, to make the long exposure practical), long exposures can cause moving objects to vanish entirely, because they don't remain stationary long enough to register in a photograph.

Three Ways to Take Long Exposures

There are three common types of lengthy exposures: *timed exposures*, *bulb exposures*, and *time exposures*. The EOS 6D Mark II offers all three. Because of the length of the exposure, all the following techniques should be used with a tripod to hold the camera steady.

- Timed exposures. These are long exposures from 1 second to 30 seconds, measured by the camera itself. To take a picture in this range, simply use Manual or Tv modes and use the Main Dial to set the shutter speed to the length of time you want, choosing from preset speeds of 1.0, 1.5, 2.0, 3.0, 4.0, 6.0, 8.0, 10.0, 15.0, 20.0, or 30.0 seconds (if you've specified 1/2-stop increments for exposure adjustments), or 1.0, 1.3, 1.6, 2.0, 2.5, 3.0, 4.0, 5.0, 6.0, 8.0, 10.0, 13.0, 15.0, 20.0, 25.0, and 30.0 seconds (if you're using 1/3-stop increments). The advantage of timed exposures is that the camera does all the calculating for you. There's no need for a stopwatch. If you review your image on the LCD and decide to try again with the exposure doubled or halved, you can dial in the correct exposure with precision. The disadvantage of timed exposures is that you can't take a photo for longer than 30 seconds.
- **Bulb exposures.** This type of exposure is so-called because in the olden days the photographer squeezed and held an air bulb attached to a tube that provided the force necessary to keep the shutter open. Traditionally, a bulb exposure is one that lasts as long as the shutter release button is pressed; when you release the button, the exposure ends. To make a bulb exposure with the 6D Mark II, set the camera on B using the Mode Dial. Then, press the shutter to start the exposure, and press it again to close the shutter.
- Time exposures. This is a setting found on some cameras to produce longer exposures. With the 6D Mark II, it's actually an enhancement of the Bulb exposure feature. With the camera's Mode Dial set to Bulb, locate the Bulb Timer setting in the Shooting 4 menu. Press SET, and in the screen that pops up, highlight Enable. Press SET again, and a screen appears that will allow you to set an exposure time of up to 99 hours, 59 minutes, and 59 seconds. You'll rarely need extra-long exposures (unless you're shooting continuous star trails), but many exposures longer than 30 seconds are quite useful. For example, if many star photographers shoot multiple one-minute exposures (any longer than that, and the star pinpoints become blurs) and then merge them together to get a different kind of sky photograph.

When using this type of Bulb exposure, you can press the shutter release button, go off for a few minutes, and come back to take your next shot (assuming your camera is still there). The disadvantages of this mode are exposures must be timed manually, and with shorter exposures, it's possible for the vibration of manually opening and closing the shutter to register in the photo. For longer exposures, the period of vibration is relatively brief and not usually a problem—and there is always the wired release option to eliminate photographer-caused camera shake entirely.

Working with Long Exposures

Because the EOS 6D Mark II produces such good images at longer exposures, and there are so many creative things you can do with long-exposure techniques, you'll want to do some experimenting. Get yourself a tripod or another firm support and take some test shots with long exposure noise reduction both enabled and disabled using the entry in the Shooting 3 menu, as explained in Chapter 11 (to see whether you prefer low noise or high detail), and get started. Here are some things to try:

- Make people invisible. One very cool thing about long exposures is that objects that move rapidly enough won't register at all in a photograph, while the subjects that remain stationary are portrayed in the normal way. That makes it easy to produce people-free landscape photos and architectural photos at night or, even, in full daylight if you use a neutral-density filter (or two or three) to allow an exposure of at least a few seconds. At ISO 100, f/22, and a pair of 8X (three-stop) neutral-density filters, you can use exposures of nearly two seconds; overcast days and/or more neutral-density filtration would work even better if daylight people-vanishing is your goal. They'll have to be walking *very* briskly and across the field of view (rather than directly toward the camera) for this to work. At night, it's much easier to achieve this effect with the 20- to 30-second exposures that are possible, as you can see in Figure 6.5.
- Create streaks. If you aren't shooting for total invisibility, long exposures with the camera on a tripod or monopod can produce some interesting streaky effects, as you can see in Figure 6.6, left. You don't need to limit yourself to indoor photography, however. Even a single 8X ND filter will let you shoot at f/22 and 1/6th second in full daylight at ISO 100.
- Produce light trails. At night, car headlights and taillights and other moving sources of illumination can generate interesting light trails. Your camera doesn't even need to be mounted on a tripod; hand-holding the 6D Mark II for longer exposures adds movement and patterns to your trails. If you're shooting fireworks (preferably with a tripod), a longer exposure of several seconds may allow you to combine several bursts into one picture. Or, you can record the movement of a Ferris wheel, as shown in Figure 6.6, right.

- Blur waterfalls, etc. You'll find that waterfalls and other sources of moving liquid produce a special type of long exposure blur, because the water merges into a fantasy-like veil that looks different at different exposure times, and with different waterfalls. Cascades with turbulent flow produce a rougher look at a given longer exposure than falls that flow smoothly. Although blurred waterfalls have become almost a cliché, there are still plenty of variations for a creative photographer to explore, as you can see in Figure 6.7, left.
- Show total darkness in new ways. Even on the darkest nights, there is enough starlight or glow from distant illumination sources to see by, and, if you use a long exposure, there is enough light to take a picture, too. Figure 6.7, right, shows San Juan, Puerto Rico late at night.

Figure 6.5 This alleyway is thronged with people, as you can see in this two-second exposure using only the available illumination (left). With the camera still on a tripod, a 30-second exposure rendered the passersby almost invisible (right).

Figure 6.6 Left: These dancers produced a swirl of movement during the 1/8th second exposure. Right: A long exposure allows capturing the movement of this Ferris wheel.

Figure 6.7 Left: A 1/4-second exposure blurred the falling water. Right: A 20-second exposure revealed this view of San Juan, Puerto Rico.

Delayed Exposures

Sometimes it's desirable to have a delay of some sort before a picture is taken. Perhaps you'd like to get in the picture yourself, and would appreciate it if the camera waited 10 seconds after you press the shutter release to take the picture. Maybe you want to give a tripod-mounted camera time to settle down and damp any residual vibration after the release is pressed to improve sharpness for an exposure with a relatively slow shutter speed. It's possible you want to explore the world of time-lapse photography. The next sections present your delayed exposure options.

Self-Timer

The EOS 6D Mark II has a built-in self-timer with 10-second and 2-second delays, plus a continuous exposure option for shooting from 2 to 10 photos after the 10-second timer has elapsed. Activate the timer by pressing the DRIVE button and rotating the QCD to select the drive modes. Press the shutter release button halfway to lock in focus on your subjects (if you're taking a self-portrait, focus on an object at a similar distance and use focus lock). When you're ready to take the photo, continue pressing the shutter release the rest of the way. The lamp on the front of the camera will blink slowly for eight seconds (when using the 10-second timer) and the beeper will chirp (if you haven't disabled it in the Shooting menu, as described in Chapter 11). During the final two seconds, the beeper sounds more rapidly and the lamp remains on until the picture is taken. The top-panel LCD displays a countdown while all this is going on.

Another way to use the self-timer is in conjunction with the mirror lockup feature (which can be enabled using the Shooting 4 menu entry, as explained in Chapter 11). This is something you might want to do if you're shooting close-ups, landscapes, or other types of pictures using the self-timer, to trip the shutter in the most vibration-free way possible. Forget to bring along your tripod, but still want to take a close-up picture with a precise focus setting? Set your digital camera to the

self-timer function, then put the camera on any reasonably steady support, such as a fence post or a rock. When you're ready to take the picture, press the shutter release. The camera might teeter back and forth for a second or two, but it will settle back to its original position before the self-timer activates the shutter. The self-timer remains active until you turn it off—even if you power down the 6D Mark II, so remember to turn it off when finished.

Interval/Time Lapse Photography

Who hasn't marveled at interval stills, shot moments or minutes apart to document an event, or wasn't enrapt by a time-lapse movie of a flower opening, a series of shots of the moon marching across the sky, or one of those extreme interval or time-lapse photography productions showing something that takes a very, very long time, such as a building under construction.

You probably won't be shooting such construction shots, unless you have a spare 6D Mark II you don't need for a few months (or are willing to go through the rigmarole of figuring out how to set up your camera in precisely the same position using the same lens settings to shoot a series of pictures at intervals). However, other kinds of time-lapse photography are entirely within reach.

The 6D Mark II has built-in features that allow you to create a set of still photographs taken at intervals you specify, or shoot time-lapse movies easily. Before I explain how to use these features, here are a few things to keep in mind:

- Use AC power. If you're shooting a long sequence, consider connecting your camera to an AC adapter, as leaving the 6D Mark II on for long periods of time will rapidly deplete the battery. The optional Canon DC Coupler DR-E6 and AC Adapter AC-6N are perfect for this application. While shooting time-lapse movies, auto power off will not take place.
- **Disabled functions.** While capturing time-lapse movies, ISO must be ISO 6400 or slower; shooting and menu functions and playback are disabled, along with Movie Servo AF. You can't shoot time-lapse movies if digital zoom is enabled, and sound is not recorded.
- Make sure you have enough storage space. Unless your memory card has enough capacity to hold all the images you'll be taking, you might want to change to a higher compression rate or reduced resolution to maximize the image count.
- **Protect your camera.** If your camera will be set up for an extended period (longer than an hour or two), make sure it's protected from weather, earthquakes, animals, young children, innocent bystanders, and theft.
- Vary intervals. Experiment with different time intervals. You don't want to take pictures or frames too often or less often than necessary to capture the changes you hope to image in your movies or still series.

Interval Timer

The 6D Mark II allows you to shoot a series of still shots at intervals you specify. The function is like time-lapse movie shooting (described next) in many respects, but must be done in still photography mode (with the Live View/Movie switch set to the Live View position, although you cannot be in Live View mode to use this feature). Nor can you shoot movies or use Bulb exposures while Interval Timer is enabled. Here are some other things to consider:

- Interval timing can be combined with other functions. You can use auto exposure and white balance bracketing, shoot multiple exposures, or access HDR mode. I particularly like to shoot multiple exposures combined with interval shots when doing manual HDR work. For example, I've set my 6D Mark II on a tripod and configured it to shoot bracketed shots of a sunset at intervals, so I ended up with groups of pictures taken over a span of time that I could combine in Photoshop.
- The 6D Mark II is smart enough to override auto power off settings. After powering down, it will turn itself on roughly one minute before the next shot is taken.
- You don't have to use the menu to disable interval shooting. Just turn the 6D Mark II off.
- Use manual focus if you can. Manual focus is best when your subject is not moving. If the camera is unable to autofocus, the shot will not be captured.
- Flash is okay. But make sure the interval between shots is longer than the flash's normal recycling time.

Just follow these steps:

- 1. **Access Interval Timer.** Visit the Shooting 4 menu and choose Interval Timer, the first entry on the screen.
- 2. Enable. Highlight Enable and the settings display shown in Figure 6.8, left, appears.

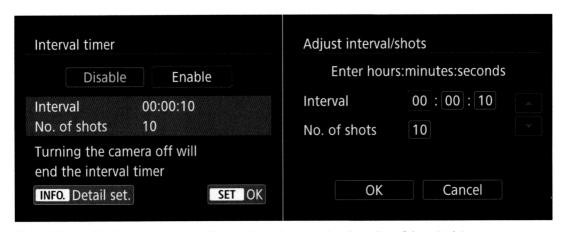

Figure 6.8 Enable the interval timer (left) and adjust the interval and number of shots (right).

- 3. **Access settings.** Press the INFO. button to produce the Adjust Interval/Shots screen seen in Figure 6.8, right.
- 4. **Choose an interval between exposures,** in hours, minutes, and seconds, from 00:00:01 to 99:59:59.
- 5. **Specify number of shots.** Choose from 01 to 99, or you can select Unlimited (00) and the camera will continue to capture stills until you stop the timer, the memory card fills, or the battery runs out of juice.
- 6. Confirm. Highlight OK and press SET.
- 7. **Make other settings.** In the screen that appears next, you can Enable/Disable Anti-Flicker correction. When active, anti-flicker (enabled in the Shooting 4 menu, discussed in Chapter 8) may slow down capture. You can also Enable/Disable a Bulb exposure timer, turn mirror lockup on or off, and specify an aspect ratio for the image's capture.
- 8. Exit. When finished setting up press the MENU button to exit.
- 9. **Press the shutter release to begin.** The Timer indicator on the top-panel LCD status panel will blink. Once the series is complete, the 6D Mark II will cancel interval timer shooting automatically.

Time-lapse Movies

The 6D Mark II's time-lapse movie facility is actually a still photography mode that shoots images at intervals you specify, and then stitches them together automatically to create a MOV-format movie in Full HD (1920 \times 1080) at a playback rate of 30/25 fps. Alternatively, the time-lapse feature can let you shoot a 4K movie (3840 \times 2160), even though the 6D Mark II doesn't offer a 4K option for conventional video. To create a time-lapse movie, just follow these steps:

- 1. **Set the Live View/Movie switch to the Movie position.** Even though time-lapse clips are a series of stills, you must be in Movie mode to access the feature. Even though individual images are still photographs, no stills are stored; the 6D Mark II converts them to a movie file even if you take only one shot in time-lapse mode.
- 2. **Navigate to the Shooting 5 (Movie) menu.** (Use the Shooting 3 menu if the Mode Dial is set to Scene Intelligent Auto.) Select Time-Lapse Movie and press SET.
- 3. **Choose Enable.** Highlight either Enable 4K or Enable FHD and press SET. The current settings will be shown. Both recording sizes produce video with 16:9 aspect ratios.
 - 4K (3840 × 2160) size. The frame rate is 30 fps for NTSC for North America and some other locations, and 25 fps for PAL systems for most other countries. The recording format is Motion JPEG/MOV. (I explain these terms in more detail in Chapter 14.)
 - FHD (1920 \times 1080) size. The frame rate is 30/25 and the movie file format is MOV/ALL-I.

- 4. **Make your settings.** Time-lapse movies are like Interval Timer sequences. You can specify each of these parameters, as shown in Figure 6.9:
 - Interval. You can select an interval between shots from 1 second to 99 hours, 59 minutes, 59 seconds. As you specify the timing, the Interval screen will display the time required to capture the movie at the current settings.
 - Number of Shots. This determines how long your movie clip will be when played back at 30 fps. For example, if you selected 300 shots, the resulting video would display in 10 seconds.
 - Auto Exposure. You can choose to use the exposure calculated for the first frame for all subsequent frames, or have the camera adjust the exposure for each frame individually. Use Fixed 1st Frame for time-lapse movies that are intended to show the fluctuations in illumination—say, when photographing a dawn-to-dusk sequence. If you allow the 6D Mark II to recalculate exposure for each shot, the dawn and high-noon pictures will have the same brightness level—but the shadows cast on a sunny day would be wildly different.
 - LCD Auto Off. You can enable LCD Auto Off to save battery power, or disable Auto Off to allow you to use the LCD monitor during shooting.
 - Beep as image is taken. Enable if you'd like to be notified when an image is captured. I use this as a way of knowing that the sequence is being exposed as expected. The beep is often easier to hear than the shutter click.
- 5. **Confirm.** When finished setting parameters, highlight OK and press SET to confirm. The expected elapsed time for the entire sequence is shown near the bottom of the screen.
- 6. Exit menu and test settings. Press MENU to exit the menu system. A message appears on the LCD monitor advising you to make your exposure settings and press the shutter release to take a test shot. Note that you can use a full range of shutter speeds from 1/4,000th to 1/30th second and if you've selected a speed slower than 1/60th second, when capture ends the camera will change to a shutter speed allowable for movie shooting.

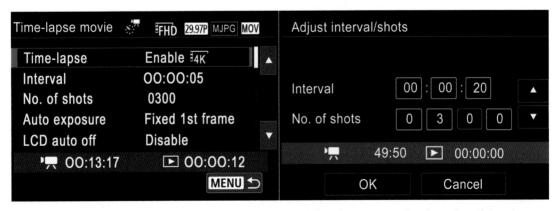

Figure 6.9 Enable/disable and check settings on this screen (left). Choose interval and number of shots here (right).

- 7. Exit setup. When satisfied with your exposure settings, press OK to exit the set-up screen.
- 8. **Check settings (optional).** You can check your settings by accessing the Shooting 5 (Movie) menu and selecting Time-Lapse Movie again. The current settings appear in the screen.
- 9. **Start time-lapse.** When ready to begin, press the Start/Stop button to commence your time-lapse movie.
- 10. Stop capture. While the time-lapse movie is recording, you can press the shutter release to start or stop capture, or the Start/Stop button to return to the exposure set-up screen. When time-lapse shooting ends, the settings are cleared and the 6D Mark II resumes normal Movie shooting mode.

Introducing Wi-Fi

Your 6D Mark II has built-in wireless communications capabilities that allow you to link the camera to multiple devices. The various permutations and features are complex, to the extent that Canon includes a 48-page basic Wi-Fi manual as part of its basic 6D Mark II product guide, and a separate exhaustive (and exhausting) 180-page Wireless Communication Function Instruction Manual. This book concentrates on still photography rather than information technology and, obviously, I can't devote 48 pages or 180 pages just to Wi-Fi topics. However, I think you'll find enough information in the following sections to get you started.

First, here is a list of the connections you can make with the 6D Mark II's built-in Wi-Fi:

- Phones and tablets. You can connect to a smartphone or tablet and use an app on the device to operate the camera remotely or review images on your memory card. Both Android and iOS are supported. Quick connection with Android devices using NFC (Near Field Communications) is available, but, to date, Apple's iOS supports NFC only for Apple Pay. That may change while this book is in print, given the expected long product life of the 6D Mark II.
- Connect Station. Canon offers the Connect Station, a 1TB storage device that can download images from the 6D Mark II over a wireless connection, or transfer them directly using its two memory card slots. The transferred images can be viewed using a web browser, or directed to an HDMI-compatible monitor/HDTV over a cable connection. An included remote control allows you to display the images in slide-show fashion.
- **Remote control.** The 6D Mark II can be operated remotely using a computer with EOS Utility software installed.
- **Direct printing.** If you have a Wi-Fi-compatible printer that supports PictBridge, you can make hard copies of your images with a wireless connection.
- FTP transfer. You can send your images to an FTP server for immediate availability by anyone with permissions to access that server.
- Web upload. The free Canon iMage Gateway you can sign up for to share your images with colleagues, family, or friends over the Internet.

I'll explain these in the next sections, but first you need to consider some general guidelines for the 6D Mark II's built-in wireless functions.

General Wi-Fi Guidelines

Here are some general tips for using the EOS 6D Mark II's built-in Wi-Fi functions:

- Conserve processing power. Wi-Fi uses some of your camera's internal CPU's processing muscle, so when the 6D Mark II is busy communicating with another device, give Wi-Fi top priority. Don't press the shutter release, rotate the Mode Dial, or review images with the Playback button. If you do, Wi-Fi functions may be interrupted.
- Some functions are disabled. When Wi-Fi is enabled, the 6D Mark II cannot communicate with a computer, printer, external monitor, GPS, or other device with a direct (cable) connection, USB, or HDMI cable link. For example, if you're viewing your camera's output on a monitor using an HDMI connection, the monitor will go dark during Wi-Fi communication. In addition, you can't use an Eye-Fi card (an SD card with its own built-in Wi-Fi functions) and the internal Wi-Fi functions simultaneously; if you've set the 6D Mark II's Wi-Fi functions to Enable, any Eye-Fi card is automatically disabled. The camera cannot be connected to other NFC devices, including printers, when you're using the NFC function.
- No auto shutoff. When using Wi-Fi, the camera's power-saving shutdown feature is disabled.
- Monitor connection status. Wi-Fi status can be seen within the information displays on both the camera's LCD monitor and LCD panel. When Wi-Fi is disabled, or enabled but no connection is available, an OFF indicator is shown in both places. When a connection is available, the indicators are animated when data is being transmitted, and blink if the camera is waiting for a reconnection or there is a connection error.

Using Wi-Fi, Bluetooth, and NFC

Your 6D Mark II can communicate using standard Wi-Fi communications, Bluetooth, or, with Android devices, NFC (Near Field Communications). The latter is a radio protocol similar to Bluetooth that makes automatic connections simply by touching the NFC indicator on the side of the camera with the memory card door to the NFC indicator on the Android phone or tablet. I'll explain how to use each type of connection separately.

Enabling Wi-Fi

Using a Wi-Fi connection is your most versatile choice if you want to connect to a variety of devices. Note that when using Wi-Fi, you cannot connect your camera to another device using a USB cable; and if connected with a USB cable, you cannot access the wireless communications settings. Wi-Fi also disables Eye-Fi card transfer. To activate and begin using the 6D Mark II's Wi-Fi capabilities,

just follow these steps (there are many screens, so I won't tell you to press SET to progress to the next screen each time):

- 1. **Enable Wi-Fi.** Choose the Wireless Communication Settings entry at the bottom of the Set-up 1 menu. In the screen that appears (see Figure 6.10, left), choose Wi-Fi Settings. In the next screen that pops up (see Figure 6.10, right), choose Wi-Fi, and select Enable. Press MENU to return to the first screen.
- 2. **Enter a Nickname.** You can accept the default nickname (EOS6D2) by doing nothing, or highlight Nickname and enter one of your own. Organizations that have more than one EOS6D2 might want to do this to differentiate among cameras, or, you simply might prefer a custom name. You'll find it much easier to use the touch screen to enter your nickname. (See Figure 6.11.) Press MENU and select OK in the confirmation screen to exit.

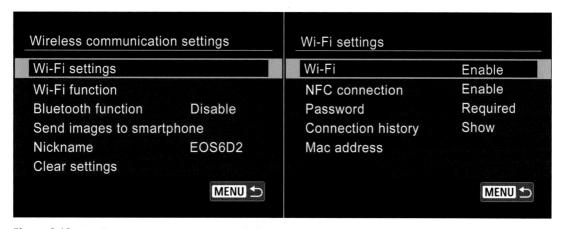

Figure 6.10 Wireless communication settings (left); Wi-Fi Settings (right).

Connecting to a Camera with Wi-Fi

If you have another Wi-Fi-capable Canon EOS camera, you can connect your 6D Mark II to that camera and transfer images between them. Just follow these steps:

- 1. Enable Wi-Fi. You must first enable Wi-Fi as described in Steps 1 and 2 above.
- 2. **Access Wi-Fi Function.** In the Wireless Communications Settings screen (shown earlier in Figure 6.10 left), choose Wi-Fi Function. The screen shown in Figure 6.12 appears.
- 3. **Select Transfer Images Between Cameras.** Choose the camera icon in the top row.
- 4. **Register the other cameras.** Choose Register a Device for Connection. A screen appears asking you to Start Connection on Target Camera.
- 5. **Set up target camera.** Using your other camera, set it up for a Wi-Fi connection. The steps differ depending on your second camera, so follow the instructions for that camera's manual to connect.
- 6. **Connection made.** When the target camera is connected to your 6D Mark II, an image on your card will appear on the LCD.
- 7. **Select images to transmit.** Choose the images you want to send on the camera where they currently reside. The receiving camera should not be operated while transfer is taking place. You can select an individual image on your 6D Mark II with the QCD, pressing SET to transfer it. Or, press the Magnify button and rotate the QCD counterclockwise to select images from an index/thumbnail display.
- 8. **Send image.** You can choose to send selected images, a range of images, all images on the memory card, or only the image displayed on the LCD monitor. Choose Resize Image to send a reduced-size copy of the image (which is faster). Choose Send when finished.
- 9. **End connection.** Press MENU and then OK to terminate the link.

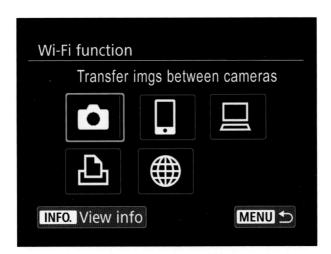

Figure 6.12
Wi-Fi Function
screen with icons
representing connections to a camera,
smart device, computer (top row),
printer, and Web
services (bottom
row).

Connecting to Connect Station with Wi-Fi/NFC

The optional Canon Connect Station (about \$260) allows you to share photos and movies to your TV, smartphone, or network. It uses both NFC (to link camera and Connect Station) and Wi-Fi (to share with other devices). Note that you do *not* have to own an NFC-compatible smartphone to use Connect Station. Only an NFC link from the camera and Connect Station (which both support NFC) is necessary. Follow these steps:

- 1. **Enable NFC on camera.** In the Wi-Fi Settings screen shown earlier in Figure 6.10, right, use the NFC Connection entry to enable NFC.
- 2. **Power up 6D Mark II and Connect Station.** Hold the camera's NFC mark, located on the left side of the camera (as you hold it to take photos).
- 3. **Message appears.** A message will be shown on the 6D Mark II's LCD monitor when the connection is established. Once it appears, you no longer have to hold the camera near the Connect Station.
- 4. **Automatic transfer.** The Connect Station automatically retrieves *only* the unsaved images on your memory card, and stores them internally.
- 5. **Terminate link.** Once all the images are saved, you'll see a message telling you how many images were transferred. Press SET to end the connection.

Using the EOS Utility with Wi-Fi

You can operate the 6D Mark II remotely from a computer using a Wi-Fi connection and the Canon EOS Utility. You can also use the Utility for additional features, such as entering text screens. You'll need to install the EOS Utility first and familiarize yourself with its functions and features; this book is not intended to serve as a software manual. This section will help you get started with making the connection.

- 1. **Access Wi-Fi Function.** From the Wireless Communications page, select Wi-Fi Function to view the screen shown earlier in Figure 6.12.
- 2. Choose Remote Control (EOS Utility). It's the icon at far right in the top row.
- 3. **Select Register a Device for Connection.** A screen like the one shown in Figure 6.13 appears.
- 4. Confirm Network and Password. Check the network name (SSID) shown. If several networks are within range of the camera, you can choose Switch Network to scan and select another or use manual settings. If you have set Password to None instead of Required (see Figure 6.10 right), then no password will be shown or required to connect.
- 5. **Connect your computer.** Use your computer's operating system's network features to select the Canon network displayed in Step 4. The procedure differs, depending on your Mac or Windows platform. Figure 6.14 shows the Windows network selection screen.
- 6. Confirm pairing. On the camera, choose OK when pairing begins.
- 7. **Operate EOS Utility.** Back at your computer, run the EOS Utility, connect to your camera, and establish the Wi-Fi connection on the camera.

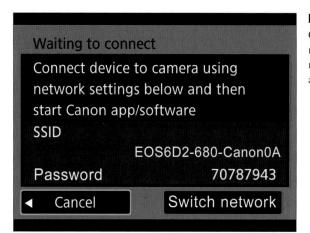

Figure 6.13
Check password (if required) and connection, or switch to a different network.

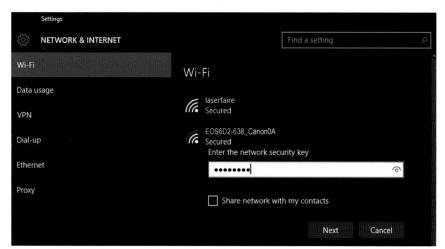

Figure 6.14 Microsoft Windows 10 network connection screen.

Connecting to a Printer with Wi-Fi

Many (perhaps most) printers today have built-in wireless capabilities, allowing you to print out directly from your computer without a physical link between the computer and printer. The EOS 6D Mark II adds the same function to your camera/printer setup, so you can make hard copies of your images from files in your camera without the bother of transferring them to a computer first. All you need is your 6D Mark II and a PictBridge-compatible printer that conforms to the DPS over IP standard. (More alphabet soup: *Digital Photo Solutions* and *Internet Protocol*.)

To use this feature, you must:

- Configure your printer for wireless printing. The instructions vary from printer to printer, so you should consult your printer manual for the procedures. Once you've done this, you'll be able to print photos from your camera, plus files from your computer and other compatible devices, such as smartphones. Wireless printing is *not* limited to camera-to-printer communications.
- Link your camera to the printer. The procedures are the same as those mentioned earlier. You can use your camera's built-in access point or connect to your local area network (*infrastructure network*). A list of detected printers is displayed, and, as before, you can save the camera-printer connection to a setting for re-use later. Multiple printer connections can be registered.
 - If your printer *does not* connect wirelessly, you can still connect to the camera using your LAN, as described shortly under "Connecting to a Wi-Fi Access Point."
- **Printing images.** Once linked, you can print by pressing the Playback button and scrolling to the image you want to output. Select printing parameters, number of prints, and other settings just as you would for printing over a wired connection to a PictBridge printer.

You can print images directly from your 6D Mark II using a Wi-Fi connection instead of a USB/ PictBridge connection. The procedure is similar to connecting to the EOS Utility in Steps 1–4 above, except that in Step 2 you should choose Print From Wi-Fi, using the icon at far left in the bottom row in the Wi-Fi Function page.

After that, you'll need to follow the instructions for your specific printer to choose a network to connect the printer to. Select the Canon network, which will have an SSID ending in _Canon0A. If you have enabled passwords, you'll need to enter it when prompted.

From then on, selecting images to print proceeds as described in Chapter 12. You can create a print order or select individual images to print, specify paper size, paper type, page layout, add printing effects, crop the image, and other parameters.

Connecting to Web Services

This wireless option allows you to select images and upload them to the Canon iMage Gateway, which is a free-of-charge service. You can register online through your computer and through this entry. Once you've become a member, you can upload photos, create photo albums, and use other Canon Image Gateway services. The site also can interface with other web services you have an account with, including e-mail, Twitter, YouTube, and Facebook.

All you need is your EOS 6D Mark II and a computer with the EOS Utility installed. Before you can interface with the Canon gateway wirelessly, you must connect your camera and computer using the conventional digital/USB connection, log onto the Gateway through the "globe" icon,

and configure the camera's settings to allow access to the web services. (Remember that Wireless capabilities must be set to Disable any time you want to use a wired connection between your camera and computer.)

Then, you can remove the direct link, turn wireless features back on, and connect to your computer through the wireless access methods described earlier in this chapter. Still images can be uploaded to the Gateway, and movies to YouTube. Images can be uploaded directly to Facebook, or shared with Facebook and Twitter users by posting a link back to the Canon Image Gateway location of the files. As with the image transfer features described earlier, you can resize images before uploading, and send photos one by one or in batches.

Connecting to a Wi-Fi Access Point

Computer techies will be delighted to know that the 6D Mark II can connect directly to a computer using an access point, using WPS (Wi-Fi Protected Setup) in both PBC and PIN modes, with Open System, Shared Key, WPA/WPA2-PSK authentication, and WEP, TKIP, or AES encryption. Whew!

Delving that deeply into computer technology is beyond the scope of this book, and would require a full chapter to cover. Fortunately, Canon provides all the gory details in its Canon EOS 6D Mark II Wi-Fi (Wireless Communication) Function Instruction Manual, which you can download from the Canon website in your country. It's an extra step, but I expect only a minority of readers require that much detail, with the rest of us preferring to concentrate on photographic topics. We still need to leave room for tips on connecting your smartphone or tablet to the 6D Mark II.

Connecting to Your Smartphone or Tablet

I expect that using a smartphone or tablet to connect to the 6D Mark II will be the most common wireless option for most of the readers of this book. You can connect using Wi-Fi/Bluetooth or NFC. The first step is to visit the Android or iOS app stores and download the free Canon Camera Connect application. You can display a QR code on the camera's LCD monitor that will take you directly to the appropriate app store, using the Bluetooth entry in the Wireless Communications Settings screen. Set Bluetooth to Smartphone, then choose Pairing and you'll be offered a choice to display Android or iOS QR codes.

After you've installed the app, you can connect your Bluetooth-compatible Android or iOS device to the 6D Mark II by following these steps:

1. **Enable Bluetooth.** From the Wireless Communications Settings entry at the bottom of the Set-up 1 menu, choose Bluetooth Function, and Select Smartphone. (You can enter/change a nickname, as described earlier, if necessary.) A Bluetooth icon will appear at the left side of the top-panel monochrome LCD.

- 2. **Select Pairing.** As Camera Connect should already be installed, choose Do Not Display from the screen that appears. This message appears next: "Pairing in Progress. Use Canon App/ software on the smartphone to finish pairing." The camera will now be discoverable.
- 3. **Enable Bluetooth on your smartphone/device.** In the Camera Connect App, a message will appear offering to pair with the 6D Mark II. Tap the EOS6D2 label to connect. A series of screens like the ones shown in Figure 6.15 will appear as you follow the prompts.
- 4. **Accept pairing.** When Connect to this Smartphone message appears on the camera's LCD monitor, select OK. The pairing will complete.
- 5. **Connect Wi-Fi.** Once the Bluetooth connection is complete, you can connect the camera to the Camera Connect app using Wi-Fi. With an Android device, the Wi-Fi connection will be established automatically; for iOS devices, you need to check the SSID and Password (if enabled), and go to the device's Settings screen and choose the "_Canon0A" device as your Wi-Fi connection.

Figure 6.15
Typical connection
screens on an iOS
device; Android
prompts will be
similar.

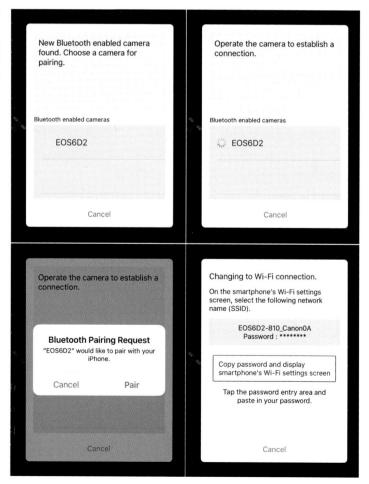

164

If your Android device is not Bluetooth compatible, you can still connect using NFC by touching it to the camera's NFC point on the left side of the 6D Mark II, following these steps:

- 1. **Enable Wi-Fi/NFC.** In the 6D Mark II's Wi-Fi Settings screen, enable both Wi-Fi and NFC. If your smartphone requires enabling NFC, do that, too.
- 2. **Touch to camera.** Touch the NFC mark on the smartphone to the camera's NFC mark so they touch. Some phones that are NFC compatible do not have a mark; consult your device's manual to find the antenna location.
- 3. **Wait for connection notification.** The LCD monitor will tell you when a connection has been established. You can then move the smart device away from the camera.
- 4. **Camera Connect Launches.** Camera Connect will start on the smart device and establish a connection automatically. The first time you make a connection to a given device, a screen asking you to confirm the link appears. Select OK.

If your smart device does not have NFC or Bluetooth, you can still connect using Wi-Fi, following these steps:

- 1. **Choose Wi-Fi Function.** In the Wi-Fi Function screen shown in Figure 6.12, choose Connect to Smartphone, the center icon in the top row.
- 2. **Register Device.** Select Register Device for Connection, and choose Do Not Display from the next screen that appears. (I'm assuming you've already installed Camera Connect.)
- 3. **Check SSID and Password.** Check the SSID (choose Switch Network to change to a different network) and Password (if enabled).
- 4. **Select Camera.** In your operating system's Wi-Fi connection screen, select the SSID (network name) of the 6D Mark II (it will end in "_Canon0a").
- 5. **Launch Camera Connect.** While the Waiting to Connect message appears on the 6D Mark II's screen, start Camera Connect on the smart device. A Connect to this Smartphone message will appear on the camera's LCD monitor. Choose OK.
- 6. Use Camera Connect. You can now use Camera Connect's features.

Once you have successfully linked your camera and smart device, you can use the Camera Connect features shown in Figure 6.16. The main screen (at left in the figure) lets you view images residing on your camera's memory card, shoot remotely while previewing the camera's live view image (center), or make many camera settings (right).

Figure 6.16

Camera Connect
allows using your
smart device to view
images on your camera, remote control
shooting, and
changing many
camera settings.

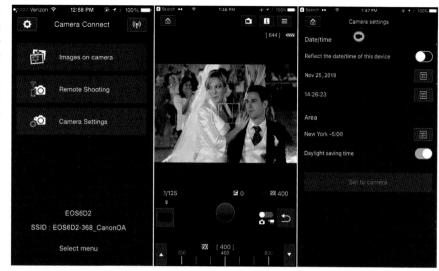

Geotagging

Geotagging is a way to associate the geographical location where the photographer was when a picture was taken with the actual photograph itself. Geotagging can also be done by attaching geographic information to the photo after it's already been taken. This is often done with online services that allow you to associate your uploaded photographs with a map, city, street address, or postal code. When properly geotagged and uploaded to compatible sites, users can browse through your photos using a map, finding pictures you've taken in a given area, or even searching through photos taken at the same location by other users.

You EOS 6D Mark II includes a built-in GPS receiver. It records locational data such as latitude, longitude, and altitude, and saves it to the EXIF metadata in your image files, where it can be retrieved by compatible software to plot to maps or inserted into your uploads to Flickr or other sites. You can even track your trajectory of movement with the receiver's logging function.

The 6D Mark II has GPS features integrated right into the body, located internally at the top of the camera body, near the accessory shoe. In most cases, its features are all you need for geotagging your photographs. The big advantages of the internal receiver are that you don't need to carry an extra piece of equipment, or remember to attach it when geotagging is wanted, or give up use of your camera's hot shoe for other accessories, including a flash. (While geotagging is generally performed outdoors, you still might want to use flash, if only for fill outside, when working with GPS.)

If your familiarity with GPS is limited to that gadget that sits atop your dashboard, you'll be pleasantly surprised at the things that a GPS-equipped camera can do with locational information. When active, the GPS system records the latitude and longitude of each location where a picture is snapped, the elevation, Coordinated Universal Time Code (UTC), and the satellite reception status.

This information is embedded in the EXIF metadata included in each photo, where it can be read and manipulated by compatible software. That includes Canon utilities, such as the Map Utility, Digital Photo Professional, and ImageBrowser EX programs; third-party image-editing software, including iPhoto for the Mac and the Map Module in Lightroom; and many photo-sharing sites that can display the location where each image was taken when you upload your pictures to an online album. Google Earth can also use your EXIF data.

You can view GPS data on the 6D Mark II's LCD monitor as you review images. Press the INFO. button until the view with a histogram appears, then scroll down using the multi-controller until you reach the screen shown at left in Figure 6.17. When the GPS is active, you can also view the information for your current location in the GPS menu, as I'll describe shortly. I often use this feature when I am traveling around and want to record a specific site that I want to return to later. I can view the latitude and longitude and enter them into my portable Garmin Etrex GPS, or the GPS in my car, and then return by accessing the data I've saved. While GPS data is most often used to pinpoint the shooting location of individual images, the receiver's logging function allows you to re-create the route you took in capturing those photos, thanks to the Canon Map Utility.

Using the Internal GPS Receiver

To activate your 6D Mark II's internal GPS receiver, just follow these steps:

- 1. **Navigate to the Set-up 4 menu and choose GPS Settings.** The screen shown in Figure 6.18 appears.
- 2. Set GPS mode. You can disable GPS here (to save power), or choose one of two modes:
 - Mode 1. When the camera is powered down, the GPS receiver still functions at intervals, keeping track of your location. That's useful if you'll be using GPS a lot during a shooting session and don't want to wait for the receiver to re-acquire GPS satellites (it can take valuable seconds or even minutes). The penalty is that the 6D Mark II draws power continually and your battery life is shortened. Carry plenty of extra batteries if you use this mode.
 - Mode 2. When you turn the camera off, GPS is turned off too and no longer drains power. However, if the camera goes to "sleep" due to your auto-power-off setting, the GPS will receive signals at intervals and draw some power. This mode uses less power than Mode 1, but gives you the option of shutting off the GPS when you know you won't be using it for a while, but not disabling it when your auto power off setting kicks in.
- 3. Choose time update. With the Auto time setting option, the 6D Mark II can use time data embedded in the GPS signal to set the camera's internal clock accurately. You can choose Auto Update to set the time automatically whenever the camera is powered up and GPS data is available; alternatively, you can completely disable this function, or Set Now to update immediately. The receiver must be able to link with at least five GPS satellites for the time function to operate; when activated, the time setting in your camera will maintain plus/minus one-second accuracy. (This feature is great for synchronizing several GPS-equipped cameras, especially when shooting and editing videos and still shots contemporaneously.)

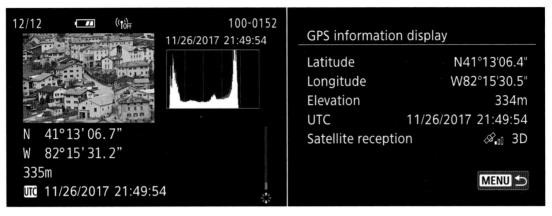

Figure 6.17 Display GPS information about an image (left) or your camera's current location (right).

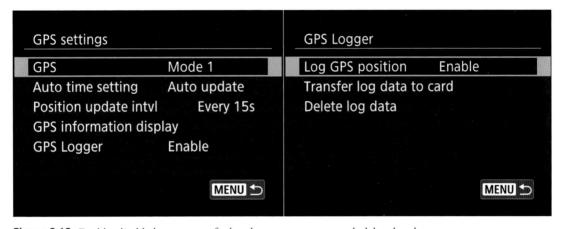

Figure 6.18 Enable, disable logger; transfer log data to a memory card; delete log data.

- 4. **Position update timing.** Use this to specify the interval the GPS device uses to update position information. Choose from every 1, 5, 10, 15, or 30 seconds, or every 1, 2, or 5 minutes. Select a shorter interval when you are moving and/or accuracy is critical, or a longer interval to save power, when GPS reception is not optimal, or you are shooting from one position for a longer period.
- 5. **GPS information display.** This entry simply displays a screen of current GPS information, including latitude, longitude, elevation, UTC time (essentially Greenwich Mean Time), and Satellite reception strength/status, as shown earlier in Figure 6.17, right.
- 6. **GPS logger.** Allows you to enable or disable tracking of GPS position data, transfer log data to your memory card for later manipulation by an appropriate software program, or to delete the camera's current GPS log. (See Figure 6.18.) Nature and wildlife photographers (now, *where* did

I photograph those rare flowers?), law enforcement personnel, business users, and anyone wandering through a strange city during a vacation will love the ability to track not only individual locations but the routes taken to get from one shooting spot to another.

Your Canon Map Utility, when connected to the Internet through your computer, can easily trace a path for you on a standard road map or satellite view (see Figure 6.19). The logger's NMEA-0813 format log file, which includes all the information for a single day's shooting, can be converted by the utility to a .KMZ file and uploaded to Google Earth, where it can be shared and viewed. A new log is created each day, or each time you change time zones. Depending on how often the position update timing is recorded (from every second to every five minutes), the 6D Mark II can store from less than a week to as much as 100 days' worth of data. However, you'll probably use the Transfer Log Data to Card option more often than that.

7. **Begin using GPS.** After a delay of about 30 to 60 seconds while the receiver connects to the optimum number of satellites, GPS functions will be activated, and remain so until you return to the menu to disable GPS features. If you turn the camera off, it will automatically re-acquire the satellites within a few seconds when it's powered up again, assuming that GPS reception is available at that location.

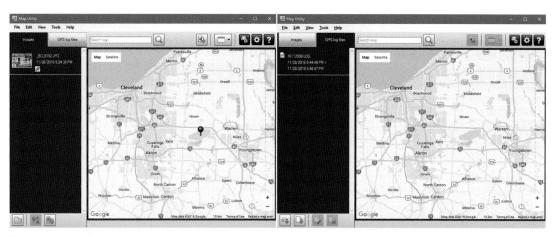

Figure 6.19 Canon's Map Utility can display the GPS data for an image (left), or show you the log data for a shooting session (right).

Choosing Your Lens Arsenal

The Canon EOS 6D Mark II is frequently purchased with a lens, often the upgraded Canon EF 24-105mm f/4L IS II USM lens introduced in August 2016. It has improved image stabilization, less vignetting in the corners, a 10-blade circular aperture with incredible bokeh (creamy background blur), and a coating that does a better job of reducing flare and ghost images.

However, you can also purchase the 6D Mark II in a body-only configuration, as I did, because advanced shooters and professionals are very likely buying the new model to replace an older camera, or adding an additional body to their kit. Because I was in replacement mode, I opted to get the body, and use it with the older version of the lens, shown in Figure 7.1. As you might expect, even the older "L" (luxury) optic is a remarkable performer. At this writing, both the old and new lens remain in the Canon line. The Mark II lens is priced \$100 higher at \$1,099, and I expect the original version will be phased out as quantities are depleted. Unless there are close-out discounts, most will choose the newer lens for such a slight price difference.

Figure 7.1
The Canon EF
24-105mm f/4 IS L
autofocus zoom
makes a good walkaround lens for the
6D Mark II.

Ti

Throughout this chapter, I'm going to use the current Canon manufacturer suggested list price (MSRP) when it's available. (I'll use the Canon store price if it's not.) You should know that many lenses are available for less at the Canon store for your country or at retailers, and that prices can (and will) change throughout the life of this book.

If you are switching to full frame and don't already own a lens compatible with your 6D Mark II, you can't go wrong with the 24-105mm optic. Many photographers, especially old-school film shooters, prefer working with prime lenses as much as they can, and may prefer a "normal" lens, like the EF 50mm f/1.4 USM (\$399 MSRP) or the sublime EF 50mm f/1.2L (\$1,349).

So, depending on which category you fall into, you'll need to make a decision about what lens to buy, or decide what other kind of lenses you need to fill out your complement of Canon optics. This section will cover "first lens" concerns, while later in the chapter we'll look at "add-on lens" considerations. When deciding on your initial lens purchases, there are several factors you'll want to consider:

- Cost. You might have stretched your budget a bit to purchase your 6D Mark II, so you might want to keep the cost of your add-on lenses fairly low. Fortunately, there are excellent lenses available that will add from \$100 to \$500 to the price of your camera if purchased at the same time.
- Zoom range. If you have only one lens, you'll want a fairly long zoom range to provide as much flexibility as possible. Fortunately, several of the most popular basic lenses for the 6D Mark II have 3X to 5X zoom ranges, extending from moderate wide-angle/normal out to medium telephoto. These are fine for everyday shooting, portraits, and some types of sports.
- Adequate maximum aperture. You'll want an f/stop of at least f/3.5 to f/4 for shooting under low-light conditions. The thing to watch for is the maximum aperture when the lens is zoomed to its telephoto end. You may end up with no better than an f/5.6 maximum aperture. That's not great, but you can often live with it.
- Image quality. Your starter lens should have good image quality, befitting a camera with 26 MP of resolution, because that's one of the primary factors that will be used to judge your photos.
- Size matters. A good walking-around lens is compact in size and light in weight. My favorite, the 24-105mm f/4 isn't tiny, but having it mounted on the camera most of the time isn't a burden, either. Considering its image quality and zoom range, I think it's worth every ounce.
- Fast/close focusing. Your first lens should have a speedy autofocus system (which is where the ultrasonic motor/USM or STM found in nearly all moderately priced lenses is an advantage). Close focusing (to 12 inches or closer) will let you use your basic lens for some types of macro photography.

You can find comparisons of the lenses discussed in the next section, as well as third-party lenses from Sigma, Tokina, Tamron, and other vendors, in online groups and websites. There are many excellent third-party optics, especially since Sigma introduced its top-notch Art and Sport lineup. Because of the sheer number of options, I'm going to concentrate on Canon lenses only, even though I own and use quite a few non-Canon lenses (with the aging, but capable, Sigma 15mm f/2.8 EX DG fisheye among my favorites). I'll provide my recommendations, but more information available from online sources is always helpful.

Buy Now, Expand Later

The 6D Mark II is commonly available with several good, basic lenses that each can serve you well as a "walk-around" lens (one you keep on the camera most of the time, especially when you're out and about without your camera bag). The number of options available to you is quite amazing, even if your budget is limited.

One important thing to keep in mind is that Canon has been producing EF lenses for a very long time, and some excellent lenses have been replaced with newer models, or dropped from the Canon lineup entirely. If you want to choose from the broadest variety of lenses at reduced prices, you definitely should consider buying gently used optics.

I highly recommend KEH Camera in Smyrna, Georgia, as a source for affordable used gear. I've purchased many lenses from their website (www.keh.com). Their prices may not be the lowest available, but you'll save significantly from the new price for the same lens, and the company is notorious for exceeding their own lens grading standards: the lenses I've purchased from them listed as Excellent were difficult to tell from new, and their "Bargain" optics often show only minor wear and near-perfect glass. For each lens you're considering, you can usually select from three or more different grades, plus choose lenses with or without hoods and/or front and rear caps. Because of the ready availability of used and discontinued lenses for Canon full-frame models, I'm going to cast a broad net when making my recommendations for lenses you should consider. Canon's best-bet first lenses are as follows:

- Canon EF 17-40mm f/4L USM lens. Not everyone needs a wide angle—to-medium telephoto lens, and this \$750 optic is perfect for those who tend to see the world from a wide-angle perspective. It provides a broader 104-degree field of view than your typical walk-around lens (which usually start at around 24mm), and zooms only to a near-normal 40mm. Its f/4 constant maximum aperture (it delivers f/4 at every zoom position) is large enough for much low-light shooting, particularly since it is sharp wide open. It focuses down to about 11 inches.
- Canon Zoom Wide-Angle-Telephoto EF 24-70mm f/2.8L II USM lens. I couldn't leave the latest version of this premium lens out of the mix, even though it costs \$1,899. As part of Canon's L-series line, it offers better sharpness over its focal range than many of the other lenses in this list. Best of all, it's fast (for a zoom), with an f/2.8 maximum aperture that doesn't change

as you zoom out. Unlike some other lenses, which may offer only an f/5.6 maximum f/stop at their longest zoom setting, this is another constant aperture lens, which retains its maximum f/stop. The added sharpness, constant aperture, and ultra-smooth USM motor are what you're paying for with this lens.

- Canon EF 24-85mm f/3.5-4.5 USM Autofocus Wide-Angle Telephoto Zoom lens. If you can get by with wide angle—to-short telephoto range, this older ("classic") consumer-grade lens might suit you. It can often be found used in the \$300 price range and offers a useful range of focal lengths.
- Canon EF 24-105mm f/4L IS USM Autofocus Wide-Angle Telephoto Zoom lens. This is the previous version, now replaced by the Mark II. It is still the first choice of many 6D Mark II owners at its new MSRP of \$999 (or even cheaper if bought in a kit), and is the closest you can come to a true do-everything zoom. Like the new lens, it focuses no closer than about 18 inches however, but at 3.3 × 4.2 inches and less than 24 ounces, it's compact and lightweight.
- Canon EF 28-105mm f/3.5-4.5 II USM Autofocus Wide-Angle Telephoto Zoom lens. Discontinued a few years ago, this lens is a little slower than its 28-105mm L-class counterpart, but it's priced roughly in the range of the 24-85mm lens mentioned earlier and offers more reach.
- Canon EF 28-135mm f/3.5-5.6 IS USM Image-Stabilized Autofocus Wide-Angle Telephoto Zoom lens. Image stabilization is especially useful at longer focal lengths, which makes this lens worth its \$480 price tag. Its big disadvantage is that it is *very* slow at 135mm, with a maximum aperture of f/5.6. (See Figure 7.2.)
- Canon EF 28-200mm f/3.5-5.6 USM Autofocus Wide-Angle Telephoto Zoom lens. If you want one affordable lens to do everything except ultra-wide-angle photography, this discontinued 7X zoom lens can be found used for around \$250.
- Canon EF 55-200mm f/4.5-5.6 II USM Telephoto Zoom lens. This one goes from normal to medium-long focal lengths. It features a desirable ultrasonic motor. Best of all, it's very affordable at an MSRP of \$349.
- Canon EF 40mm f/2.8 STM lens. This fairly fast prime lens (less than \$200) has the quiet STM motor, making it excellent as a wide/normal lens for video. But that's not why I bought it. I like this cheap lens as a "pancake" walk-around lens for unobtrusive street photography. (See Figure 7.3.)
- Canon EF 50mm f/1.8 STM lens. If a "normal" lens is not your cup of tea for everyday use, you can skip Canon's pricey f/1.4 and f/1.2 options. Instead, add that focal length to your kit with this low-cost \$125 lens for less than you might pay for a high-quality 77mm polarizing filter.

Figure 7.2 The Canon EF 28-135mm f/3.5-5.6 IS USM lens is compact, sharp, and inexpensive.

Figure 7.3 Another budget option is the Canon EF 40mm f/2.8 STM lens.

What Lenses Can You Use?

The previous section helped you sort out what lens you might want to buy with your 6D Mark II (assuming you already didn't own any Canon EF lenses). Now, you're probably wondering what lenses can be added to your growing collection (trust me, it will grow). You need to know which lenses are suitable and, most importantly, which lenses are fully compatible with your 6D Mark II.

With the Canon 6D Mark II, the compatibility issue is a simple one: It accepts any lens with the EF designation, with full availability of all autofocus, auto aperture, autoexposure, and image-stabilization features (if present). It's comforting to know that any EF lens will work as designed with your camera. You *cannot* use Canon EF-S lenses, or lenses from other vendors offered in EF-S or APS-C mounts. They won't fit on your camera at all.

But wait, there's more. You can also attach Canon F mount, Leica R, Olympus OM, and M42 ("Pentax screw mount") lenses with a simple adapter, if you don't mind losing automatic focus and aperture control. If you use one of these lenses, you'll need to focus manually (even if the lens

operates in Autofocus mode on the camera it was designed for), and adjust the f/stop to the aperture you want to use to take the picture. That means that lenses that don't have an aperture ring must be used only at their maximum aperture if you use them with a simple adapter. However, Novoflex makes expensive adapter rings (the Canon-Lens-on-Canon-Camera version is called EOS/NIK NT) with an integral aperture control that allows adjusting the aperture of lenses that do not have an old-style aperture ring. Expect to pay as much as \$225 or more for an adapter of this type.

Because of these limitations, you probably won't want to make extensive use of "foreign" lenses on your 6D Mark II, but an adapter can help you when you really, really need to use a particular focal length but don't have a suitable Canon-compatible lens. For example, I occasionally use an older 400mm lens that was originally designed for the Nikon line on my 6D Mark II. The lens needs to be mounted on a tripod for steadiness, anyway, so its slower operation isn't a major pain. Another good match is the 105mm Micro-Nikkor I sometimes use with my Canon 6D Mark II. Macro photos, too, are most often taken with the camera mounted on a tripod, and manual focus makes a lot of sense for fine-tuning focus and depth-of-field. Because of the contemplative nature of close-up photography, it's not much of an inconvenience to stop down to the "taking" aperture (photo jargon for the f/stop used to capture a picture) just before exposure.

The limitations on use of lenses within Canon's own product line (as well as lenses produced for earlier Canon SLRs by third-party vendors) are clear cut. The 6D Mark II cannot be used with any of Canon's earlier lens mounting schemes for its film cameras, including the immediate predecessor to the EF mount, the FD mount (introduced with the Canon F1 in 1964 and used until the Canon T60 in 1990), FL (1964–1971), or the original Canon R mount (1959–1964). While you'll find FD-to-EF adapters for about \$40, you'll lose so many functions that it's rarely worth the bother. Nor, as I noted, can you use EF-S lenses. (Don't even try.) That's really all you need to know.

In retrospect, the switch to the EF mount seems like a very good idea, as the initial EOS film cameras can now be seen as the beginning of Canon's rise to eventually become the leader in film and (later) digital SLR cameras. By completely revamping its lens mounting system, the company could take advantage of the latest advances in technology without compromise, incorporating new motorized autofocus technology (EF stands for "electro focus").

EF vs. EF-S

As I noted earlier, lenses with the EF-S designation cannot be used with your 6D Mark II. The EF-S (the S stands for "short back focus") mount has one important chief difference (as you might expect), with lens components that extend farther back into the camera body of some of Canon's latest non-full-frame digital cameras, such as the 7D Mark II, 80D, and digital Rebel models.

Canon's EF-S lens mount variation was born in 2003, when the company virtually invented the consumer-oriented digital SLR category by introducing the original EOS 300D/Digital Rebel, with the APS-C (16mm × 24mm) sensor size and 1.6X "crop" factor. With EF-S lenses, elements of

shorter focal length lenses (wide angles) can extend *into* the camera, space that was off limits in other models because the mirror passed through that territory as it flipped up to expose the shutter and sensor. (Canon even calls its flip-up reflector a "half mirror.")

In short (so to speak), the EF-S mount made it easier to design less-expensive wide-angle lenses that could be used *only* with 1.6X-crop cameras, and featured a simpler design and reduced coverage area suitable for those non-full-frame models. The new mount made it possible to produce lenses like the ultra-wide EF-S 10-22mm f/3.5-4.5 USM lens, which has the equivalent field of view as a 16-35mm zoom on a full-frame camera.

It's easy to tell an EF lens from an EF-S lens: The latter incorporates EF-S into their name! Plus, EF lenses have a raised red dot on the barrel that is used to align the lens with a matching dot on the camera when attaching the lens. EF-S lenses and compatible bodies use a white square instead. Some EF-S lenses also have a rubber ring at the attachment end that provides a bit of weather/dust sealing and protects the back components of the lens if a user attempts to mount it on a camera that is not EF-S compatible.

Ingredients of Canon's Alphanumeric Soup

The actual product names of individual Canon lenses are easy to decipher; they'll include either the EF or EF-S designation, the focal length or focal length range of the lens, its maximum aperture, and some other information. Additional data may be engraved or painted on the barrel or ring surrounding the front element of the lens, as shown in Figure 7.4.

Figure 7.4
Most of the key specifications of the lens are marked on the ring around the front element.

Here's a decoding of what the individual designations mean:

- **EF/EF-S.** If the lens is marked EF, it can safely be used on any Canon EOS camera, film or digital. If it is an EF-S lens, it should be used only on an EF-S-compatible camera.
- **Focal length.** Given in millimeters or a millimeter range, such as 60mm in the case of a popular Canon macro lens, or 24-105mm, used to describe a medium-wide to short-telephoto zoom.
- Maximum aperture. The largest f/stop available with a particular lens is given in a string of numbers that might seem confusing at first glance. For example, you might see 1:1.8 for a fixed-focal length (prime) lens, and 1:4.5-5.6 for a zoom. The initial 1: signifies that the f/stop given is actually a ratio or fraction (in regular notation, f/ replaces the 1:), which is why a 1:2 (or f/2) aperture is larger than a 1:4 (or f/4) aperture—just as 1/2 is larger than 1/4. With most zoom lenses, the maximum aperture changes as the lens is zoomed to the telephoto position, so a range is given instead: 1:4.5-5.6. (Some zooms, called constant aperture lenses, keep the same maximum aperture throughout their range.)
- Autofocus type. Many newer Canon lenses that aren't of the bargain-basement type use Canon's *ultrasonic motor* autofocus system (more on that later) and are given the USM designation. If USM does not appear on the lens or its model name, an older lens *may* use the less sophisticated AFD (arc-form drive) autofocus system or the micromotor (MM) drive mechanism. The newer STM designation indicates a stepper-motor drive, which is quieter and especially useful for video.
- Series. Canon adds a Roman numeral to many of its products to represent an updated model with the same focal length or focal length range, so some lenses will have a II or III added to their name. The revamped EF 24-70mm f/2.8L II USM lens is an example of a series update.
- **Pro quality.** Canon's more expensive lenses with more rugged construction and higher optical quality, intended for professional use, include the letter L (for "luxury") in their product name. You can further differentiate these lenses visually by a red ring around the lens barrel and the off-white color of the metal barrel itself in virtually all telephoto L-series lenses. (Some L-series lenses have shiny or textured black plastic exterior barrels.) Internally, every L lens includes at least one lens element that is built of ultra-low dispersion glass, is constructed of expensive fluorite crystal, or uses an expensive ground (not molded) aspheric (non-spherical) lens component.
- Filter size. You'll find the front lens filter thread diameter in millimeters included on the lens, preceded by a Ø symbol, as in Ø67 or Ø77. One advantage of Canon's L lenses is that many of them use 77mm filters, so you don't have to purchase a new set (or step-up/step-down adapter rings) each time you buy a lens.
- Special-purpose lenses. Some Canon lenses are designed for specific types of work, and they include appropriate designations in their names. For example, close-focusing lenses incorporate the word *Macro* into their name. Lenses with perspective control features preface the lens name with T-SE (for tilt-shift). Lenses with built-in image-stabilization features, such as the nifty EF 28-300mm f/3.5-5.6L IS USM Telephoto Zoom include *IS* in their product names.

SORTING THE MOTOR DRIVES

Incorporating the autofocus motor inside the lens was an innovative move by Canon, and this allowed the company to produce better and more sophisticated lenses as technology became available to upgrade the focusing system. As a result, you'll find four different types of motors in Canon-designed lenses, each with cost and practical considerations.

- AFD (Arc-form drive) and Micromotor (MM) drives are built around tiny versions of electromagnetic motors, which generally use gear trains to produce the motion needed to adjust the focus of the lens. Both are slow, noisy, and not particularly effective with larger lenses. Manual focus adjustments are possible only when the motor drive is disengaged.
- Micromotor ultrasonic motor (USM) drives use high-frequency vibration to produce the motion used to drive the gear train, resulting in a quieter operating system at a cost that's not much more than that of electromagnetic motor drives. With the exception of a couple of lenses that have a slipping clutch mechanism, manual focus with this kind of system is possible only when the motor drive is switched off and the lens is set in Manual mode. This is the kind of USM system you'll find in lower-cost lenses.
- Ring ultrasonic motor (USM) drives, available in two different types (*electronic focus ring USM* and *ring USM*), also use high-frequency movement, but generate motion using a pair of vibrating metal rings to adjust focus. Both variations allow a feature called Full Time Manual (FTM) focus, which lets you make manual adjustments to the lens's focus even when the autofocus mechanism is engaged. With electronic focus ring USM, manual focus is possible only when the lens is mounted on the camera and the camera is turned on; the focus ring of lenses with ring USM can be turned at any time.
- Stepper motor (STM) drives. In autofocus mode, the precision motor of STM lenses, along with a new aperture mechanism, allows lenses equipped with this technology to focus quickly, accurately, silently, and with smooth continuous increments. If you think about video capture, you can see how these advantages pay off. Silent operation is a plus, especially when noise from autofocusing can easily be transferred to the camera's built-in microphones through the air or transmitted through the body itself. In addition, because autofocus is often done *during* capture, it's important that the focus increments are continuous. USM motors are not as smooth, but are better at jumping quickly to the exact focus point. You can adjust focus manually, using a focus-by-wire process. As you rotate the focus ring, that action doesn't move the lens elements; instead, your rotation of the ring sends a signal to the motor to change the focus.

More Interesting Optics

There are lots of interesting lenses that belong in your camera bag, and this chapter wouldn't be complete without me mentioning some of them. The next sections will give you a quick summary of some potential objects of your Lens Lust.

The Magic Three

If you cruise the forums, you'll find the same three lenses mentioned over and over, often referred to as "The Trinity," "The Magic Three," or some other affectionate nickname. They are the three lenses you'll find in the kit of just about every serious Canon photographer (including me). They're fast, expensive, heavier than you might expect, and provide such exquisite image quality that once you equip yourself with the Trinity, you'll never be happy with anything else.

There are actually dual versions of each focal length, and I've arbitrarily divided them into two groups, the (relatively) affordable versions, and the deluxe, top-of-the-line trio.

The Affordable Magic Three

Neither lens trio is cheap, but these three lenses carry relatively reasonable price tags for anyone with the means to spring for a camera like the 6D Mark II. All of them share several attributes. All are full-frame L-series lenses; all have f/4 maximum apertures; and they each cost up to half the price of their top-of-the-line stablemates.

- EF 17-40mm f/4L USM lens. I recommended this lens earlier as a "kit" lens for wide-angle shooters because of its moderate \$799 price tag, but it can be an integral part of anyone's three-lens kit. When I am shooting landscapes, doing street photography, or some types of indoor sports, this lens can go on my 6D Mark II and never come off. The lens is slower than its top-line equivalent, but provides a useful focal length range, and accepts 77mm filters (use thin filters to avoid vignetting at the 17mm setting).
- EF 24-70mm f/4L IS USM lens. The f/4 maximum aperture of this \$899 lens isn't truly a handicap, because it includes image stabilization, and Canon's f/2.8 version does not. That makes them roughly equivalent for hand-held photography of subjects that aren't moving (and when you don't need the reduced depth-of-field of an f/2.8 aperture). This lens is wonderfully sharp, and well-suited for anything from sports to portraiture that falls within its focal length range. I know many photographers who aren't heavily into landscapes who use this lens as their main lens. It focuses down to 1.25 feet, so you can get decent magnification by moving close to your subjects at 70mm.

■ EF 70-200mm f/4L IS USM lens. Canon offers no fewer than four 70-200mm zooms, and this \$1,099 version is your best bet among the affordable alternatives. While you can also choose one of two others with an f/4 and f/2.8 maximum aperture (for \$599 and \$1,249, respectively), neither have image stabilization. Unless you absolutely must have the largest possible maximum aperture (or need to save some bucks), this one is the best overall choice. It is perfect for some indoor and many outdoor sports, on a monopod, or hand-held, and can be used for portraiture, street photography, wildlife (especially with the 1.4X teleconverter), and even distant scenics. I use it for concerts, too, alternating between this lens and my 85mm f/1.2. It takes me in close to the performer, and can be used wide-open or at f/5.6 with good image quality. Its chief drawbacks are that it focuses only down to about 4 feet, and uses 67mm filters.

The Reigning Magic Three

If you have around \$6,500 burning a hole in your pocket, you can purchase the top tier of the Canon line. If their 6.6-pound heft seems like a lot (the 6D Mark II itself weighs less than a third as much), remember that this trio of lenses embraces every focal length from 16mm to 200mm, with maximum apertures of f/2.8 over the full range. The deluxe lineup looks like this:

- EF 16-35mm f/2.8L III USM lens. The image quality of this \$2,199 lens is incredible, with very low barrel distortion (outward bowing at the edges) and very little of the chromatic aberrations common to lenses this wide. It focuses down to about 11 inches, allowing for some interesting close-up/wide-angle effects. The downside? The outward-curving front element requires the use of large, expensive, 82mm filters—of course, as the use of polarizers, in particular, would be problematic at wider focal lengths. The polarizing effect would be highly variable because of this lens's extremely wide field of view.
- EF 24-70mm f/2.8 II USM lens. This lens, at \$1,899 MSRP, provides outstanding image quality thanks to its single Super UD lens element paired with two UD elements to minimize chromatic aberrations. But if you have the cash and opportunity to purchase this newer lens, you won't be making a mistake. Some were surprised when it was introduced without the IS feature, but Canon has kept the size of this useful lens down, while maintaining a reasonable price for a "pro" level lens. It's another lens that uses 82mm filters, so if you own the 16-35mm optic, too, your filters can do double duty.
- EF 70-200mm f/2.8L IS USM lens. This is my all-time favorite Canon lens. I'm a telephoto/selective focus kind of shooter, and if I could afford only one Magic Three lens, this (roughly) \$2,000 lens would be the one I would get. There's an older version, also with IS, for less, and, as I mentioned earlier, an f/2.8 version with no stabilization at all. But of Canon's three 70-200mm f/2.8 lenses (which all take 77mm filters), this one is the sharpest, focuses the fastest and closest, and is more ruggedly built. You might end up making this your workhorse, as I have.

More Winners

Although all the five or six dozen readily available Canon lenses are beyond the scope of this book, the company makes a variety of other interesting lenses. Here are some of my favorites.

- EF 8-15mm f/4L Fisheye USM lens. Yup, a fisheye zoom. I was enamored of a Tokina (nee Pentax) 10-17mm fisheye zoom for APS-C cameras for a long time, but it wasn't particularly sharp and had chromatic aberrations that wouldn't quit. For a mere \$1,249 you can buy the coolest lens you own, and start capturing some mind-bending images, or just add some interest to a simple landscape shot, like the one in Figure 7.5.
- EF 100-400mm f/4.5-5.6L II USM lens. A 400mm lens really comes in handy when shooting field sports, wildlife, and other distant subjects. This \$2,199 lens is long enough and fast enough to prove useful in a variety of demanding situations. And, it's a lot more affordable than Canon's "exotic" lenses in this range, such as the EF 400mm f/2.8L II USM lens (\$9,999). Although, at three pounds, this lens isn't really the boat anchor you might think it is; you'll want to mount it on a sturdy tripod (for wildlife) or monopod (for sports) to get the sharpest images.

Figure 7.5 Because lines at the center of the frame aren't bent, some fisheye shots don't look like fisheye images on first glance.

- EF 85mm f/1.2L II USM lens. This exquisite lens is the perfect optic for head-and-shoulders portraits, with its remarkable bokeh, excellent sharpness, and shallow depth-of-field for selective focus effects. The \$1,999 MSRP lens's huge maximum aperture means you can hand-hold it for sports, portraits, or other types of shooting.
- EF 85mm f/1.4L IS USM. Introduced in August 2017, this is the first Canon EF 85mm lens to feature image stabilization, providing up to four stops of shake correction. The \$1,600 lens uses one large diameter precision molded glass aspherical lens and a new anti-flare coating. Compared to the older f/1.2 version, the new lens appears to be sharper wide open and has comparable bokeh. Many photographers may be willing to give up the f/1.2 version's slight maximum aperture advantage for the all-new design and slightly lower price.
- Extender EF 1.4X III lens. This focal-length multiplier is almost a must for anyone owning one of Canon's 70-200mm f/2.8 lenses. It transforms your workhorse into a 98-280mm f/4 lens with virtually no loss in sharpness, for about \$429. It performs the same magic with any other compatible lens, too. Canon also offers a 2X extender for the same price, but this one is the most "transparent" in use, so to speak.
- TS-E 90mm f/2.8 lens (or any other tilt-shift lens). Manual focus won't bother you with this lens, because the most exciting capability of any tilt-shift lens is to let you manipulate the plane of focus in useful and/or interesting ways. Whether you want to correct the focal plane for architectural images, create "miniature" special effects, or produce unusual selective focus in portraits, these lenses offer interesting capabilities. The 90mm f/2.8 optic at \$1,399 is relatively affordable, but Canon also offers 17mm, 24mm, and 45mm TS-E lenses for around \$1,399 to \$2,149.
 - In August 2017, Canon introduced three additional tilt-shift lenses: the TS-E 50mm F2.8L Macro, TS-E 90mm F2.8L Macro, and TS-E 135mm F4L Macro optics, each priced at a whopping \$2,200. They include molded aspherical glass and UD elements for better sharpness at the edges, two anti-reflective coatings to reduce flare and ghosting, and larger, more convenient controls.
- A macro. Canon offers an assortment of full-frame macro lenses, priced at less than \$400 to less than \$1,399, including the unique MP-E 65mm f/2.8 1-5X macro for close-up use only (it doesn't focus to infinity). All are non-zooms and they range in focal length from 50mm to 180mm, and one (the EF 100mm f/2.8L Macro IS USM) includes image stabilization for handheld work. Choose your lens based on how close you want to work from your subject, and their closest focusing distance. Everybody needs a macro, especially for a rainy day when you want to photograph your collection of salt-shakers rather than venture out into the elements.

■ Super-bargain telephoto. Canon makes several inexpensive telephoto zooms, but for my money, the super-bargain of the line is the EF 75-300mm f/4-5.6 III, shown in Figure 7.6. Its strongest feature is its price: \$199, which makes it irresistible to those who feel they have little need for a tele zoom (because they use prime lenses or wide angles for most of their work), but would like to have one in their kit for occasional sports or casual wildlife photography. You don't get image stabilization, but the lens weighs just over one pound and focuses down to 4.9 feet. The f/5.6 maximum aperture at 300mm is only about a stop slower than many more expensive lenses with a similar range. The main quirk is that the lens gets longer—by quite a bit—as you zoom and focus, as you can see at right in the figure. It uses that low-end Micromotor focus mechanism I mentioned earlier, so don't expect lightning-fast focus. Still, it's reasonably sharp and on a dollars-per-millimeter of focal length basis, it's inexpensive.

Figure 7.6 An inexpensive telephoto zoom alternative (left) that gets longer as you zoom out (right).

Making Light Work for You

Successful photographers and artists have an intimate understanding of the importance of light in shaping an image. The photographer may have little or no control over the subject (other than posing human subjects) but can often adjust both viewing angle *and* the nature of the light source to create a compelling image. The direction and intensity of the light sources create the shapes and textures that we see. The distribution and proportions determine the contrast and tonal values: whether the image is stark or high key, or muted and low in contrast. The colors of the light (because even "white" light has a color balance that the sensor can detect), and how much of those colors the subject reflects or absorbs, paint the hues visible in the image.

This chapter introduces using *continuous* lighting (such as daylight, incandescent, or fluorescent sources) for those who have rarely used auxiliary lights. More advanced photographers can skim through this chapter quickly, and move ahead to the discussion of electronic flash in the two chapters that follow this one.

Continuous Illumination versus Electronic Flash

Continuous lighting is exactly what you might think: uninterrupted illumination that is available all the time during a shooting session. Daylight, moonlight, and the artificial lighting encountered both indoors and outdoors count as continuous light sources (although all of them can be "interrupted" by passing clouds, solar eclipses, a blown fuse, or simply by switching a lamp off). Indoor continuous illumination includes both the lights that are there already (such as incandescent lamps or overhead fluorescent lights indoors) and fixtures you supply yourself, including photoflood lamps or reflectors used to bounce existing light onto your subject.

Electronic flash is notable because it can be much more intense than continuous lighting, lasts only a moment, and can be much more portable than supplementary incandescent sources. It's a light source you can carry with you and use anywhere. There are advantages and disadvantages to each type of illumination. Here's a quick checklist of pros and cons:

- Lighting preview—Pro: continuous lighting. With continuous lighting, you always know exactly what kind of lighting effect you're going to get and, if multiple lights are used, how they will interact with each other, even if the illumination is subtle, as you can see in Figure 8.1.
- Lighting preview—Con: electronic flash. With electronic flash, the general effect you're going to see may be a mystery until you've built some experience, and you may need to review a shot on the LCD monitor, make some adjustments, and then reshoot to get the look you want. An image like the one in Figure 8.1 would have been difficult to achieve with an off-camera battery-powered flash unit, because it would be tricky to preview exactly how the shadows would fall without a true continuous modeling light.

Figure 8.1
You always know how the lighting will look when using continuous illumination.

- Exposure calculation—Pro: continuous lighting. Your 6D Mark II has no problem calculating exposure for continuous lighting, because it remains constant and can be measured through the exposure sensor that interprets the light reaching the viewfinder (or, when using live view, the sensor). The amount of light available just before the exposure will, in almost all cases, be the same amount of light present when the shutter is released. The 6D Mark II's Spot metering mode can be used to measure and compare the proportions of light in the highlights and shadows, so you can make an adjustment (such as using more or less fill light) if necessary. You can even use a hand-held light meter to measure the light yourself.
- Exposure calculation—Con: electronic flash. Electronic flash illumination doesn't exist until the flash fires, and so can't be measured by the 6D Mark II's sensors at the moment of exposure. Instead, the light must be measured by metering the intensity of a *pre-flash* triggered an instant before the main flash, as it is reflected back to the camera and through the lens. A less attractive alternative, available with higher-end Canon flash units like the Speedlite 600EX II-RT, is to use a sensor built into the external flash itself and measure reflected light that bounces back, but which has not traveled through the lens. If you have a do-it-yourself bent, there are hand-held flash meters, too, including models that measure both flash and continuous light, so you need only one meter for both types of illumination.
- Evenness of illumination—Pro/con: continuous lighting. Of the continuous light sources, daylight, in particular, provides illumination that tends to fill an image completely, lighting up the foreground, background, and your subject almost equally. Shadows do come into play, of course, so you might need to use reflectors or fill-in additional light sources to even out the illumination further. But, barring objects that block large sections of your image from daylight, the light is spread fairly evenly. Indoors, however, continuous lighting is commonly less evenly distributed. The average living room, for example, has hot spots near the lamps and overhead lights, and dark corners located farther from those light sources. But on the plus side, you can easily see this uneven illumination and compensate with additional lamps.
- Evenness of illumination—Con: electronic flash. Electronic flash units, like continuous light sources such as lamps that don't have the advantage of being located 93 million miles from the subject, suffer from the effects of their proximity. The *inverse square law*, first applied to both gravity and light by Sir Isaac Newton, dictates that as a light source's distance increases from the subject, the amount of light reaching the subject falls off proportionately to the square of the distance. In plain English, that means that a flash or lamp that's 12 feet away from a subject provides only one-quarter as much illumination as a source that's 6 feet away (rather than half as much). (See Figure 8.2.) This translates into relatively shallow "depth-of-light."
- Action stopping—Pro: electronic flash. When it comes to the ability to freeze moving objects in their tracks, the advantage goes to electronic flash. The brief duration of electronic flash serves as a very high "shutter speed" when the flash is the main or only source of illumination for the photo. Your 6D Mark II's shutter speed may be set for 1/180th second during a flash

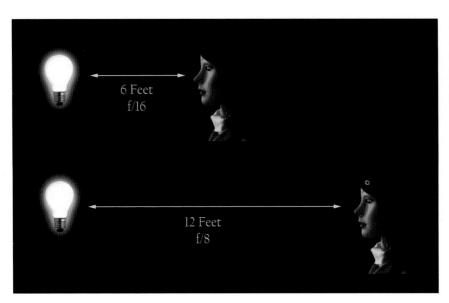

Figure 8.2
A light source that is twice as far away provides only one-quarter as much illumination.

exposure, but if the flash illumination predominates, the *effective* exposure time will be the 1/1,000th to 1/50,000th second or less duration of the flash, as you can see in Figure 8.3, because the flash unit reduces the amount of light released by cutting short the duration of the flash. The only fly in the ointment is that, if the ambient light is strong enough, it may produce a secondary, "ghost" exposure, as I'll explain later in this chapter.

- Action stopping—Con: continuous lighting. Action stopping with continuous light sources is completely dependent on the shutter speed you've dialed in on the camera. And the speeds available are dependent on the amount of light available and your ISO sensitivity setting. Outdoors in daylight, there will probably be enough sunlight to let you shoot at 1/2,000th second and f/6.3 with a non-grainy sensitivity setting for your 6D Mark II of ISO 400. That's a useful combination of settings if you're not using a super-telephoto with a small maximum aperture. But inside, the reduced illumination quickly has you pushing your 6D Mark II to its limits. For example, if you're shooting indoor sports, there probably won't be enough available light to allow you to use a 1/2,000th second shutter speed (although I routinely shoot non-flash indoor basketball with my 6D Mark II at ISO 1600 and 1/500th second at f/4). But in many indoor sports situations, the lack of available light, and the 6D Mark II's increased visual noise at settings of ISO 6400 and above, you may find yourself limited to 1/500th second or slower.
- Cost—Pro: continuous lighting. Incandescent or fluorescent lamps are generally much less expensive than electronic flash units, which can easily cost several hundred dollars. I've used everything from desktop high-intensity lamps to reflector flood lights for continuous illumination at very little cost. There are lamps made especially for photographic purposes, too. Maintenance is economical, too: many incandescent, LED, or fluorescents use bulbs that cost only a few dollars.

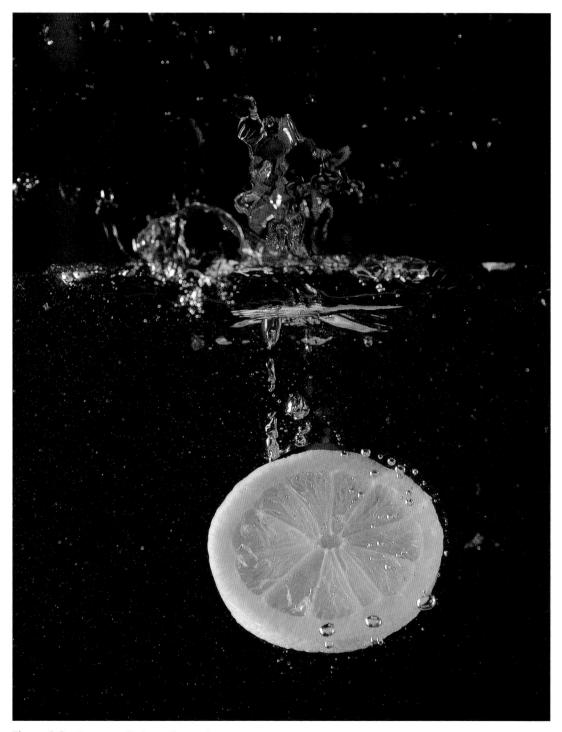

Figure 8.3 Electronic flash can freeze almost any action.

- Cost—Con: electronic flash. Electronic flash units aren't particularly cheap. The lowest-cost dedicated flash designed specifically for the Canon dSLRs is about \$150, and is probably not one that will be favored by many 6D Mark II owners. Such units are limited in features, however, and intended for those with entry-level cameras. Plan on spending some money to get the features that a sophisticated electronic flash offers. I paid more than \$600 for my 600EX II-RT, and only a little less for its "mate," a 580EX II that I purchased a couple years ago. I've got nearly \$1,000 sunk into just two battery-operated strobes, and also invested that much—and more—in studio flash units.
- Flexibility—Pro: electronic flash. Electronic flash's action-freezing power allows you to work without a tripod in the studio (and elsewhere), adding flexibility and speed when choosing angles and positions. Flash units can be easily filtered, and, because the filtration is placed over the light source rather than the lens, you don't need to use high-quality filter material. For example, Roscoe or Lee lighting gels, which may be too flimsy to use in front of the lens, can be mounted or taped in front of your flash with ease.
- Flexibility—Con: continuous lighting. Because incandescent and fluorescent lamps are not as bright as electronic flash, the slower shutter speeds required (see "Action stopping," above) mean that you may have to use a tripod more often, especially when shooting portraits. The incandescent variety of continuous lighting gets hot, especially in the studio, and the side effects range from discomfort (for your human models) to disintegration (if you happen to be shooting perishable foods like ice cream). The heat also makes it more difficult to add filtration to incandescent sources.

Continuous Lighting Basics

While continuous lighting and its effects are generally much easier to visualize and use than electronic flash, there are some factors you need to consider, particularly the color temperature of the light, how accurately a given form of illumination reproduces colors (we've all seen the ghastly looks human faces assume under mercury-vapor lamps outdoors), and other considerations.

One important aspect is color temperature. Of course, color temperature concerns aren't exclusive to continuous light sources, but the variations tend to be more extreme and less predictable than those of electronic flash, which output relatively consistent daylight-like illumination.

Living with Color Temperature

In practical terms, color temperature is how "bluish" or how "reddish" the light appears to be to the digital camera's sensor. Indoor illumination is quite warm, comparatively, and appears reddish to the sensor. Daylight, in contrast, seems much bluer to the sensor. Our eyes (our brains, actually) are quite adaptable to these variations, so white objects don't appear to have an orange tinge when viewed indoors, nor do they seem excessively blue outdoors in full daylight. Yet, these color

temperature variations are real and the sensor is not fooled. To capture the most accurate colors, we need to take the color temperature into account in setting the color balance (or *white balance*) of the 6D Mark II—either automatically using the camera's intelligence or manually using our own knowledge and experience.

While Canon has been valiant in its efforts to smarten up the 6D Mark II's ability to adjust for color balance automatically, an entire cottage industry has developed to provide us additional help, including gadgets like the ExpoDisc filter/caps (see Figure 8.4) and their ilk (www.expoimaging.com), which allow the camera's add-on external custom white balance measuring feature to evaluate the illumi-

Figure 8.4 The ExpoDisc is placed on a lens and used as a neutral subject for measuring white balance.

nation that passes through the disc/cap/filter/Pringle's can lid, or whatever neutral-color substitute you employ. (A white or gray card also works.) Unfortunately, to help us tangle with the many different types of non-incandescent/non-daylight sources, Canon has provided the 6D Mark II with only a single White Fluorescent setting (some competing models offer more than a half-dozen different presets for fluorescents, sodium-vapor, and mercury vapor illumination). When it comes to zeroing in on the exact color temperature for a scene, your main tools will be custom white balances set using neutral targets like the ExpoDisc, and adjustment of RAW files when you import photos into your image editor.

The only time you need to think in terms of actual color temperature is when you're making adjustments using the Color Temp. setting in the White Balance entry, as I'll describe in Chapter 11. It allows you to dial in exact color temperatures, if known. You can also shift and bias color balance along the blue/amber and magenta/green axes, and bracket white balance.

In most cases, however, the Auto setting in the Shooting menu's White Balance entry will do a good job of calculating white balance for you. Auto can be used as your choice most of the time. Use the preset values or set a custom white balance that matches the current shooting conditions when you need to.

Remember that if you shoot RAW, you can specify the white balance of your image when you import it into Photoshop, Photoshop Elements, or another image editor using Adobe Camera Raw, or your preferred RAW converter. While color-balancing filters that fit on the front of the lens exist, they are primarily useful for film cameras, because film's color balance can't be tweaked as extensively as that of a sensor.

White Balance Bracketing

When using WB bracketing, the 6D Mark II takes a single shot, and then saves multiple JPEG copies, each with a different color balance. It's not necessary to capture multiple shots, as the camera uses the raw information retrieved from the sensor for the single exposure and then processes it to generate the multiple different versions. The bracketing adjustments are made only on the amber/blue axis (no bracketing in the magenta/green bias is possible), but you can select whether the bracketed shots are spread in the blue *or* amber directions (that is, each one bluer/less blue or yellower/less yellow) or balanced to provide both blue- and amber-oriented brackets.

Making these adjustments are the only times you're likely to be confused by a seeming contradiction in how color temperatures are named: warmer (more reddish) color temperatures (measured in degrees Kelvin) are the *lower* numbers, while cooler (bluer) color temperatures are *higher* numbers. It might not make sense to say that 3,400K is warmer than 6,000K, but that's the way it is. If it helps, think of a glowing red ember contrasted with a white-hot welder's torch, rather than fire and ice.

The confusion comes from physics. Scientists calculate color temperature from the light emitted by a mythical object called a black body radiator, which absorbs all the radiant energy that strikes it, and reflects none at all. Such a black body not only *absorbs* light perfectly, but it *emits* it perfectly when heated (and since nothing in the universe is perfect, that makes it mythical).

At a particular physical temperature, this imaginary object always emits light of the same wavelength or color. That makes it possible to define color temperature in terms of actual temperature in degrees on the Kelvin scale that scientists use. Incandescent light, for example, typically has a color temperature of 3,200K to 3,400K. Daylight might range from 5,500K to 6,000K. Each type of illumination we use for photography has its own color temperature range—with some cautions.

Daylight

Daylight is produced by the sun, and so is moonlight (which is just reflected sunlight). Daylight is present, of course, even when you can't see the sun. When sunlight is direct, it can be bright and harsh. If daylight is diffused by clouds, softened by bouncing off objects such as walls or your photo reflectors, or filtered by shade, it can be much dimmer and less contrasty.

Daylight's color temperature can vary quite widely. It is highest in temperature (most blue) at noon when the sun is directly overhead, because the light is traveling through a minimum amount of the filtering layer we call the atmosphere. The color temperature at high noon may be 6,000K. At other times of day, the sun is lower in the sky and the particles in the air provide a filtering effect that warms the illumination to about 5,500K for most of the day. Starting an hour before dusk and for an hour after sunrise, the warm appearance of the sunlight is even visible to our eyes when the color temperature may dip to 5,000K–4,500K, as shown in Figure 8.5.

Because you'll be taking so many photos in daylight, you'll want to learn how to use or compensate for the brightness and contrast of sunlight, as well as how to deal with its color temperature. I'll provide some hints later in this chapter.

Incandescent/Tungsten Light

The term incandescent or tungsten illumination is usually applied to the direct descendants of Thomas Edison's original electric lamp. Such lights consist of a glass bulb that contains a vacuum, or is filled with a halogen gas, and contains a tungsten filament that is heated by an electrical current, producing photons and heat. Tungsten-halogen lamps are a variation on the basic lightbulb, using a more rugged (and longer-lasting) filament that can be heated to a higher temperature, housed in a thicker glass or quartz envelope, and filled with iodine or bromine ("halogen") gases. The higher temperature allows tungsten-halogen (or quartz-halogen/quartz-iodine, depending on their construction) lamps to burn "hotter" and whiter.

Fluorescent Light/Other Light Sources

Fluorescent light has some advantages in terms of illumination, but some disadvantages from a photographic standpoint, including compact fluorescent lights (CFLs). This type of lamp generates light through an electro-chemical reaction that emits most of its energy as visible light, rather than heat, which is why the bulbs don't get as hot. The type of light produced varies depending on the phosphor coatings and type of gas in the tube. So, the illumination fluorescent bulbs produce can vary widely in its characteristics.

That's not great news for photographers. Different types of lamps have different "color temperatures" that can't be precisely measured in degrees Kelvin, because the light isn't produced by heating. Worse, fluorescent lamps have a discontinuous spectrum of light that can have some colors missing entirely. A particular type of tube can lack certain shades of red or other colors (see Figure 8.6), which is why fluorescent lamps and other alternative technologies such as sodium-vapor illumination can produce ghastly looking human skin tones. Their spectra can lack the reddish tones we associate with healthy skin and emphasize the blues and greens popular in horror movies.

Today, LED illumination is rapidly gaining favor over all other types of non-flash artificial illumination, and will continue to do so as prices drop. LED lamps often have more accurate color renditions, some types are easily dimmable, and can readily be powered by rechargeable batteries instead of AC. Because of their compact size, LED lights can be produced in novel, extra-useful form factors. Figure 8.7 shows a Lume Cube mounted on my 6D. It's a compact LED light source with four different power levels that make it handy as a video light, fill light, or even a main light in darkened locations. The Lume Cube is rechargeable and operates underwater (so you can use it with a submersible rig or your watertight point-and-shoot or action camera). The \$80 device can function as a "flash" to emit a brief burst of light that can also trigger additional Lume Cubes.

Figure 8.6 The uncorrected fluorescent lighting in the gym added a distinct greenish cast to this image when exposed with a daylight white balance setting.

Figure 8.7 The Lume Cube is a versatile LED light source.

Electronic Flash Basics

Until you delve into the situation deeply enough, it might appear that serious photographers have a love/hate relationship with electronic flash. You'll often hear that flash photography is less natural looking, and that the built-in flash in most cameras should never be used as the primary source of illumination because it provides a harsh, garish look. In truth, however, the bias is against *bad* flash photography, the kind produced when you clamp a flash on top of the camera (as shown in Figure 9.1) and point it directly at your subject.

Figure 9.1
An add-on flash is a versatile accessory when used correctly.

In that mode, you'll often end up with well-exposed (thanks to Canon's e-TTL II metering system), but *harshly lit* images. Yet, in other configurations, flash has become the studio light source of choice for pro photographers, because it's more intense (and its intensity can be varied to order by the photographer), freezes action, frees you from using a tripod (unless you want to use one to lock down a composition), and has a snappy, consistent light quality that matches daylight. (While color balance changes as the flash duration shortens, some Canon flash units can communicate to the camera the exact white balance provided for that shot.) And even pros will cede that an external flash has some important uses as an adjunct to existing light, particularly to illuminate dark shadows using a technique called *fill flash*. Moreover, creative photographers can use an external Speedlite with their 6D Mark II in remarkably creative ways, especially in wireless and multiple flash modes (which I'll explain in Chapter 10).

But electronic flash isn't as inherently easy to use as continuous lighting. As I noted in Chapter 8, electronic flash units are more expensive, don't show you exactly what the lighting effect will be (unless you use a second, relatively continuous source called a *modeling light* for a preview), and the exposure of electronic flash units is more difficult to calculate accurately.

How Electronic Flash Works

The bursts of light we call electronic flash are produced by a flash of photons generated by an electrical charge that is accumulated in a component called a *capacitor* and then directed through a glass tube containing xenon gas, which absorbs the energy and emits the brief flash. For a typical external flash attached to the EOS 6D Mark II, such as the top-of-the-line Speedlite 600EX II-RT, the full burst of light lasts about 1/1,000th of a second and provides enough illumination to shoot a subject 12 feet away at f/16 using the ISO 100 setting.

Because the duration of the burst is so brief, if the external flash is the main source of illumination, the effective exposure time is short, typically 1/1,000th to 1/50,000th second, freezing a moving subject dramatically, as shown in Figure 9.2. These short bursts can also be repeated, producing multiple-exposure/stroboscopic effects, as described later in this chapter.

An electronic flash is triggered at the instant of exposure, during a period when the sensor is fully exposed by the shutter. The 6D Mark II has a vertically traveling shutter that consists of two curtains. The first curtain opens and moves to the opposite side of the frame, at which point the shutter is completely open. The flash can be triggered at this point (so-called *first-curtain sync*), making the flash exposure. Then, after a delay that can vary from 30 seconds to 1/180th second (with the EOS 6D Mark II; other cameras may sync at a faster or slower speed), a second curtain begins moving across the sensor plane, covering up the sensor again. If the flash is triggered just before the second curtain starts to close, then *second-curtain sync* is used. In both cases, though, a shutter speed of 1/180th second is the maximum that can be used to take a photo (unless you're using high-speed sync, discussed later in this chapter).

Figure 9.2 An external flash placed to the left produced a brief burst that froze this lime in mid-fall.

Figure 9.3
A focal plane shutter has two curtains, the upper, or first curtain, and a lower, second curtain.

Figure 9.3 illustrates how this works. At upper left, you can see a fanciful illustration of a generic shutter (your EOS 6D Mark II's shutter does *not* look like this), with both curtains tightly closed. At upper right, the first curtain begins to move downward, starting to expose a narrow slit that reveals the sensor behind the shutter. At lower left, the first curtain moves downward farther until, as you can see at lower right in the figure, the sensor is fully exposed.

When first-curtain sync is used, the flash is triggered at the instant that the sensor is completely exposed. The shutter then remains open for an additional length of time (from 30 seconds to 1/180th second), and the second curtain begins to move downward, covering the sensor once more. When second-curtain sync is activated, the flash is triggered *after* the main exposure is over, just before the second curtain begins to move downward.

Ghost Images

The difference between triggering the flash when the shutter just opens, or just when it begins to close might not seem like much. But whether you use first-curtain sync (the default setting) or second-curtain sync (an optional setting) can make a significant difference to your photograph *if the ambient light in your scene also contributes to the image*. You can set either of these sync modes in the Shooting 1 menu, under External Speedlite control where you'll find the Flash Function setting option.

At faster shutter speeds, particularly 1/180th second, there isn't much time for the ambient light to register, unless it is very bright. It's likely that the electronic flash will provide almost all the illumination, so first-curtain sync or second-curtain sync isn't very important. However, at slower shutter speeds, or with very bright ambient light levels, there is a significant difference, particularly if your subject is moving, or the camera isn't steady.

In any of those situations, the ambient light will register as a second image accompanying the flash exposure, and if there is movement (camera or subject), that additional image will not be in the same place as the flash exposure. It will show as a ghost image and, if the movement is significant enough, as a blurred ghost image trailing in front of or behind your subject in the direction of the movement.

As I noted, when you're using first-curtain sync, the flash's main burst goes off the instant the shutter opens fully (a pre-flash used to measure exposure in auto flash modes fires *before* the shutter opens). This produces an image of the subject on the sensor. Then, the shutter remains open for an additional period (30 seconds to 1/180th second, as I said). If your subject is moving, say, toward the right side of the frame, the ghost image produced by the ambient light will produce a blur on the right side of the original subject image, making it look as if your sharp (flash-produced) image is chasing the ghost. For those of us who grew up with lightning-fast superheroes who always left a ghost trail *behind them*, that looks unnatural (see Figure 9.4).

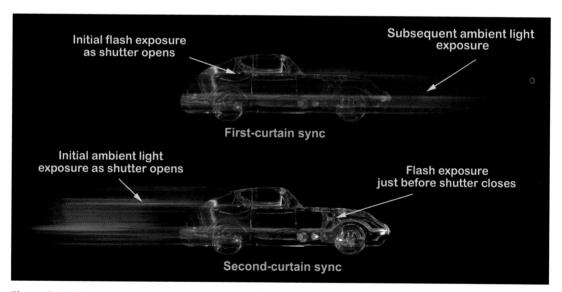

Figure 9.4 First-curtain sync produces an image that trails in front of the flash exposure (top), whereas second-curtain sync creates a more "natural-looking" trail behind the flash image.

So, Canon uses second-curtain sync to remedy the situation. In that mode, the shutter opens, as before. The shutter remains open for its designated duration, and the ghost image forms. If your subject moves from the left side of the frame to the right side, the ghost will move from left to right, too. *Then*, about 1.5 milliseconds before the second shutter curtain closes, the flash is triggered, producing a nice, sharp flash image *ahead* of the ghost image. Voilà! We have monsieur *Speed Racer* outdriving his own trailing image.

Avoiding Sync Speed Problems

Using a shutter speed faster than 1/180th second can cause problems. Triggering the electronic flash only when the shutter is completely open makes a lot of sense if you think about what's going on. To obtain shutter speeds faster than 1/180th second, the 6D Mark II exposes only part of the sensor at one time, by starting the second curtain on its journey before the first curtain has completely opened, as shown in Figure 9.5. That effectively provides a briefer exposure as the gap between the curtains forms a slit, narrower than the full height of the sensor, that passes above its surface. If the flash were to fire during the time when the first and second curtains partially obscured the sensor, only the slit that was actually open would be exposed.

You'd end up with only a narrow band, representing the portion of the sensor that was exposed when the picture is taken. For shutter speeds *faster* than 1/180th second, the second curtain begins moving *before* the first curtain reaches the bottom of the frame. As a result, a moving slit, the distance between the first and second curtains, exposes one portion of the sensor at a time as it moves from the top to the bottom. Figure 9.5 shows three views of our typical (but imaginary) focal plane shutter. At left is pictured the closed shutter; in the middle version, you can see the first curtain has moved down about 1/4 of the distance from the top; and in the right-hand version, the second curtain has started to "chase" the first curtain across the frame toward the bottom.

If the flash is triggered while this slit is moving, only the exposed portion of the sensor will receive any illumination. You end up with a photo like the one shown in Figure 9.6. Note that a band across the bottom of the image is black. That's a shadow of the second shutter curtain, which had started to move when the flash was triggered. Sharp-eyed readers will wonder why the black band is at the *bottom* of the frame rather than at the top, where the second curtain begins its journey. The answer

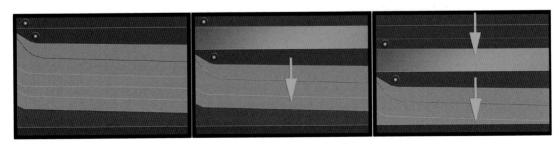

Figure 9.5 A closed shutter (left); partially open shutter as the first curtain begins to move downward (middle); only part of the sensor is exposed as the slit moves (right).

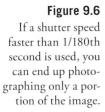

is simple: your lens flips the image upside down and forms it on the sensor in a reversed position. You never notice that, because the camera is smart enough to show you the pixels that make up your photo in their proper orientation. But this image flip is why, if your sensor gets dirty and you detect a spot of dust in the upper half of a test photo, if cleaning manually, you need to look for the speck in the *bottom* half of the sensor.

I generally end up with sync speed problems only when shooting in the studio, using studio flash units rather than my 6D Mark II's Canon-dedicated Speedlite. That's because if you're using a "smart" (dedicated) flash, the camera knows that a strobe is attached, and remedies any unintentional goof in shutter speed settings. If you happen to set the 6D Mark II's shutter to a faster speed in Tv or M mode, the camera will automatically adjust the shutter speed down to 1/180th second. In Av, P, or any of the automatic modes, where the 6D Mark II selects the shutter speed, it will never choose a shutter speed higher than 1/180th second when using flash. In P mode, shutter speed is automatically set between 1/60th to 1/180th second when using flash.

But problems arise when using a non-dedicated flash, such as a studio unit fired with a wireless trigger or plugged into a PC/X adapter in the 6D Mark II's hot shoe. The camera has no way of knowing that a flash is connected, so shutter speeds faster than 1/180th second can be set inadvertently. Note that the 6D Mark II can use a feature called *high-speed sync* that allows shutter speeds faster than 1/180th second with certain external dedicated Canon flash units. When using high-speed sync (HSS), the flash fires a continuous series of bursts at *reduced power* for the entire exposure, so that the duration of the illumination is sufficient to expose the sensor as the slit moves. High-speed sync is set using the controls on the attached and powered-up compatible external flash. I'll explain HSS later.

Determining Exposure

Calculating the proper exposure for an electronic flash photograph is a bit more complicated than determining the settings by continuous light. The right exposure isn't simply a function of how far away your subject is (which the 6D Mark II can figure out based on the autofocus distance that's locked in just prior to taking the picture). Various objects reflect more or less light at the same distance so, obviously, the camera needs to measure the amount of light reflected back and through the lens. Yet, as the flash itself isn't available for measuring until it's triggered, the 6D Mark II has nothing to measure.

The solution is to fire the flash multiple times. The initial shot is a pre-flash that can be analyzed, then followed by a main flash that's given exactly the calculated intensity needed to provide a correct exposure. If the main flash is serving as a master to trigger off-camera flash units, additional coded pulses can convey settings information to the slave flashes and trigger their firing. Of course, if *radio* signals rather than optical signals are in play, the sequences may be different. I'll cover various radio and optical wireless flash modes in Chapter 10; this chapter just explains the basics.

Because of the need to abbreviate or quench a flash burst to provide the optimum exposure, the primary flash may be longer for distant objects and shorter for closer subjects, depending on the required intensity. This through-the-lens evaluative flash exposure system is called E-TTL II, and it operates whenever you have attached a Canon dedicated flash unit to the 6D Mark II.

Guide Numbers

Guide numbers, usually abbreviated GN, are a way of specifying the power of an electronic flash in a way that can be used to determine the right f/stop to use at a particular shooting distance and ISO setting. In fact, before automatic flash units became prevalent, the GN was used to do just that. A GN is usually given as a pair of numbers for both feet and meters that represent the range at ISO 100. For example, consider the Canon Speedlite 270EX II, the least powerful of Canon's current external flash units (aside from the mini 90EX, primarily intended for use on Canon's non-dSLR models). The 270EX II has a GN of 89 at ISO 100. That Guide Number applies when the flash is set to the 50mm zoom setting (so that the unit's coverage is optimized to fill up the frame when using a 50mm focal length on a *full-frame* camera body like the 6D Mark II). (The effective Guide Number is just 72 when the flash is mounted on a "cropped" sensor camera like the EOS 7D II.) If you're using the 270EX II set to the 28mm zoom position, the light spreads out more to cover the wider area captured at that focal length, and the Guide Number of the unit drops to 79.

Of course, the question remains, what can you *do* with a Guide Number, other than to evaluate relative light output when comparing different flash units? In theory, you could use the GN to calculate the approximate exposure that would be needed to take a photo at a given distance. To calculate the right exposure at ISO 100, you'd divide the guide number by the distance to arrive at the appropriate f/stop. (Remember that the shutter speed has no bearing on the *flash* exposure; the

flash burst will occur while the shutter is wide open, and will have a duration of *less* than the time the shutter is open.)

Again, using the 270EX II as an example, at ISO 100 with its GN of 89, if you wanted to shoot a subject at a distance of 11 feet, you'd use f/8 (89 divided by 11). At approximately 16 feet, an f/stop of f/5.6 would be used. Some quick mental calculations with the GN will give you any electronic flash's range. You can easily see that the 270EX II would begin to peter out at about 32 feet, where you'd need an aperture of roughly f/2.8 at ISO 100. Of course, in the real world you'd probably bump the sensitivity up to a setting of ISO 400 so you could use a more practical f/5.6 at that distance.

You should use guide numbers as an *estimate* only. Other factors can affect the relative "power" of a flash unit. For example, if you're shooting in a small room. Some light will bounce off ceilings and walls—even with the flash pointed straight ahead—and give your flash a slight boost, especially if you're not shooting extra close to your subject. Use the same flash outdoors at night, say, on a football field, and the flash will have less relative power, because helpful reflections from surrounding objects are not likely.

So, today, guide numbers are most useful for comparing the power of various flash units. You don't need to be a math genius to see that an electronic flash with a GN of, say, 197 (like the 600EX II-RT) would be *a lot* more powerful than that of the 270EX II. You could use f/12 instead of f/5.6 at 16 feet. That's slightly more than two full f/stops' difference. As a Canon 6D Mark II owner, we can safely assume you'll be using one of the more powerful flash units in the Canon line (or perhaps a similar unit from a third-party vendor).

Getting Started with Electronic Flash

The Canon EOS 6D Mark II's accessory flash is one of the most useful add-ons you can have. I'll include detailed explanations of your flash settings options later in the chapter. This section will get you started quickly.

When you're using Scene Intelligent Auto, P, Av, Tv, B, or Manual exposure modes, attach the flash and turn it on. The behavior of the external flash varies, depending on which exposure mode you're using:

- Scene Intelligent Auto. When the 6D Mark II is set to this mode, the flash will fire automatically, if it is attached and powered up.
- P. In Program mode, the 6D Mark II fully automates the exposure process, giving you subtle fill flash effects in daylight, and fully illuminating your subject under dimmer lighting conditions. The camera selects a shutter speed from 1/60th to 1/180th second and sets an appropriate aperture.

■ Av. In Aperture-priority mode, you set the aperture as always, and the 6D Mark II chooses a shutter speed from 30 seconds to 1/180th second. Use this mode with care, because if the camera detects a dark background, it will use the flash to expose the main subject in the foreground, and then leave the shutter open long enough to allow the background to be exposed correctly, too. If you're not using an image-stabilized lens, you can end up with blurry ghost images even of non-moving subjects at exposures longer than 1/30th second, and if your camera is not mounted on a tripod, you'll see these blurs at exposures longer than about 1/8th second even if you are using IS.

To disable use of a slow shutter speed with flash, access Flash Sync. Speed in Av mode from the External Speedlite Control entry in the Shooting 1 menu, and change from the default setting (Auto) to either 1/180-1/60sec. auto or 1/180sec. (fixed).

- Tv. When using flash in Tv mode, you set the shutter speed from 30 seconds to 1/180th second, and the 6D Mark II will choose the correct aperture for the correct flash exposure. If you accidentally set the shutter speed higher than 1/180th second, the camera will reduce it to 1/180th second when you're using the flash.
- M/B. In Manual or Bulb exposure modes, you select both shutter speed (30 seconds to 1/180th second) and aperture. The camera will adjust the shutter speed to 1/180th second if you try to use a faster speed with a flash. The E-TTL II system will provide the correct amount of exposure for your main subject at the aperture you've chosen (if the subject is within the flash's range, of course). In Bulb mode, the shutter will remain open for as long as the release button on top of the camera is held down, or the release of your remote control is activated. If you use the Bulb timer, you can specify long exposures.

Flash Exposure Compensation and FE Lock

If you want to lock flash exposure for a subject that is not centered in the frame, you can use the FE Lock (the * button) to lock in a specific flash exposure. Just depress and hold the shutter button halfway to lock in focus, then center the viewfinder on the subject you want to correctly expose and press the * button. The pre-flash fires and calculates exposure, displaying the FEL (flash exposure lock) message in the viewfinder. The 6D Mark II remembers the correct exposure until you take a picture, and the FEL indicator in the viewfinder is your reminder. If you want to recalculate your flash exposure, just press the * button again. When you're ready to shoot, recompose your photo and press the shutter down the rest of the way to take the picture.

You can also manually add or subtract exposure to the flash exposure calculated by the 6D Mark II on the camera itself, without needing to touch the flash. When using Program AE, Aperture-priority, Shutter-priority, or Manual, you can access flash exposure compensation (FEC) in four different ways, with two of them illustrated in Figure 9.7, and arranged from fastest to slower (the two slowest aren't illustrated).

Your options are:

- Press the Q button. Then use the directional buttons to navigate to the Flash Exposure compensation area on the Quick Control screen (if necessary), and when it's highlighted, rotate the QCD or the Main Dial to add or subtract flash exposure. If you subsequently want to make another adjustment and haven't used the Quick Control screen for any other function, the next time you press the Q button, Flash Exposure compensation will automatically be highlighted. (See Figure 9.7, left.)
- Press SET on the Quick Control screen when Flash Exposure compensation is highlighted. It produces the screen seen at right in Figure 9.7. You might want to do this if you preferred to use the touch screen to make your adjustments, or needed the extra legibility the larger screen provides.
- **Press the INFO. button.** If you've enabled the Quick Control screen for display by the INFO. button (using the entry in the Set-up 4 menu), you can press the INFO. button followed by SET to access the Quick Control screen and adjust flash exposure compensation.
- Access External Speedlite Control. Find it in the Shooting 1 menu, press SET, and, if your flash is attached and powered up, select Flash Function settings from the External Speedlite control screen that pops up. Then navigate to the Flash Exposure Compensation icon in the second row of the screen. This is the slowest method of all. You might go this route if you were making multiple settings, including FEC, from that screen, which I'll show you in Figure 9.9 when I describe more of your options.

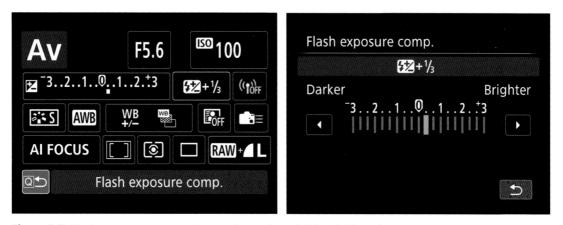

Figure 9.7 Flash exposure compensation can be set from the Quick Control screen.

SETTING FEC ON THE FLASH

While setting flash exposure compensation within the camera is usually most convenient, with some Canon Speedlites (such as the 600EX II-RT), you can set exposure compensation on the external flash instead. With either unit, in ETTL, M, or MULTI modes, press the #2 button to highlight the +/— FEC indicator, then rotate the flash's Select dial to set the specific amount. Press the Select/SET button to confirm your choice.

If you want to avoid accidentally changing the FEC value on the flash, say, while making other adjustments, use either flash unit's C.Fn-13 (not to be confused with the 6D Mark II's own Custom Functions). When set to the default, 0, rotating the Select dial specifies the amount; change to 1, instead, and you must *first* press the Select/SET button before rotating the dial.

Flash exposure compensation can work in tandem with non-flash exposure compensation, so you can adjust the amount of light registered from the scene by ambient light even while you're tweaking the amount of illumination absorbed from your flash unit. As with non-flash exposure compensation, the compensation you make remains in effect for the pictures that follow, and even when you've turned the camera off, remember to cancel the flash exposure compensation adjustment by reversing the steps used to set it when you're done using it.

Tip

If you've enabled the Auto Lighting Optimizer in the Shooting 2 menu, it may cancel out any EV you've subtracted using flash exposure compensation. Disable the Auto Lighting Optimizer if you find your images are still too bright when using flash exposure compensation.

Flash Range

The illumination of the EOS 6D Mark II's external flash varies with distance, focal length, and ISO sensitivity setting.

- **Distance.** The farther away your subject is from the camera, the greater the light fall-off, thanks to the inverse square law discussed earlier. Keep in mind that a subject that's twice as far away receives only one-quarter as much light, which is two f/stops' worth.
- Focal length. A non-zooming flash "covers" only a limited angle of view, which doesn't change. So, when you're using a lens that is wider than the default focal length, the frame may not be covered fully, and you'll experience dark areas, especially in the corners. As you zoom in using

longer focal lengths, some of the illumination is outside the area of view and is "wasted." (This phenomenon is why some external flash units, such as the 600EX II-RT or the old standby 580EX II, automatically "zoom" to match the zoom setting of your lens to concentrate the available flash burst onto the actual subject area.)

■ **ISO setting.** The higher the ISO sensitivity, the more photons captured by the sensor. So, doubling the sensitivity from ISO 100 to 200 produces the same effect as, say, opening up your lens from f/8 to f/5.6.

External Speedlite Control

The Shooting 1 menu's External Speedlite control menu offers several options (see Figure 9.8). The next sections will explain your choices.

Flash Firing

This menu entry has two options: Enable and Disable. It can be used to activate or deactivate any attached external electronic dedicated flash unit. When disabled, the flash cannot fire even if you have an accessory flash attached and turned on. However, you should keep in mind that the AF-assist beam can still be used. If you want to disable that, too, you'll need to turn it off using the AF-Assist Beam Firing entry in the C.Fn II-6 menu.

Figure 9.8
The External
Speedlite control
menu has six
options.

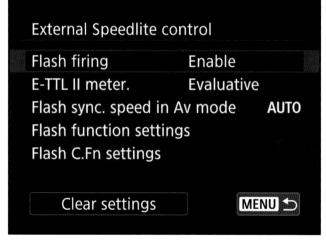

E-TTL II Meter.

When you're using E-TTL II mode, you can specify whether the 6D Mark II uses Evaluative (Matrix) or Average metering modes for the electronic flash exposure meter. Evaluative metering intelligently looks at selected areas in the scene and compares its measurements to a database of typical scene "layouts" to calculate exposure, while Average calculates flash exposure by reading the entire scene. Your choice becomes active when you select E-TTL II as your flash mode, using the entry listed first on this menu screen, and described in more detail in the next section.

Flash Sync Speed in Av Mode

You can select the flash synchronization speed that will be used when working in Aperture-priority mode. In Aperture-priority mode when using flash, you specify the f/stop to be locked in. The exposure is then adjusted by varying the output of the electronic flash (rather than by adjusting the shutter speed, which is norm with non-flash images). Because the primary exposure comes from the flash, the main effect of the shutter speed selected is on the *secondary* exposure from the ambient light within the scene.

Auto is your best choice under most conditions. The 6D Mark II will choose a shutter speed that balances the flash exposure and available, ambient light. The 1/180th–1/60th second setting locks out slower shutter speeds, preventing blur from camera/subject movement in the secondary ("ghost") exposure. However, the background may be rendered dark, if the flash is not strong enough to illuminate it. The 1/180th second (fixed) setting further reduces the chance of getting those blurry ghosts, but there is more of a chance the background will be dark.

- *Auto. The camera selects the shutter speed from 30 seconds to 1/180th second; however, high-speed sync (HSS) can also be activated at the flash.
- *1/180–1/60 auto. Only shutter speeds from 1/180th to 1/60th second will be used. This locks out shutter speeds slower than 1/60th second, and is useful when you want to avoid blur in the secondary, ambient light exposure due to subject movement and/or camera shake. The 6D Mark II will always expose the main subject correctly using the flash, but, as noted earlier, the unavailability of slower shutter speeds may mean that the camera is unable to balance the flash with ambient illumination, making the background too dark. HSS is not possible in Av mode with this setting.
- *1/180 sec. (fixed). A shutter speed of 1/180th second will be used with flash at all times. Use this setting when you want to make sure that the highest flash sync speed is used, minimizing the possibility of blur in the secondary, ambient light exposure. As with the previous setting, using a fixed 1/180th second shutter speed may cause the background to appear darker because less of the ambient light can be used to balance the exposure. HSS is not possible in Av mode with this setting.

Flash Function Settings

This entry (see Figure 9.9) provides access to functions that may differ between different flash units. Because the available features may vary, you can't access this screen unless the Speedlite you'll be using is attached and powered up; the 6D Mark II needs to know what flash it is working with to properly display this submenu. It has six sections that can be used to adjust flash mode, wireless functions, zoom head coverage, shutter sync, flash exposure compensation, and flash exposure bracketing.

- Flash mode. This entry offers up to five choices, depending on the flash unit you have mounted:
 - E-TTL. This E-TTL II is the standard mode for EX-series Speedlites.
 - M. This Manual flash can be used to set a fixed flash output, from full power (1/1) to 1/128th power.
 - MULTI. This MULTI flash is used to produce stroboscopic effects.
 - Ext. A/Ext. M. These two, Auto External Flash and Manual External flash, don't measure light through the lens at all, but, instead, meter the illumination falling on an external sensor (with an unvarying 20-degree angle of view) that's built into the flash. The former method performs automatic exposure calculation using this information, while the latter provides data you can use for manual flash exposure. I don't recommend either of those two, but you can find more information about them in your flash's manual.

Figure 9.9
The entries in the Flash Function Settings screen.

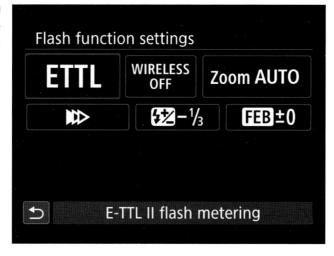

- Wireless functions. Functions vary, depending on the attached Speedlite. If you're not working with wireless flash, your only choice is Wireless: OFF. If you do want to use an attached flash (or a flash trigger unit) as a master flash, you may be able to select Wireless: Optical Transmission; Wireless: Radio Transmission; and, with either of those two, additional functions, such as mode, channel, firing group, and other options become available. These options are explained in Chapter 10.
- **Zoom.** Select this entry and press the SET button. Then, you can rotate the Quick Control Dial to choose Auto (the flash zooms to the correct setting based on information about focal length supplied to the flash by the camera), or 24, 28, 35, 50, 70, 80, or 105mm (available with the older 580EX II) plus 135 and 200mm (with the 600EX II-RT).
- Shutter sync. You can choose First-curtain sync (which fires the main flash as soon as the shutter is completely open) or Second-curtain sync (which waits until just before the shutter starts to close to fire the main flash). If you have a compatible Canon Speedlite attached, you can also select High-speed sync (HSS), which allows using shutter speeds faster than 1/180th second.
- Flash exposure compensation. If you'd rather adjust flash exposure using a menu than with the Quick Control screen or by using the ISO-Exposure compensation button, you can do that here. Select this option with the SET button, then dial in the amount of flash EV compensation you want using the multi-controller or Quick Control Dial. The EV that was in place before you started to make your adjustment is shown as a blue indicator, so you can return to that value quickly. Press SET again to confirm your change, then press the MENU button twice to exit. Keep in mind that using this entry overrides any flash exposure compensation you might set using the ISO-Exposure compensation button on top of the camera, or with any flash function settings.
- Flash exposure bracketing (FEB). This operates similarly to regular exposure bracketing, discussed in Chapter 4. Highlight this entry, press SET, and you can rotate the Quick Control Dial to specify up to three stops of compensation over/under the metered exposure for a set of three flash pictures.

If you enable wireless flash, additional options appear in this menu. I'll cover these in more detail in Chapter 10:

- Channel. All flashes used wirelessly can communicate on one of four channels. This setting allows you to choose which channel is used. Channels are especially helpful when you're working around other Canon photographers; each can select a different channel so one photographer's flash units don't trigger those of another photographer.
- Master flash. You can enable or disable use of the external flash as the master controller for the other wireless flashes. When set to enable, the attached external flash is used as the master.

- Flash Firing Group. Multiple flash units can be assigned to a group. This choice allows specifying which groups are triggered, A/B, A/B plus C, or All. The 600EX-RT/600EX II-RT offer additional groups when using radio control mode, Groups D and E.
- **A:B fire ratio.** If you select A/B or A/B plus C, this option appears, and allows you to set the proportionate outputs of Groups A and B, in ratios from 8:1 to 1:8 as explained in Chapter 12.
- **Group C exposure compensation.** If you select A/B plus C, this option appears, too, allowing you to set flash exposure compensation separately for Group C flashes.

Flash C.Fn Settings

This menu entry produces a screen that allows you to set any available Custom Functions in your flash, from the camera. The functions available will depend on the C.Fn's included in the flash unit. (See Figure 9.10, which shows a full array available with the 600EX-RT.) To set flash Custom Functions, rotate the QCD to choose the C.Fn number to be adjusted, then press SET. Rotate the Quick Control Dial again to choose from that function's options, then press SET again to confirm.

Clear Settings

Select this menu entry, located at the bottom of the screen, and you'll be asked if you want to change all the flash settings to their factory default values. You have two choices: Clear Flash Settings (the settings internal to the 6D Mark II) and Clear All Speedlite C.Fn's, which returns all the *attached* Speedlite's Custom Function settings to their factory defaults. The only exception is C.Fn-0: Distance Indicator Display, which will remain at its set value.

Figure 9.10
Custom Functions
for your Speedlite
can be set from the
camera's Flash C.Fn
menu.

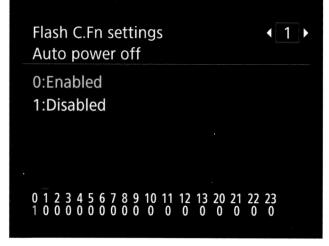

Using Flash Settings

This section includes some tips for using the available Flash settings.

When to Disable Flash Firing

There are a few applications where I always disable my flash and AF-assist beam, even though my 6D Mark II won't fire an attached flash without my intervention anyway. Some situations are too important to take chances.

- Venues where flash is forbidden. I've discovered that many No Photography signs mean "No Flash Photography," either because those who make the decisions feel that flash is distracting or they fear it may potentially damage works of art. Tourists may not understand the difference between flash and available-light photography, or may be unable to set their camera to turn off the flash. One of the first phrases I learn in any foreign language is "Is it permitted to take photos if I do not use flash?" A polite request, while brandishing an advanced camera like the 6D Mark II (which may indicate you know what you are doing), can often result in permission to shoot away.
- Venues where flash is ineffective anyway. We've all seen the concert goers who stand up in the last row to shoot flash pictures from 100 yards away. I tend to not tell friends that their pictures are not going to come out, because they usually come back to me with a dismal, grainy shot (actually exposed by the dim available light) that they find satisfactory, just to prove I was wrong.
- Venues where flash is annoying. If I'm taking pictures in a situation where flash is permitted, but mostly supplies little more than visual pollution, I'll disable or avoid using it. Concerts or religious ceremonies may *allow* flash photography, but who needs to add to the blinding bursts when you have a camera that will take perfectly good pictures at ISO 3200? Of course, I invariably see one or two people flashing away at events where flash is not allowed, but that doesn't mean I am eager to join in the festivities.

More on Flash Modes

In choosing Flash mode, you have three choices. The available modes are E-TTL II, the standard mode for EX-series Speedlites; Manual flash, which you can use to set a fixed flash output, from full power (1/1) to 1/128th power; and MULTI flash, used to produce stroboscopic effects.

E-TTL II

You'll leave Flash mode at this setting most of the time. In this mode, the camera fires a pre-flash prior to the exposure, and measures the amount of light reflected to calculate the proper settings. As noted earlier, when you've selected the E-TTL II flash mode, you can also choose either Evaluative or Average metering methods. If you select Manual flash or MULTI flash, that option is removed from the menu.

Manual Flash

Use this setting when you want to specify exactly how much light is emitted by the flash, and don't want the 6D Mark II's E-TTL II exposure system to calculate the f/stop for you. When you activate this option, a new entry appears in the Flash Func. Setting menu, with a sliding scale from 1/1 (full power) to 1/128th power. Highlight the scale and press the SET button. You can then rotate the Quick Control Dial and choose any of the settings. (Only 1/4, 1/2, 1/1, and the intermediate settings between them appear when 1/1 is chosen; view the other power settings by rotating the QCD counterclockwise.) A blue dot appears under the 1/1 setting, and a white dot under your new setting, a reminder that you've chosen something other than full power.

Here are some situations where you might want to use manual flash settings:

- Close-ups. You're shooting macro photos and the E-TTL II exposure is not precisely what you'd like. You can dial in exposure compensation, or set the output manually. Close-up photos are problematic, because the power of the flash may be too much (choose 1/128th power to minimize the output), or the reflected light may not be interpreted accurately by the throughthe-lens metering system. Manual flash gives you greater control.
- Fill flash. Although E-TTL II can be used in full daylight to provide fill flash to brighten shadows, using manual flash allows you to tweak the amount of light being emitted in precise steps. Perhaps you want just a little more illumination in the shadows to retain a dramatic lighting effect without the dark portions losing all detail. Again, you can try using exposure compensation to make this adjustment, but I prefer to use manual flash settings. (See Figure 9.11.)
- Action stopping. The lower the power of the flash, the shorter the effective exposure. Use 1/128th power in a darkened room (so that there is no ambient light to contribute to the exposure and cause a "ghost" image) and you can end up with a "shutter speed" that's the equivalent of 1/50,000th second!

Figure 9.11 You can fine-tune fill illumination by adjusting the output of your camera's flash manually.

MULTI Flash

The MULTI flash setting makes it possible to shoot cool stroboscopic effects, with the flash firing several times in quick succession. You can use the capability to produce multiple images of moving objects, to trace movement (say, your golf swing). When you've activated MULTI flash, three parameters appear on the Flash Function Setting menu, as shown in Figure 9.12. They include:

- Flash output. Like the Flash Output option in Manual mode, you can choose the intensity of each individual flash in your multiple flash sequence, from 1/4 to 1/128th power (the 1/1 and 1/2 power settings are not available).
- Frequency. This figure specifies the number of bursts per second. With the external flash, you can choose (theoretically) 1 to 199 bursts per second. The actual number of flashes produced will be determined by your flash count (which turns off the flash after the specified number of flashes), flash output (higher output levels will deplete the available energy in your flash unit), and shutter speed.
- **Flash count.** This setting determines the number of flashes in a given burst, and can be set from 1 to 30 flashes.

These factors work together to determine the maximum number of flashes you can string together in a single shot. The exact number will vary, depending on your settings and your Speedlite model.

Figure 9.12 MULTI flash settings.

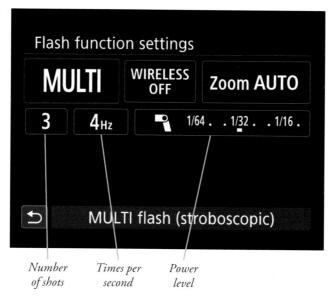

Here are some guidelines you can use:

■ Output. As you cut the power from 1/4 to 1/128th, the output of the flash drops dramatically, and so does the maximum distance you can shoot at any f/stop. The 1/4 power setting, the most powerful setting available with MULTI flash, will give you the greatest flash range in this mode. With your 6D Mark II's sensitivity set to ISO 1600, your flash will allow you to photograph a subject at 10 feet using f/8 and one-quarter power. (If you remember the discussion of guide numbers from earlier in this chapter, the flash would have an effective GN of 80 at ISO 1600.)

If you wanted to use the 1/16th power setting instead, you'd need to use f/4 to account for the reduced output of the flash. By the time you dial down to 1/128th power, your flash has a feeble guide number of about 14 (at ISO 1600!), so to shoot at f/4 you'd be able to locate your subject *no farther* than 3.5 feet from the camera.

The output level also determines the maximum number of flashes that are possible before the charge stored in your flash's capacitor is depleted. The capacitor partially recharges itself as you shoot, so the number of flashes also varies by the flashes-per-second rate. At the 1Hz (one flash per second) rate and 1/4 power, you can expect about 6 to 7 flashes before the Speedlite's power poops out. By the time you reach 10Hz (10 flashes per second) and higher, the unit can crank out no more than two flashes per second at 1/4 power.

Logically, as output levels decrease, more flashes can be pumped out in a given time period. At 1/128th power, you can expect as many as 100 flashes at the 1Hz rate, and up to 40 consecutive flashes at the 20Hz to 199Hz frequency.

- Flashes per second. Cycles per second are, by convention, measured using an increment called *Hertz*. The more flashes you want during the time the shutter is open, the higher the rate you must select. You can select rates of 1Hz to 199Hz, or 1 to 199 flashes per second, plus "--" (more on that later). To maximize the number of flashes in a second, you'll also need to choose the lowest power output level that you find acceptable. The flash unit can emit a lot more fractional 1/128th power bursts in a given period than it can more robust (relatively) 1/4 power bursts.
 - When you choose "--" for your frequency, the flash will continue firing until the shutter closes, or its internal storage is depleted. (In any case, you should not use the MULTI flash feature for more than 10 consecutive pictures. At that point, you should allow the flash to "rest" for at least 15 minutes. But don't worry, the unit will shut down automatically to avoid overheating.)
- **Flash count.** Chose the number of flashes, from 1 to 30, that you want in your multiple exposure, given the output and flash frequency constraints described above.

High-Speed Sync

High-speed sync is a special mode that allows you to synchronize a compatible external flash at all shutter speeds, rather than just 1/180th second and slower. The entire frame is illuminated by a series of continuous bursts as the shutter opening moves across the sensor plane, so you do *not* end up with a horizontal black band, as shown earlier in Figure 9.6.

HSS is especially useful in three situations, all related to problems associated with high ambient light levels:

■ Eliminate "ghosts" with moving images. When shooting with flash, the primary source of illumination may be the flash itself. However, if there is enough available light, a secondary image may be recorded by that light (as described under "Ghost Images" earlier in this chapter). If your main subject is not moving, the secondary image may be acceptable or even desirable. But if your subject is moving, the secondary image creates a ghost image.

High-speed sync gives you the ability to use a higher shutter speed. If ambient light produces a ghost image at 1/180th second, upping the shutter speed to 1/500th or 1/1,000th second may eliminate it.

Of course, HSS *reduces* the amount of light the flash produces. If your subject is not close to the camera, the waning illumination of the flash may force you to use a larger f/stop to capture the flash exposure. So, while shifting from 1/180th second at f/8 to 1/500th second at f/8 *will* reduce ghost images, if you switch to 1/500th second at f/5.6 (because the flash is effectively less intense), you'll end up with the same ambient light exposure. Still, it's worth a try.

■ Improved fill flash in daylight. The 6D Mark II can use an attached flash unit to fill in inky shadows—both automatically and using manually specified power ratios, as described earlier in this chapter. However, both methods force you to use a 1/180th second (or slower) shutter speed. That limitation can cause three complications.

First, in very bright surroundings, such as beach or snow scenes, it may be difficult to get the correct exposure at 1/180th second. You might have to use f/16 or a smaller f/stop to expose a given image, even at ISO 100. If you want to use a larger f/stop for selective focus, then you encounter the second problem—1/180th second won't allow apertures wider than f/8 or f/5.6 under many daylight conditions at ISO 100. (See the discussion of fill flash with Aperture-priority in the next bullet.)

Finally, if you're shooting action, you'll probably want a shutter speed faster than 1/180th second, if at all possible, under the current lighting. That's because, in fill flash situations, the ambient light (often daylight) provides the primary source of illumination. For many sports and fast-moving subjects, 1/500th second, or faster, is desirable. HSS allows you to increase your shutter speed and still avail yourself of fill flash. This assumes that your subject is close enough to your camera that the fill flash has some effect; forget about using fill and HSS with subjects a dozen feet away or farther. The flash won't be powerful enough to have much effect on the shadows.

■ When using fill flash with Aperture-priority. The difficulties of using selective focus with fill flash, mentioned earlier, become particularly acute when you switch to Av exposure mode. Selecting f/5.6, f/4, or a wider aperture when using flash is guaranteed to create problems when photographing close-in subjects, particularly at ISO settings higher than ISO 100. If you own a compatible external flash unit, HSS may be the solution you are looking for.

To use High-speed sync, just follow these steps:

- 1. **Attach the flash.** Mount/connect the external flash on the 6D Mark II, using the hot shoe or a dedicated flash cable. (HSS cannot be used in wireless radio mode with the 600EX II-RT, nor with a flash linked through a PC/X terminal adapter.)
- 2. Power up. Turn the flash and camera on.
- 3. **Select HSS in the camera.** Set the External Flash Function setting *in the camera* to HSS as the 6D Mark II's sync mode.
- 4. **Choose HSS on the flash.** Activate HSS (FP flash) on your attached external flash. With the older (but still common) Speedlite 580EX II, press the High-speed sync/Sync button on the back of the flash unit (it's the second from the right under the LCD). If you're using the 600EX II-RT, press the #4 function button (of the array under the LCD) until the HSS icon appears on the LCD.
- 5. **Confirm HSS is active.** The HSS icon will be displayed on the flash unit's LCD (at the upper-left side with the 580EX II and 600EX II-RT), and at bottom left in the 6D Mark II's view-finder. If you choose a shutter speed of 1/180th second or slower, the indicator will not appear in the viewfinder, as HSS will not be used at slower speeds.
- 6. **View minimum/maximum shooting distance.** Choose a distance based on the maximum shown in the line at the bottom of the flash's LCD display (from 0.5 to 18 meters).
- 7. **Shoot.** Take the picture. To turn off HSS, press the button on the flash again. Remember that you can't use MULTI flash or Wireless flash when working with high-speed sync.

Using External Electronic Flash

Once the capacitor is charged, the burst of light that produces the main exposure can be initiated by a signal from the 6D Mark II that commands the internal or connected flash units to fire. External strobes can be linked to the camera in several different ways:

- Camera-mounted/hardwired external dedicated flash. Units offered by Canon or other vendors that are compatible with Canon's lighting system can be clipped onto the accessory "hot" shoe on top of the camera or linked through a wired system such as the Canon Off Shoe Camera Cord OC-E3.
- Wireless dedicated flash. A compatible unit can be triggered by signals produced by a preflash (before the main flash burst begins), which offers two-way communication between the camera and flash unit. The triggering flash can be an external flash unit in Master mode, or a wireless non-flashing accessory, such as the Canon Speedlite Transmitter ST-E2 and more recent radio-controlled wireless trigger, the Speedlite Transmitter ST-E3-RT, which each do nothing but "talk" to the external flashes. You'll find more on this mode in Chapter 10.

- Wired, non-intelligent mode. If you connect a flash to a PC/X terminal adapter, you can use non-dedicated flash units, including studio strobes, through a non-intelligent camera/flash link that sends just one piece of information, one way: it tells a connected flash to fire. There is no other exchange of information between the camera and flash. The PC/X connector can be used to link the 6D Mark II to studio flash units, manual flash, flash units from other vendors that can use a PC cable, or even Canon-brand Speedlites that you elect to connect to the 6D Mark II in "unintelligent" mode.
- Infrared/radio transmitter/receivers. Another way to link flash units to the 6D Mark II is through third-party wireless infrared or radio transmitters, like a Pocket Wizard, Radio Popper, or the Paul C. Buff CyberSync trigger. These are generally mounted on the accessory shoe of the camera, and emit a signal when the 6D Mark II sends a command to fire through the hot shoe. The simplest of these function as a wireless PC/X connector, with no other communication between the camera and flash (other than the instruction to fire). However, sophisticated units have their own built-in controls and can send additional commands to the receivers when connected to compatible flash units. I use one to adjust the power output of my Alien Bees studio flash from the camera, without the need to walk over to the flash itself.
- Simple slave connection. In the days before intelligent wireless communication, the most common way to trigger off-camera, non-wired flash units was through a *slave* unit. These can be small external triggers connected to the remote flash (or built into the flash itself), and set off when the slave's optical sensor detects a burst initiated by the camera. When it "sees" the main flash (from the 6D Mark II's attached external flash, or another flash), the slave flash units are triggered quickly enough to contribute to the same exposure. The main problem with this type of connection—other than the lack of any intelligent communication between the camera and flash—is that the slave may be fooled by any pre-flashes that are emitted by the other strobes, and fire too soon. Modern slave triggers have a special "digital" mode that ignores the pre-flash and fires only from the main flash burst.

Canon offers a broad range of accessory electronic flash units for the 6D Mark II. They can be mounted to the flash accessory shoe, or used off-camera with a dedicated cord that plugs into the flash shoe to maintain full communication with the camera for all special features. (Non-dedicated flash units, such as studio flash, can be connected using a PC/X terminal adapter.) They range from the Speedlite 600EX II-RT and Speedlite 580EX II, which can correctly expose subjects up to 24 feet away at f/11 and ISO 200, to the 270EX II, which is good out to 9 feet at f/11 and ISO 200. (You'll get greater ranges at even higher ISO settings, of course.) There are also two electronic flash units specifically for specialized close-up flash photography.

I power my Speedlites with Panasonic Eneloop AA nickel metal hydride batteries, seen in Figure 9.13. These are a special type of rechargeable battery with a feature that's ideal for electronic flash use. The Eneloop cells, unlike conventional batteries, don't self-discharge over relative short periods of time. Once charged, they can hold onto most of their juice for a year or more. That means you can stuff some of these into your Speedlite, along with a few spares in your camera bag, and not worry about whether the batteries have retained their power between uses. There's nothing worse than firing up your strobe after not using it for a month, and discovering that the batteries are dead.

Speedlite 600EX-RT/600EX II-RT

This flagship of the Canon accessory flash line (and most expensive at about \$580) is the most powerful unit the company offers, with a GN of 197 and a manual/automatic zoom flash head that covers the full frame of lenses from 24mm wide angle to 200mm telephoto. (There's a flip-down, wide-angle diffuser that spreads the flash to cover a 14mm lens's field of view, too.) All angle specifications given by Canon refer to full-frame sensors, but this flash unit automatically converts its field of view coverage to accommodate the crop factor of the 6D Mark II and the other 1.6X crop Canon dSLRs. The latest 600EX II-RT has improved continuous flash firing rates (up to 2X faster with an optional CP-E4N battery pack).

The 600EX II-RT and 600EX-RT (shown in Figure 9.14) share their basic features with the discontinued (but still widely used) 580EX II, described next, so I won't repeat them here, because the typical veteran Canon owner is more likely to own multiple Speedlites.

Figure 9.13 Panasonic's Eneloop AA batteries are a perfect power source for Canon Speedlites.

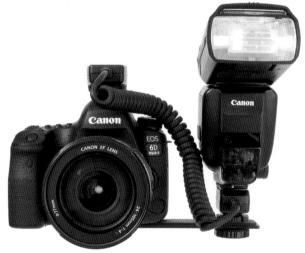

Figure 9.14 Canon's flagship Speedlites can be side mounted using a bracket and the OC-E3 off-camera flash cord.

The killer feature of this unit is the new wireless two-way radio communication between the camera and this flash (or ST-E3-RT wireless controller and the flash) at distances of up to 98 feet. You can link up to 15 different flash units with radio control, using *five* groups (A, B, C, D, and E), and no line-of-sight connection is needed. (You can hide the flash under a desk or in a potted plant.) With the latest Canon cameras having a revised "intelligent" hot shoe (which includes the 6D Mark II), a second 600EX-RT/600EX II-RT can be used to trigger a *camera* that also has a 600EX-RT/600EX II-RT mounted, from a remote location. That means you can set up multiple cameras equipped with multiple flash units to all fire simultaneously! For example, if you were shooting a wedding, you could photograph the bridal couple from two different angles, with the second camera set up on a tripod, say, behind the altar. A pro shooter might find the 6D Mark II to be an excellent, affordable second (or third) camera to use in such situations.

600EX (NON-RADIO)

If you see references to a 600EX model (non-RT), you'll find that a version with the radio control crippled is sold only outside the USA in countries where obtaining permission to use the relevant radio spectrum is problematic.

The 600EX II-RT maintains backward compatibility with optical transmission used by earlier cameras. However, it's a bit pricey for the average EOS 6D Mark II owner, who is unlikely to be able to take advantage of all its features. If you're looking for a high-end flash unit and don't need radio control, I still recommend the Speedlite 580EX II (described next), which is still widely available and is the most-used high-end flash Canon has ever offered.

Remember that with the 600EX II-RT, you can't use radio control and some other features unless you own at least *two* radio-controlled Speedlites, such as a 600EX II-RT or 430EX III-RT (described later) or one 600EX II-RT plus the ST-E3-RT, which costs about \$300. Radio control is possible only between a camera that has a radio-capable flash or ST-E3-RT in the hot shoe, and an additional radio-capable flash or ST-E3-RT. (At \$470, the ST-E3-RT alone costs as much as a decent flash unit!)

Some Custom Functions of the 600EX II-RT can be set using the 6D Mark II's External Flash C.Fn Setting menu. Additional Personal Functions can be specified on the flash itself. The 6D Mark II–friendly functions include:

C.Fn-00 Distance indicator display (Meters/Feet)

C.Fn-01 Auto power off (Enabled/Disabled)

C.Fn-02 Modeling flash (Enabled-DOF preview button/Enabled-test firing button/Enabled-both buttons/Disabled)

C.Fn-03 FEB Flash exposure bracketing auto cancel (Enabled/Disabled)

220

C.Fn-04	FEB Flash exposure bracketing sequence (Metered > Decreased > Increased
	Exposure/Decreased > Metered > Increased Exposure)
C.Fn-05	Flash metering mode (E-TTL II/E-TTL/TTL/External metering: Auto/External metering: Manual)
C.Fn-06	Quickflash with continuous shot (Disabled/Enabled)
C.Fn-07	Test firing with autoflash (1/32/Full power)
C.Fn-08	AF-assist beam firing (Enabled/Disabled)
C.Fn-09	Auto zoom adjusted for image/sensor size (Enabled/Disabled)
C.Fn-10	Slave auto power off timer (60 minutes/10 minutes)
C.Fn-11	Cancellation of slave unit auto power off by master unit (within 8 hours/within
	1 hour)
C.Fn-12	Flash recycling on external power (Use internal and external power/Use only external power)
C.Fn-13	Flash exposure metering setting button (Speedlite button and dial/Speedlite dial only)
C.Fn-20	Beep (Enable/Disable)
C.Fn-21	Light distribution (Standard, Guide number priority, Even coverage)
C.Fn-22	LCD panel illumination (On for 12 seconds, Disable, Always on)
C.Fn-23	Slave flash battery check (AF-assist beam/Flash lamp, Flash lamp only)

The Personal Functions available include the following. Note that you can set the LCD panel color to differentiate at a glance whether a given flash is functioning in Master or Slave mode.

differentiate at a giance whether a given riash is functioning in Master or Slave mode.		
P.Fn-01	LCD panel display contrast (Five levels of contrast)	
P.Fn-02	LCD panel illumination color: Normal (Green, Orange)	
P.Fn-03	LCD panel illumination color: Master (Green, Orange)	
P.Fn-04	LCD panel illumination color: Slave (Green, Orange)	
P.Fn-05	Color filter auto detection (Auto, Disable)	
P.Fn-06	Wireless button toggle sequence (Normal > Radio > Optical, Normal < > Radio, Normal < > Optical)	
P.Fn-07	Flash firing during linked shooting (Disabled, Enabled)	

Speedlite 580EX II

If you were using Canon cameras prior to purchasing your 6D Mark II, you might already own this deposed flagship of the Canon accessory flash line. Despite the introduction of the 600EX-RT/600EX II-RT, this unit is still the most widely used Canon Speedlite, popular because of its relatively lower price and wide availability new (from some retailers) or used. The 580EX II is the second-most powerful unit the company offered, with a GN of 190, and a manual/automatic zoom flash head that covers the full frame of lenses from 24mm wide angle to 105mm telephoto, as well as 14mm optics with a flip-down diffuser.

Like the 600EX II-RT, this unit offers full-swivel, 180-degrees in either direction, and has its own built-in AF-assist beam and an exposure system that's compatible with the nine focus points of the 6D Mark II. Powered by economical AA-size batteries, the unit recycles in 0.1 to 6 seconds, and can squeeze 100 to 700 flashes from a set of alkaline batteries.

The 580EX II automatically communicates white balance information to your camera, allowing it to adjust WB to match the flash output. You can even simulate a modeling light effect: When you press the depth-of-field preview button on the 6D Mark II, the 580EX II emits a one-second burst of light that allows you to judge the flash effect. If you're using multiple flash units with Canon's wireless E-TTL system, this model can serve as a master flash that controls the slave units you've set up (more about this later) or function as a slave itself.

It's easy to access all the features of this unit, because it has a large backlit LCD panel on the back that provides information about all flash settings. There are 14 Custom Functions that can be controlled from the flash, numbered from 00 to 13. These functions are (the first setting is the default value):

C.Fn-00	Distance indicator display (Meters/Feet)
C.Fn-01	Auto power off (Enabled/Disabled)
C.Fn-02	Modeling flash (Enabled-DOF preview button/Enabled-test firing button/ Enabled-both buttons/Disabled)
C.Fn-03	FEB Flash exposure bracketing auto cancel (Enabled/Disabled)
C.Fn-04	FEB Flash exposure bracketing sequence (Metered > Decreased > Increased Exposure/Decreased > Metered > Increased Exposure)
C.Fn-05	Flash metering mode (E-TTL II-E-TTL/TTL/External metering: Auto/External metering: Manual)
C.Fn-06	Quickflash with continuous shot (Disabled/Enabled)
C.Fn-07	Test firing with autoflash (1/32/Full power)
C.Fn-08	AF-assist beam firing (Enabled/Disabled)
C.Fn-08	AF-assist beam firing (Enabled/Disabled)

- **C.Fn-09** Auto zoom adjusted for image/sensor size (Enabled/Disabled)
- **C.Fn-10** Slave auto power off timer (60 minutes/10 minutes)
- **C.Fn-11** Cancellation of slave unit auto power off by master unit (within 8 hours/within 1 hour)
- **C.Fn-12** Flash recycling on external power (Use internal and external power/Use only external power)
- **C.Fn-13** Flash exposure metering setting button (Speedlite button and dial/Speedlite dial only)

Speedlite 430EX III-RT

This less pricey electronic flash (available for less than \$300) is an affordable replacement for the 580EX II for those who don't need the beefy power of the older Speedlite. It also makes radio control wireless triggering available to those who can't afford the 600EX-RT's price tag. The 430EX III-RT has automatic and manual zoom coverage from 24mm to 105mm, and the same wide-angle pullout panel found on the 600EX-RT/600EX II-RT that covers the area of a 14mm lens on a full-frame camera, and automatic conversion to the cropped frame area of the 6D Mark II and other 1.6X crop Canon dSLRs. The 430EX III-RT also communicates white balance information with the camera, and has its own AF-assist beam. Compatible with Canon's wireless E-TTL system, it makes a good slave unit, but cannot serve as a master flash. It, too, uses AA batteries, and offers recycle times of 0.1 to 3.7 seconds for 200 to 1,400 flashes, depending on subject distance.

This long-overdue replacement for the 430EX II has as its biggest selling point the ability to communicate either optically (as a slave) with any compatible master flash, or by radio transmission (as either master or slave) with other RT flashes, including the 600EX RT. Previously, you needed either two of the expensive 600EX RT/600EX II-RT units or one 600EX RT/600EX II-RT and an ST-E3-RT trigger to use radio communications.

The Canon Speedlite 430EX III-RT offers a sophisticated set of features, including an LCD panel that allows you to navigate the unit's menu and view its status. These features, along with powerful output and automatic zoom means this unit has more in common with Canon's high-end Speedlites than it does with the 320EX or the 270EX II. The Speedlite 430EX III-RT is compatible with E-TTL II and earlier flash technologies. It can serve as a slave unit in an optical wireless configuration. The Speedlite 430EX III-RT has a guide number of 43/141 (meters/feet) at ISO 100, at 105mm focal length.

Speedlite 320EX

This \$249 flash has a GN of 105. Lightweight and more pocket-sized than the 430EX III-RT and 600EX-RT, this bounceable (both horizontally and vertically) flash has some interesting features, including a built-in LED video light that can be used for shooting movies with the 6D Mark II, or as a modeling light or even AF-assist beam when shooting with live view. Canon says that this efficient LED light can provide up to four hours of illumination with a set of AA batteries. It can be used as a wireless slave unit, and has a new flash release function that allows the shutter to be triggered remotely with a two-second delay. I showed you this flash at the beginning of the chapter, in Figure 9.1.

Speedlite 270EX II

The Canon Speedlite 270EX II is designed to work with compatible EOS cameras utilizing E-TTL II and E-TTL automatic flash technologies. This flash unit is entirely controlled from the camera, making it as simple to use as a built-in flash. Its options can be selected and set via the camera's menu system. The 270EX II can also be used as an off-camera slave unit when controlled by a master Speedlite, transmitter unit, or a camera with an integrated Speedlite transmitter. One interesting feature of this unit is that it is also a remote-control transmitter, allowing you to wirelessly release the shutter on cameras compatible with certain remote controller units. The Speedlite 270EX II has a guide number of 27/89 (meters/feet) at ISO 100, with the flash head pulled forward.

This \$170 ultra-compact unit is Canon's entry-level Speedlite, and suitable for 6D Mark II owners who want a simple strobe for occasional use, without sacrificing the ability to operate it as a wireless slave unit. With its modest guide number, it provides a little extra pop for fill flash applications. It has vertical bounce capabilities of up to 90 degrees, and can be switched between Tele modes to Normal (28mm full-frame coverage) at a reduced guide number of 72.

The 270EX II functions as a wireless slave unit triggered by any Canon EOS unit or flash (such as the 430EX III-RT) with a Master function. It also has the new flash release function with a two-second delay that lets you reposition the flash. There's a built-in AF-assist beam, and this 5.5-ounce, $2.6 \times 2.6 \times 3$ -inch unit is powered by just two AA-size batteries.

Close-Up Lites

Canon has offered two lites, especially suitable for close-up photography: the Macro Ring Lite MR-14EX II and Macro Twin Lite flash MD-24EX. As this book was being written, a third macro light, the Macro Twin Lite MT-26EX-RT (which can be radio controlled) was introduced, with a price of almost \$1,000. As you might guess from their names, these lites are especially suitable for close-up, or macro photography, because they provide a relatively shadowless illumination. It's always tricky photographing small subjects up close, because there often isn't room enough between the camera lens and the subject to position lights effectively. Ring lites, in particular, especially those with their own modeling lamps to help you visualize the illumination you're going to get, mount around the lens at the camera position, and help solve many close-up lighting problems.

But, in recent years, the ring lite has gone far beyond the macro realm and is now probably even more popular as a light source for fashion and glamour photography. The right ring lite, properly used, can provide killer illumination for glamour shots, while eliminating the need to move and reset lights for those shots that lend themselves to ring lite illumination. As you, the photographer, move around your subject, the ring lite moves with you.

One of the key drawbacks to ring lites (whether used for macro or glamour photography) is that they are somewhat bulky and clumsy to use (they must be fastened around the camera lens itself, or the photographer must position the ring lite, and then shoot "through" the opening or ring). That means that you might not be moving around your subject as much as you thought and will, instead, mount the ring lite and camera on a tripod, studio stand, or other support.

Another drawback is the cost. The MR-14EX and MR-24EX close-up lites are priced in the \$550 and \$830 range, respectively, with the MR-24EX-RT topping out at roughly \$1,000, as I mentioned. You have to be planning a *lot* of macro or fashion work to pay for one of those. Specialists take note. I tend to favor a third-party substitute for close-up photography, the Alien Bees ABR800 Ringflash. It's priced at about \$400, and, besides, it integrates very well with my other Alien Bees studio flash units.

Working with Wireless Flash

The key to effective flash photography is to get the flash off the camera, so its illumination can be used to paint your subject in interesting and subtle ways from a variety of angles. But, sometimes, using a cable to liberate your flash from the accessory shoe isn't enough. Nor is the use of just a single electronic flash always the best solution. What we really have needed is a way to trigger one—or more—flash units wirelessly, giving us the freedom to place the electronic flash anywhere in the scene and, if our budgets and time allow, to work in this mode with multiple flashes.

Wireless Evolution

It's not possible to cover every aspect of wireless flash in one chapter. There are too many permutations involved. For example, you can use an external flash or the ST-E2 optical transmitter (or ST-E3-RT radio transmitter) as the master. You may have one external "slave" flash, or use several. It's possible to control all your wireless flash units as if they were one multi-headed flash, or you can allocate them into "groups" that can be managed individually. You may select one of several "channels" to communicate with your strobes (or any of multiple wireless IDs when using radio-controlled units like the 600EX II-RT). These are all aspects that you'll want to explore as you become used to working with the 6D Mark II's impressive wireless capabilities.

What I hope to do in this chapter is provide the introduction to the basics that you won't find in the other guidebooks, so you can learn how to operate the 6D Mark II's wireless capabilities quickly, and then embark on your own exploration of the possibilities. You'll find more complete information in *David Busch's Guide to Canon Flash Photography* or similar publications from Rocky Nook.

YOUR STEPS MAY VARY

This chapter is intended to teach you the basics of wireless flash: why to use it, how a dedicated flash or add-on controller can be used to trigger and manipulate additional units, and what lighting ratios, channels, and groups are. I'm going to provide instructions on getting set up with wireless flash, but, depending on what flash unit you're working with (and how many you have), your specific steps may vary. The final authority on working with wireless flash should be the manual furnished with your flash unit.

Elements of Wireless Flash

Here are some of the key concepts to electronic flash and wireless flash that I'll be describing in this chapter. Learn what these are, and you'll have gone a long way toward understanding how to use wireless flash. You need to understand the various combinations of flashes that can be used, how they can be controlled individually and together, and why you might want to use multiple and off-camera flash units. I'm going to address all these points in this section.

Flash Combinations

Your 6D Mark II's attached on-camera external flash can be used alone, or, if it has the capability to serve as a *master flash* (not all Canon Speedlites do), in combination with other, external flash units. Here's a quick summary of the permutations available to you.

- On-camera flash used alone. Your external flash can function as the only flash illumination used to take a picture. In that mode, the flash can provide the primary illumination source (the traditional "flash photo") with the ambient light in the scene contributing little to the overall exposure. (See Figure 10.1, left.) Or, the external flash can be used in conjunction with the scene's natural illumination to provide a balanced lighting effect. (Figure 10.1, center.) In this mode, the flash doesn't overpower the ambient light, but, instead, serves to supplement it. Finally, the external flash can be used as a "fill" light in scenes that are illuminated predominantly by a natural main light source, such as daylight. In this mode, the flash serves to brighten dark shadows created by the primary illumination, such as the glaring daylight in Figure 10.1, right.
- On-camera flash used simultaneously with off-camera flash. You can use the off-camera flash as a *main light* and supply *fill light* from the external flash to produce interesting effects and pleasing portraits.
- On-camera flash used as a trigger only for off-camera flash. Use the 6D Mark II's external wireless flash controller to command single or multiple Speedlites for studio-like lighting effects, without having the flash contribute to the exposure itself.

Figure 10.1 On-camera flash alone (left), as a supplement (center), and for fill flash (right).

Controlling Flash Units

There are multiple ways of controlling flash units, both through direct or wired connections and wirelessly. Here are the primary methods used:

- **Direct connection.** The external flash, of course, is directly connected to the 6D Mark II, and triggered electronically when a picture is taken. External flash units can also be controlled directly by linking them to a camera with a dedicated flash cord that in turn attaches to the accessory hot shoe, such as the Canon OC-E3 EOS Dedicated TTL off-camera shoe cord (illustrated in the previous chapter in Figure 9.14).
 - When used in these modes, the camera has full communication with the flash, which can receive information about zoom lens position, correct exposure required, and the signals required to fire the flash. You can also plug a non-dedicated strobe, such as studio flash units, into an optional PC/X adapter that plugs into the camera's hot shoe. Such a connection is "dumb" and conveys no information other than the signal to fire.
- Dedicated wireless optical signals. In this mode, external flash units communicate with the camera through a pre-flash, which is used to measure exposure prior to the "real" flash burst an instant later. The pre-flashes can also wirelessly send information from the camera to the flash unit, to determine the duration of the burst to achieve the desired exposure. The pulses also can be used to adjust zoom head position (if the flash has that feature). In the case of Canon flash units, the pre-flash information is sent and received as visible light, sent so quickly just before the main burst that you may not be able to distinguish them from the "real" flash.

- Dedicated wireless infrared signals. Some devices, such as the Canon ST-E2 Speedlite Transmitter, can communicate with dedicated flash units through infrared signals—much like the remote control of your television. (And, also like your TV remote, the IR signal can bounce around the room somewhat, but you more or less need a line-of-sight connection for the communication to work properly.) The transmitter attaches to the accessory shoe or is connected to the accessory shoe through a dedicated cable. It was an option for wireless flash for Canon cameras prior to the EOS 7D (and later models with an in-camera wireless controller), as well as for Canon cameras that have no flash unit at all (such as the EOS 1D and 5D series). Although the ST-E2 costs about \$250, it's still less expensive than using a unit like the 580EX II or 600EX II-RT as a master controller, particularly when external flash is not desired.
- Canon and third-party IR and radio transmitters. The 600EX-RT/600EX II-RT, 430EX III-RT, and ST-E3-RT from Canon can communicate as master flash units using radio signals. The 600EX-RT/600EX II-RT can also serve as a master optical flash, and as a radio or optical slave, while the 430 EX III-RT functions as a slave only in optical mode. In September 2017, Canon introduced a radio-controlled macro light, the Macro Twin Lite MT-26EX-RT. This \$1,000 flash system wasn't available before this book went to press, so I won't be explaining its use here.
 - In addition, some excellent wireless flash controllers that use IR or radio signals to operate external flash units are available from sources like PocketWizard and RadioPopper. Some of these third-party units can dial in exposure/output adjustments from the transmitter mounted on the accessory shoe of the camera.
- Optical slave units. A relatively low-tech/low-versatility option is to use optical slave units that trigger the off-camera flash units when they detect the firing of the main flash. Slave triggers are inexpensive, but dumb: they don't allow making any adjustments to the external flash units, and are not compatible with the 6D Mark II's E-TTL II exposure system. Moreover, you should make sure that the slave trigger responds to the *main* flash burst only, rather than a pre-flash, using a so-called *digital* mode. Otherwise, your slave units will fire before the main flash, and not contribute to the exposure.

Why Use Wireless Flash?

Canon's wireless flash system gives you a few advantages, including the ability to use directional lighting, which can help bring out detail or emphasize certain aspects of the picture area. It also lets you operate multiple strobes; with models like the old favorite 580EX II that's as many as four flash units in each of three groups, or twelve in all (although most of us won't own 12 Canon Speedlites). With the 600EX-RT/600EX II-RT and 430EX III-RT, which also have radio control in addition to optical transmission, you can control many more flash units optically, but only 15 radio-controlled Speedlites, in five different groups.

You can set up complicated portrait or location lighting configurations. Since the two top Canon Speedlites pump out a lot of light for a shoe-mount flash, a set of these units can give you near studio-quality lighting. Of course, the cost of these high-end Speedlites approaches or exceeds that of some studio monolights—but the Canon battery-powered units are smaller, compatible with Canon's E-TTL exposure system, are generally more portable, and don't require an external AC or DC power source.

Key Wireless Concepts

There are three key concepts you must understand before jumping into wireless flash photography: channels, groups, and flash ratios. Here is an explanation of each:

■ **Channel controls.** Canon's wireless flash system offers users the ability to determine on which of four possible channels the flash units can communicate. (The pilots, ham radio operators, or scanner listeners among you can think of the channels as individual communications frequencies.) When using optical transmission, the channels are numbered 1, 2, 3, and 4, and each flash must be assigned to one of them. Moreover, in general, each of the flash units you are working with should be assigned to the *same* channel, because the slave Speedlites will respond *only* to a master flash that is on the same channel.

When using the 600EX II-RT or 430EX III-RT in radio control mode, there are 15 different channels, plus an Auto setting that allows the flash to select a channel. In addition, you can assign a four-digit Wireless Radio ID that further differentiates the communications channel your flashes use.

The channel ability is important when you're working around other photographers who are also using the same system. Photojournalists, including sports photographers, encounter this situation frequently. At any event populated by a sea of "white" lenses, you'll often find photographers who are using Canon flash units triggered by Canon's own optical or (now) radio control. Third-party triggers from PocketWizard or RadioPopper are also popular, but Canon's technology remains a mainstay for many shooters.

Each photographer sets flash units to a different channel to not accidentally trigger other users' strobes. (At big events with more than four photographers using Canon flash and optical transmission, you may need to negotiate.) I use this capability at workshops I conduct where we have two different setups. Photographers working with one setup use a different channel than those using the other setup, and can work independently even though we're at opposite ends of the same large room.

There is less chance of a channel conflict when working with radio control and all radio-compatible Canon flash units. With 15 channels to select from, and almost 10,000 wireless radio IDs to choose from, any overlap is unlikely. (It's smart not to use a radio ID like 0000, 1111, 2222, etc., to avoid increasing the chances of conflicts. I use the last four digits of my mother-in-law's Social Security Number.) Remember that you must use either all optical or all radio transmission for all your flash units; you can't mix and match.

■ **Groups.** Canon's wireless flash system lets you designate multiple flash units in separate groups. There can be as many as three groups with earlier Speedlites like the 580EX II, labeled A, B, and C.

With the 600EX II-RT, 430EX III-RT, and ST-E3-RT, up to five groups (A, B, C, D, and E) can be used with as many as 15 different flash units. All the flashes in all the groups use the exact same *channel* and all respond to the same master controller, but you can set the output levels of each group separately. So, Speedlites in Group A might serve as the main light, while Speedlites in Group B might be adjusted to produce less illumination and serve as a fill light. It's convenient to be able to adjust the output of all the units within a given group simultaneously. This lets you create different styles of lighting for portraits and other shots.

TIP

It's often smart to assign flash units that will reside to the left of the camera to the A group, and flashes that will be placed to the right of the camera to the B group. It's easier to adjust the comparative power ratios because you won't have to stop and think where your groups are located. That's because the adjustment controls in the *menus* are always arranged in the same A-B-C left-to-right alignment.

For example, if your A group is used as a main light on the left, and the B group as fill on the right, you intuitively know to specify more power to the A group, and less output to the B group. Reserve the C group (if used) to some other purpose, such as background or hair lights.

■ Flash ratios. This ability to control the output of one flash (or set of flashes) compared to another flash or set allows you to produce lighting *ratios*. You can control the power of multiple off-camera Speedlites to adjust each unit's relative contribution to the image, for more dramatic portraits and other effects.

Which Flashes Can Be Operated Wirelessly?

A Speedlite can have one of two functions. It can serve as a *master* flash that's capable of triggering other compatible Canon units that are on the same channel. Or, a Speedlite can be triggered wirelessly as a *slave unit* that's activated by a *master*, with full control over exposure through the camera's eTTL flash system. The second function is easy: all current and many recent Canon shoe-mount flash, including the 600EX II-RT, 580EX II, 430EX II, 430EX III, 430EX III-RT, 320EX, and 270EX II can be triggered wirelessly. In addition, some Speedlites can serve as a master flash.

I'm not going to discuss most older flash units in this chapter; if you own one, particularly a non-Canon unit, it may or may not function as a slave. For example, the early Speedlite 380EX lacked the wireless capabilities added with later models, such as the 420EX, 430EX, 430EX II, 430EX III, 430EX III.

Here's a quick rundown of current flash capabilities:

- Canon Speedlite 600EX-RT/600EX II-RT. These top-of-the-line flashes can function as a master flash when physically attached to any Canon EOS model, using either optical or radio transmission, and can be triggered wirelessly by another master flash, such as a compatible EOS model, another 600EX-RT/600EX II-RT or 580EX II, or the ST-E2/ST-E3-RT transmitters.
- Canon Speedlite 580EX II. This discontinued flash can function as a master flash when physically attached to any Canon EOS model, and can be triggered wirelessly by an optical (not radio) transmission from another master flash from a compatible EOS camera, another 580EX II, a 600EX II-RT, 600EX II-RT, 430EX III-RT, or the ST-E2 transmitter. (The ST-E3-RT transmitter operates in radio mode only.)
- Canon Speedlite 430EX III. This sibling of the radio-compatible version described next cannot function as a master, but can be used as a slave when working with optical triggering technology.
- Canon Speedlite 430EX III-RT. This newer flash can function as a master (in radio mode only) and as a slave when using both optical and radio technology.
- Canon Speedlite 430EX II. This discontinued flash cannot function as a master, but can be triggered wirelessly by a master flash, including a compatible EOS camera, a Speedlite 600EX II-RT/580EX II, or the ST-E-2 transmitters.
- Canon Speedlite 320EX. This flash can be triggered wirelessly by a master flash, including a compatible EOS camera, a 600EX-RT/600EX II-RT, 580EX II, or the ST-E-2 transmitter.
- Canon Speedlite 270EX II. This flash can be triggered wirelessly by a compatible camera's master flash, a 600EX-RT/600EX II-RT, 580EX II, or the ST-E2 and ST-E3-RT transmitters in optical mode.

You can use any combination of compatible flash units in your wireless setup. You can use an attached 600EX-RT/600EX II-RT, 580EX II, 430EX III-RT, or ST-E2/ST-E3-RT as a master, with any number of 600EX II-RT, 580EX II, 430EX III, 430EX III-RT, 430EX II, 320EX, or 270EX II units (or older compatible Speedlites not discussed in this chapter) as wireless slaves. I'll get you started assigning these flash to groups and channels later in this chapter.

Setting Up a Master Flash or Controller

The first step in working with wireless flash is to set up one unit (either a flash or controller) as the *master*. You can mount a Speedlite 580EX, 580EX II, or 600EX-RT/600EX II-RT to your camera, which can serve as the master unit, transmitting E-TTL II optical signals to one or more off-camera Speedlite *slave* units. The master unit can have its flash output set to "off" so that it controls the remote units with the pre-flash, but omitting the main flash so the master unit does not contribute any illumination of its own to the exposure. This is useful for images where you don't want noticeable flash illumination coming in from the camera position. The next sections explain your options for setting up a master unit for fully automatic, E-TTL II exposure. You can also use manual exposure instead of E-TTL II automatic exposure in wireless mode. Setting up your master flash for manual operation is beyond the scope of this introductory wireless chapter.

Using a Speedlite as an Optical Master

Here are the steps to follow to set up and use a compatible Speedlite as a camera-mounted master unit for automatic exposure. For each individual flash unit described below, check your flash's manual if you have any questions about particular button location.

600EX-RT/600EX II-RT

- 1. Press the Wireless button repeatedly until the LCD panel indicates you are in optical wireless master mode.
- 2. Press MODE to cycle through the ETTL, M, and Multi modes.
- 3. Use the menu system to control and make changes to RATIO, output, and other options on the master and slave units.

580EX II

- 1. Press and hold the ZOOM button to bring up the wireless options. Use the Select dial to cycle through the OFF, MASTER on, and SLAVE on options. Select and confirm MASTER on.
- 2. Press MODE to cycle through the ETTL, M, and Multi modes.
- 3. Press the ZOOM button repeatedly to cycle through the following options: Flash zoom, RATIO, CH., flash emitter ON/OFF. Use the Select dial and Select/SET button to make any changes to these options.
- 4. Use the Select/SET button to select and confirm the output power settings when using Manual and Multi modes, or to use FEC or FEB when in ETTL mode.

580EX

- 1. Slide the OFF/MASTER/SLAVE wireless switch near the base of the unit to MASTER.
- 2. Press MODE to cycle through the ETTL, M, and Multi modes.
- 3. Press the ZOOM button repeatedly to cycle through the following options: Flash zoom, RATIO, CH., flash emitter ON/OFF. Use the Select dial and Select/SET button to make any changes to these options.
- 4. Use the Select/SET button to select and confirm the output power settings when using Manual and Multi modes, or to use FEC or FEB when in ETTL mode.

Using the ST-E2 Transmitter as Master

Canon's Speedlite Transmitter (ST-E2) is mounted on the camera's hot shoe and provides a way to control one or more Speedlites and/or units assigned to Groups A and B. The ST-E2 does not provide any flash output of its own and will not trigger units assigned to Group C. It has the following features and controls:

- **Transmitter.** Located on the top front of the unit, the transmitter emits E-TTL II pulses through an infrared filter.
- **AF-assist beam emitter.** Just below the transmitter, the AF-assist beam emitter works similarly to the Speedlite 430EX II and higher models.
- **Battery compartment.** The ST-E2 uses a 6.0V 2CR5 lithium battery. The battery compartment is accessed from the top of the unit.
- Lock slider and mounting foot. The lock slider is located on the right side of the unit when facing the front. Sliding it to the left lowers the lock pin in the mounting foot (located on the bottom of the unit) to secure it to the camera's hot shoe.
- Back panel. The rear of the unit features several indicators and controls:
 - Ratio indicator. A series of red LED lights indicating the current A:B ratio setting.
 - Flash ratio control lamp. A red LED that lights up when flash ratio is in use.
 - Flash ratio setting button. Next to the flash ratio control lamp. Press this button to activate flash ratio control.
 - Flash ratio adjustment buttons. Two buttons with raised arrows (same color as buttons) pointing left and right. Use these to change the A:B ratio setting.
 - Channel indicator. The channel number in use (1–4) glows red.
 - Channel selector button. Next to the channel indicator. Press this button to select the communication channel.

- **High-speed sync (FP flash) indicator.** A red LED that glows when high-speed sync is in use.
- High-speed sync button. Press this button to activate/deactivate high-speed sync.
- ETTL indicator. A red LED that glows when E-TTL II is in use.
- Off/On/HOLD switch. Slide this switch to turn the unit off, on, or on with adjustments disabled (HOLD). The ST-E2 will power off after approximately 90 seconds of idle time. It will turn back on when the shutter button or test transmission button is pressed.
- Pilot lamp/Test transmission button. This lamp works similarly to the Speedlite pilot lamp/test buttons. The lamp glows red when ready to transmit. Press the lamp button to send a test transmission to the slave units.
- **Flash confirmation lamp.** This lamp glows green for about three seconds when the ST-E2 detects a good flash exposure.

Here are the steps to follow to set up and use the ST-E2 transmitter (see Figure 10.2) as a cameramounted master unit:

- 1. Mount the ST-E2 unit on your 6D Mark II.
- 2. Make sure both the ST-E2 unit and your camera are powered on.
- 3. Make sure the slave units are set to E-TTL II, assigned to the appropriate group(s), and that all units are operating on the same channel.
- 4. If you'd like to set a flash ratio between Groups A and B, press the flash ratio setting button and flash ratio adjustment buttons to select the desired ratio. Press the high-speed sync button to use high-speed sync (often helpful with outdoor shooting).

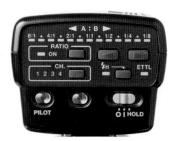

Figure 10.2 ST-E2 transmitter.

Using the Speedlite 600EX-RT/600EX II-RT as Radio Master

The Speedlite 600EX-RT/600EX II-RT can serve as the master unit when mounted to your camera, transmitting radio signals to one or more off-camera Speedlite 600EX-RT/600EX II-RT slave units. The master unit can have its flash output set to "off" so that it controls the remote units without contributing any flash output of its own to the exposure. This is useful for images where you don't want noticeable flash illumination coming in from the camera position.

Here are the steps to follow to set up and use a Speedlite 600EX-RT/600EX II-RT as a cameramounted master unit for radio wireless E-TTL II operation.

- 1. Mount the Speedlite 600EX-RT/600EX II-RT to your 6D Mark II.
- 2. Make sure the 600EX II-RT master units, slave units, and the camera are powered on.
- 3. Set the camera-mounted unit to radio wireless MASTER mode. Press the Wireless button until the LCD panel indicates you are on radio wireless master mode.
- 4. Set the slave 600EX-RT/600EX II-RT or 430EX III-RT units to radio wireless SLAVE mode. For each 600EX II-RT unit, press the Wireless button until the LCD panel indicates you are on radio wireless slave mode. For each 430EX III-RT slave, press the left directional key and rotate the Select dial until Slave appears on the LCD. Then press the Select button to confirm.
- 5. Confirm that all units are set to E-TTL II, assigned to the appropriate group(s), and that all units are operating on the same channel and ID number. The LINK lamps on all units should glow green.

Using the Speedlite 430EX III-RT as Radio Master

The Speedlite 430EX III-RT can serve as a radio master unit to trigger another 430EX III-RT or a 600EX II-RT flash. Just follow these steps:

- 1. Press the left directional key on the Select dial. It's marked with a lightning bolt symbol.
- 2. Rotate the Select dial until MASTER appears on the LCD.
- 3. Press the Select button in the center of the Select dial.
- 4. Set any 600EX II-RT or 430EX III-RT units that you will be using as slaves to the Slave mode.
 - For the 600EX II-RT, press the Wireless button until the LCD panel indicates you are in radio wireless slave mode.
 - For any 430EX III-RT slaves, press the left directional key and rotate the Select dial until Slave appears on the LCD. Then press the Select button to confirm.
- 5. Repeat Step 4 for any additional Slave units.
- 6. When master and slaves are communicating, the LINK lamps on all units will glow green.

Using the ST-E3-RT as Radio Master

The ST-E3-RT transmitter can be mounted to the camera's hot shoe and used as a master controller to one or more slave Speedlite 600EX II-RT units. The ST-E3-RT and the 600EX II-RT share essentially the same radio control capabilities except that the ST-E3-RT does not produce flash, provide AF-assist, or otherwise emit light and is therefore incapable of optical wireless transmission.

The layout of the ST-E3-RT's control panel is virtually identical to the 600EX II-RT. So is the menu system and operation, except that, as stated earlier, it will only operate as a radio wireless transmitter. Here are the steps to follow to set up and use the ST-E3-RT transmitter as a cameramounted master unit for radio wireless E-TTL II operation:

- 1. Mount the ST-E3-RT unit on your 6D Mark II.
- 2. Make sure both the ST-E3-RT unit and your camera are powered on.
- 3. Set the slave 600EX II-RT or 430EX III-RT units to radio wireless SLAVE mode. For each 600EX II-RT unit, press the Wireless button until the LCD panel indicates you are on radio wireless slave mode. For each 430EX III-RT slave, press the left directional key and rotate the Select dial until Slave appears on the LCD. Then press the Select button to confirm.
- 4. Confirm that all units are set to E-TTL II, assigned to the appropriate group(s), and that all units are operating on the same channel and ID number. The LINK lamps on all units should glow green.

The ST-E3-RT controls slave units as described earlier in the section, "Speedlite 600EX-RT/600EX II-RT as Radio Master."

Setting Up a Slave Flash

The whole point of working wirelessly is to have a master flash/controller trigger and adjust one or more slave flash units. So, once you've defined your master flash, the next step is to switch your remaining Speedlites into slave mode. That's done differently with each Canon Speedlite.

- Speedlite 600EX-RT/600EX II-RT. Press the Wireless button repeatedly until the LCD panel indicates that the unit is in optical wireless slave mode or radio wireless slave mode. In this mode, the 600EX II-RT is assigned a flash mode by the master transmitter, either a flash or ST-E2 or ST-E3-RT.
- Speedlite 580EX II. Press and hold the ZOOM button until the wireless setting options appear. Use the Select dial and Select/SET button to select and confirm that wireless is on and in slave mode.
- Speedlite 430EX III/430EX III-RT. For each 430EX III-RT slave, press the left directional key and rotate the Select dial until Slave appears on the LCD. Then press the Select button to confirm.

- **Speedlite 430EX II.** Press and hold the ZOOM button for two seconds or more until the wireless setting options appear. Use the Select dial and Select/SET button to select and confirm that wireless is on and in slave mode.
- Speedlite 320EX. This flash has an On/Off/Slave switch at the lower left of the back panel. In Slave mode, you can use the flash's C.Fn-10 to tell the unit to power down after either 10 or 60 minutes of idle time. That can help preserve the 320EX's batteries. The unit's C.Fn-11 can be set to allow the master transmitter to "wake" a sleeping 320EX after your choice of within 1 hour or within 8 hours. Note that the C.Fn settings of the 320EX and 270EX II (described next) can be set only while the Speedlites are connected to the camera with the hot shoe.
- Speedlite 270EX II. This flash has an Off/Slave/On switch. If left on and idle, the 270EX II will power itself off after approximately 90 seconds. C.Fn-1 can be used to disable auto power off. As with the 320EX, in Slave mode, you can use the flash's C.Fn-10 to tell the unit to power down after either 10 or 60 minutes of idle time. The unit's C.Fn-11 can be set to allow the master transmitter to "wake" a sleeping unit after your choice of within 1 hour or within 8 hours.

Choosing a Channel

In optical mode, Canon's wireless flash system can work on any of four channels, so if more than one photographer is using the Canon system, each can set his gear to a different channel so they don't accidentally trigger each other's strobes. You need to be sure all your gear is set to the same channel. Selecting a channel is done differently with each flash model.

The ability to operate flash units on a particular channel isn't really important unless you're shooting in an environment where other photographers are also using the Canon wireless flash system. If the system only offered one channel, then each photographer's wireless flash controller would be firing every Canon flash set for wireless operation. By having four channels available, the photographers can coordinate their use to avoid that problem. Such situations are common at sporting events and other activities that draw a lot of shooters.

It's always a good idea to double-check your flash units before you set them up to make sure they're all set to the same channel, and this should also be one of your first troubleshooting questions if a flash doesn't fire the first time you try to use it wirelessly.

You do this as follows:

1. Set flash units to the channel you want to use for all your groups. Before you use the 6D Mark II's controls to configure your flash exposures, you must first make adjustments on the external Speedlite. Each flash unit may use its own procedure for setting that strobe's channel. Consult your Speedlite's manual for instructions. With the 580EX II, press the Zoom button repeatedly until the CH. indicator blinks, then rotate the control dial to select Channel 1, 2, 3, or 4. Press the control dial center button to confirm. With the 600EX-RT/600EX II-RT, press Fn Button 4 until Menu 2 appears, then press Fn Button 1 to select a channel.

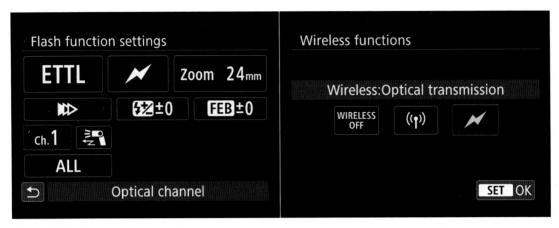

Figure 10.3 You can choose the Channel, Groups, and other parameters from the Flash Functions screen (left); activate wireless functions (right).

- 2. Activate wireless operation. From the External Speedlite Control entry in the Shooting 1 menu, navigate to the Flash Function Settings choice, Flash Functions. Highlight the second icon from the left in the top row (as seen in Figure 10.3, left) and press SET. Then choose Wireless: Optical Transmission from the screen that appears (Figure 10.3, right). Press SET to confirm and exit.
- 3. **Navigate to the 6D Mark II's channel selection option.** Navigate to the Channel Setting (highlighted in red at left in Figure 10.3) and push the SET button.
- 4. **Select the channel your flashes are set to.** You can then use the QCD to cycle the channel number from 1 to 4.
- 5. **Enable/disable master flash firing.** The icon to the immediate right of the Channel Setting icon allows you to enable or disable firing of the master flash. When disabled, the master flash will still control external flashes wirelessly with a preflash burst, but won't contribute to the exposure. This is useful if you want all the illumination to come from your slave flash units, such as when shooting close-up or macro images, or when you're simulating a studio flash setup with Speedlites.
- 6. Double-check to make sure your off-camera flash units are set to the appropriate channel. Your wireless flash units must be set to the same channel as the 6D Mark II's wireless flash controller; otherwise, the Speedlites won't fire.

Working with Groups

With what you've already learned, you can shoot wirelessly using your camera's on-camera flash and one or more external flash units. All these strobes will work together with the 6D Mark II for automatic exposure using E-TTL II exposure mode. You can vary the power ratio between your oncamera external flash and the other external units. As you become more comfortable with wireless

flash photography, you can even switch the individual external flash units into manual mode, and adjust their lighting ratios manually.

But there's a lot more you can do if you've splurged and own two or more compatible external flash units (some photographers I know own five or six Speedlite 580EX II or 600EX II-RT units). Canon wireless photography lets you collect individual strobes into *groups*, and control all the Speedlites within a given group together. You can operate as few as two strobes in two groups or three strobes in three groups, while controlling more units if desired. You can also have them fire at equal output settings (A+B+C mode) versus using them at different power ratios (A:B or A:B C modes). Setting each group's strobes to different power ratios gives you more control over lighting for portraiture and other uses.

This is one of the more powerful options of the EOS wireless flash system. I prefer to keep my Speedlites set to different groups normally. I can always set the power ratio to 1:1 if I want to operate the flash units all at the same power. If I change my mind and need to adjust, I can just change the wireless flash controller and then manipulate the different groups' output as desired.

Canon's wireless flash system works with a number of Canon flashes and even some third-party units. I routinely mix a 600EX II-RT, 580EX II, 550EX, and 420EX. I control these flash units either with the EOS 6D Mark II's on-camera external flash or using a Canon ST-E2 Speedlite Transmitter.

The ST-E2 is a hot shoe mount device that offers wireless flash control for a wide variety of Canon wireless flash—capable strobes and can even control flash units wirelessly for high-speed sync (HSS) photography. (HSS is described in Chapter 9.) The ST-E2 can only control two flash groups, however, and it also can support flash exposure bracketing.

Here's how you set up groups:

- 1. **Set flash units to the desired group.** Each flash unit may use its own procedure for setting that strobe's group. Consult your Speedlite's manual for instructions.
- 2. Navigate to the 6D Mark II's group selection option. From the External Speedlite Control entry in the Shooting 1 menu, navigate to the Flash Function Settings choice, Flash Functions. Navigate to the Group setting (located just below the Channel and Master Flash Firing options) and push the SET button.
- 3. Select the group configuration you want. You can then use the QCD to cycle to select ALL, A:B, or A:B C. If you're using the 600EX-RT/600EX II-RT in radio control mode, you can also activate Groups D and E.
- 4. **Double-check to make sure your flash units are set to the appropriate channel.** Your wireless flash units must be set to the same channel as the 6D Mark II's wireless flash controller; otherwise, the Speedlites won't fire.

Ratio Control

By default, all the flashes in each group will fire at full power. However, for more advanced lighting setups, you can select lighting ratios.

Your on-camera master flash and your wireless slave flash units have their own individual *oomph*—how much illumination they put out. This option lets you choose the relationship between these units, a *power ratio* between your on-camera flash and your wireless flash units—the relative strength of each. That ability can be especially useful if you want to use the on-camera flash for just a little fill light, while letting your off-camera units do the heavy work.

Having the ability to vary the power of each flash unit or group of flash units wirelessly gives you greater flexibility and control. Varying the light output of each flash unit makes it possible to create specific types of lighting (such as traditional portrait lighting, which frequently calls for a 3:1 lighting ratio between main light and fill light) or to use illumination to highlight one part of the photo while reducing contrast in another.

Lighting ratios determine the contrast between the main light (sometimes called a "key" light) and fill light. For portraiture, usually the main light is placed at a 45-degree angle to the subject (although there are some variations), with the fill-in light on the opposite side or closer to the camera position. Choosing the right lighting ratio can do a lot to create a particular look or mood. For instance, a 1:1 ratio produces what's known as "flat" lighting. While this is good for copying or documentation, it's not usually as interesting for portraiture. Instead, making the main light more powerful than the fill light creates interesting shadows for more dramatic images. (See Figure 10.4.)

Figure 10.4 More dramatic lighting ratios produce more dramatic-looking illumination.

By selecting the power ratio between the flash units, you can change the relative illumination between them. Figure 10.5 shows a series of four images with a single main flash located at a 45-degree angle off to the right and slightly behind the model. The on-camera flash at the camera provided illumination to fill in the shadows on the side of the face closest to the camera. The ratio between the two Speedlites flash was varied using 2:1 (upper left), 3:1 (upper right), 4:1 (lower left), and 5:1 (lower right) ratios.

Figure 10.5
The main light (to the right and behind the model) and fill light (at the camera position) were varied using 2:1 and 3:1 (top row, left to right) as well as 4:1 and 5:1 (bottom row, left to right) ratios.

242

Here's how to set the lighting ratio between the master flash and one additional external wireless flash unit:

- 1. Navigate to the 6D Mark II's Flash Group selection option. With wireless flash already activated, visit the External Speedlite Control entry in the Shooting 1 menu, navigate to the Flash Function Settings choice, Flash Functions. Navigate to the Flash Group choice at the lower left of the screen, and push the SET button.
- Choose Group Configuration. You can select ALL, A:B, or A:B C. If you're using the 600EX-RT/600EX II-RT in radio transmission mode, you can also select Groups D and E. Press SET to confirm.
- 3. **Select Ratio.** If you've chosen A:B C, use the QCD to navigate to the A:B Ratio Control option, highlighted in red at left in Figure 10.6, press SET and select a ratio from 8:1 to 1:8 (see Figure 10.6, right). Group A at 1:8 supplies 1/8th the output of Group B. At 8:1, the ratio is reversed.
- 4. **Confirm.** Press SET to confirm your ratio.

Here's how the various basic group configurations work:

- ALL. All groups will fire at the power level set at the flash unit itself. That may be full power, or you may have set individual flashes to fire at some other power level. It's usually simpler to set your flashes at full power and allow the master to control their output.
- **A:B.** In this configuration, you can specify the ratio of the power levels of Groups A and B, as described in Step 3 above.
- **A:B C.** In this group configuration, you can specify the power ratio between Groups A and B, but *not* the output of Group C flashes. Those can be controlled only using Flash Exposure Compensation, the option immediately above the A:B Power Ratio setting in Figure 10.6.

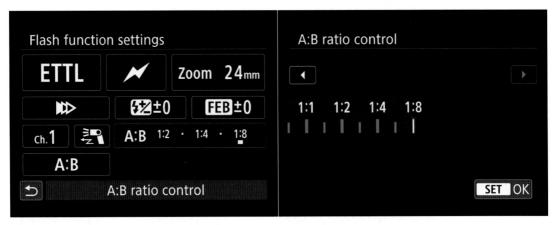

Figure 10.6 Select your Group Configuration.

Customizing with the Shooting Menu

This chapter and the next two will help you sort out the settings you can make to customize how your Canon EOS 6D Mark II uses its features, shoots photos, displays images, and processes the pictures after they've been taken. I'm not going to waste a lot of space on some of the more obvious menu choices. For example, you can probably figure out that the Release Shutter without Card option in the Shooting 1 menu deals with whether you can "take" a picture even if no memory card is present. You can certainly decipher the import of the two options available (Enable and Disable). In this chapter, I'll devote no more than a sentence or two to the blatantly obvious settings and concentrate on the more confusing aspects of 6D Mark II set-up, such as Automatic Exposure Bracketing.

Anatomy of the 6D Mark II's Menus

The 6D Mark II divides the entries into six major sections—Shooting, Autofocus, Playback, Set-up, Custom Functions, and My Menu—each of which (except for the last) is further subdivided into three to six separate pages. Each page's listings are shown as a separate screen with no scrolling.

The menus are easy to use, too. Just press the MENU button, spin the Main Dial to highlight the menu tab and page you want to access, and then scroll up and down within a menu with the Quick Control Dial. What could be easier?

Tapping the MENU button brings up a typical menu like the one shown in Figure 11.1. (If the camera goes to "sleep" while you're reviewing a menu, you may need to wake it up again by tapping the shutter release button.) Different menu tabs are provided, depending on the shooting mode, shown in Table 11.1.

The 6D Mark II's tabs are color-coded: red for Shooting, blue for Playback, amber for Set-up, orange for Custom Functions, and Green for My Menu. The currently selected menu tab's icon is white within a background corresponding to its color code. A lineup immediately underneath shows the page numbers available, and, at far right, the name of the page (for example, SHOOT1). The current screen's number is highlighted. All the inactive menus are gray and dimmed.

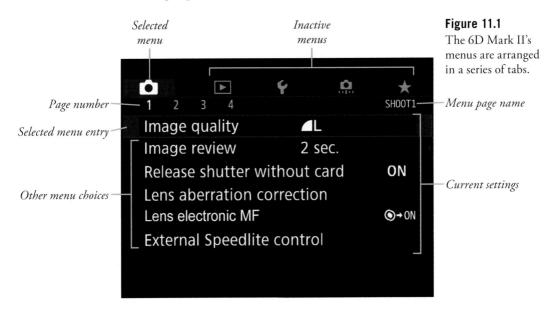

Table 11.1 Available Menus	
Modes	Available Menu Tabs
Bulb, M, Tv, Av, P Modes	Shooting 1–4, Playback 1–3, Set-up 1–5, Custom Functions 1, My Menu
Scene Intelligent Auto	Shooting 1, Playback 1–3, Set-up 1–5
Movie mode	Shooting 1–3, Playback 1–3, Set-up 1–5

HYPER MENU NAVIGATION

As I mentioned, you can use the Main Dial to move from menu to menu, and the Quick Control Dial to highlight a menu entry. Press the SET button to select a menu item. That procedure is probably the best way to start out, because those controls are used to make so many settings with the EOS 6D Mark II that they quickly become almost intuitive. The 6D Mark II manual uses the Main Dial/Quick Control Dial method in its Menu Setting description. But, there are two alternate methods.

You can use the touch screen to tap on a specific menu tab, page number, and individual entry, if you like. Or, if you have an agile thumb, you can do all your menu navigation with the multi-controller directional buttons:

- Press left/right to jump from tab to tab.
- Press up/down to move within the menu choices of a given tab.
- Press the SET button to select a menu item.

It gets even better. You can jump from tab to tab with the Quick Control Dial, even if you've highlighted a menu setting on another tab—and the 6D Mark II will remember which menu entry you've highlighted when you return to that menu. The memorization works even if you leave the menu system or turn off your camera. The 6D Mark II always remembers the last menu entry you used within a tab. So, if you generally use the Format command each time you access the Set-up 1 menu, that's the entry that will be highlighted when you choose that tab. The camera remembers which tab was last used, too, so, potentially, formatting your memory card might take just a couple of presses (the MENU button, the SET button to select the highlighted Format command, then a click of the Quick Control Dial to choose OK, and another press of SET to start the format process).

Here are the things to watch for as you navigate the menus:

- Menu tabs. In the top row of the menu screen, the menu that is currently active will be highlighted as described earlier. The numbers within the tab let you know if you are in, say, Shooting 1, Shooting 2, Shooting 3, or Shooting 4, as shown in Figure 11.1. The menu page name of the currently active menu is shown at the right side of the second line. Just remember that the red camera icons stand for still, live view, and movie shooting options. When highlighted, the blue right-pointing triangles represent playback options; the yellow wrench icons stand for set-up options; the orange camera icons represent Custom Functions; and the green star stands for personalized menus defined for the star of the show—you.
- **Selected menu item.** The currently selected menu entry within a given tab will have a black background and will be surrounded by a box the same hue as its color code.

- Other menu choices. The other menu items visible on the screen will have a dark gray background.
- Current setting. The current settings for visible menu items are shown in the right-hand column, until one menu entry is selected (by pressing the SET key). Current settings aren't appropriate for some menu entries (for example, the Protect Images or Resize options in the Playback 1 and 2 screens), so the right column is left blank.

When you've moved the menu highlighting to the menu item you want to work with, press the SET button to select it. The current settings for the other menu items in the list will be hidden, and a list of options for the selected menu item (or a submenu screen) will appear. Or, you may be shown a separate settings screen for that entry. Within the menu choices, you can scroll up or down with the Quick Control Dial; press SET to select the choice you've made; and press the MENU button again to exit.

Shooting Menu Options

The various direct setting buttons on the top panel of the camera for metering mode/white balance, autofocus/drive mode, and ISO/flash exposure compensation are likely to be the most common settings changes you make, with changes during a session common. You'll find that the Shooting menu options are those that you access second most frequently when you're using your 6D Mark II. You might make such adjustments as you begin a shooting session, or when you move from one type of subject to another. Canon makes accessing these changes very easy.

This section explains the options of the Shooting menus and how to use them. The options you'll find in these red-coded menus include:

- Image Quality
- Image Review
- Release Shutter without Card
- Lens Aberration Correction
- Lens Electronic MF
- External Speedlite Control
- Exposure Compensation/AEB (Automatic Exposure Bracketing)
- ISO Speed Settings
- Auto Lighting Optimizer
- White Balance
- Custom White Balance
- WB Shift/Bkt
- Color Space

- Picture Style
- Long Exposure Noise Reduction
- High ISO Speed Noise Reduction
- Highlight Tone Priority
- Dust Delete Data
- Multiple Exposure
- HDR Mode
- Interval Timer
- Bulb Timer
- Anti-flicker Shooting
- Mirror Lockup
- Aspect Ratio
- Live View Shooting

Image Quality

Options: Resolution: Large (default), Medium, Small 1, Small 2, Small 3; JPEG Compression: Fine (default), Standard; JPEG (default), RAW, or RAW+JPEG

My preference: Resolution: Large; JPEG Compression: Fine; RAW+JPEG

You can choose the image quality settings used by the 6D Mark II to store its files. This is the first entry in the Shooting 1 menu, shown in Figure 11.1. You have three choices to make when selecting a quality setting:

- **Resolution.** The number of pixels captured determines the absolute resolution of the photos you shoot with your 6D Mark II. Your choices range from 26 megapixels (Large or L), measuring 6240 × 4160; 12 megapixels (Medium or M), measuring 4160 × 2768; 6.5 megapixels (Small 1 or S1), measuring 3120 × 2080; and 3.8 megapixels (Small 2 or S2), measuring 2400 × 1600. You can also choose RAW-only sizes of RAW (6240 × 41600; 26MP); M-RAW (4680 × 3120, 15MP); or S-RAW (3120 × 2080, 6.5MP).
- JPEG compression. To reduce the size of your image files and allow more photos to be stored on a given memory card, the 6D Mark II uses JPEG compression to squeeze the images down to a smaller size. This compacting reduces the image quality a little, so you're offered your choice of Fine compression and Normal compression. The symbols help you remember that Fine compression (represented by a quarter-circle) provides the smoothest results, while Normal compression (signified by a stair-step icon) provides "jaggier" images.
- JPEG, RAW, or both. You can elect to store only JPEG versions of the images you shoot or you can save your photos as uncompressed, loss-free RAW files, which consume about four times as much space on your memory card. Or, you can store both at once as you shoot. Many photographers elect to save *both* a JPEG and a RAW file, so they'll have a JPEG version that might be usable as-is, as well as the original "digital negative" RAW file in case they want to do some processing of the image later. You'll end up with two different versions of the same file: one with a JPG extension, and one with the CR2 extension that signifies a Canon RAW file.

To choose the combination you want, access the menus, scroll to Image Quality, and press the SET button. A screen like the one shown in Figure 11.2 will appear with two rows of choices. Spin the Main Dial to choose from:—(no RAW), RAW, M RAW, or S RAW. Rotate the QCD or press the left/right buttons to select one of the JPEG choices:—(no JPEG), Large, Medium, or Small in Fine or Normal compression (represented by smooth and stepped icons, respectively), plus Small 1 and 2, at the resolutions listed above. A red box appears around the currently selected choice. If you choose "--" for both RAW and JPEG, then JPEG Fine will be used. As always, when you've highlighted your selection, press SET to confirm.

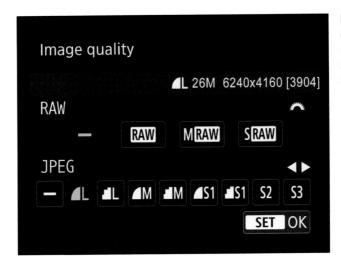

Figure 11.2 Choose your resolution, JPEG compression, and file format from this screen.

Why so many choices? There are some limited advantages to using the Medium and Small resolution settings, Normal JPEG compression setting, and the two lower resolution RAW formats. They all allow stretching the capacity of your memory card so you can shoehorn quite a few more pictures onto a single memory card. That can come in useful when on vacation and you're running out of storage, or when you're shooting non-critical work that doesn't require full resolution. The Small 1 and 2 setting can be useful for photos taken for real estate listings, web page display, photo ID cards, or similar non-critical applications.

For most work, using lower resolution and extra compression is often false economy. You never know when you might need that extra bit of picture detail. Your best bet is to have enough memory cards to handle all the shooting you want to do until you have the chance to transfer your photos to your computer or a personal storage device.

However, reduced image quality can sometimes be beneficial if you're shooting sequences of photos rapidly, as the 6D Mark II is able to hold more of them in its internal memory buffer before transferring to the memory card. Still, for most sports and other applications, you'd probably rather have better, sharper pictures than longer periods of continuous shooting.

JPEG vs. RAW

You'll sometimes be told that RAW files are the "unprocessed" image information your camera produces, before it's been modified. That's nonsense. RAW files are no more unprocessed than your camera film is after it's been through the chemicals to produce a negative or transparency. A lot can happen in the developer that can affect the quality of a film image—positively and negatively—and, similarly, your digital image undergoes a significant amount of processing before it is saved as a RAW file. Canon even applies a name (DIGIC 7) to the digital image processing (DIP) chip used to perform this magic.

A RAW file is more like a film camera's processed negative. It contains all the information, captured in 14-bit channels per color (and stored in a 16-bit space), with no compression, no sharpening, no application of any special filters or other settings you might have specified when you took the picture. Those settings are *stored* with the RAW file so they can be applied when the image is converted to a form compatible with your favorite image editor. However, using RAW conversion software such as Adobe Camera Raw or Canon's Digital Photo Professional, you can override those settings and apply settings of your own. You can select essentially the same changes there that you might have specified in your camera's picture-taking options.

RAW exists because sometimes we want to have access to all the information captured by the camera, before the camera's internal logic has processed it and converted the image to a standard file format. RAW doesn't save as much space as JPEG. What it does do is preserve all the information captured by your camera after it's been converted from analog to digital form. Of course, the 6D Mark II's RAW format preserves the *settings* information.

So, why don't we always use RAW? Although some photographers do save only in RAW format, it's more common to use either RAW plus one of the JPEG options or just shoot JPEG and avoid RAW altogether. That's because having only RAW files to work with can significantly slow down your workflow. RAW is overwhelmingly helpful when an image needs to be fine-tuned. When all you really need is a good-quality, un-tweaked JPEG image, fiddling with a RAW file consumes time that you may not want to waste. For example, RAW images take longer to store on the memory card, and require more post-processing effort, whether you elect to go with the default settings in force when the picture was taken, or just make minor adjustments.

Thus, those who depend on speedy access to images or who shoot large numbers of photos at once may prefer JPEG over RAW. Wedding photographers, for example, might expose several thousand photos during a bridal affair and offer hundreds to clients as electronic proofs for possible inclusion in an album or transfer to a CD or DVD. These wedding shooters, who want JPEG images as their final product, take the time to make sure that their in-camera settings are correct, minimizing the need to post-process photos after the event. Given that their JPEGs are so good (in most cases thanks, in large part, to the pro photographer's extensive experience), there is little need to get bogged down shooting RAW.

JPEG was invented as a more compact file format that can store most of the information in a digital image, but in a much smaller size. JPEG predates most digital SLRs, and was initially used to squeeze down files for transmission over slow dialup connections. Even if you were using an early dSLR with 1.3-megapixel files for news photography, you didn't want to send them back to the office over a modem (Google it) at 1,200 bps.

But, as I noted, JPEG provides smaller files by compressing the information in a way that loses some image data. JPEG remains a viable alternative because it offers several different quality levels. At the highest-quality Fine level, you might not be able to tell the difference between the original RAW file and the JPEG version. You've squeezed the image significantly without losing much visual information at all. (See Figure 11.3.)

In my case, I shoot virtually everything at RAW+JPEG Fine. Most of the time, I'm not concerned about filling up my memory cards, as I usually have a minimum of five fast 32GB or 64GB memory cards with me. If I think I may fill up all those cards, I have Apple's Camera Connection Kit for my iPad, and can transfer photos to that device. As I mentioned earlier, when shooting sports, I'll shift to JPEG Fine (with no RAW file) to squeeze a little extra speed out of my 6D Mark II's continuous shooting mode, and to reduce the need to wade through eight-photo bursts taken in RAW format. On the other hand, on my last trip to Europe, I took only RAW (instead of my customary RAW+JPEG) photos to fit more images onto my iPad, as I planned on doing at least some post-processing on many of the images for a travel book I was working on.

Figure 11.3 Low compression yields the best image (left); at high compression, pixelation and artifacts rear their ugly heads.

Image Review

Options: 2 sec. (default), Off, 4 sec., 8 sec., Hold

My preference: 2 sec.

You can adjust the amount of time an image is displayed for review on the LCD after each shot is taken. You can elect to disable this review entirely (Off), or choose display times of 2, 4, or 8 seconds. You can also select Hold, an indefinite display, which will keep your image on the screen until you use one of the other controls, such as the shutter button, Main Dial, or Quick Control Dial. Turning the review display off or choosing a brief duration can help preserve battery power. However, the 6D Mark II will always override the review display when the shutter button is partially or fully depressed, so you'll never miss a shot because a previous image was on the screen. Choose Review Time from the Shooting 1 menu, and select Off, 2 sec., 4 sec., 8 sec., or Hold. If you want to retain an image on the screen for a longer period, but don't want to use Hold as your default, press the Erase button under the LCD monitor. The image will display until you choose Cancel or Erase from the menu that pops up at the bottom of the screen. A longer review time gives you an opportunity to delete a non-keeper quickly without a visit to the menu system.

Release Shutter without Card

Options: Enable (default), Disable

My preference: Disable

This entry in the Shooting 1 menu gives you the ability to snap off "pictures" without a memory card installed—or to lock the camera shutter release if that is the case. It is sometimes called Play mode, because you can experiment with your camera's features or even hand your 6D Mark II to a friend to let him/her fool around, without any danger of pictures being taken. Back in our film days, we'd sometimes finish a roll, rewind the film back into its cassette surreptitiously, and then hand the camera to a child to take a few pictures—without wasting any film. It's hard to waste digital film, but Release Shutter without Card mode is still appreciated by some, especially camera vendors who want to be able to demo a camera at a store or trade show, but don't want to have to equip every demonstrator model with a memory card. Choose this menu item, press SET, select Enable or Disable, and press SET again to turn this capability on or off.

Lens Aberration Correction

Options: Peripheral illumination correction: Enable (default)/Disable; Distortion correction: Enable/Disable (default); Chromatic Aberration correction: Enable (default)/Disable; Diffraction correction: Enable (default)/Disable

My preference: Use the default values

The 6D Mark II can automatically partially correct for lens aberrations in four different ways, as long as you are using a lens for which correction data is available. Previously, several of these corrections were available only when post-processing the image in Digital Photo Professional or another utility. The four choices (see Figure 11.4), all described in detail in the section that follows, are:

- Peripheral illumination correction. Fixes light fall-off at the edges of an image.
- **Distortion correction.** Adjusts for barrel and pincushion distortion.
- Chromatic aberration correction. Reduces color fringes around the edges of subjects.
- **Diffraction correction.** Corrects for moiré effects produced when shooting at a very small aperture.

I'll explain what each of these components do one at a time, and include some examples of those aspects that can be easily illustrated. When you select this menu option from the Shooting 1 menu, the screen shown in Figure 11.4 appears. The lens currently attached to the camera is shown, along with a notation whether correction data needed to brighten the corners is already registered in the camera. (Information about 25 of the most popular lenses is included in the 6D Mark II's firmware.) If so, you can choose Enable to activate the feature, or Disable to turn it off. Press the SET button to confirm your choice. Note that in-camera correction must be specified *before* you take the photo, so that the advanced DIGIC 7 processing engine can correct your photo before it is saved to the memory card.

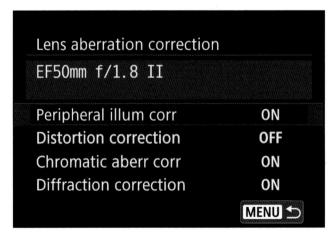

Figure 11.4The Lens Aberration Correction screen.

Peripheral Illumination Correction

One defect is caused by a phenomenon called *vignetting*, which is a darkening of the four corners of the frame because of a slight amount of fall-off in illumination at those nether regions. This menu option allows you to activate Peripheral Illumination Correction, a clever feature built in to the 6D Mark II that partially (or fully) compensates for this effect for any lens included in the camera's internal, updateable (through firmware upgrades) database. Depending on the f/stop you use, the lens mounted on the camera, and the focal length setting, vignetting can be non-existent, slight, or may be so strong that it appears you've used a too-small hood on your camera. (Indeed, the wrong lens hood can produce a vignette effect of its own.) Vignetting can be affected by the use of a telephoto converter.

Peripheral illumination drop-off, even if pronounced, may not be much of a problem. I add vignetting, sometimes, when shooting portraits and some other subjects. Slightly dark corners tend to focus attention on a subject in the middle of the frame. On the other hand, vignetting with subjects that are supposed to be evenly illuminated, such as landscapes, is seldom a benefit.

To minimize the effects of corner light fall-off, you can process RAW files using Digital Photo Professional or, if you want your JPEG files fixed as you shoot them, by using this menu option. Figure 11.5 shows an image at top left without peripheral illumination correction, and a corrected image at bottom left. I've exaggerated the vignetting a little to make it more evident on the printed page. Keep in mind that the amount of correction available with Digital Photo Pro can be a little more intense than that applied in the camera. In addition, the higher the ISO speed, the less correction is applied. If you see severe vignetting with a particular lens, focal length, or ISO setting, you might want to turn off this feature, shoot RAW, and apply correction using DPP instead.

Distortion Correction

This option makes adjustments to correct barrel and pincushion distortion, based on information in the camera's database.

Barrel distortion is found in some wide-angle lenses, and causes straight lines to bow outward, with the strongest effect at the edges. In fisheye (or *curvilinear*) lenses, this defect is a feature. When distortion is not desired, you'll need to use a lens that has corrected barrel distortion. Manufacturers like Canon do their best to minimize or eliminate it (producing a *rectilinear* lens), often using *aspherical* lens elements (which are not cross-sections of a sphere). You can also minimize less severe barrel distortion simply by framing your photo with some extra space all around, so the edges where the defect is most obvious can be cropped out of the picture. If none of the above work, you can apply this feature, which is disabled by default, to "undistort" your image with some bending of its own.

Pincushion distortion is a trait of many telephoto lenses, producing lines that curve inward toward the center of the frame. You might find after a bit of testing that it is worse at certain focal lengths with your particular zoom lens. Like chromatic aberration, it can be partially corrected using tools like Photoshop's Lens Correction filter and Photoshop Elements' Correct Camera Distortion filter, Digital Photo Professional, or this in-camera feature.

Chromatic Aberration

Another defect involves fringes of color around backlit objects, produced by *chromatic aberration*, which comes in two forms: *longitudinal/axial*, in which all the colors of light don't focus in the same plane, and *lateral/transverse*, in which the colors are shifted in one direction. (See Figure 11.5, top right.) When this feature is enabled, the camera will automatically correct images taken with one of the supported lenses to reduce or eliminate the amount of color fringing seen in the final photograph. (See Figure 11.5, bottom right.)

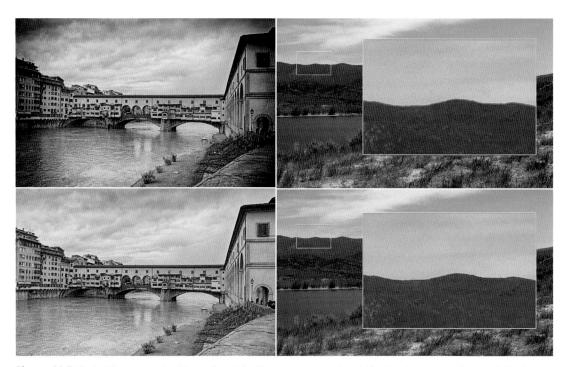

Figure 11.5 Left: Vignetting (top) is undesirable. You can correct this defect in the camera (bottom). Right: Color fringes can be corrected using the lens aberration correction feature (right top and bottom).

Diffraction Correction

Diffraction is a phenomenon that can cause a reduction in the apparent sharpness of your image due to scattering and interference of photons as they pass through smaller lens openings. In effect, the edges of your lens aperture affects proportionately more photons as the f/stop grows smaller. The relative amount of space available to pass freely decreases, and the amount of edge surface that can collide with incoming light increases.

The best analogy I can think of is a pond with two floating docks sticking out into the water, as shown in Figure 11.6. Throw a big rock in the pond, and the ripples pass between the docks relatively smoothly if the structures are relatively far apart (top). Move them closer together (bottom), and some ripples rebound off each dock to interfere with the incoming wavelets. In a lens, smaller apertures produce the same effect.

With the 6D Mark II, Canon has greatly expanded the list of lens data included within the camera itself. However, if lens aberration correction information for your lens is not registered in the camera, you can often remedy that deficit using the most recent version of the EOS Utility.

Figure 11.6
Diffraction
interference can
be visualized as
ripples on a lake.

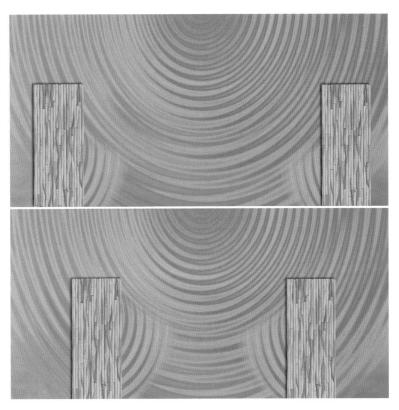

Just follow these steps:

- 1. Link up your camera. Connect your 6D Mark II to your computer using a USB cable.
- 2. **Launch the EOS utility.** Load the utility and click on Camera Settings/Remote Shooting from the splash screen that appears.
- 3. **Select the Shooting menu.** It's located on the menu bar located about midway in the control panel that appears on your computer display. The Shooting menu icon is the white camera on a red background.
- 4. Click on the Lens Aberration Correction choice. The selection screen will appear.
- 5. **Choose your lens.** Select the category containing the lens you want to register from the panels at the top of the new screen; then place a check mark next to all the lenses you'd like to register in the camera.
- 6. **Confirm your choice.** Click OK to send the data from your computer to the 6D Mark II and register your lenses.
- 7. **Activate correction.** When a newly registered lens is mounted on the camera, you will be able to activate the anti-vignetting feature for that lens from the Set-up 1 menu.

Lens Electronic Manual Focus

Options: Disable after One-Shot AF (default), Enable after One-Shot AF

My preference: Disable

Certain Canon lenses with USM or STM focus motors offer an electronic manual focus option when using the One-Shot AF mode. When enabled, you can continue to adjust the focus already achieved by the AF system as long as you hold the shutter button down halfway. If you release the button, the 6D Mark II will refocus the next time you press the shutter release.

At the time I write this, there are nearly two-dozen lenses with this feature. Check page 155 of your 6D Mark II manual, or Canon's web page for the most up-to-date listing. I'll explain the difference between USM, STM, and other AF motors in Chapter 10. When this feature is enabled, you can fine-tune focus using the electronic focus system, which is also called "focus-by-wire" because the focus motor is used to make the adjustment rather than mechanical gearing. It works with compatible lenses to fine-tune focus manually after autofocus has taken place. This capability can be used for both movies and still photography.

External Speedlite Control

This multi-level menu entry includes settings for controlling the Canon 6D Mark II's accessory flash units attached to the camera (see Figure 11.7). I'll provide in-depth coverage of how you can use these options in Chapters 9 and 10, but will list the main options here for reference.

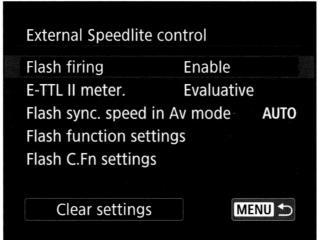

Flash Firing

Use this option to enable or disable the attached electronic flash. Choose Enable, and the flash fires normally when it's attached to the camera and powered up. Select Disable, and the flash itself will not fire, but the AF-assist beam emitted by the unit will function normally. You might want to use the latter option when you prefer to shoot under low levels of existing light, but still need the autofocusing boost the flash's AF beam provides.

E-TTL II Metering

You can choose Evaluative (Matrix) or Average metering modes for the electronic flash exposure meter. Evaluative looks at selected areas in the scene to calculate exposure, and is the best choice for most images because it attempts to interpret the type of scene being shot; Average calculates flash exposure by reading the entire scene, and it is possibly a good option if you want exposure to be calculated for the overall scene.

Flash Sync Speed in Av Mode

You can select the flash synchronization speed that will be used when working in Aperture-priority mode; choose from Auto (the 6D Mark II selects the shutter speed from 30 seconds to 1/180th second), to a range embracing only the speeds from 1/180th to 1/60th second, or fixed at 1/180th second.

Normally, in Aperture-priority mode when using flash, you specify the f/stop to be locked in. The camera then adjusts exposure by varying the output of the electronic flash. Because the primary exposure comes from the flash, the main effect of the shutter speed selected is on the secondary exposure from the ambient light remaining on the scene.

Auto is your best choice under most conditions. The 6D Mark II will choose a shutter speed that balances the flash exposure and available, ambient light. The 1/180th-1/60th second setting locks out slower shutter speeds, preventing blur from camera/subject movement in the secondary ("ghost") exposure. However, the background may be rendered dark if the flash is not strong enough to illuminate it. The 1/180th second (fixed) setting further reduces the chance of getting those blurry ghosts, but there is more of a chance the background will be dark. You'll find a more detailed explanation of these options in Chapter 9.

Flash Function Settings

There is a total of six possible choices for this menu screen, plus Clear Settings. The additional options are grayed out unless you're working in wireless flash mode. All these are explained in Chapters 9 and 10.

- Flash mode. This entry allows you to choose from automatic exposure calculation (E-TTL II) or manual flash exposure.
- Wireless functions. These choices include Mode, Channel, Firing Group, and other options used only when you're working in wireless mode to control a wireless-capable external flash. If you've disabled wireless functions, the other options don't appear on the menu. I'm going to leave the explanation of these options for Chapter 10, which is an entire chapter dedicated to using the 6D Mark II's wireless shooting capabilities.
- Zoom. Use this to select a flash zoom head setting to adjust coverage area of compatible Speedlites.
- Shutter sync. You can choose First-curtain sync, which fires the pre-flash used to calculate the exposure before the shutter opens, followed by the main flash as soon as the shutter is completely open. This is the default mode, and you'll generally perceive the pre-flash and main flash as a single burst. Alternatively, you can select Second-curtain sync, which fires the preflash as soon as the shutter opens, and then triggers the main flash in a second burst at the end of the exposure, just before the shutter starts to close. (If the shutter speed is slow enough, you may clearly see both the pre-flash and main flash as separate bursts of light.) This action allows photographing a blurred trail of light of moving objects with sharp flash exposures at the beginning and the end of the exposure. This type of flash exposure is slightly different from what some other cameras produce using second-curtain sync. I explained how it works in Chapter 9. If you have an external compatible Speedlite attached, you can also choose High-speed sync,

which allows you to use shutter speeds faster than 1/180th second, using the External Flash Function Setting menu.

- Flash exposure compensation. If you'd rather adjust flash exposure using a menu than with the ISO/Flash exposure compensation button, you can do that here. (If you happen to specify a value with both, this menu entry overrides the button-selected value.) Select this option with the SET button, then dial in the amount of flash EV compensation you want using the Quick Control Dial. The EV that was in place before you started to make your adjustment is shown as a blue indicator, so you can return to that value quickly. Press SET again to confirm your change, then press the MENU button twice to exit.
- Flash exposure bracketing. Use these settings to specify options for adjusting the output of your unit when using bracketing with your compatible electronic flash.

Clear Flash Settings

This entry changes the settings of a compatible EX-series flash to their defaults. You can access this menu only when you have a compatible electronic flash attached and switched on.

Flash Custom Function Settings

Many external Speedlites from Canon include their own list of Custom Functions, which can be used to specify things like flash metering mode and flash bracketing sequences, as well as more sophisticated features, such as modeling light/flash (if available), use of external power sources (if attached), and functions of any slave unit attached to the external flash. This menu entry allows you to set an external flash unit's Custom Functions from your 6D Mark II's menu. The exact functions available will vary by flash unit. For example, with the Speedlite 320EX, only Custom Functions 1 (Auto Power Off), 6 (Quick Flash with Continuous Shot), 10 (Slave Auto Power Off Timer), and 11 (Slave Auto Power Off Cancel) are available. With high-end units, like the Speedlite 600EX-RT, a broader range of choices (described in Chapter 9) are at your disposal.

Exposure Compensation/Automatic Exposure Bracketing

Options: Exposure comp./Auto exposure bracketing

My preference: N/A

The first entry on the Shooting 2 menu is Expo. Comp./AEB, or exposure compensation and automatic exposure bracketing. (See Figure 11.8.) As you learned in Chapter 4, exposure compensation (added/subtracted by pressing the Quick Control Dial while this menu screen is visible) increases or decreases exposure from the metered value.

Exposure bracketing using the 6D Mark II's AEB feature is a way to shoot several consecutive exposures using different settings, to improve the odds that one will be exactly right. Automatic exposure bracketing is also an excellent way of creating the base exposures you'll need when you want to combine several shots to create a high dynamic range (HDR) image. (You'll find a discussion of HDR photography in Chapter 4, too.)

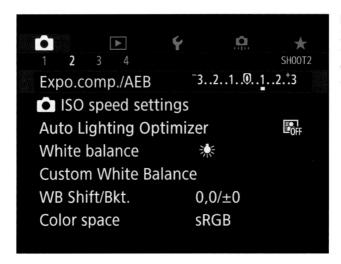

Figure 11.8
Exposure compensation/AEB is the first entry in the Shooting 2 menu.

To activate automatic exposure bracketing, select this menu choice, then rotate the Main Dial to spread or contract the three lines beneath the scale until you've defined the range you want the bracket to cover, which can be up to plus/minus three stops from the base exposure, as shown in Figure 11.9. Then, use the Quick Control Dial to move the bracket set right or left, moving the base exposure point from the metered (0) value and biasing the bracketing toward underexposure (rotate left) or overexposure (rotate right).

When AEB is activated, the bracketed shots will be exposed in this sequence: metered exposure, decreased exposure, increased exposure. You'll find more information about exposure bracketing in Chapter 4.

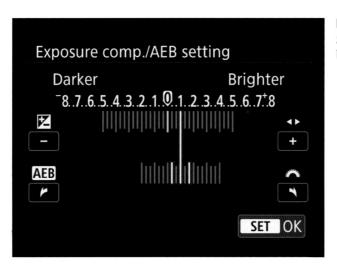

Figure 11.9 Set the range of the bracketed exposures.

ISO Speed Settings

Options: ISO speed, Range for stills, Auto range, Minimum shutter speed My preference: N/A

Use this entry to select a specific ISO speed using a menu instead of the top-panel ISO button/menus, or to limit the range of ISO settings and shutter speeds that the camera selects automatically. The four subentries include:

- **ISO speed.** This scale allows you to choose from the enabled ISO speeds, plus Auto, using a sliding scale that can be adjusted using the QCD, multi-controller, or the touch screen. Press INFO. when the scale is visible to activate Auto.
- Range for stills. You can specify the minimum and maximum ISO sensitivity available, including "expanded" settings such as Low (ISO 50 equivalent) and H1 or H2 (ISO 51200 and 102400 equivalent, respectively). I find myself using this feature frequently to keep me from accidentally switching to a setting I'd rather (or need to) avoid. For example, at concerts I may switch from ISO 1600 to 6400 as the lighting changes, and I set those two values as my minimum or maximum. Outdoors in daylight, I might prefer to lock out ISO values lower than ISO 100 or higher than ISO 800.
- **Auto range.** This is the equivalent "safety net" for Auto ISO operation. You can set the *minimum* no lower than ISO 100 and the maximum to ISO 25600, and no further. The *maximum* can be set within the range of ISO 200 to ISO 40000. Use this entry to apply your own "smarts" to the auto ISO setting.
- Minimum shutter speed. You can choose whether to allow the 6D Mark II to select the slowest shutter speed used before Auto ISO kicks in when using Program or Aperture-priority modes (these are the semi-auto modes that can adjust shutter speeds). The idea here is that you'll probably want to boost ISO sooner if you're using a long lens with P and Av modes (in which the camera selects the shutter speed). If you specify, for example, a minimum shutter speed of 1/250th second, if P or Av mode needs a slower shutter speed for the proper exposure, it will boost ISO instead, within the range you've specified with Auto Range.

This setting has two modes. In Auto mode, the camera decides when the shutter speed is too low. You can fine-tune this by choosing Slower or Faster on the scale (–3 to +3) that appears. Or, you can manually select the "trigger" shutter speed, from 1 second to 1/4000th second.

However, if you've handicapped the 6D Mark II by selecting an Auto ISO range that doesn't include a sensitivity high enough, the camera will *override this setting* and use a shutter speed lower than the minimum you specify anyway. The camera assumes (rightly or wrongly) that your upper ISO boundary is more important than your lower shutter speed limit. The lesson here is that if you really, really want to enforce a minimum shutter speed when using Auto ISO, make sure your upper limit is high enough. Note that the Minimum Shutter Speed setting is ignored when using flash.

Auto Lighting Optimizer

Options: Disable, Low, Standard (default), High

My preference: Disable

The Auto Lighting Optimizer provides a partial fix for images that are too dark or flat. Such photos typically have low contrast, and the Auto Lighting Optimizer improves them—as you shoot—by increasing both the brightness and contrast as required. The feature can be activated in Program, Aperture-priority, and Shutter-priority modes. You can select from four settings: Standard (the default value, which is always selected when using Scene Intelligent Auto mode, and used for Figure 11.10), plus Low, High, and Disable. Press the INFO. button to add/remove a check mark icon that

Figure 11.10
Auto Lighting
Optimizer can
brighten dark,
low-contrast images
(top), giving them a
little extra snap and
brightness (bottom).

indicates the Auto Lighting Optimizer is disabled during manual exposure. Since you're likely to be specifying an exposure in Manual mode, you probably don't want the optimizer to interfere with your settings, so disabling the feature is the default.

White Balance

Options: Auto (default), Daylight, Shade, Cloudy, Tungsten, White fluorescent, Flash, Custom, Color Temperature

My preference: N/A

If automatic white balance or one of the preset settings available (Auto, Daylight, Shade, Cloudy, Tungsten, White Fluorescent, or Flash) aren't suitable, you can set a custom white balance using this menu option or a specific color temperature value. The screen shown in Figure 11.11 is identical to the one that pops up when you select White Balance from the Quick Control screen. You can also select White Balance using the Metering Mode/WB button on top of the camera, which produces a slightly different screen that allows you to choose metering mode with the Main Dial, and White Balance with the Quick Control Dial. If you choose the "K" entry, you can select an exact color temperature from 2,500K to 10,000K using the Main Dial.

Of course, unless you own a specialized tool called a color temperature meter, you probably won't know the exact color temperature of your scene. However, knowing the color temperatures of the preset options can help you if you decide to tweak them by choosing a different color temperature setting.

Figure 11.11
White balance presets can be chosen here.

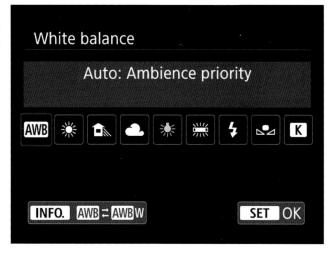

The values used by the 6D Mark II are as follows, with two options available for Auto:

- Auto (AWB). 3,000–7,000K Press the INFO. button when this is selected to toggle between Ambience Priority (to keep warm color under tungsten light) or White Priority (to produce neutral whites even under tungsten illumination).
- **Daylight.** 5,200K
- **Shade.** 7,000K
- **Cloudy.** 6,000K
- **Tungsten.** 3,200K
- White fluorescent. 4,000K
- Flash. 6,000K
- **Custom.** 2,000–10,000K
- Color temperature. 2,500–10,000K (Settable in 100K increments)

Choosing the right white balance can have a dramatic effect on the colors of your image, as you can see in Figure 11.12.

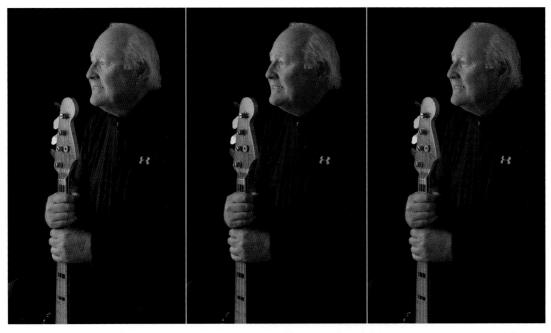

Figure 11.12 Adjusting color temperature can provide different results of the same subject at 3,400K (left), 5,000K (center), and 2,800K (right).

The problem with the available presets (Daylight, Shade, etc.) is that you have only six of them, and in any given situation, all of them are likely to be wrong—strictly speaking. The good news is that they are likely to be only a *little bit* wrong. The human eye is very adaptable, so in most cases you'll be perfectly happy with the results you get if you use Auto, or choose a preset that's in the white balance ballpark.

But if you absolutely must have the correct color balance, or are frequently dissatisfied with the color balance the 6D Mark II produces when using Auto or one of the presets, you can always shoot RAW, and adjust the final color balance in your image editor when converting the .cr2 file. Or, you can use a custom white balance procedure, described next.

If automatic white balance or one of the preset settings aren't suitable, you can set a custom white balance using this menu option. The custom setting you establish will then be applied whenever you select Custom using the White Balance menu entry described earlier.

To set the white balance to an appropriate color temperature under the current ambient lighting conditions, focus manually (with the lens set on MF) on a plain white or gray object, such as a card or wall, making sure the object fills the spot metering circle in the center of the viewfinder. Then, take a photo. Next press the MENU button and select Custom WB from the Shooting 2 menu. Use the Quick Control Dial until the reference image you just took appears and press the SET button to store the white balance of the image as your Custom setting.

Using an ExpoDisc

Many photographers prefer to use a gadget called an ExpoDisc, from ExpoImaging, Inc. (www.expoimaging.com), which fits over (or attaches to) the front of your lens and provides a diffuse neutral (or semi-neutral) subject to measure with your camera's custom white balance feature. ExpoDiscs cost \$75 to \$100 or so, depending on the filter size of your lens, but many just buy the 77mm version and hold it in front of their lens. (There's a strap attached, so you won't lose it.) Others have had mixed success using less-expensive alternatives (such as the lid of a Pringles can). ExpoImaging also makes ExpoCap lens caps with similar diffusing features, and you can leave one of them on your lens at all times (at least, when you're not shooting).

There are two models, the standard ExpoDisc Neutral, and a Portrait model that produces a slightly warmer color balance suitable for portraits. The product produces the best results when you use it to measure the *incident light*; that is, the light falling onto your subject. In other words, instead of aiming your camera at your subject from the shooting position, take the time (if it's possible) to position yourself at the subject position and point your ExpoDisc-equipped lens toward the light source that will illuminate the scene. (However, don't point your camera directly at the Sun! Aim at the sky instead.)

I like to use the ExpoDisc in two situations:

- Outdoors under mixed lighting. When you're shooting outdoors, you'll often find that your scene is illuminated by direct sunlight as well as by open shade, full shade, or a mixture of these. A custom white balance reading can help you zero in on the correct color balance in a situation that's hard to judge visually.
- When using studio flash. It's a nasty secret that many studio flash units change color temperature when you adjust the power slider to scale down the output. Perhaps your 1600ws (watt second) flash puts out too much light to allow you to use a larger f/stop for selective focus. So, you dial it down to 1/4 power. That will likely change the color temperature of the unit slightly, particularly when compared to your 800ws fill light, which you've reduced to half power. You can use the ExpoDisc to measure the color temperature of your main light at its new setting, or aim it between two lights to obtain an average reading. The result will probably be close enough to the correct color temperature to satisfy most studio shooters.

Custom White Balance

Options: White balance setting

My preference: N/A

If automatic white balance or one of the preset settings (Daylight, Shade, Cloudy, Tungsten, White Fluorescent, or Flash) aren't suitable, you can set a custom white balance using this menu option. The custom setting you establish will then be applied whenever you select Custom using the White Balance menu.

To set the white balance to an appropriate color temperature under the current ambient lighting conditions, focus manually (with the lens set on MF) on a plain white or gray object, such as a card or wall, making sure the object fills the spot metering circle in the center of the viewfinder. Then, take a photo. Next, press the MENU button and select Custom WB from the Shooting 2 menu. Rotate the Quick Control Dial until the reference image you just took appears and choose SET to store the white balance of the image as your Custom setting. Only compatible images that can be used to specify a custom white balance will be shown on the screen. Custom white balance images are marked with a custom icon, and cannot be removed (although they can be replaced with a new custom white balance image).

White Balance Shift/Bracketing

Options: WB bias and WB bracketing

My preference: N/A

White balance shift allows you to dial in a white balance color bias along the blue/amber (yellow) dimensions, and/or green/magenta scale. In other words, you can set your color balance so that it is a little bluer or yellower (only), a little more magenta or green (only), or a combination of the two bias dimensions. You can also bracket exposures, taking several consecutive pictures each with a slightly different color balance biased in the directions you specify.

The process is a little easier to visualize if you look at Figure 11.13. The center intersection of lines BA and GM (remember high school geometry!) is the point of zero bias. Use the multi-selector directional buttons to shift the white balance, and the Quick Control Dial to activate bracketing at any point on the graph using the blue/amber and green/magenta coordinates. The amount of shift will be displayed in the SHIFT box to the right of the graph.

White balance bracketing is like white balance shifting, only the bracketed changes occur along the bias axis you specify. The three squares in Figure 11.13 show that the white balance bracketing will occur in three-stop steps, shifted two increments "up" toward the green bias, and two increments "right" along the blue/amber axis. The amount of the bracketing is shown in the boxes at the right side of the graph.

This form of bracketing is like exposure bracketing, but with the added dimension of hue. Bias bracketing can be performed in any JPEG-only mode. You can't use any RAW format or RAW+JPEG format because the RAW files already contain the information needed to fine-tune the white balance and white balance bias.

Figure 11.13

Use the Quick
Control Dial and
multi-controller to
specify color balance
bracketing using
green/magenta bias
or to specify blue/
amber bias.

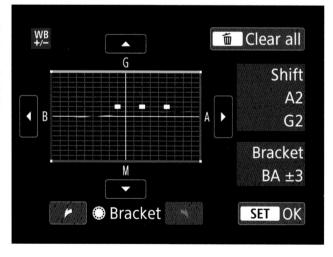

When you select WB SHIFT/BKT, the adjustment screen appears. First, you press the Quick Control Dial to set the *range* of the shift in either the green/magenta dimension (move to the left to change the vertical separation of the three dots representing the separate exposures) or in the blue/amber dimension by pressing to the right. Use the multi-controller directional buttons to move the bracket set around within the color space, and outside the green/magenta or blue/amber axes.

In most cases, it's easy to determine if you want your image to be more green, more magenta, more blue, or more yellow, although judging your current shots on the LCD screen can be tricky unless you view the screen in a darkened location so it will be bright and easy to see. Bracketing is covered in Chapter 4.

Color Space

Options: sRGB (default), Adobe RGB

My preference: I use the expanded Adobe RGB color space.

When you are using one of the Creative Zone modes, you can select one of two different color spaces (also called *color gamuts*) using this menu entry, shown previously among the other menu choices in Figure 11.8. One color space is named *Adobe RGB* (because it was developed by Adobe Systems in 1998), while the other is called *sRGB* (supposedly because it is the *standard* RGB color space). These two color gamuts define a specific set of colors that can be applied to the images your 6D Mark II captures.

The Color Space menu choice applies directly to JPEG images shot using P, Tv, Av, and M exposure modes. When you're using Scene Intelligent Auto mode, the 6D Mark II uses the sRGB color space for all the JPEG images you take. RAW images are a special case. They have the information for both sRGB and Adobe RGB, but when you load such photos into your image editor, it will default to sRGB (with Scene Intelligent Auto or Creative Auto shots) or the color space specified here, unless you change that setting while importing the photos. (See the "Best of Both Worlds" sidebar that follows for more information.)

You may be surprised to learn that the 6D Mark II doesn't automatically capture *all* the colors we see. Unfortunately, that's impossible because of the limitations of the sensor and the filters used to capture the fundamental red, green, and blue colors, as well as that of the elements used to display those colors on your camera and computer monitors. Nor is it possible to *print* every color our eyes detect, because the inks or pigments used don't absorb and reflect colors perfectly. In short, your sensor doesn't capture all the colors that we can see, your monitor can't display all the colors that the sensor captures, and your printer outputs yet another version.

On the other hand, the 6D Mark II does capture quite a few more colors than we need. The original 14-bit RAW image contains a possible 4.4 *trillion* different hues, which are condensed down to a mere 16.8 million possible colors when converted to a 24-bit (eight bits per channel) image. While 16.8 million colors may seem like a lot, it's a small subset of 4.4 trillion captured, and an even

smaller subset of all the possible colors we can see. The set of colors, or gamut, that can be reproduced or captured by a given device (scanner, digital camera, monitor, printer, or some other piece of equipment) is represented as a color space that exists within the larger full range of colors.

That full range is represented by the odd-shaped splotch of color shown in Figure 11.14, as defined by scientists at an international organization called the International Commission on Illumination (usually known as the CIE for its French name *Commission internationale de l'éclairage*) back in 1931. The colors possible with Adobe RGB are represented by the larger, black triangle in the figure, while the sRGB gamut is represented by the smaller white triangle.

A third color space, ProPhoto RGB, represented by the yellow triangle in the figure, has become more popular among professional photographers as more and more color printing labs support it. While you cannot *save* images using the ProPhoto gamut with your 6D Mark II, you can convert your photos to 16-bit ProPhoto format using Adobe Camera RAW when you import RAW photos into an image editor. ProPhoto encompasses virtually all the colors we can see (and some we can't), giving advanced photographers better tools to work with in processing their photos. It has richer reds, greens, and blues, although, as you can see from the figure, its green and blue primaries are imaginary (they extend outside the visible color gamut). Those with exacting standards need not use a commercial printing service if they want to explore ProPhoto RGB: many inkjet printers can handle cyans, magentas, and yellows that extend outside the Adobe RGB gamut.

Figure 11.14
The outer curved figure shows all the colors we can see; the outlines show the boundaries of Adobe RGB (black triangle), sRGB (white triangle), and ProPhoto RGB (yellow triangle).

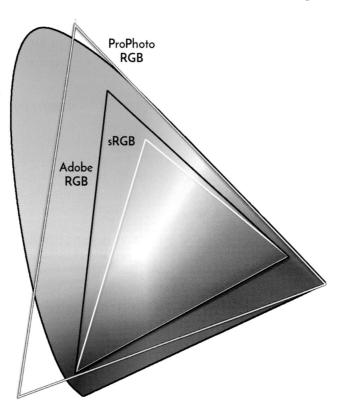

270

Regardless of which triangle—or color space—is used by the 6D Mark II, you end up with some combination of 16.8 million different colors that can be used in your photograph. (No one image will contain all 16.8 million! To require that many, only about two pixels of any one color could be the same in a 36-megapixel image!) But, as you can see from the figure, the colors available will be different.

Adobe RGB, like ProPhoto RGB, is an expanded color space useful for commercial and professional printing, and it can reproduce a wider range of colors. It can also come in useful if an image is going to be extensively retouched, especially within an advanced image editor, like Adobe Photoshop, which has sophisticated color management capabilities that can be tailored to specific color spaces. As an advanced user, you don't need to automatically "upgrade" your 6D Mark II to Adobe RGB, because images tend to look less saturated on your monitor and, it is likely, significantly different from what you will get if you output the photo to your personal inkjet. (You can *profile* your monitor for the Adobe RGB color space to improve your on-screen rendition using widely available color calibrating hardware and software.)

While both Adobe RGB and sRGB can reproduce the exact same 16.8 million absolute colors, Adobe RGB spreads those colors over a larger portion of the visible spectrum, as you can see in the figure. Think of a box of crayons (the jumbo 16.8 million crayon variety). Some of the basic crayons from the original sRGB set have been removed and replaced with new hues not contained in the original box. Your "new" box contains colors that can't be reproduced by your computer monitor, but which work just fine with a commercial printing press. For example, Adobe RGB has more "crayons" available in the cyan-green portion of the box, compared to sRGB, which is unlikely to be an advantage unless your image's final destination are the cyan, magenta, yellow, and black inks of a printing press.

The other color space, sRGB, is recommended for images that will be output locally on the user's own printer, as this color space matches that of the typical inkjet printer fairly closely. You might prefer sRGB, which is the default for the Nikon 6D Mark II and most other cameras, as it is well suited for the range of colors that can be displayed on a computer screen and viewed over the Internet. If you plan to take your image file to a retailer's kiosk for printing, sRGB is your best choice, because those automated output devices are calibrated for the sRGB color space that consumers use.

BEST OF BOTH WORLDS

As I mentioned, if you're using a Basic Zone mode, the 6D Mark II selects the sRGB color space automatically. In addition, you may choose to set the sRGB color space with this menu entry to apply that gamut to all your other photos as well. But, in either case, you can still easily obtain Adobe RGB versions of your photos if you need them. Just shoot using RAW+JPEG. You'll end up with sRGB JPEGs suitable for output on your own printer, but you can still extract an Adobe RGB version from the RAW file at any time. It's like capturing two different color spaces at once—sRGB and Adobe RGB—and getting the best of both worlds.

Of course, choosing the right color space doesn't solve the problems that result from having each device in the image chain manipulating or producing a slightly different set of colors. To that end, you'll need to investigate the wonderful world of *color management*, which uses hardware and software tools to match or *calibrate* all your devices, as closely as possible, so that what you see more closely resembles what you capture, what you see on your computer display, and what ends up on a printed hardcopy. Entire books have been devoted to color management, and most of what you need to know doesn't directly involve your Canon 6D Mark II, so I won't detail the nuts and bolts here.

To manage your color, you'll need, at the bare minimum, some sort of calibration system for your computer display, so that your monitor can be adjusted to show a standardized set of colors that is repeatable over time. (What you see on the screen can vary as the monitor ages, or even when the room light changes.) I use a Datacolor (www.datacolor.com) Spyder 5 monitor color correction system for my computer's dual 26-inch wide-screen LCD displays. It checks room light levels every five minutes, and reminds me to recalibrate every week or two using a small sensor device that attaches temporarily to the front of the screen and interprets test patches that the software displays during calibration. The rest of the time, the sensor sits in the stand, measuring the room illumination, and adjusting my monitors for higher or lower ambient light levels.

Picture Style

Options: Auto (default), Standard, Portrait, Landscape, Fine detail, Neutral, Faithful, Monochrome, three User Styles

My preference: Auto

Jump to the Shooting 3 menu, and the entry you'll find at the top of the listings is Picture Style (see Figure 11.15). This feature is one of the most important tools for customizing the way your Canon 6D Mark II renders its photos. Picture Styles are a type of fine-tuning you can apply to your photos to change certain characteristics of each image taken using a particular Picture Style setting. The parameters you can specify for full-color images include the amount of sharpness, degree of contrast, the richness of the color, and the hue of skin tones. For black-and-white images, you can tweak the sharpness and contrast, but the two color adjustments (meaningless in a monochrome image) are replaced by controls for filter effects (which I'll explain shortly), and sepia, blue, purple, or green tone overlays.

The Canon 6D Mark II has preset Picture Styles for Standard, Portrait, Landscape, Fine Detail, Neutral, and Faithful pictures, plus Auto, and three user-definable settings called User Def. 1, User Def. 2, and User Def. 3, which you can define to apply to any sort of shooting situation you want, such as sports, architecture, or baby pictures. There is also a seventh, Monochrome, Picture Style that allows you to adjust filter effects or add color toning to your black-and-white images. See Figure 11.16 for the main Picture Style menu.

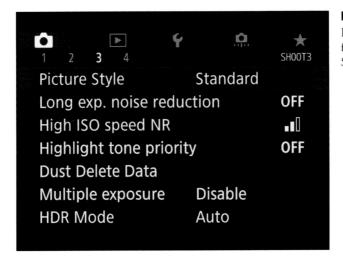

Figure 11.15 Picture Style is the first entry in the Shooting 3 menu.

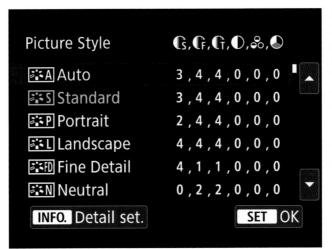

Figure 11.16
Picture Styles are available from this scrolling menu; these six, plus Faithful,
Monochrome, and three User Def. styles that become visible when you scroll down the list.

Picture Styles are extremely flexible. Canon has set the parameters for Auto and the predefined color Picture Styles and the single monochrome Picture Style to suit the needs of most photographers. But you can adjust any of those "canned" Picture Styles to settings you prefer. Better yet, you can use those three User Definition files to create brand-new styles that are all your own. If you want rich, bright colors to emulate Velvia film or the work of legendary photographer Pete Turner, you can build your own color-soaked style. If you want soft, muted colors and less sharpness to create a romantic look, you can do that, too. Perhaps you'd like a setting with extra contrast for shooting outdoors on hazy or cloudy days.

The current settings for each are arrayed along the top in Figure 11.16 as icons, left to right: S (sharpness strength), F (sharpness fineness), T (sharpness threshold), Contrast (a half white/half black circle), Saturation (a triangle composed of three circles), and Color Tone (a circle divided into thirds). When you scroll down within the Monochrome Picture Style, Filter Effect (overlapping circles) and Toning Effect (paintbrush tip) appear. These parameters, applied when using Picture Styles, are described next.

- Sharpness. This parameter determines the apparent contrast between the outlines or edges in an image, which we perceive as image sharpness. When adjusting sharpness, remember that more is not always a good thing. A little softness is necessary (and is introduced by a blurring "anti-alias" filter in front of the sensor) to reduce or eliminate the moiré effects that can result when details in your image form a pattern that is too close to the pattern, or frequency, of the sensor itself. The default levels of sharpening were chosen by Canon to allow most moiré interference to be safely blurred to invisibility, at the cost of a little sharpness. As you boost sharpness (either using a Picture Style or in your image editor), moiré can become a problem, plus, you may end up with those noxious "halos" that appear around the edges of images that have been oversharpened. Use this adjustment with care. You have three individual parameters within this setting that you can adjust individually:
 - **Strength.** Set the intensity of the sharpening on an eight-step scale from 0 (weak outline emphasis) to 7 (strong outline emphasis). Adding too much strength can result in a halo and excess detail around the edges within your image.
 - Fineness. This determines which edges will be emphasized, on a scale of 1 (sharpens the finest lines in your image) to 5 (sharpens only larger, coarser lines). Use a lower number if you anticipate your image will have a wealth of fine detail that you want to emphasize, such as a heavily textured subject. A larger number might be better for portraits, so that eyes and hair might be sharpened, but not skin defects. Changes in Fineness and Threshold (which follows) do not apply when shooting movies.
 - Threshold. This setting uses contrast between the edges being sharpened and the surrounding areas, to determine the degree of sharpening applied to the outlines. It uses a scale from 1 to 5, with lower numbers allowing sharpening when there is less contrast between the edge and surroundings. There is an increase in noise when a low threshold is set. Higher numbers produce sharpening only when the contrast between edge and adjacent pixels is already high. The highest numbers can produce excessive contrast and a posterlike effect.
- **Contrast.** Use this control, with values from −4 (low contrast) to +4 (higher contrast), to change the number of middle tones between the deepest blacks and brightest whites. Low-contrast settings produce a flatter-looking photo, while high-contrast adjustments may improve the tonal rendition while possibly losing detail in the shadows or highlights.

- 274
 - **Saturation.** This parameter, adjustable from −4 (low saturation) to +4 (high saturation) controls the richness of the color, making, say, a red tone appear to be deeper and fuller when you increase saturation, and tend more toward lighter, pinkish hues when you decrease saturation of the reds. Boosting the saturation too much can mean that detail may be lost in one or more of the color channels, producing what is called "clipping." You can detect this phenomenon when using the RGB histograms, as described in Chapter 4.
 - Color tone. This adjustment has the most effect on skin tones, making them either redder (0 to -4) or yellower (0 to +4).
 - Filter effect (Monochrome only). Filter effects do not add any color to a black-and-white image. Instead, they change the rendition of gray tones as if the picture were taken through a color filter. I'll explain this distinction more completely in the sidebar "Filters vs. Toning" later in this section.
 - Toning effect (Monochrome only). Using toning effects preserves the monochrome tonal values in your image, but adds a color overlay that gives the photo a sepia, blue, purple, or green cast.

The predefined Picture Styles are as follows:

- Auto. Adjusts the color to make outdoor scenes look more vivid, with richer colors.
- **Standard.** This Picture Style applies a set of parameters, including boosted sharpness, that are useful for most picture taking, and which are applied automatically when using Basic Zone modes other than Portrait or Landscape.
- Portrait. This style boosts saturation for richer colors when shooting portraits, which is particularly beneficial for women and children, while reducing sharpness slightly to provide more flattering skin texture. The Basic Mode Portrait setting uses this Picture Style. You might prefer the Faithful style for portraits of men when you want a more rugged or masculine look, or when you want to emphasize character lines in the faces of older subjects of either gender.
- Landscape. This style increases the saturation of blues and greens, and increases both color saturation and sharpness for more vivid landscape images. The Basic Zone Landscape mode uses this setting.
- Fine detail. As you might expect, this setting uses sharpening and contrast to produce an image with optimum detail, at the expense of possibly adding some visual noise.
- **Neutral.** This Picture Style is a less-saturated and lower-contrast version of the Standard style. Use it when you want a more muted look to your images, or when the photos you are taking seem too bright and contrasty (say, at the beach on a sunny day).
- Faithful. The goal of this style is to render the colors of your image as accurately as possible, roughly in the same relationships as seen by the eye.

■ Monochrome. Use this Picture Style to create black-and-white photos in the camera. If you're shooting JPEG only, the colors are gone forever. But if you're shooting JPEG+RAW you can convert the RAW files to color as you import them into your image editor, even if you've shot using the Monochrome Picture Style. Your 6D Mark II displays the images in black-and-white on the screen during playback, but the colors are there in the RAW file for later retrieval.

Tip

You can use the Monochrome Picture Style even if you are using one of the RAW formats alone, without a JPEG version. The 6D Mark II displays your images on the screen in black-and-white, and marks the RAW image as monochrome so it will *default* to that style when you import it into your image editor. However, the color information is still present in the RAW file and can be retrieved, at your option, when importing the image.

Selecting Picture Styles

Canon makes selecting a Picture Style for use very easy, and, to prevent you from accidentally changing an existing style when you don't mean to, divides *selection* and *modification* functions into two separate tasks. There are several different ways to choose from among your existing Picture Styles:

- Picture Styles menu. Use this menu entry and scroll down the list shown in Figure 11.17 with the Quick Control Dial or multi-controller until the style you want to use is highlighted. Then press SET.
- Quick Control screen. Press the Q button and navigate to the Picture Styles icon at center left of the Quick Control screen with the multi-controller. Press SET, then highlight the Style you want to use and press SET again.

Defining Picture Styles

Canon makes interpreting current Picture Style settings and applying changes very easy. As you saw in Figures 11.15 and 11.16, the current settings of the visible Picture Style options are shown as numeric values on the menu screen. Some camera vendors use word descriptions, like Sharp, Extra Sharp, or Vivid, More Vivid that are difficult to relate to. You can change one of the existing Picture Styles or define your own whenever the Picture Styles menu is visible. Just press the INFO. button and follow these steps:

- 1. **Choose a style to modify.** Use the Quick Control Dial to highlight the style you'd like to adjust.
- 2. **Activate adjustment mode.** Press the INFO. button to choose Detail Set. The screen that appears next will be like the one shown at left in Figure 11.17 for the six color styles or three User Def. styles. The Monochrome screen looks like the one at right in Figure 11.17. In either case, you must scroll down to view all the options.

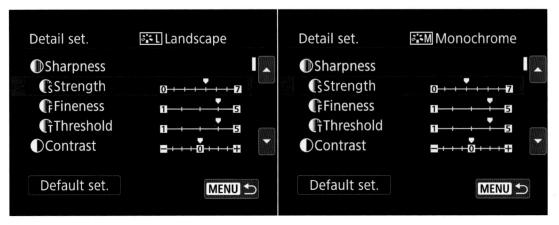

Figure 11.17 Each parameter can be changed separately for color Picture Styles, such as the Landscape style pictured (left), and Monochrome (right).

- 3. **Choose a parameter to change.** Use the Quick Control Dial to scroll among the parameters, plus Default Set. at the bottom of the screen, which restores the values to the preset numbers.
- 4. **Activate changes.** Press SET to change the values of a highlighted parameter.
- 5. Adjust values. Use the Quick Control Dial to move the triangle to the value you want to use. Note that the previous value remains on the scale, represented by a gray triangle. This makes it easy to return to the original setting if you want.
- 6. **Confirm changes.** Press the SET button to lock in that value, then press the MENU button three times to back out of the menu system.

Any Picture Style that has been changed from its defaults will be shown in the Picture Style menu with blue highlighting the altered parameter. You don't have to worry about changing a Picture Style and then forgetting that you've modified it. A quick glance at the Picture Style menu will show you which styles and parameters have been changed.

Making changes in the Monochrome Picture Style is slightly different, as the Saturation and Color Tone parameters are replaced with Filter Effect and Toning Effect options. (Keep in mind that once you've taken a JPEG photo using a Monochrome Picture Style, you can't convert the image back to full color.) You can choose from Yellow, Orange, Red, Green filters, or None, and specify Sepia, Blue, Purple, or Green toning, or None. You can still set the Sharpness and Contrast parameters that are available with the other Picture Styles.

FILTERS VS. TONING

Although some of the color choices overlap, you'll get very different looks when choosing between Filter Effects and Toning Effects. Filter Effects add no color to the monochrome image. Instead, they reproduce the look of black-and-white film that has been shot through a color filter. That is, Yellow will make the sky darker and the clouds will stand out more, whereas Orange makes the sky even darker and sunsets more full of detail. The Red filter produces the darkest sky of all and darkens green objects, such as leaves. Human skin may appear lighter than normal. The Green filter has the opposite effect on leaves, making them appear lighter in tone. Figure 11.18, left, shows the same scene shot with no filter, then Yellow, Green, and Red filters.

The Sepia, Blue, Purple, and Green Toning Effects, on the other hand, all add a color cast to your monochrome image. Use these when you want an old-time look or a special effect, without bothering to recolor your shots in an image editor. Figure 11.18, right, shows the various Toning Effects available.

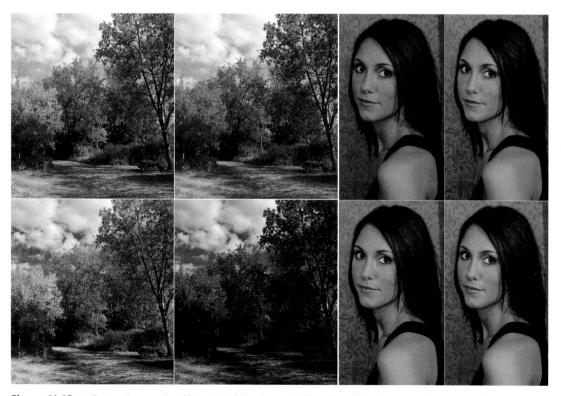

Figure 11.18 Left: Applying color filters: No filter (upper left); Yellow filter (upper right); Green filter (lower left); and Red filter (lower right). Right: Toning: Sepia (top left); Blue (top right); Purple (lower left); and Green (lower right).

Adjusting Styles with the Picture Style Editor

If you'd rather edit Picture Styles in your computer, the Picture Style Editor supplied for your camera in versions for both Windows and Macs allows you to create your own custom Picture Styles, or edit existing styles, including the Standard, Landscape, Faithful, and other predefined settings already present in your 6D Mark II. You can change sharpness, contrast, color saturation, and color tone—and a lot more—and then save the modifications as a PF2 file that can be uploaded to the camera, or used by Digital Photo Professional to modify a RAW image as it is imported.

To create and load your own Picture Style, just follow these steps:

- 1. **Load the editor.** Launch the Picture Style Editor (PSE, not to be confused with the *other* PSE, Photoshop Elements).
- 2. Access a RAW file. Load a RAW CR2 image you'd like to use as a reference into PSE. You can drag a file from a folder into the editor's main window, or use the Open command in the File menu.
- 3. Choose an existing style to base your new style on. Select any of the base styles except for Standard. Your new style will begin with all the attributes of the base style you choose, so start with one that already is close to the look you want to achieve ("tweaking" is easier than building a style from the ground up).
- 4. **Split the screen.** You can compare the appearance of your new style with the base style you are working from. Near the lower-left edge of the display pane are three buttons you can click to split the old/new styles vertically, horizontally, or return to a single image.
- 5. Dial in basic changes. Click the Advanced button in the Tool palette to pop up the Advanced Picture Style Settings dialog box that appears at left in the figure. These are the same parameters you can change in the camera. Click OK when you're finished.
- 6. **Make advanced changes.** The Tool palette has additional functions for adjusting hue, tonal range, and curves. Use of these tools is beyond the scope of a single chapter, let alone a notation in a list, but if you're familiar with the advanced tools in Photoshop, Photoshop Elements, Digital Photo Pro, or another image editor, you can experiment to your heart's content. Note that these modifications go way beyond what you can do with Picture Styles in the camera itself, so learning how to work with them is worth the effort.
- 7. Save your Picture Style. When you're finished, choose Save Picture Style File from the File menu to store your new style as a PF2 file on your hard disk. Add a caption and copyright information to your style in the boxes provided. If you click Disable Subsequent Editing, your style will be "locked" and protected from further changes, and the modifications you did make will be hidden from view (just in case you dream up your own personal, "secret" style). But you'll be unable to edit that style later. If you think you might want to change your custom Picture Style, save a second copy without marking the Disable Subsequent Editing box.

Uploading a Picture Style to the Camera

Now it's time to upload your new style to your Canon 6D Mark II into one of your three User Def. slots in the Picture Style array. Just follow these steps:

- 1. **Link your camera for upload.** Connect your camera to your computer using the USB cable, turn the 6D Mark II on, launch the EOS Utility, and click the Camera Settings/Remote Shooting choice in the splash screen.
- Choose the Shooting menu. It's marked with an icon of a white camera on a red background, from the menu bar located about midway in the control panel that appears on your computer display.
- 3. **Select Register User Defined Style.** Click on the box to produce the Register Picture Style dialog box.
- 4. **Choose a User Def. tab.** Click on one of the three tabs, labeled User Def. 1, User Def. 2, or User Def. 3. Each tab will include the name of the current Picture Style active in that tab.
- 5. Click the Open File button and choose the Picture Style file to load. The Picture Styles you've saved (or downloaded from another source) will appear with a PF2 extension. Click on the one you want to use, and then click the Open button in the Open dialog box.
- 6. **Upload Picture Style to the camera.** The Register Picture Style File dialog box will return. Click OK and the Picture Style will be uploaded to the camera in the User Def. "slot" represented by the tab you've chosen. The name of the Picture Style will appear in the 6D Mark II's menu in place of User Def. 1 (or User Def. 2/User Def. 3).

Changing a Picture Style's Settings from the EOS Utility

You can modify the settings of a Picture Style that's already loaded into your camera from the EOS Utility when your camera is linked to your computer. Just follow these steps:

- 1. **Link your camera to the computer.** Connect your camera to your computer using the USB cable, turn the 6D Mark II on, launch the EOS Utility, and click the Camera Settings/Remote Shooting choice in the splash screen.
- 2. **Choose the Shooting menu.** It's marked with an icon of a white camera on a red background, from the menu bar located about midway in the control panel that appears on your computer display.
- 3. **Access the Picture Style.** Click on the Picture Style choice. The currently active Picture Style in the camera will be shown, along with its detail settings.
- 4. **Choose a Picture Style to modify.** Click the Picture Style box to produce a listing of all the available Picture Styles.

- 5. **Click Detail Set.** At lower left, Landscape is now highlighted. When you click on Detail Set., a dialog box appears. You can move the sliders to change the settings, as described earlier. You can also click the Default Set. button to return the settings to their original values.
- 6. **Confirm choice.** Click Return when you've finished making changes, and the Picture Style you've modified will be changed in the camera.
- 7. **Exit EOS Utility.** Disconnect your camera from your computer, and your modified style is ready to use.

Getting More Picture Styles

I've found that careful Googling can unearth other Picture Styles that helpful fellow EOS owners have made available, and even a few from the helpful Canon company itself. My own search turned up this link: http://web.canon.jp/imaging/picturestyle/file/index.html, where Canon offers useful PF2 files you can download and install on your own. Remember that Picture Style files are compatible between various Canon EOS camera models (that is, you can use a style created for the Canon 80D with your 6D Mark II), but you should be working with the latest software versions to work with the latest cameras and Picture Styles. Try the additional styles Canon offers. They include:

- Studio Portrait. Compared to the Portrait style built into the camera, this one, Canon says, expresses translucent skin in smooth tones, but with less contrast. (Like films in the pre-digital age that were intended for studio portraiture.)
- Snapshot Portrait. This is another "translucent skin" style, but with increased contrast with enhanced contrast indoors or out.
- **Nostalgia.** This style adds an amber tone to your images, while reducing the saturation of blue and green tones.
- Clear. This style adds contrast for what Canon says is additional "depth and clarity."
- Twilight. Adds a purple tone to the sky just before and after sunset or sunrise.
- Emerald. Emphasizes blues and greens.
- **Autumn Hues.** Increases the richness of browns and red tones seen in Fall colors.

Long Exposure Noise Reduction

Options: Off/Disable (default), Auto, Enable

My preference: Auto

This entry allows you to enable or disable long exposure noise reduction, or allow the 6D Mark II to evaluate your scene and decide whether to use this noise-canceling adjustment. Visual noise is that graininess that shows up as multicolored specks in images, and this setting helps you manage it. In some ways, noise is like the excessive grain found in some high-speed photographic films. However, while photographic grain is sometimes used as a special effect, it's rarely desirable in a digital photograph.

The visual noise-producing process is something like listening to music in your car, and then rolling down all the windows. You're adding sonic noise to the audio signal, and while increasing the volume may help a bit, you're still contending with an unfavorable signal-to-noise ratio that probably mutes tones (especially higher treble notes) that you really want to hear. Although my car's audio system is capable of automatically boosting the volume the faster the vehicle is traveling—it really doesn't help when the road noise is high!

The same thing happens when the analog signal is amplified: You're increasing the image information in the signal, but boosting the background fuzziness at the same time. Tune in a very faint or distant AM radio station on your car stereo. Then turn up the volume. After a certain point, turning up the volume further no longer helps you hear better. There's a similar point of diminishing returns for digital sensor ISO increases and signal amplification as well.

These processes create several different kinds of noise. Noise can be produced from high ISO settings. As the captured information is amplified to produce higher ISO sensitivities, some random noise in the signal is amplified along with the photon information. Increasing the ISO setting of your camera raises the threshold of sensitivity so that fewer and fewer photons are needed to register as an exposed pixel. Yet, that also increases the chances of one of those phantom photons being counted among the real-life light particles, too.

Fortunately, the 6D Mark II's sensor and its digital processing chip are optimized to produce the low noise levels, so ratings as high as ISO 800 or ISO 1600 can be used routinely (although there will be some noise, of course), and even ISO 3200 can generate good results.

A second way noise is created is through longer exposures. Extended exposure times allow more photons to reach the sensor, but increase the likelihood that some photosites will react randomly even though not struck by a particle of light. Moreover, as the sensor remains switched on for the longer exposure, it heats, and this heat can be mistakenly recorded as if it were a barrage of photons. This entry can be used to tailor the amount of noise-canceling performed by the digital signal processor.

■ Off/Disable. Disables long exposure noise reduction. Use this setting when you want the maximum amount of detail present in your photograph, even though higher noise levels will result. This setting also eliminates the extra time needed to take a picture caused by the noise reduction process. If you plan to use only lower ISO settings (thereby reducing the noise caused by ISO amplification), the noise levels produced by longer exposures may be acceptable. For example, you might be shooting a river spilling over rocks at ISO 100 with the camera mounted on a tripod, using a neutral-density filter and long exposure to cause the pounding water to blur slightly. To maximize detail in the non-moving portions of your photos, you can switch off long exposure noise reduction. Because the noise-reduction process used with Auto and On can effectively double the time required to take a picture, Off is a good setting to use when you want to avoid this delay when possible.

- Auto. The 6D Mark II examines your photo taken with an exposure of one second or longer, and if long exposure noise is detected, a second, blank exposure is made and compared to the first image. Noise found in the "dark frame" image is subtracted from your original picture, and only the noise-corrected image is saved to your memory card.
- On/Enable. When this setting is activated, the 6D Mark II applies dark frame subtraction to all exposures longer than one second. You might want to use this option when you're working with high ISO settings (which will already have noise boosted a bit) and want to make sure that any additional noise from long exposures is eliminated, too. Noise reduction will be applied to some exposures that would not have caused it to kick in using the Auto setting.

III

While the "dark frame" is being exposed, the LCD screen will be blank during Live View mode, and the number of shots you can take in continuous shooting mode will be reduced. White balance bracketing is disabled during this process.

High ISO Speed Noise Reduction

Options: Disable, Low, Standard (default), High, Multi Shot Noise Reduction **My preference:** Low, with further noise reduction as required in an image editor

The other type of noise results from using higher ISO settings. This entry allows you to specify just how much or how little of this noise reduction to apply, which can be a valuable option because noise reduction does eliminate detail while blurring the amount of noise. The default is Standard noise reduction, but you can specify Low or High noise reduction, or disable noise reduction entirely. At lower ISO values, noise reduction improves the appearance of shadow areas without affecting highlights; at higher ISO settings, noise reduction is applied to the entire photo. Note that when the High option is selected, the maximum number of continuous shots that can be taken will decrease significantly, because of the additional processing time for the images.

- **Disable.** No additional noise reduction will be applied.
- Low. A smaller amount of noise reduction is used. This will increase the grainy appearance, but preserve more fine image detail.
- **Standard.** At lower ISO values, noise reduction is applied primarily to shadow areas; at higher ISO settings, noise reduction affects the entire image.

- **High.** More aggressive noise reduction is used, at the cost of some image detail, adding a "mushy" appearance that may be noticeable and objectionable. Because of the image processing applied by this setting, your continuous shooting maximum burst will decrease significantly.
- Multi Shot Noise Reduction. When this option is active, the 6D Mark II takes four separate shots continuously. It then aligns them (in case there was movement between images) and then merges them, using the dark frame subtraction technique to ignore random pixels caused by noise. The result is a JPEG image that is of better quality than the High setting.

Multi Shot NR works best if the camera is mounted on a tripod and your subject is not moving. It is not available when Image Quality is set to RAW or RAW+JPEG or Dual Pixel RAW, nor when using flash, live view, shooting multiple or Bulb exposures, or performing autoexposure/ white balance bracketing.

Highlight Tone Priority

Options: Disable/OFF (default), Enable/D+

My preference: Disable

This setting concentrates the available tones in an image from the middle grays up to the brightest highlights, in effect expanding the dynamic range of the image at the expense of shadow detail. You'd want to activate this option when shooting subjects in which there is lots of important detail in the highlights, and less detail in shadow areas. Highlight tones will be preserved, while shadows will be allowed to go dark more readily (and may exhibit an increase in noise levels). Bright beach or snow scenes, especially those with few shadows (think high noon, when the shadows are smaller) can benefit from using Highlight Tone Priority. Your choices:

- **Disable/OFF.** The 6D Mark II's normal dynamic range is applied. Note that when Highlight Tone Priority is switched off, the related Auto Lighting Optimizer setting (discussed earlier in this chapter) functions normally.
- Enable/D+. Highlight areas are given expanded tonal values, while the tones available for shadow areas are reduced. The ISO 100 sensitivity setting is disabled and only ISO 200 to ISO 32000 (or ISO 200 to ISO 12800 for movies) are available. When this restriction is in effect a D+ icon shows in the viewfinder, on the ISO Selection screen, and in the shooting information display for a particular image. Image noise may slightly increase as the camera manipulates the image. Note that this setting disables the Auto Lighting Optimizer.

Dust Delete Data

Options: Store Delete Data

My preference: N/A

This menu choice lets you "take a picture" of any dust or other particles that may be adhering to your sensor. The 6D Mark II will then append information about the location of this dust to your photos, so that the Digital Photo Professional software can use this reference information to identify dust in your images and remove it automatically. You should capture a Dust Delete Data photo from time to time as your final line of defense against sensor dust.

To use this feature, select Dust Delete Data, select OK and press the SET button. The camera will first perform a self-cleaning operation by applying ultrasonic vibration to the low-pass filter that resides on top of the sensor. Then, a screen will appear asking you to press the shutter button. Point the 6D Mark II at a solid-white card with the lens set on manual focus and rotate the focus ring to infinity. When you press the shutter release, the camera takes a photo of the card using Aperture-priority and f/22 (which provides enough depth-of-field [in this case, depth-of-focus] to image the dust sharply). The "picture" is not saved to your memory card but, rather, is stored in a special memory area in the camera. Finally, a "Data obtained" screen appears.

The Dust Delete Data information is retained in the camera until you update it by taking a new "picture." The 6D Mark II adds the information to each image file automatically.

Multiple Exposure

Options: Multiple exposure, Multiple exposure control, Number of exposures, Continue multiple exposure, Select image for multi-exposure

My preference: N/A

This option, shown in Figure 11.19, lets you combine two to nine separate images into one photo without the need for an image editor like Photoshop and can be an entertaining way to return to those thrilling days of yesteryear, when complex photos were created in the camera itself. In truth, prior to the digital age, multiple exposures were a cool, groovy, far-out, hep/hip, phat, sick, fabulous way of producing composite images. Today, it's more common to take the lazy way out, snap two or more pictures, and then assemble them in an image editor like Photoshop.

However, if you're willing to spend the time planning a multiple exposure (or are open to some happy accidents), there is a lot to recommend the multiple exposure capability that Canon has bestowed on the 6D Mark II. For one thing, the camera can combine two or more images using the RAW data from the sensor, producing photos that are blended together more smoothly than is

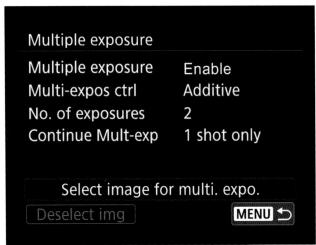

likely for anyone who's not a Photoshop guru. In addition, Canon has eliminated one annoying aspect of the feature found in some cameras: it's not necessary to return to the menu to activate multiple exposure for every set. If you want to take a series of pictures, you can set it once, and forget it. (But don't forget to turn it off when you're done!)

Multiple exposures cannot be captured if white balance bracketing, HDR shooting, or movie-making modes are in use. Before you begin snapping your own multi-exposures, you'll need to set your parameters using the following options discussed below.

Multiple Exposure

The Disable option deactivates the multi-exposure feature, but you can quickly choose either of the two On variations. This is the "master control" that allows you to turn multiple exposure on and off (leaving the other parameters you've set unchanged).

Multi-Expos Ctrl

This essential parameter can determine how successful your multiple exposure is, by controlling how each individual exposure is merged with the overlapping portions of the other images in the series. Picture an image like the one shown at left in Figure 11.20. The performer, Todd Cooper of the Alan Parsons Live Project, was photographed against a plain, dark background. He happened to be moving, so neither of the two images overlapped with each other, or with any details of the featureless background. But in Figure 11.20, right, the dancer remained in place, so that each subsequent image overlapped the others slightly.

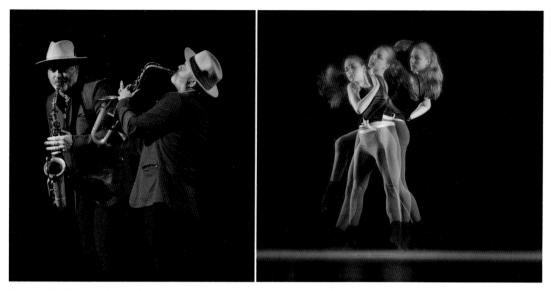

Figure 11.20 Left: Multiple exposure using Additive exposure, and no exposure compensation. Right: Multiple exposure using Average exposure.

The Multi-Exposure Control feature allows you to specify how the images are combined with these two choices:

- Additive. Each individual shot in the series is, by default, given the full exposure, which is what I used for Figure 11.20, left. Because the background was totally black and the subject was moving and did not overlap, the cumulative exposure effect was to combine two separate images into one image.
 - However, you can manually adjust the amount of exposure each shot is given by dialing in exposure compensation, making this mode useful for overlapping images as well. The customary procedure is to specify -1-stop exposure compensation for two shots, -1.5 EV for three-shot multiple exposures, and -2 EV for four-shot multis. Manually calculating the amount of negative exposure compensation allows you to fine-tune the look of overlapping images.
- Average. Choose this option and the 6D Mark II will apply appropriate negative exposure compensation for you, based on the number of exposures you're combining into a single image. If your multiple exposures happen to be of the same scene (rather than separate subjects), the camera will attempt to ensure that the background receives the equivalent of a full exposure. I used this option for Figure 11.20, right.

No. of Exposures

You can choose from 2 to 9 exposures in each multiple exposure set. Highlight the option, press SET, and spin the QCD to choose the number of exposures. I recommend starting out with three multiple exposures when you begin exploring this tool; you'll quickly discover picture opportunities that call for more or fewer combined shots in a single image.

Continue Mult-Exp

Choose 1 Shot Only or Continuously. Choose the former if you want to take a single multiple exposure series and then return to normal shooting with Multiple Exposure then disabled. Select Continuously if you plan to shoot a batch of different multiple exposures and don't want to return to the menu system to reactivate the feature after each shot.

Select Image for Multi-Exposure

If you like, you can use an image you already took as the base image for a subsequent multiexposure. The base image can only be a RAW image (not M RAW or S RAW). When RAW images taken with your camera are available, this option will be selectable. A RAW image that is already a multiple exposure can be used as your base image.

With the option highlighted, press SET and choose the image you want to use. Rotate the QCD to view compatible RAW images and press SET to choose one. Press OK. You can then take the *remaining* exposures in your set. That is, if you've chosen to combine three shots in a multiple exposure, the base image counts as one, so you'll be able to add two more by pressing and holding the shutter release.

MULTI NOTES

Some special conditions are required for your 6D Mark II to shoot multiple exposures. Some features are disabled, and others are locked in at particular values.

- Auto Lighting Optimizer, Highlight Tone Priority, and Peripheral Illumination/Chromatic Aberration Correction are disabled, and the Standard Picture Style will be used if you've chosen the Auto Picture Style setting. Multiple exposures are disabled if your camera is connected to a computer or printer via the USB cable.
- Most settings used for the first shot in a series are locked in for all subsequent images in that series, including image recording quality, ISO sensitivity, Picture Style, high ISO noise reduction, and color space.
- Other functions that cannot be changed while shooting multiple exposures will be dimmed in the camera menu.

Note that images using Highlight Tone Priority or an Aspect Ratio other than 3:2 cannot be used as your base image, and Lens Aberration Correction and Auto Lighting Optimizer will not be applied to your set. If the RAW image specifies the Auto Picture Style, the camera will revert to Standard for the rest of the images.

HDR Mode

Options: Disable (default), Adjust dynamic range, Effect, Continuous HDR, Auto image align **My preference:** N/A

I described using the 6D Mark II's HDR Mode in detail in Chapter 4. To recap, this menu entry has several subentries you can adjust:

- Adjust dynamic range. Select Disable HDR, allow the camera to select a dynamic range automatically, or select the range yourself to achieve a particular look. You can choose plus/minus 1, 2, or 3 EV.
- Effect. You can add special effects on top of any Picture Style you are using to produce an even more dramatic HDR image. Your choices are as follows:
 - Natural. Provides the most useful range of highlight and shadow details.
 - Art Standard. Offers a great deal of highlight and shadow detail, but with lower overall
 contrast and outlines accentuated, making the image look more like a painting. Saturation,
 bold outline, and brightness are adjusted to the default levels, and tonal range is lower in
 contrast.
 - Art Vivid. Like Art Standard, but saturation is boosted to produce richer colors, and the bold
 outlines not as strong, producing a poster-like effect.
 - Art Bold. Even higher saturation than Art Vivid, with emphasized edge transitions, producing what Canon calls an "oil painting" effect.
 - **Art Embossed.** Reduced saturation, darker tones, and lower contrast give the image a faded, aged look. The edge transitions are brighter or darker to emphasize them.
- Continuous HDR. Choose 1 Shot Only if you plan to take just a single HDR exposure and want the feature disabled automatically thereafter, or Every Shot to continue using HDR mode for all subsequent exposures until you turn it off. This is like the multiple exposure option described earlier.
- Auto image align. You can choose Enable to have the camera attempt to align all three HDR exposures when shooting hand-held, or select Disable when using a tripod. The success of the automatic alignment will vary, depending on the shutter speed used (higher is better), and the amount of camera movement (less is better!).

Interval Timer

Options: Disable (default), Enable, Interval, Number of shots

My preference: N/A

This is the first entry on the Shooting 4 menu. (See Figure 11.21.) I explained how to use the Interval Timer in Chapter 6 and will not repeat the discussion here. Press the INFO. button to enter parameters for your timed shoot. Your choices include:

- Disable/Enable. Turn the feature on or off.
- Interval. Choose the interval between shots up to 99 hours, 59 minutes, and 59 seconds.
- Number of shots. Select up to 99 total shots.

Bulb Timer

Options: Disable (default), Enable, Exposure time

My preference: N/A

This feature, available only when the Mode Dial is set to the B (Bulb) position, allows you to specify exposure times up to 99 hours, 59 minutes, and 59 seconds. I described use of this feature in Chapter 6.

Figure 11.21
The Shooting 4

Anti-Flicker Shooting

Options: Enable, Disable (default)

My preference: Disable, unless shooting under flickering light source

Novice sports photographers often ask me why shots they take in certain gymnasiums or arenas have inconsistent exposure, wildly varying color, or banding. The answer is that certain types of artificial lighting have a blinking cycle that is imperceptible to the eye, but which the camera can capture. This setting, when enabled, detects the frequency (it's optimized for 100 to 120 Hz illumination) of the light source that is blinking, and takes the picture at the moment when the flicker has the least effect on the final image. It cannot be used in live view or movie shooting.

You may experience a slight shutter release time lag as the camera "waits" for the proper instant, and your continuous shooting speed may be reduced, which makes this setting a necessary evil for sports and other activities involving action. Your results may vary when using P or Av modes, because the shutter speed can change between shots as proper exposure requires. You're better off using Tv or M mode, so the shutter speed remains constant.

A handy Flicker! warning will appear in the viewfinder, alerting you that the feature is enabled, as long as you've set Viewfinder Display in the Set-up 2 menu to include that alert. Anti-Flicker is disabled when using Mirror Lockup (explained next), and may not work as well with dark backgrounds, when a bright light is within the image area, when using wireless flash, and under other shooting conditions. Canon recommends taking test shots to see how effective the feature is under the light source you are working with.

Mirror Lockup

Options: Enable, Disable (default)

My preference: N/A

This option, available only when Anti-Flicker Shooting is disabled, allows you to flip up the 6D Mark II's mirror prior to exposure. Note that the camera has a second mirror lockup option available under Sensor Cleaning in the Set-up 3 menu. You should be extra careful not to confuse the two. Here is the difference:

■ Mirror lockup. This option is used while shooting. When enabled from this menu entry, the camera flips the mirror up out of the way when you press the shutter button down all the way. At that point, the viewfinder image will vanish (the mirror is no longer reflecting the image toward the focus screen), and a blinking mirror-up icon appears on the LCD panel. Shooting function settings and menu adjustments are disabled at this point. You must press the shutter release fully a *second* time to take the photo. The net result is that the (minor) vibration caused by the action of the mirror is eliminated, which can be important when shooting with a very long telephoto lens, or taking close-ups.

■ Clean manually. Select Clean Manually from the Sensor Cleaning entry in the Set-up 3 menu. The mirror will flip up immediately and the shutter will open, exposing the sensor. You can then safely clean your sensor using your favorite method. The shutter won't close and the mirror won't flip down until you power off the camera. The function can't be activated unless your battery or external source has enough power to maintain this configuration.

In general, only advanced dSLRs like the 6D Mark II offer the Mirror Lockup option in Shooting mode, so you might not even be familiar with its advantages. In recent years, only the cleaning mode mirror flip-up feature has been common. When using Mirror Lockup, keep the following in mind:

- Avoid excessive lockup times. Unlike cleaning mode, the shutter remains closed while the mirror is locked up, and, in virtually all cases, a lens will be attached to the camera and focusing light on the sensor plane (or shutter curtains, before exposure). This bright light can damage the shutter, particularly if the camera is accidentally pointed toward the sun. So, a good rule of thumb is to lock up the mirror only just before you want to take the picture (the mirror's vibration will be damped within about one second), and never shoot directly toward the sun. Fortunately, if you lock the mirror up and *don't* take a picture, the mirror will flip back down after 30 seconds automatically.
- **Use a tripod.** Obviously, if you're using mirror lockup to avoid vibration, you're almost certainly working with the camera on a tripod, too. Even with image stabilization, a handheld camera will produce more vibration than any mirror action.
- Self-timer or remote release recommended. Even though you've delayed the exposure until mirror vibration has damped, pressing the shutter release (even gently) can introduce a bit of motion to a camera mounted on the sturdiest tripod. The 6D Mark II's self-timer can be used, but that option doesn't allow you to select the precise moment of exposure. Instead, use a remote release. Perhaps you've framed a shot of some distant wildlife with a super-telephoto. Your first press flips the mirror up to ready the camera for the shot; then, a second or two later your quarry looks toward the camera and you press again to take the picture. With a self-timer, you don't have that flexibility.
- Self-timer with Bulb exposures. This combination can be problematic. You'll need to hold the shutter button down during the self-timer countdown when using a Bulb exposure. Releasing the button before the countdown has elapsed eliminates the actual exposure. You'll hear a shutter click, but no picture will be taken. You're better off using a remote release for mirror-up Bulb exposures.
- No continuous shooting. Sorry, but you can't lock up the mirror and take a series of shots. Continuous shooting is disabled when Mirror Lockup is active.

Aspect Ratio

Options: 3:2 (default), 4:3, 16:9, 1:1

My preference: 3:2

Allows you to choose an aspect ratio, or proportions of your image, from 3:2, 4:3, 16:9, or 1:1. JPEG images will be stored using the selected ratio; RAW images will be saved using the default 3:2 proportions, but the desired cropping can be restored in your image-editing software. Selecting proportions other than the 3:2 default results in a cropped image, and the live view display provides a black border on the LCD to show the limits of the image area (see Figure 11.22). At the Large or RAW size setting, you end up with images that measure $6240 \times 4160/36$ MP (3:2 ratio); $5536 \times 4160/23$ MP (4:3 ratio); $6240 \times 3504/22$ MP (16:9 ratio); and $4160 \times 4160/17.3$ MP (1:1 ratio). At Medium (M), Small 1 (S1), Small 2 (S2), and Small 3 (S3), the images are proportionately smaller.

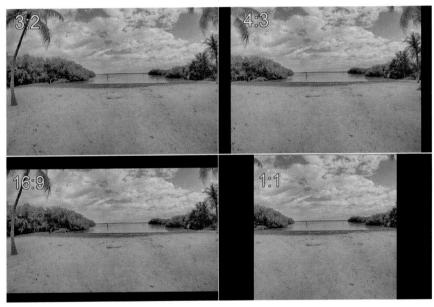

Figure 11.22
You can choose the proportions of your image.

Live View Shooting

Options: Enable (default), Disable

My preference: Enable

This menu entry enables/disables live view shooting and the Live View button. Disabling live view does not affect movie shooting, which is activated by rotating the On/Off/Movie switch to the Movie position and pressing the LV button. I explain live view in detail in Chapter 14.

Customizing with the Playback and Set-up Menus

In the last chapter, I introduced you to the layout and general functions of the Canon EOS 6D Mark II's menu system, with specifics on how to customize your camera with the Shooting menu. In this chapter, you'll learn how to work with the Playback and four Set-up menus. If you're jumping directly to this chapter and need some guidance in how to navigate the 6D Mark II's menu system, review the first few pages of Chapter 11. Otherwise, you're welcome to dive right in.

Playback Menu Options

The blue-coded Playback menus are where you select options related to the display, review, transfer, and printing of the photos you've taken. I won't be showing default values for the Playback menu items, as only three of them have a true default: Image Jump with Main Dial (10 images), Magnification (2X), and Control over HDMI (Disable). The choices you'll find include:

- Protect Images
- Rotate Image
- Erase Images
- Print Order
- Photobook Set-up
- RAW Image Processing
- Cropping

- Resize
- Rating
- Slide Show
- Set Image Search Conditions
- Image Jump with Main Dial

- Highlight Alert
- AF Point Disp.
- Playback Grid
- Histogram Disp.
- Magnification (apx)
- Ctrl over HDMI

Protect Images

Options: Select Images, Select Range, All Images in Folder, Unprotect All Images in Folder, All Images on Card, Unprotect All Images on Card

My recommendation: N/A

This is the first of six entries in the Playback 1 menu (see Figure 12.1). If you want to keep an image from being accidentally erased (either with the Erase button or by using the Erase menu), you can mark that image for protection. There are two ways to protect one or more images.

- Q button. This is probably one of the quickest ways to protect a single image. While viewing a photo in playback mode, press the Q button. A Quick Control screen appears with a column of playback function choices in the left column (see Figure 12.2). Protect is at the top, and when highlighted allows you to choose from Disable and Enable to mark an image as protected. A tap or two on the touch screen will do the job, or you can protect the image from this screen using the conventional controls. Press INFO. to protect multiple images. You're offered the choice of Select Range, All Images on Card, and Unprotect All Images on Card.
- Playback menu. To protect multiple images, you'll probably want to use this menu entry, which offers more options. Choose Protect Images and a screen appears with six choices:
 - Select Images. Choose individual images and press SET.
 - **Select Range.** Mark the first image to protect, press SET, and then scroll/navigate to the last image and press SET again.
 - All Images in Folder. You'll see a list of available folders. Select one and press SET.
 - Unprotect All Images in Folder. Use this to unmark/unprotect images in a folder of your choice.
 - All Images on Card. Protects all images on your memory card.
 - Unprotect All Images on Card. Removes protection from all the images on your card.

If you choose Select Images, you can view and select individual images and enable protection by pressing the SET button when they are displayed on the screen. A key icon will appear at the upper edge of the information display while still in the protection screen, and when reviewing that image later. To remove protection, repeat the process. You can scroll among the other images on your memory card using the QCD and protect/unprotect them in the same way. Image protection will not save your images from removal when the card is reformatted.

Figure 12.1 The Playback 1 menu.

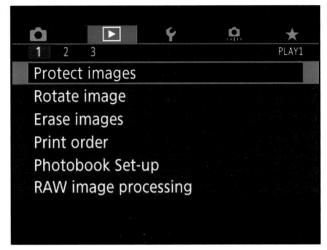

Figure 12.2
Protected images
can be locked
against accidental
erasure (but not preserved from
formatting).

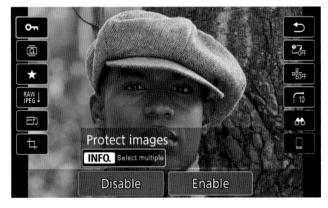

Rotate Image

Options: Rotate Image

My recommendation: N/A

While you can set the EOS 6D Mark II to automatically rotate images taken in a vertical orientation using the Auto Rotate option in the Set-up 1 menu (as described later in this chapter), you can manually rotate an image during playback using this menu selection. Select Rotate from the Playback 1 menu, use the Quick Control Dial to page through the available images on your memory card until the one you want to rotate appears, then press SET. The image will appear on the screen rotated 90 degrees. Press SET again, and the image will be rotated 270 degrees. (See Figure 12.3.)

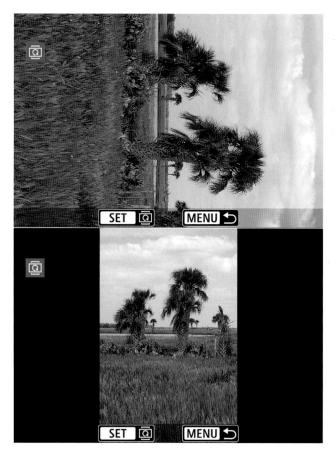

Figure 12.3
A vertically oriented image that isn't rotated appears larger on the LCD (top), but rotation allows viewing the photo without turning the camera (bottom).

Erase Images

Options: Select and Erase Images, Select Range, All Images in Folder, All Images on Card My recommendation: N/A

Choose this menu entry and you'll be given four choices: Select and Erase Images, Select Range, All Images in Folder, and All Images on Card. The first option displays the most recent image. Press SET to mark that image for deletion, and then rotate the Quick Control Dial to view other images, using the SET button to mark those you want to delete. When finished marking pictures, press the Trash button, and you'll see a screen that says Erase Selected Images with two options, Cancel and OK. Use the Quick Control Dial to choose OK, then press the SET button to erase the images, or select Cancel and press the SET button to return to the selection screen. Press the MENU button to unmark your selections and return to the menu. The Select Range option removes a group of images you select.

The All Images on Card choice removes all the pictures on the card, except for those you've marked with the Protect command, and does not reformat the memory card.

Print Order

Options: Number of Prints; Select Image; Multiple; Set up: Print Type, Date, File Number My recommendation: N/A

The EOS 6D Mark II supports the DPOF (Digital Print Order Format) that is now almost universally used by digital cameras to specify which images on your memory card should be printed, and the number of prints desired of each image. This information is recorded on the memory card, and can be interpreted by a compatible printer when the camera is linked to the printer using a USB cable, or when the memory card is inserted into a card reader slot on the printer itself. Photo labs are also equipped to read this data and make prints when you supply your memory card to them.

If you don't want to print directly from the camera using PictBridge, you can set some of the same options from the Playback 1 menu's Print Order entry, and designate single or multiple images on your memory card for printing. Once marked for DPOF printing, you can print the selected images, or take your memory card to a digital lab or kiosk, which is equipped to read the print order and make the copies you've specified. (You can't "order" prints of RAW images or movies.)

IMAGE SEARCH

When reviewing images or selecting images for printing, you can select parameters, such as Rating, Date, Folder, Protected, or File Type, used to determine which shots to display. Do this before you start to make your selections. I'll show you how to specify the parameters later in this chapter.

To create a DPOF print order, just follow these steps. First up, selecting images to print individually, or individually with an accompanying index "proof sheet" of multiple shots:

- 1. Access Print Order screen. In the Playback 1 menu, navigate to Print Order. Press SET.
- 2. **Access Set Up.** The Print Order screen will appear. (See Figure 12.4.) Use the Quick Control Dial to highlight Set Up. Press SET.
- 3. **Select Print type.** Choose Print Type (Standard, Index/Thumbnails print, or Both), and specify whether Date or File Number imprinting should be turned on or off. (You can turn one or the other on, but not both Date and File Number imprinting.) Press MENU to return to the Print Order screen.
- 4. **Choose selection method.** Highlight Sel. Image (choose individual images). I'll describe the Multiple option shortly.

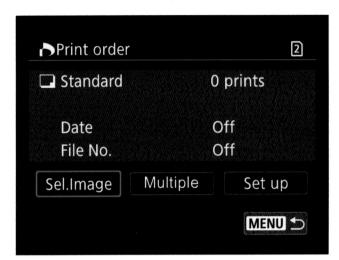

Figure 12.4
Select the images to be printed individually, by folder, or all the images on your memory card.

- 5. **Select individual images.** With Sel. Image, use the QCD or Main Dial to view the images. Only JPEG images that can be printed will be appear when you review the shots on your card, and if you've set Image Search conditions in the Playback 2 menu, the display will be filtered to show only matching JPEG images. Movies and RAW images cannot be printed.
- 6. **Zoom in/out.** If you press the Magnify button, rotating the Main Dial to the right allows you to zoom in on the current image; rotating to the left zooms back out, and thence to a three-image display of the current image and the two that follow. Use the directional buttons or tap the touch screen to scroll among those thumbnails and those that follow.
- 7. Mark or unmark a highlighted image for printing. Press the SET button to select an image.
- 8. **Choose number of prints.** If you've chosen Standard or Both as Print Type in Step 3, once an image is selected, rotate the QCD to specify 1 to 99 prints for that image. If you selected Index as your Print Type, pressing SET does not let you choose the number of prints. SET only adds the highlighted image to the index "proof sheet," while pressing SET a second time removes it from the index sheet.
- 9. **Use the QCD to select additional images.** Press MENU when finished selecting to return to the Print Order screen.
- 10. Output your hardcopies. If the camera is linked to a PictBridge-compatible printer, an additional option appears on the Print Order screen—Print. You can select that; optionally, adjust Paper Settings, and start the printing process. Alternately, you can exit the Print Order screen by tapping the shutter release button. Then turn off the camera and printer, remove the memory card, and insert it in the memory card slot of a compatible printer, retailer kiosk, or digital minilab.

To select and print multiple images, just follow these steps. The first three are the same as for selecting images individually:

- 1. Access Print Order screen. In the Playback 1 menu, navigate to Print Order. Press SET.
- 2. **Access Set Up.** The Print Order screen will appear. Use the Quick Control Dial to highlight Set Up. Press SET.
- 3. **Select Print type.** Choose Print Type (Standard, Index/Thumbnails print, or Both), and specify whether Date or File Number imprinting should be turned on or off. (You can turn one or the other on, but not both Date and File Number imprinting.) Press MENU to return to the Print Order screen.
- 4. Choose selection method. To quickly choose multiple images, select Multiple.
- 5. **Select images.** In this mode, you cannot select a single image, but instead will choose images according to Range, Folder, or Card. Your Set Image Search Conditions from the Playback 2 menu will be applied.
 - Select Range. You'll be shown a screen of thumbnails, and can highlight the first image you want to print. Press the Magnify button to view an enlarged version of the image. Press SET, and then navigate to the next image to be printed. Press SET again. All the images in your range will be printed. Technically, you can select only one image, press SET, and then MENU to exit, so you *can* choose one individual image with this mode. Check marks display next to selected images while you are making your sources, but no check mark is shown in conventional image display.
 - Mark All in Folder. You'll be able to select a folder, with thumbnails shown at right as a hint to what the folder contains. If your card contains only one folder, that will be your only choice. Press SET to select and MENU to confirm and exit.
 - Mark All Found Images. If you set Image Search parameters, you will have the choice Mark All Found Images.
 - Mark All on Card. No options here other than Cancel and OK.
 - Clear All in Folder/Clear All On Card/Clear All Found Images. Use this to delete all the images in a folder or card (or from an Image Search) from your print order.
- 6. Output your hardcopies. You cannot choose the number of prints to be made from your multiple images. If the camera is linked to a PictBridge-compatible printer, an additional option appears on the Print Order screen—Print. You can select that; optionally, adjust Paper Settings, and start the printing process. Alternately, you can exit the Print Order screen by tapping the shutter release button. Then turn off the camera and printer, remove the memory card, and insert it in the memory card slot of a compatible printer, retailer kiosk, or digital minilab.

Photobook Set-up

Options: Select Individual Images; Select Multiple: Select Range, All Images in Folder, Clear All in Folder, All Images on Card, Clear All on Card

My preference: N/A

You can select up to 998 images on your memory card, and then use the EOS Utility to copy them all to a specific folder on your computer. This is a handy way to transfer only specific images to a particular folder, and is especially useful when you're collecting photos to assemble in a photobook. Your choices include:

- Select Individual images. You can mark individual images one at a time from any folder on your memory card. The selection method is the same as described earlier for Print Orders.
- Select Multiple. With this choice, you can choose images in a range, in a folder, or on a memory card, as well as clear images from your folder or card, using the same method described earlier for Print Orders.

Once you marked the images you want to transfer to the specified folder, use the EOS Utility to copy them.

RAW Image Processing

Options: Brightness, White Balance, Picture Style, Auto Lighting Optimizer, High ISO Noise Reduction, Image Quality, Color Space, Lens Aberration Correction

My recommendation: N/A

You can produce JPEG versions of your full-size RAW images (but not M RAW or S RAW files) right in the camera. The original RAW shot is not modified. When you select this menu entry, only compatible RAW images are offered for your selection. Just follow these steps:

- 1. **Press the Playback button.** Navigate to the RAW Image Processing entry and press SET. Only RAW images will be displayed.
- 2. **Review RAW images.** Rotate the Main Dial or QCD to scroll through compatible images in full-frame mode. Press the Magnify button and rotate the Main Dial counterclockwise to view a selection of index images instead; or press Magnify and rotate the Main Dial clockwise to zoom in on a highlighted image.
- 3. Select image to process. Press SET to select an image for processing.

- 4. **Specify parameters.** A screen appears with a selection of parameters you can adjust. (See Figure 12.5.) Navigate to the parameter you want to manipulate using the directional buttons. Your choices include:
 - Brightness
 - White Balance
 - Picture Style
 - Auto Lighting Optimizer

- High ISO Noise Reduction
- Image Quality
- Color Space
- Lens Aberration Correction

(If you want to work with Lens Aberration Correction, highlight the option and press SET to produce a subscreen where you can choose Peripheral Illumination Correction, Distortion Correction, or Chromatic Aberration Correction.)

- 5. **Make adjustments.** When a parameter is highlighted you can rotate the Main Dial or QCD to change settings. Or, you can press SET to change the settings using a more detailed screen. You can press INFO. to reset the settings to the original values of the RAW image; press the Magnify button to zoom in on the image.
- 6. **Save JPEG.** Navigate to (or tap) the Save icon (located just above the Return arrow at the bottom right of the screen) and press SET. Choose OK to save as a new file, or Cancel to abort the process. If the original was shot using live view and an aspect ratio other than 3:2, the image will be displayed in those proportions, and the JPEG will be saved in that aspect ratio.

Figure 12.5 Select from eight types of correction using RAW Image Processing.

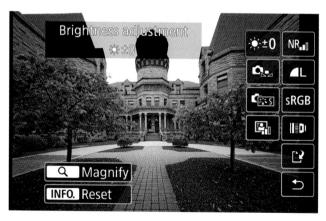

Cropping

Options: Crop, Aspect Ratio My recommendation: N/A

This entry is the first on the Playback 2 menu. (See Figure 12.6.) If you need to crop an image, you can do it here. You don't have as much control as you would have in an image editor, but if you, say, need to crop an image for emailing or uploading to a social media site, this may do the job. You can crop *only* JPEG images in Large, Medium, S1, or S2 sizes.

Simply select this menu entry and press SET. All compatible JPEG images appear. Use the Main Dial or QCD to select an image for cropping. Press SET when you've chosen your image. Then, you can apply one of these tools:

- Enlarge/reduce crop. Rotate the Main Dial to enlarge and reduce the green cropping frame, seen in Figure 12.7.
- **Position crop frame.** Use the multi-controller directional buttons to slide the cropping frame around within the image.
- Adjust aspect ratio. Rotate the QCD to cycle the cropping frame's proportions among 3:2, 16:9, 4:3, and 1:1 aspect ratios and for horizontal or vertical cropping.
- **Change crop orientation.** To crop a horizontal image using vertical orientation instead, choose the "reverse" proportions: 2:3, 9:16, or 3:4.
- Correct for tilt. You can correct for image tilt by plus/minus 10 degrees. Press the INFO. button and rotate the QCD to correct in 0.1-degree increments; tap the "rotate" icons shown in the upper left of the screen to correct in larger 0.5-degree increments. Press SET to confirm and exit.

Figure 12.6Cropping is the first entry in the Playback 2 menu.

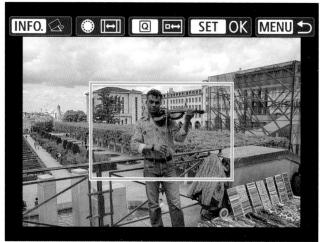

- Check your crop. Press the Q button and the cropped image will be shown with the area outside the frame removed.
- Save cropped image. Press SET and select OK to save your cropped image as a new file. Your original image is retained unharmed.

Resize

Options: Medium, Small 1, Small 2, Small 3 image sizes

My recommendation: N/A

If you've already taken an image and would like to create a smaller version (say, to send by e-mail), you can create one from this menu entry. Just follow these steps:

- 1. Choose Resize. Select this menu entry from the Playback 2 menu.
- 2. View images to resize. You can scroll through the available images with the touch screen or directional buttons. Only images that can be resized are shown. They include JPEG Large, Medium, Small 1, and Small 2 images. RAW images of any type cannot be resized.
- 3. **Select an image.** Choose SET to select an image to resize. A pop-up menu will appear on the screen offering the choice of reduced-size images as you rotate the QCD. These include M (Medium: 12MP, 4160 × 2768 pixels); S1 (Small 1: 6.5MP, 3210 × 2080 pixels); or S2 (Small 2: 2.5MP, 2400 × 1600 pixels). You cannot resize an image to a size that is larger than its current size; that is, you cannot save a JPEG Medium image as JPEG Large.
- 4. **Resize and save.** Choose SET to save as a new file, and confirm your choice by selecting OK from the screen that pops up, or cancel to exit without saving a new version. The old version of the image is untouched.

Rating

Options: Select Images, Select Range, All Images in Folder, All Images on Card; One to five stars My recommendation: N/A

If you want to apply a quality rating to images or movies you've shot (or use the rating system to represent some other criteria), you can simply press the Rating button during playback multiple times to apply a rating. Or, alternatively, use this entry to give images one, two, three, four, or five stars, or turn the rating system off. The Image Jump function can display only images with a given rating. Suppose you were photographing a track meet with multiple events. You could apply a one-star rating to jumping events, two stars to relays, three stars to throwing events, four stars to hurdles, and five stars to dashes. Then, using the Image Jump feature, you could review only images of one type.

With a little imagination, you can apply the rating system to all sorts of categories. At a wedding, you could classify pictures of the bride, the groom, guests, attendants, and parents of the couple. If you were shooting school portraits, one rating could apply to first grade, another to second grade, and so on. Given a little thought, this feature has many more applications than you might think. Ratings can be used to specify images for a slide show, too, or to select images in Digital Photo Professional.

To use the Ratings menu entry, just follow these steps:

- 1. Choose the Rating menu item.
- 2. Choose from Select Images, Select Range, All Images in Folder, All Images on Card.
- 3. Select one or multiple images, using the standard image selection options explained earlier. When an image or movie you want to rate is visible, press SET.
- 4. Now rotate the QCD to apply a one- to five-star rating, or turn a rating off. You can rate up to 999 images.
- 5. When finished rating, choose MENU to exit.

Slide Show

Options: Set up: Display Time, Repeat, Transition Effect, Background Music; Start My recommendation: N/A

Slide Show is a convenient way to review images one after another, without the need to manually switch between them. To activate, just choose Slide Show from the Playback 2 menu. During playback, you can press the SET button to pause or restart the "slide show" (in case you want to examine an image more closely), or the INFO. button to change the amount of information displayed on the screen with each image. For example, you might want to review a set of images and their histograms to judge the exposure of the group of pictures. To set up your slide show, follow these steps:

- 1. **Begin setup.** If you want to use *all* the images on the card, proceed to the next step. If you want to use only *some* of the images on your card, first use the Set Image Search Conditions (described next) to specify which images will be used. Then return and begin at Step 2.
- 2. Choose Set up. Select Set up from the screen shown at left in Figure 12.8, and press SET.
- 3. **Set Display and Repeat options.** Rotate the Quick Command Dial to highlight Set up to choose Display Time (specify 1, 2, 3, 5, 10, or 20 seconds per image), and Repeat options (Enable or Disable). (See Figure 12.8, right.) When you've specified either value, press the MENU button to confirm your choice, and then SET once more to go back to the Set up options screen.
- 4. **Add optional Transition Effects.** Next, highlight Transition Effect and choose from two "slide-in" transitions and three "fade-in" options. Try out each to see which you prefer. Select Off to disable transitions. Press SET to confirm and return to the main options screen.

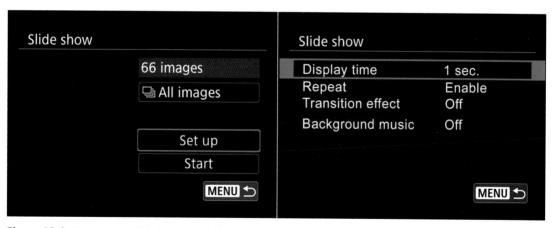

Figure 12.8 Set up your slide show using these screens.

- 5. Add optional Music. Next, highlight Music and press SET. You can use this entry only if you have copied music files to your memory card. Use the EOS Utility to copy files such as Angels, Beloved, Go Sports, or Memories. To hear a sample of the music tracks you've copied, highlight the music title and press the INFO. button. Highlight a track and press SET to specify that track; you can choose multiple music tracks if you want, and change track during playback by pressing the up/down directional buttons. Sound volume can be adjusted by rotating the Main Dial.
- 6. **Start the show.** In the main Slide Show screen, rotate the QCD to highlight Start and press SET to begin your show. (If you'd rather cancel the show you've just set up, press MENU instead.)
- 7. **Use show options during display.** Press SET to pause/restart; INFO. to cycle among the four information displays; MENU to stop the show.

Set Image Search Conditions

Options: Rating, Date, Folder, Protected, Type of File My recommendation: N/A

Many image playback selection screens can be filtered using this menu item, which allows you to choose search parameters including star rating, date captured, storage folder, protected status, and type of image file. The parameters can be finely detailed, as you can choose any one or all of the search criteria to, say, look for protected movies assigned five stars taken on a certain date and located in a particular folder. If you've assigned a parameter and changed your mind, highlight it and press the INFO. button to remove the check mark. The Trash button can be used to clear all parameters. If no images meet your search conditions, the 6D Mark II will not let you proceed to the display step. Your choices include:

- Rating. You can choose All with Rating to include every image (and *only* those images) that has been assigned a rating. Alternatively, you can specify only images that have received 1 to 5 stars; those with 2 to 4 stars or *higher*; those with 2 to 4 stars or *fewer*; or only those that have *not* been assigned a rating at all.
- Date. Select to view images captured on a particular date. You will be allowed to select only from the dates which actually contain images on the card (which makes sense).
- Folder. Include in the search images contained in any one of the folders available on your memory card.
- **Protected.** Choose to include in the search Protected or Unprotected images.
- **Type of File.** Narrow your search to include JPEG only, Movies, Stills only, RAW only, RAW and RAW+JPEG, only RAW+JPEG, or RAW+JPEG *and* JPEG images.

Image Jump with Main Dial

Options: 1 Image, 10 Images, Specified number of images, Date, Folder, Movies Only, Stills Only, Protected Images Only, Image Rating

My recommendation: N/A

As first described in Chapter 2, you can leap ahead or back during picture review by rotating the Main Dial, using a variety of increments that you can select using this menu entry. The Jump method is shown briefly on the screen as you leap ahead to the next image displayed, as shown in Figure 12.9. Your options are as follows:

- 1 Image. Rotating the Main Dial one click jumps forward or back 1 image.
- 10 Images. Rotating the Main Dial one click jumps forward or back 10 images.
- **Specified number of images.** Rotating the Main Dial one click jumps forward or back a number you can specify when this choice is highlighted. Rotate the Main Dial to choose from 1 to 100 images per jump (the default is 30).
- **Date.** Rotating the Main Dial one click jumps forward or back to the first image taken on the next or previous calendar date.
- **Folder.** Rotating the Main Dial one click jumps forward or back to the first image in the next folder available on your memory card (if one exists).
- Movies Only. Jumps among movies only using the Main Dial.
- Stills Only. Jumps among still photos only using the Main Dial.
- **Protected Images Only.** Jumps among images that have been marked as protected.
- Image Rating. When this option is visible, rotate the Main Dial to select the rating you want to use. Then, during picture review, spinning the Main Dial will jump among photos with the rating you selected.

Figure 12.9
The Jump method
is shown on the
LCD briefly when
you leap forward or
back using the
Main Dial.

Highlight Alert

Options: Enable, Disable

My recommendation: N/A

Choose Enable, and overexposed highlight areas will blink on the LCD screen during picture review. Set to Disable if you find this alert distracting. Many 6D Mark II users use the histogram displays during playback as a more precise indicator of over- (and under-) exposure. This is the first entry in the Playback 3 menu. (See Figure 12.10.)

AF Point Disp.

Options: Enable, Disable My recommendation: N/A

Select Enable, and the exact AF point(s) used to determine focus will be highlighted in red. If automatic AF point selection was used, you may find multiple points highlighted.

Playback Grid

Options: 3×3 , 6×4 , 3×3 + diagonal lines

My recommendation: N/A

You can superimpose a 3×3 , 6×4 , or 3×3 plus diagonal lines grid over your image during playback, or disable the grid display entirely. You can review the layout of the grids, which can also be shown during shooting.

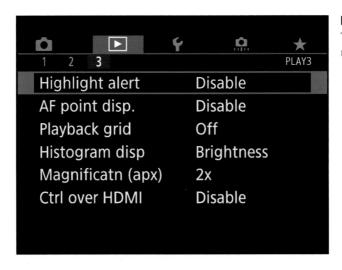

Figure 12.10 The Playback 3 menu.

Histogram Disp.

Options: Brightness, RGB My recommendation: N/A

Select from Brightness (luminance) or RGB histogram as the first displayed during playback. You can scroll down the playback screen to view the alternate type of histogram. I described use of histograms in Chapter 4.

Magnification (apx)

Options: 1X, 2X, 4X, 8X, 10X, Actual size, Same as last magnification

My recommendation: Same as last magnification

This setting allows you to specify the initial magnification for magnified view during playback, as well as the starting position on the screen. Choose your starter magnification based on how often you tend to take a close-up look at your images during review. If you're a pixel-peeper, you might want an in-depth 10X view each time you magnify your image. If you're more sedate in your zooming habits, the 1X magnification will start you off with a full-screen view you can zoom in on. I like to use the same magnification I most recently used, because I am likely to examine a series of similar images at the same zoom level during a shooting or review session. Your options are as follows:

- 1X (no magnification). When you press the Magnify button, the initial view will be the single-image display with no magnification. Continue pressing Magnify to zoom in.
- 2X, 4X, 8X, 10X (from the center of the frame). The initial magnified view will be 2, 4, 8, or 10X (your choice), centered around the middle of the frame.
- Actual size (from selected point). Magnified view starts at 100 percent, centered around the autofocus point used to achieve focus; if manual focus was used, the image will be centered around the middle of the frame.
- Same as last magnification (from the center point). The 6D Mark II uses the same magnification value you last used, centered around the middle of the frame.

Ctrl over HDMI

Options: Enable, Disable My recommendation: N/A

When enabled, you can control playback operations over the HDMI cable and a television set's remote control when displaying your camera's output on an HDMI CEC-compatible television with a remote control. This option will allow you to access menus, choose a 9-image index, play movies and slide shows, change the amount of information displayed (similarly to the INFO. button), or rotate the image. Set to Disable if you do not have the correct TV hardware, or when testing has shown that your HDMI CEC television does not operate correctly in this mode.

Set-up Menu Options

The amber-coded Set-up menus are where you adjust how your camera *behaves* during your shooting session, as differentiated from the Shooting menu, which adjusts how the pictures are taken. Your choices include:

- Select Folder
- File Numbering
- Auto Rotate
- Format Card
- Eye-Fi Settings
- Wireless Communications Settings
- Auto Power Off
- LCD Brightness
- LCD Off/On Button
- Date/Time/Zone
- Language
- Viewfinder Display
- GPS Settings
- Video System
- Mode Guide

- Feature Guide
- Help Text Size
- Touch Control
- Beep
- Battery Information
- Sensor Cleaning
- INFO. Button Display Options
- Multi Function Lock
- Custom Shooting Mode (C1–C2)
- Clear All Camera Settings
- Copyright Information
- Manuals/Software URL
- Certification Logo Display
- Firmware

Select Folder

Options: Select Folder, Create Folder

My preference: N/A

Choose this menu option, the first on the Set-up 1 menu (see Figure 12.11), to create a folder where the images you capture will be stored on your memory card, or to switch between existing folders. Just follow these steps:

- 1. **Choose Select Folder.** Access the option from the Set-up 1 menu.
- 2. **View list of available folders.** The Select Folder screen pops up with a list of the available folders on your memory card, with names like 100CANON, 101CANON, etc.
- 3. **Choose a different folder.** To store subsequent images in a different existing folder, use the touch screen or directional buttons to highlight the label for the folder you want to use. When a folder that already has photos is selected, two thumbnails representing images in that folder are displayed at the right side of the screen.

- 4. **Confirm the folder.** Choose SET to confirm your choice of an existing folder.
- 5. **Create new folder.** If you'd rather create a new folder, highlight Create Folder in the Select Folder screen and choose SET. The name of the folder that will be created is displayed, along with a choice to Cancel or OK creating the folder. Choose SET to confirm your choice.
- 6. Exit. Press MENU to return to the Set-up 1 menu.

The folders your 6D Mark II create always follow the *nnn*CANON convention. You can also use your computer to create folders with names that depart from this arrangement, as long as you adhere to the camera's general rules for memory card folder names. Here's how to create folders with personalized names:

- 1. Access the memory card from your computer. There are two ways to do this.
 - **a. USB link.** Plug the USB cable into the port on the left side of the 6D Mark II and connect to a USB connector on your computer. In Windows, the 6D Mark II will appear as a generic digital camera icon. A similar icon will appear on the Mac OS X desktop.
 - **b.** Use a card reader. Remove the card from the 6D Mark II and insert it in a card reader attached to your computer.
- 2. **Open the camera/memory card in your computer.** A folder called DCIM will appear at the top level. All the folders your 6D Mark II can access must be located inside the DCIM folder.
- 3. **Create a new folder within the DCIM folder.** Although you're not limited to the *nnn*CANON arrangement, you must adhere to the rules in the steps that follow.

- 4. **Type in a three-digit folder number.** You can use any three numbers from 100 to 999, as long as those numbers are not already in use on that memory card. In other words, you can't have folders named 101CANON and 101SPAIN.
- 5. Add a five-character description of your choice. You can use any uppercase or lowercase letters from A to z, plus the underscore character (to represent a space). You cannot use an actual space, nor any other characters, even if your computer allows them in a file name. An invalid folder name will end up being "invisible" to the 6D Mark II, even if it actually exists on your memory card.

With a little imagination (and caution, to avoid creating "bad" folder names), you can develop some useful folder names, and switch among them at will. I find this capability especially useful when working with very large (128GB or 64GB) cards, because I can do a great deal of organizing right on the card itself. Perhaps I have some images in a particular folder that I use as a "slide show" for display on my 6D Mark II's back-panel LCD. Or, I might want to sort images by location or date. For example, I could use 104_USA_, 105SPAIN, 106FRANC, or 107GBRIT to indicate the location where the images were shot.

File Numbering

Options: Continuous, Automatic Reset, Manual Reset

My recommendation: Continuous

The EOS 6D Mark II will automatically apply a file number to each picture you take, using consecutive numbering for all your photos over a long period, spanning many different memory cards, starting over from scratch when you insert a new card, or when you manually reset the numbers. Numbers are applied from 0001 to 9999, at which time the camera creates a new folder on the card (100, 101, 102, and so forth), so you can have 0001 to 9999 in folder 100, then numbering will start over in folder 101.

The camera keeps track of the last number used in its internal memory. That can lead to a few quirks you should be aware of. For example, if you insert a memory card that had been used with a different camera, the 6D Mark II may start numbering with the next number after the highest number used by the previous camera. (I once had a brand-new Canon camera start numbering files in the 8,000 range.) Note that if your folder number is 999 and the file number reaches 9999, the 6D Mark II does not "roll over" and you'll be locked out of shooting. On the surface, the numbering system seems simple enough: In the menu, you can choose Continuous, Automatic Reset, or Manual Reset.

Here is how each works:

- **Continuous.** If you're using a blank/reformatted memory card, the 6D Mark II will apply a number that is one greater than the number stored in the camera's internal memory. If the card is not blank and contains images, then the next number will be one greater than the highest number on the card *or* in internal memory. (In other words, if you want to use continuous file numbering consistently, you must always use a card that is blank or freshly formatted.) Here are some examples.
 - You've taken 4,235 shots with the camera, and you insert a blank/reformatted memory card. The next number assigned will be 4,236, based on the value stored in internal memory.
 - You've taken 4,235 shots with the camera, and you insert a memory card with a picture numbered 2,728. The next picture will be numbered 4,236.
 - You've taken 4,235 shots with the camera, and you insert a memory card with a picture numbered 8,281. The next picture will be numbered 8,282, and that value will be stored in the camera's menu as the "high" shot number (and will be applied when you next insert a blank card).
- Automatic Reset. If you're using a blank/reformatted memory card, the next photo taken will be numbered 0001. If you use a card that is not blank, the next number will be one greater than the highest number found on the memory card. Each time you insert a memory card, the next number will either be 0001 or one higher than the highest already on the card.
- Manual Reset. The 6D Mark II creates a new folder numbered one higher than the last folder created, and restarts the file numbers at 0001. Then, the camera uses the numbering scheme that was previously set, either Continuous or Automatic reset, each time you subsequently insert a blank or non-blank memory card.

Auto Rotate

Options: Camera+Computer, Computer, Off My recommendation: Camera+Computer

You can turn this feature On or Off. When activated, the EOS 6D Mark II rotates pictures taken in vertical orientation on the LCD screen so you don't have to turn the camera to view them comfortably. However, this orientation also means that the longest dimension of the image is shown using the shortest dimension of the LCD, so the picture is reduced in size. You have three options. The image can be autorotated when viewing in the camera *and* on your computer screen using your image-editing/viewing software (this choice is represented by a pair of camera/computer screen icons). The image can be marked to autorotate *only* when reviewing your image in your image editor or viewing software (just a computer screen icon is used). This option allows you to have rotation

applied when using your computer, while retaining the ability to maximize the image on your LCD in the camera. The third choice is Off. The image will not be rotated when displayed in the camera or with your computer. Note that if you switch Auto Rotate off, any pictures shot while the feature is disabled will not be automatically rotated when you turn Auto Rotate back on; information embedded in the image file when the photo *is taken* is used to determine whether autorotation is applied.

Format Card

Options: Cancel, OK, Low Level Format

My recommendation: N/A

Use this item to erase everything on your memory card and set up a fresh file system ready for use. When you select Format, you'll be given a choice of doing a quick format or, if you press the Trash button, a more intensive Low Level Format. A display pops up showing the capacity of the card, how much of that space is currently in use, and two choices at the bottom of the screen to Cancel or OK (proceed with the format). A blue-yellow bar appears on the screen to show the progress of the formatting step.

Eye-Fi Settings

Options: Enable, Disable, Connection information

My recommendation: Disable

This menu item appears when you have an Eye-Fi card inserted in the camera. You can enable and disable Eye-Fi wireless functions, and view connection information. (See Figure 12.12.) I no longer recommend use of Eye-Fi cards, because the 6D Mark II has better built-in communication

Figure 12.12 Eye-Fi information (left), Connection information (right).

capabilities. In addition, Eye-Fi has changed support for older memory cards, and reduced the number of features available. If you do want to use an Eye-Fi card, remember that because the card draws power from the camera even when it's switched off, you might want to Disable the card (or remove it from the camera) when you don't need to use its features.

Wireless Communication Settings

Options: Wi-Fi Settings, Wi-Fi Function, Bluetooth Function, Send Images to Smartphone, Nickname, Clear Settings

My preference: N/A

These options were covered in detail in Chapter 6 and won't be repeated here.

Auto Power Off

Options: 1 (default), 2, 4, 8, 15, 30 minutes, Disable

My recommendation: 2 minutes; 8 minutes when shooting sports

This setting, the first in the Set-up 2 menu (see Figure 12.13), allows you to determine how long the EOS 6D Mark II remains active before shutting itself off. You can select 1, 2, 4, 8, 15, or 30 minutes or Off, which leaves the camera turned on indefinitely. However, even if the camera has shut itself off, if the power switch remains in the ON position, you can bring the camera back to life by tapping the shutter button.

Figure 12.13
The Set-up 2 menu has six options.

SAVING POWER WITH THE EOS 6D Mark II

There are three settings and several techniques you can use to help stretch the longevity of your 6D Mark II's battery. The first setting is the Image Review time option described in Chapter 11 under the Shooting 1 menu. That big 3.0-inch LCD uses a lot of juice, so reducing the amount of time it is used (either for automatic review or for manually playing back your images) can boost the effectiveness of your battery. The second setting, Auto Power Off, turns off most functions (metering and autofocus shut off by themselves about six seconds after you release the shutter button or take a picture) based on the delay you specify. The third setting is the LCD Brightness adjustment described below. If you're willing to shade the LCD with your hand, you can often get away with lower brightness settings outdoors, which will further increase the useful life of your battery. The techniques? Turn off image stabilization if your lens has that feature and you feel you don't need it. When transferring pictures from your 6D Mark II to your computer, use a card reader instead of the USB cable. Linking your camera to your computer and transferring images using the cable takes longer and uses a lot more power.

LCD Brightness

Options: Adjust LCD monitor brightness

My preference: N/A

Choose this menu option and a thumbnail image with a grayscale strip appears on the LCD, as shown in Figure 12.14. You can use the touch screen, directional buttons, or the Main Dial to adjust the brightness to a comfortable viewing level. Use the gray bars as a guide; you want to be able to see both the lightest and darkest steps at top and bottom, and not lose any of the steps in the middle. Brighter settings use more battery power, but can allow you to view an image on the LCD outdoors in bright sunlight. When you have the brightness you want, select SET to lock it in and return to the menu.

Figure 12.14
Adjust LCD brightness for easier viewing under varying ambient lighting conditions.

LCD Off/On Button

Options: Shutter Btn (default), Shutter/DISP, Remains On

My preference: Remains On

The 6D Mark II offers an option to set the camera so that the shooting display on the LCD monitor does not turn off under certain circumstances. Your options include:

- **Shutter btn.** The LCD monitor display turns off when you press the shutter release halfway, as when you are locking focus/exposure, or beginning to take a picture. If you release the shutter button without taking a picture, the LCD display returns. If the display is not visible, press the DISP. button to turn it on.
- Remains on. The LCD monitor display remains on when the shutter release is pressed halfway. You can turn it on or off by pressing the DISP. button. I prefer this mode so I can rely on the LCD display to review my current exposure settings as I shoot, even though it has a very small effect on battery life.

Date/Time/Zone

Options: Date, Time, Zone, Daylight Saving

My recommendation: N/A

Use this option to set the date and time, which will be embedded in the image file along with exposure information and other data. As first outlined in Chapter 1, you can set the date and time by following these steps:

- 1. Access this menu entry from the Set-up 2 menu.
- 2. Rotate the QCD to move the highlighting down to the Date/Time entry.
- 3. Press the SET button in the center of the QCD to access the Date/Time setting screen, shown in Figure 12.15.

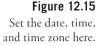

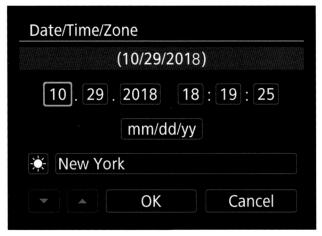

- 4. Rotate the QCD to select the value you want to change. When the gold box highlights the month, day, year, hour, minute, or second format you want to adjust, press the SET button to activate that value. A pair of up/down pointing triangles appears above the value.
- 5. Rotate the QCD to adjust the value up or down. Press the SET button to confirm the value you've entered.
- 6. Repeat steps 4 and 5 for each of the other values you want to change. The date format can be switched from the default mm/dd/yy to yy/mm/dd or dd/mm/yy; you can turn Daylight Saving time on or off, and choose an appropriate time zone.
- 7. When finished, rotate the QCD to select either OK (if you're satisfied with your changes) or Cancel (if you'd like to return to the Set-up 2 menu without making any changes). Press SET to confirm your choice.
- 8. When finished setting the date and time, press the MENU button to exit, or just tap the shutter release.

Language

Options: 25 languages

My recommendation: N/A

Choose from 25 languages for menu display, rotating the Quick Control Dial or using the multi-controller directional buttons until the language you want to select is highlighted. Press the SET button to activate. Your choices include English, German, French, Dutch, Danish, Portuguese, Finnish, Italian, Ukrainian, Norwegian, Swedish, Spanish, Greek, Russian, Polish, Czech, Magyar, Romanian, Turkish, Arabic, Thai, Simplified Chinese, Traditional Chinese, Korean, and Japanese.

If you accidentally set a language you don't read and find yourself with incomprehensible menus, don't panic. Just choose the fifth option from the top of the Set-up 2 menu, and select the idioma, sprache, langue, or kieli of your choice. English is the first selection in the list.

Viewfinder Display

Options: Electronic Level, Grid Display, Show/Hide in Viewfinder

My recommendation: N/A

Thanks to the miracle of modern technology, your optical viewfinder display can be just as crowded with information as the color LCD monitor on the back of your 6D Mark II. Fortunately, much of this clutter is optional. This menu entry allows you to select which information is shown, and which is hidden.

Figure 12.16 The viewfinder screen can become crowded with information (left). Fortunately, you can select which information is shown or hidden (right).

Here are the options:

- Electronic Level. Hide/Show. The display at the top of the frame (see Figure 12.16, left) shows how much the camera is rotated around the axis passing through the center of the front element of the lens (the horizontal indicators) or tilted up or down (the vertical indicators).
- **Grid Display.** Hide/Show. The 24-cell grid on the screen can be used for composition or leveling of horizontal or vertical components in your image, such as the horizon or architectural elements.
- Show/Hide in Viewfinder. You can select/unselect any or all of seven different indicators (Battery, Shooting Mode, AF Operation, Image Quality, Drive mode, Metering mode, Flicker warning) overlaid on the frame area, to custom tailor the amount of information displayed. (See Figure 12.16, right.)

GPS Settings

Options: Enable/Disable (default), GPS Functions: Auto Time Setting, Position Update Interval, GPS Information Display, GPS Logger

My preference: N/A

This is the first entry in the Set-up 3 menu. (See Figure 12.17.) I provided instructions for using the 6D Mark II's built-in GPS feature in Chapter 6 and will not repeat them here.

Figure 12.17
The Set-up 3 menu.

Video System

Options: NTSC/PAL My preference: N/A

This setting controls the output of the 6D Mark II when you're displaying images on an external monitor. You can select either NTSC, used in the United States, Canada, Mexico, many Central, South American, and Caribbean countries, much of Asia, and other countries, or PAL, which is used in the UK, much of Europe, Africa, India, China, and parts of the Middle East.

VIEWING ON A TELEVISION

Canon makes it quite easy to view your images on a standard television screen, and not much more difficult on a high-definition television (HDTV).

For HDTV display, purchase the optional HDMI Cable HTC-100 and connect it to the HDMI OUT terminal just below the AV Out/USB port on the left side of the camera.

Connect the other end to an HDMI input port on your television or monitor (my 42-inch HDTV has three of them; my 26-inch monitor has just two). Then turn on the camera and press the Playback button. The image will appear on the external TV/HDTV/monitor and will not be displayed on the camera's LCD. HDTV systems automatically show your images at the appropriate resolution for that set.

Mode Guide

Options: Enable/Disable My preference: Disable

When enabled, rotating the Mode Dial to a shooting mode displays a screen describing that mode at inoportune times. You can dismiss it by pressing the SET button, and read additional (useless) information by pressing the down button. You would conceivably need this feature only if you are a complete newbie who has used the camera a week or less. Disable it.

Feature Guide

Options: Enable/Disable My preference: Disable

This is the equivalent to the Mode Guide, with pithy and generally superfluous explanations of other features, spelling out, for example, what the Drive Mode options are. (Even without the Feature Guide, when you select a drive mode, it's label is generally a sufficient clue for the non-clueless.) Disable this setting, as well.

Help Text Size

Options: Small/Standard My preference: Standard

Here you can choose the size of the Help Text. The Small size allows fitting more text on the LCD monitor without the need to scroll. I leave this set at Standard, as I seldom need the Help feature and scrolling down to read all of it is less of a chore than looking for my bifocals to read the smaller text.

Touch Control

Options: Standard (default), Sensitive, Disable

My preference: N/A

Use this entry, the first in the Set-up 4 menu, to set standard sensitivity, a more sensitive response, or to totally disable the LCD touch screen feature. (See Figure 12.18.) If you find yourself accidentally triggering commands by touching the screen or frequently touch the wrong settings and want to turn it off, you can do so. I often disable touch screen control when I am wearing gloves.

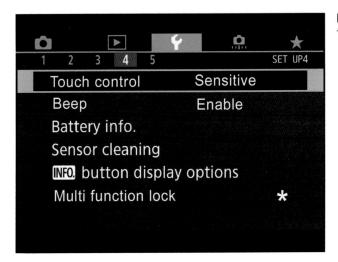

Figure 12.18 The Set-up 4 menu.

Beep

Options: Enable (default), Touch Screen, Disable

My preference: Disable

The Rebel 6D Mark II's internal beeper provides a helpful chirp to signify various functions, such as the countdown of your camera's self-timer. You can switch it off if you want to avoid the beep because it's annoying, impolite, or distracting (at a concert or museum), or undesired for any other reason. It's one of the few ways to make the 6D Mark II a bit quieter, other than Silent Single Shooting and Silent Continuous Shooting, which are *less noisy* rather than truly silent. (I've actually had new dSLR owners ask me how to turn off the "shutter sound" the camera makes; such an option was available in the point-and-shoot camera they'd used previously.) Select Beep from the menu, choose SET, and use the touch screen or directional buttons to choose Enable or Disable, or Touch To Screen (which silences the beep only during touch screen operations), as you prefer. Use SET again to activate your choice.

Battery Info.

Options: Register, Delete Info.

My recommendation: N/A

This entry is an exceptionally useful feature that allows you to view battery condition information and performance, and track the data among several different batteries. Your EOS 6D Mark II can keep track of multiple LP-E6 or LP-E6N batteries because each of them is given a unique serial number (which is either printed on or available on a sticker you can affix to the battery). The camera

reads this serial number and stores information about each of the batteries that you use and have "registered" separately. I always recommend owning at least two and, preferably three or more batteries. That's especially true if you use the Battery Grip BG-E21, which holds two battery packs itself. I also own the EOS 80D, which uses the same battery, so I'm able to justify four batteries to shuttle between my two cameras.

This feature makes it possible to see exactly how each battery you own is performing, allows you to rotate them to even out the usage, and helps you know when it's time to replace a battery. When you select this menu choice, a Battery info screen like the one shown at left in Figure 12.19 appears, with a wealth of information (if you use two LP-E6/E6N packs in a BG-E21 grip, information about both packs will appear):

- **Battery position.** The second line of the screen includes an icon that shows where the battery currently being evaluated is installed (usually the hand grip if you're not using the BG-E21).
- **Power type.** Next to the position icon is an indicator that shows the model number of the battery installed, or shows that the DC power adapter is being used instead.
- Remaining capacity. The Battery check icon appears showing the remaining capacity visually, along with a percentage number that reads out in 1% increments. You can use this as a rough gauge of how much power you have remaining. If you're in the middle of an important shooting session, you might want to switch to a fully charged battery at the 25%–33% level to avoid interruptions at the worst probable time. (If you're using six AA batteries in the BG-E6 grip instead of LP-E6 packs, only this battery capacity notice will appear; the other indicators are not shown.)
- **Shutter count.** Displays how many times the shutter has been actuated with the current charged battery. This info can help you learn just how much certain features cost you in terms of power. For example, if a battery has only 50 percent of its power remaining, but you've taken only a few dozen photos, you know that your power is being sapped by picture review, lots of autofocus, frequent image stabilization because of lower shutter speeds, or (a major culprit) that flip-up flash you've been using. While in most cases knowledge is power, in this instance knowledge can help you *save* power, with a tip-off to use fewer juice-sapping features if the current battery pack must be stretched as far as possible.
- Recharge performance. This indicator shows how well your battery pack is accepting and holding a charge. Three green bars mean that the pack's performance is fine; two bars show that recharge performance is degraded a little. A red bar indicates that your pack is on its last legs and should be replaced soon. To lengthen the service time of your batteries, you might want to rotate usage among several different packs, so they all "age" at roughly the same rate.

Registering Your Battery Packs

The EOS 6D Mark II can "remember" information about up to six LP-E6 battery packs, and provide readouts of their status individually. To register the battery currently in your camera, follow these steps:

- 1. Access the Battery Info. screen from the Set-up 3 menu.
- 2. Press the INFO. button, located to the left of the LCD screen.
- 3. Information about the current battery, including its serial number and the current date, will be shown on a new screen (see Figure 12.19, right).
- 4. Choose Register to log the battery; if the pack has already been registered, you can choose Delete Info. to remove the battery from the list. (You'd want to do this if you already had registered the limit of six batteries and want to add another one.)
- 5. Press SET to add the battery to the registry.
- 6. If you're deleting a battery, the 6D Mark II shows you a Battery Info. delete screen instead. (You can delete a battery pack without having that battery installed in the camera—which could come in handy if you lose one.) Just select the battery (by serial number) and delete.
- 7. Press MENU to back out of any of the Battery Info. screens.
- 8. Once a battery has been registered, you can check on its remaining capacity at any time (even if it isn't currently installed in the 6D Mark II) from the Battery info page. The camera remembers and updates the status of each registered battery whenever it is inserted in the 6D Mark II. The date the battery was last used is also shown.

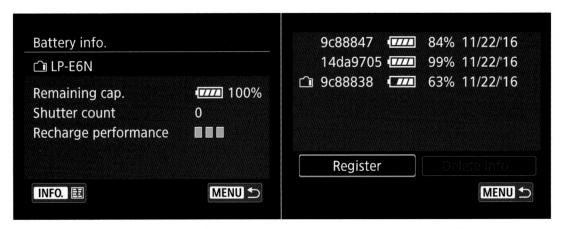

Figure 12.19 View the battery type and position, remaining capacity, number of pictures taken with the current charge, and the performance of your pack (left). Register a new battery (right).

Tip

Use this info with caution, however, as a given battery may have self-discharged slightly during storage and, of course, you may have fully recharged it since the last time it was inserted in the camera. However, this data can be useful in tracking the remaining capacity of several different battery packs during a single shooting session, or over the course of several days when you're not recharging the packs after each session.

Sensor Cleaning

Options: Auto Cleaning, Clean Now, Clean Manually

My recommendation: N/A

One of the Canon EOS 6D Mark II's most useful features is the automatic sensor cleaning system that reduces or eliminates the need to clean your camera's sensor manually using brushes, swabs, or bulb blowers. Canon has applied anti-static coatings to the sensor and other portions of the camera body interior to counter charge build-ups that attract dust. A separate filter over the sensor vibrates ultrasonically each time the 6D Mark II is powered on or off, shaking loose any dust, which is captured by a sticky strip beneath the sensor.

Use this menu entry to enable or disable automatic sensor cleaning on power up (select Auto Cleaning to choose) or to activate automatic cleaning during a shooting session (select Clean Now). You can also choose the Clean Manually option to flip up the mirror and clean the sensor yourself with a blower, brush, or swab. If the battery level is too low to safely carry out the cleaning operation, the 6D Mark II will let you know and refuse to proceed, unless you use the optional AC Adapter Kit ACK-E6N with the DC Coupler DR-E6.

INFO. Button Display Options

Options: Electronic Level, Quick Control screen

My recommendation: N/A

The INFO. button on the back panel of the Canon EOS 6D Mark II can cycle among up to two different screens on the color LCD monitor, or display a blank screen. The button alternates among Electronic Level, Quick Control, and the blank screen. If one is shown, press the INFO. button to see the others or to turn off the display entirely. This setting allows you to specify which of the screens are shown. **Note:** When in Live View or Movie modes, this entry has different options, which allow you to adjust the INFO. button settings, specify a histogram, and reset to the defaults. Live view options are covered in Chapter 14.

Multi Function Lock

Options: Main Dial, Quick Control Dial, Multi-controller (directional buttons), Touch control My recommendation: N/A

Your 6D Mark II includes a sliding lock switch just beneath the Quick Control Dial. Rotate it upward when you want to prevent the use of the QCD, Main Dial, multi-controller, or touch controls from accidentally changing a setting. You can select any or all four of the controls to lock, while freeing the others (or none) to act normally. I use this sometimes when I am using manual exposure, especially when I'm fumbling around in a darkened environment, and don't want to unintentionally manipulate my settings. The Multi Function Lock screen has one option for each control; highlight the control and press SET to lock or unlock it. A check mark appears next to the control's name when it's locked, and an L/Lock indicator appears in the viewfinder, top-panel LCD, and shooting settings display (see Figure 12.20). Even if you've locked the QCD, its touchpad functions can still be used during movie shooting even if Silent Control has been activated in the Shooting 5 (Movie) menu.

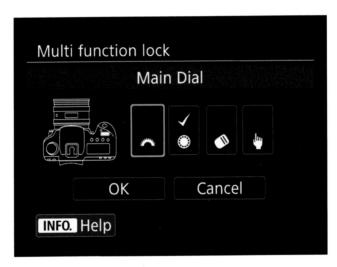

Figure 12.20 Lock any or all of these four.

Custom Shooting Mode (C1, C2)

Options: User settings saved in one of three memory slots

My recommendation: N/A

This entry is the first in the Set-up 5 menu (see Figure 12.21). It allows you to register your EOS 6D Mark II's current camera shooting settings and file them away in the C1 or C2 positions on the Mode Dial. Doing this overwrites any settings previously stored at that position. You can also clear the settings for any of the three Mode Dial positions individually, returning them to their factory default values. Table 12.1 shows the settings you can store.

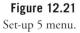

Table 12.1 Stored Camera User Settings		
Mode/Menu	Settings	
Shooting menu	Shooting 1: Image quality; Image review time; Release shutter without card; Lens aberration correction; Lens electronic MF; Flash firing; E-TTL II flash metering; Flash sync speed in AV mode	
	Shooting 2: Exposure compensation/AEB; ISO speed settings; Auto Lighting Optimizer; All white balance settings; Color space	
	Shooting 3: Picture Style; Long exposure noise reduction; High ISO speed noise reduction; Highlight tone priority; Multiple exposure; HDR mode	
	Shooting 4: Interval timer; Bulb timer; Anti-flicker shooting; Mirror lockup; Aspect ratio; Live view shooting	
	Shooting 5 (Live View): AF method; Touch shutter; Metering timer; Grid display; Exposure simulation; Silent LV shooting	
	Movie Shooting 1: Movie recording size; Image quality; Sound recording; Peripheral illumination correction; Chromatic aberration correction; Lens electronic MF	
	Movie Shooting 2: Exposure compensation; Movie ISO speed settings; Auto Lighting Optimizer; All White balance settings	

Table 12.1 Stored Camera User Settings (continued)		
Mode/Menu	Settings	
Shooting menu (continued)	Movie Shooting 4: Movie servo AF; AF method; Movie Servo AF tracking sensitivity; Movie Servo AF speed; Metering timer; Grid; Shutter button function Movie Shooting 5: Video snapshot; Time-lapse movie; Movie digital IS; Remote control	
Playback menu	Playback 2: Slide show settings; Image Jump with Main Dial Playback 3: Highlight alert; AF point display; Playback grid; Histogram display; Magnification (approximate)	
Set-up menu	Set-up 1: File numbering; Auto rotate Set-up 2: Auto power off; LCD brightness; LCD on/off button; Viewfinder display; Touch control Set-up 3: Help text size Set-up 4: Touch control; Beep; Auto Cleaning; INFO. button display options/INFO. button LV display options; Multi-function lock Set-up 5: Multi-function lock	
Custom Functions	Custom Functions I: Exposure level increments; ISO speed setting increments; Bracketing auto cancel; Bracketing sequence; Number of bracketed shots; Safety shift; Exposure compensation auto cancel; Metering mode; AE locked after focus Custom Functions II: Tracking sensitivity; Acceleration/deceleration tracking; AF point auto switching, AI Servo 1st image priority; AI Servo 2nd image priority; AF-assist beam firing; Lens drive when AF impossible; Select AF area selection mode; AF area selection method; Orientation linked AF point; Initial AF Point; AI Servo AF; Auto AF point selection; Color tracking; AF point selection movement; AF point display during focus; VF display illumination; AF Microadjustment Custom Functions III: Dial direction during Tv/Av; Retract lens on power off; Custom Controls	

Register your favorite settings for use in particular situations. I have stored settings for sports, portraits, and another for landscapes. If you switch to C1 or C2 and forget what settings you've made for that slot, just press the INFO. button to view the current settings. Keep in mind that My Menu settings are not stored individually. You can have only one roster of My Menu entries available for all the Mode Dial's positions.

This menu choice has only two options: Register (which stores your current settings in your choice of C1 or C2) and Clear Settings (which erases the settings in C1 or C2). Note that you must use this menu entry to clear your settings; when using C1 or C2, the Clear Settings option in the Set-up 3 menu is disabled. The Clear all Custom Func. (C.Fn) option in the Custom Functions menu is disabled as well.

To perform either of these tasks, just follow these steps:

- 1. **Make your settings.** Set the EOS 6D Mark II to an exposure mode other than Scene Intelligent Auto.
- Access Camera user settings. Navigate to the Custom shooting mode option in the Set-up 5 menu, and press SET.
- 3. **Choose function.** Rotate the Quick Control Dial to choose Register if you want to store your 6D Mark II's current settings in C1 or C2; or select Clear Settings if you want to erase the settings stored in either location. Press SET to access the settings screen for your choice.
- 4. **Store/Clear settings.** The individual screens for storing/clearing are virtually identical. Use the QCD to highlight Mode Dial: C1 or Mode Dial: C2, and press SET to store or clear the settings for that position. (You'll be given a choice to proceed or cancel first.)
- 5. **Auto update.** Keep in mind that if you change a setting while using one of the custom shooting modes and want to retain the new settings, your stored settings can be automatically updated to reflect the modifications. Select Auto Update Set. and choose Enable to activate this option. If you'd rather retain your custom settings until you manually decide to update, select Disable instead.
- 6. **Exit.** When you confirm, you'll be returned to the Set-up 5 menu. Press the MENU button or tap the shutter release button to exit the menu system entirely.

Clear All Camera Settings

Options: Clear settings
My recommendation: N/A

This menu choice resets all the settings to their default values. Regardless of how you've set up your EOS 6D Mark II, it will be adjusted to One-Shot AF mode, Automatic AF point selection, Evaluative metering, JPEG Fine Large image quality, automatic ISO, sRGB color mode, automatic white balance, and Standard Picture Style. Any changes you've made to exposure compensation, flash exposure compensation, and white balance will be canceled, and any bracketing for exposure or white balance nullified. Custom white balances and Dust Delete Data will be erased. Tables showing the factory default settings and my recommendations were provided in Chapter 3.

Remember, Custom Functions and Camera User Settings will *not* be cleared. If you want to cancel those as well, you'll need to use the Custom shooting mode option (described previously) and the Custom Functions clearing option.

Copyright Information

Options: Display Copyright Information, Enter Author's Name, Enter Copyright Details, Delete Copyright Information

My recommendation: N/A

Here's where you can give yourself credit for the great photos you're shooting with your 6D Mark II:

- Display Copyright Info. Enable or disable embedding copyright information in your image files. If you're a double-naught secret agent who wants to submit spy photos anonymously, you'll definitely want to disable copyright information.
- Enter Author's Name. You can add your own name (up to 63 characters) to each image file. In this case, the touch screen is definitely your best bet for typing in the text.
- Enter Copyright Details. You can add more information using the expanded character set. Up to 63 characters can be entered. Note that no copyright symbol is available. While some use a lowercase *c* within parentheses, technically the correct notification would be (Copyright) or (Copr).
- **Delete Copyright Information.** This removes all the data you've entered and gives you a clean slate, so to speak.

Manual/Software URL

Options: None

My preference: N/A

Displays a QR code you can snap with your smart device to jump to a web page where software and PDF manuals for your 6D Mark II can be downloaded.

Certification Logo Display

Options: None

My recommendation: N/A

This is an informational only screen, which allows Canon to add certification data (similar to what is printed on the bottom panel of the camera) via a firmware upgrade, and without the need to manufacture new stickers for the camera bottom.

Firmware

Options: Update firmware **My recommendation:** N/A

You can see the current firmware release in use in the menu listing. If you want to update to a new firmware version, insert a memory card containing the binary file, and press the SET button to begin the process.

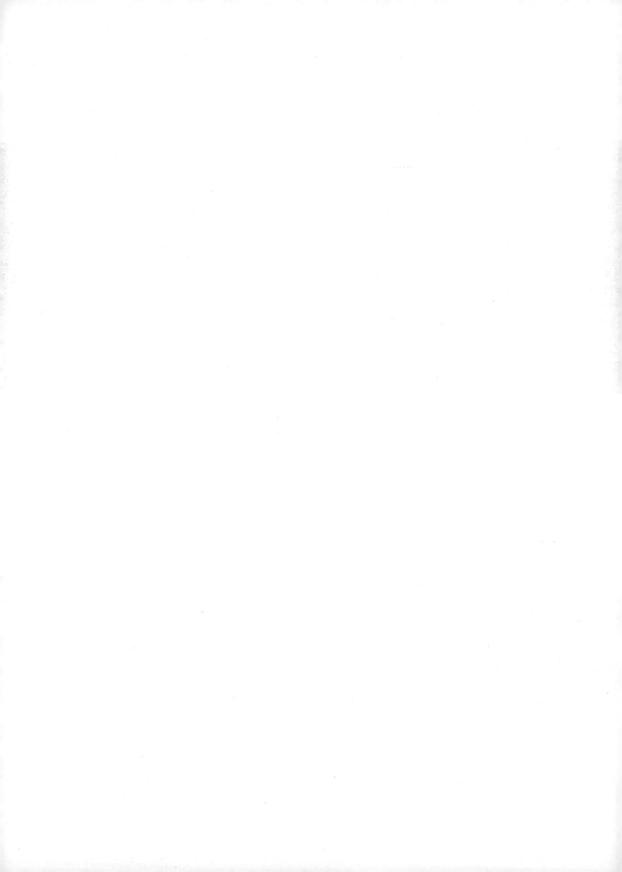

The Custom Functions and My Menus

Custom Functions let you tailor the behavior of your camera in a variety of different ways, such as the function carried out when the SET button is pressed. If you don't like the default way the camera carries out a particular task, you may be able to do something about it. You can find the Custom Functions in their own menu, color-coded orange, and visible whenever you are using P, Tv, Av, M, and B exposure modes. (See Figure 13.1.) There are 28 C.Fn entries in all, divided into separate screens: C.Fn I: Exposure, C.Fn II: Autofocus, and C.Fn III: Operation/Others. There is also a Clear All Custom Func. option to allow you to return all settings (except for your Custom Controls definitions) to their factory defaults.

Because the C.Fn II: Autofocus features are so tightly interwoven with the 6D Mark II's other AF options, I described them in Chapter 5. This chapter deals *only* with the C.Fn I: Exposure and C.Fn III: Operation/Others entries.

As I explained in Chapter 5, each Custom Function main screen provides a numbered list of available adjustments arrayed along the bottom, as seen in Figure 13.2. The number of the currently selected Custom Function is indicated by a box in the upper right of the screen, and the same number is highlighted with a colored bar above it in the number strip at the bottom. Some Custom Functions use settings screens to make adjustments; those are indicated by horizontal bar symbols beneath their number. Other Custom Functions use numbered options, with the default values always assigned number zero. A non-default (non-zero) value that has been selected is colored cyan, so you can always tell at a glance what options are active with each of these Custom Functions.

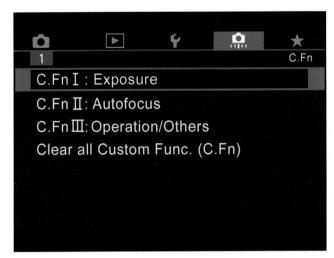

Figure 13.1
The Custom
Functions menu.

To adjust a Custom Function, highlight its number and press SET to view the adjustment screen. After you've made your adjustment, press MENU to confirm and exit. These are your options:

- Exposure Level Increments
- ISO Speed Setting Increments
- Bracketing Auto Cancel
- Bracketing Sequence
- Number of Bracketed Shots
- Safety Shift
- Exposure Compensation Auto Cancel
- Metering Mode/Exposure Locked After Focus
- Warnings in Viewfinder
- Dial Direction During Tv/Av
- Retract Lens on Power Off
- Custom Controls
- Clear All Custom Func. (C.Fn)

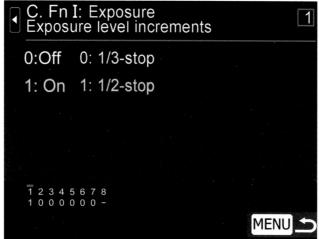

Custom Function 1 (C.Fn I): Exposure

This is the Custom Function category you can use to set the increments for exposure and ISO, define bracketing parameters, and other settings.

Exposure Level Increments

Options: 1/3 stop (default), 1/2 stop

My preference: 1/3 stop

This setting tells the EOS 6D Mark II the size of the "jumps" it should use when making exposure adjustments—either one-third or one-half stop. The increment you specify here applies to f/stops, shutter speeds, EV changes, and autoexposure bracketing.

- 1/3 stop. Choose this setting when you want the finest increments between shutter speeds and/or f/stops. For example, the 6D Mark II will use shutter speeds such as 1/60th, 1/80th, 1/100th, and 1/125th second, and f/stops such as f/5.6, f/6.3, f/7.1, and f/8, giving you (and the autoexposure system) maximum control.
- 1/2 stop. Use this setting when you want larger and more noticeable changes between increments. The 6D Mark II will apply shutter speeds such as 1/60th, 1/125th, 1/250th, and 1/500th second, and f/stops including f/5.6, f/6.7, f/8, f/9.5, and f/11. These coarser adjustments are useful when you want more dramatic changes between different exposures.

ISO Speed Setting Increments

Options: 1/3 stop (default), 1 stop

My preference: 1/3 stop

This setting determines the size of the "jumps" made when adjusting ISO—either one-third or one full stop. At the one-third stop setting, typical ISO values would be 100, 125, 160, 200, and so forth. Switch to the one-stop setting, and ISO values would be 100, 200, 400, 800, and so forth. The larger increment can help you leap from an ISO setting to one that's twice (or half) as sensitive with one click.

Bracketing Auto Cancel

Options: Enable (default), Disable

My preference: Enable

When Auto Cancel is activated (the default), AEB (Auto Exposure Bracketing) and WB-BKT (White Balance Bracketing) are cancelled when you turn the 6D Mark II off, change lenses, use the flash, or change memory cards; when Auto Cancel is deactivated, bracketing remains in effect until you manually turn it off or use the flash. When Auto Cancel is switched off, the AEB and WB-BKT settings will be kept even when the power switch is turned to the OFF position. The flash still cancels autoexposure bracketing, but your settings are retained.

I prefer the Enable setting, because I generally shoot a series of bracketed exposures and then turn off the camera when I am finished.

Bracketing Sequence

Options: 0-+ (default), -0+, +0-

My preference: -0+

You can define the sequence in which AEB and WB-BKT series are exposed. For exposure bracketing, you can determine whether the order is metered exposure, decreased exposure, increased exposure exposure, metered exposure, increased exposure; or increased exposure, metered exposure, decreased exposure. Or with white balance bracketing, if your bias preference is set to Blue/Amber in the WB SHIFT/BKT adjustments in the Shooting 2 menu, the white balance sequence when option 0 is selected will be current WB, more blue, more amber. If your bias preference is set to magenta/green, then the sequence for option 0 will be current WB, more magenta, more green. Because I shoot so many HDR images to merge in Photoshop, I prefer the -0+ sequence,

which starts with less exposure, metered exposure, and plus exposure, as that is the way I bracketed back in the film days.

- 0-+. Exposure sequence is metered exposure, decreased exposure, increased exposure. White balance sequence is current WB, more blue/more magenta (depending on how your bias is set), more amber/more green (ditto).
- -0+. The sequence is decreased exposure, metered exposure, increased exposure. White balance sequence is more blue/more magenta, current WB, more amber/more green.
- +0-. The sequence is increased exposure, metered exposure, decreased exposure. White balance sequence is more amber/more green, current WB, more blue/more magenta.

Number of Bracketed Shots

Options: 2, 3 (default), 5, 7 shots

My preference: 3

Your choices are 2, 3, 5, or 7 shots in a bracket sequence (although Canon lists them out of order, with the default 3 shots as the default entry). I find that with an increment of 2/3 or one full stop, three bracketed exposures are enough that one of them will be close to optimum.

Safety Shift

Options: Disable (default), Shutter Speed/Aperture, ISO Speed

My preference: Disable

Ordinarily, both Aperture-priority and Shutter-priority modes work fine, because you'll select an f/stop or shutter speed that allows the 6D Mark II to produce a correct exposure using the other type of setting (shutter speed for Av; aperture for Tv). However, when lighting conditions change, it may not be possible to select an appropriate setting with the available exposure options, and the camera will be unable to take a picture at all.

For example, you might be at a concert shooting the performers and, to increase your chances of getting a sharp image, you've selected Tv mode and a shutter speed of 1/250th second. Under bright lights and with an appropriate ISO setting, the 6D Mark II might select f/5.6, f/4, or even f/2.8. Then, in a dramatic moment, the stage lights are dimmed significantly. An exposure of 1/250th second at f/2 is called for, but your lens has an f/2.8 maximum aperture. If you've used this Custom Function to allow the 6D Mark II to override your selection, the camera will automatically switch to 1/125th second to allow the picture to be taken at f/2.8.

Safety Shift will make similar adjustments if your scene suddenly becomes too bright; although, in practice, you'll find that the override will be needed most often when using Tv mode. It's easier to "run out of" f/stops, which generally range no smaller than f/22 or f/32, than to deplete the available supply of shutter speeds, which can be as brief as 1/3,000th second. For example, if you're shooting at ISO 400 in Tv mode at 1/1,000th second, an extra-bright beach scene could easily call for an f/stop smaller than f/22, causing overexposure. However, Safety Shift would bump your shutter speed up to 1/2,000th second with no problem.

On the other hand, if you were shooting under the same illumination in Av mode with the preferred aperture set to f/16, the EOS 6D Mark II could use 1/1,000th, 1/2,000th, or 1/4,000th second shutter speeds to retain that f/16 aperture under conditions that are 2X, 4X, 8X, or 16X as bright as normal daylight. No Safety Shift would be needed, even if the ISO were (for some unknown reason) set much higher than the ISO 400 used in this example. These are your options:

- **Disable.** Turn off Safety Shift. Your specified shutter speed or f/stop remains locked in, even if conditions are too bright or too dim for an appropriate exposure. Use this option if you'd prefer to have the shot taken at the shutter speed, aperture, or ISO you've selected under all circumstances, even if it means an improperly exposed photo. You might be able to salvage the photo in your image editor.
- **Shutter Speed/Aperture.** Safety Shift is activated for Tv and Av modes. The 6D Mark II will adjust the preferred shutter speed or f/stop to allow a correct exposure. If you don't mind having your camera countermand your orders, this option can save images that otherwise might be incorrectly exposed. Use when working with a shutter speed or aperture that is *preferable*, but not critical.
- **ISO Speed.** This option operates in Program AE (P) mode as well as Tv and Av modes. Think of it as an "emergency" Auto ISO option. You can manually select your preferred ISO setting, and the 6D Mark II will generally stick with that, but can adjust the ISO setting if required to produce an acceptable exposure. If you've selected a minimum and maximum allowable ISO range in the ISO Speed Settings entry of the Shooting 2 menu (as explained in Chapter 11), this setting will honor those limits *unless* your current manually selected ISO is outside those boundaries.

For example, if you've chosen a minimum and maximum auto ISO range of ISO 200–800, this setting will stay within that range when adjusting ISO (even though you have Auto ISO off), but if your camera is currently manually set to ISO 100 or a value higher than ISO 800, it will go ahead and use the extra values, too.

Exposure Comp. Auto Cancel

Options: Disable (default), Enable

My preference: Disable

This setting can solve a frequent problem that some users have with the "sticky" exposure compensation setting, which continues in force even when the camera is turned off, and then powered up again. You have two choices:

- **Disable (default).** When the camera is turned off, any exposure compensation settings you previously specified are still active. I prefer this mode, because I often switch off my camera during long delays in shooting, and would rather not have to re-enter my adjustment when the session resumes. You must remember to cancel exposure compensation manually when you are finished using the exposure correction.
- Enable. Each time you turn off the camera, any existing exposure compensation is removed and the camera returns to using the metered exposure as-is. This option is especially useful for forgetful types, who often wonder why their photos are too dark or too light, not realizing that their previous exposure compensation settings are still in effect.

Exposure Metering Mode, AE Locked After Focus

Options: Evaluative, Center-Weighted, Spot, Averaging

My preference: Enable all

This entry controls whether exposure is locked when the shutter button is pressed while working in One-Shot AF mode. As you know, with One-Shot AF, the autofocus is locked when the shutter release is pressed down halfway (unless you're using back button focus, as described in Chapter 5). You can also lock *exposure* with a half-press too, and this entry allows you to choose in *which* metering modes that should happen.

The screen that appears when you invoke this entry has icons representing Evaluative, Center-Weighted, Spot, and Averaging metering in a row. Highlight any, or all, and press the SET button to place a check mark above that metering mode to enable it, or to remove the check mark and disable half-press AE lock for that metering mode.

In general, I enable all the metering modes, but you might want to disable one or more modes to suit your shooting style. For example, it is common to use Spot metering to measure a specific area and then lock exposure while you reframe your picture. But if lighting conditions are constantly changing (say, at a stage performance with lighting effects), you might want to delay locking exposure until the moment you press down the shutter release all the way to take the picture. You'd give up the reframing option for greater control over when the exposure is locked.

Or, you might want something you could think of as "reverse" back-button focus—back-button AE lock. Disable any or all the metering modes, and then you can press the shutter button halfway to lock focus, but delay exposure lock until you press the AE Lock button (on the back of the camera, marked with an asterisk).

Custom Function 3 (C.Fn III): Operation/Others

As I noted at the beginning of the chapter, Custom Function 2 (C.Fn II) settings were explained in Chapter 5 and will not be repeated here. Instead, we'll jump directly to this menu tab, which offers several options for display and controls, including the important Custom Controls feature.

Warnings in Viewfinder

Options: Monochrome Picture Style, WB Correction, Multi-Shot Noise Reduction, HDR **My preference:** N/A

This useful function lets you individually enable or disable four different viewfinder warnings, allowing you to reduce the amount of clutter in your field of view as you frame an image, while retaining the warnings that you really, really want to remain in effect. Mark any or all with a check mark by highlighting the option and pressing SET. Your choices include warnings for the following:

- Monochrome Picture Style. If you shoot JPEG most of the time, you might want a tip-off that you've set the camera in black-and-white mode, because color information cannot be added in post-processing. If you generally shoot RAW or RAW+JPEG, you won't care, because the RAW image retains the color information.
- WB Correction. It's easy to dial in some white balance correction, and easier to forget that you've done so. This warning will let you know—again, very important when shooting JPEG only.
- Multi-Shot Noise Reduction. When High-Speed Noise Reduction is set to Multi-Shot Noise Reduction, you'll receive a warning. While the availability of this extreme setting isn't normally a problem, if you feel you're likely to need a tip-off, you can activate this warning.
- HDR. Alerts you that HDR is being used.

Dial Direction During Tv/Av

Options: Normal (-+), Reverse direction (+-)

My preference: Normal

This setting reverses the result when rotating the Quick Control Dial and Main Dial when using Shutter-priority or Aperture-priority (Tv and Av). That is, rotating the Main Dial to the right will decrease the shutter speed rather than increase it; f/stops will become larger rather than smaller. Use this if you find the default rotation scheme in Tv and Av modes are not to your liking. Activating this option also reverses the dial direction in Manual exposure mode. In other shooting modes, only the Main Dial's direction will be reversed.

- 0: Normal. The Main Dial and Quick Control Dial change shutter speed and aperture normally.
- 1: Reverse direction. The dials adjust shutter speed and aperture in the reverse direction when rotated.

Retract Lens on Power Off

Options: Enable (default), Disable

My preference: Enable

Some lenses that focus using a gear mechanism (such as the EF40mm f/2.8 STM) can retract when the camera is turned off. The retracted lens is smaller and its reduced surface area is better protected against bumps, so I usually leave this setting enabled.

Custom Controls

Options: Redefine nine buttons

My preference: N/A

If you're eager to totally confuse any poor soul who is not equipped to deal with a custom-configured 6D Mark II (or, perhaps, even yourself), Canon allows you to redefine the behavior of no less than nine different controls in interesting, and potentially hilarious, ways. Just highlight any of the nine options (shown in Figure 13.3, left), press SET to view the functions you can assign, and make your choice. (See Figure 13.3, right.) You can truly manipulate your camera to work in a way that's fastest and most efficient for you. There are dozens of combinations of control possibilities (some buttons have as many as 12 different options, plus Off), spelled out in a huge matrix+legend description starting on page 498 of your factory manual. The options and explanations would take up half this chapter, so I won't duplicate that information here. Press the Trash button from the Custom Controls screen to return all your settings to the default values shown in Table 13.1.

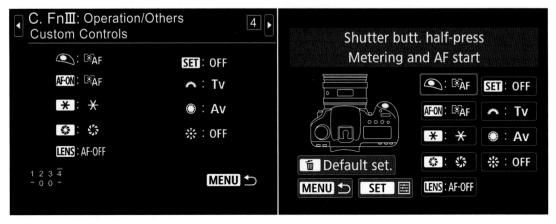

Figure 13.3 Assignable buttons.

Table 13.1 Assignable Controls			
Control	Default		
Shutter button half-press	Metering and AF start		
AF-On button	Metering and AF start		
AE Lock button	AE Lock		
DOF Preview button	Depth-of-field preview		
Lens AF stop button (if available on lens)	AF stop		
SET button	No additional function		
Main Dial	Shutter speed setting in Tv and Manual Mode		
Quick Control Dial	Aperture setting in Av and Manual Mode		
Multi-controller (directional buttons)	No additional function		

Clear All Custom Func. (C.Fn)

Options: Clear

My preference: N/A

Select this entry and choose Cancel (if you chicken out) or OK to return all your Custom Functions to their default values. But don't panic—your matrix of Custom Controls is retained. If you want to zero out those settings, you'll need to access the Custom Controls screen in the Custom Functions 3 menu, and press the Trash button.

My Menu

Options: Add My Menu Tab, Delete All My Menu Tabs, Delete All Items, Menu Display My preference: N/A

The Canon EOS 6D Mark II has a great feature that allows you to define your own menu with multiple tabs, each with just the items listed that you want. Remember that the 6D Mark II always returns to the last menu and menu entry accessed when you press the MENU button. So, you can set up My Menu to include just the items you want, and jump to those items instantly by pressing the MENU button. Or, you can set your camera so that My Menu appears when the MENU button has been pressed, regardless of what other menu entry you accessed last.

To create your own My Menu, you have to *register* the menu items you want to include. (See Figure 13.4, left.) Just follow these steps:

- 1. Press the MENU button and use the Main Dial or multi-controller to select the My Menu tab. When you first begin, the personalized menu will be empty except for the My Menu settings shown in the figure.
- 2. Rotate the Quick Control Dial to select Add My Menu Tab, then press the SET button. Highlight OK in the screen that appears, and press SET once again.
- 3. The Configure choice will appear. Press SET to view a list of options. Choose Select Items to Register, located at the top of the options screen.
- 4. Use the Quick Control Dial to scroll down through the continuous list of menu entries to find one you would like to add. Press SET.
- 5. Confirm your choice by selecting OK in the next screen and pressing SET again.
- 6. Continue to select more entries for your My Menu tab. You can add up to six for each tab.
- 7. When you're finished, press the MENU button twice to return to the My Menu screen to see your customized menu, which might look like my example in Figure 13.4, right.

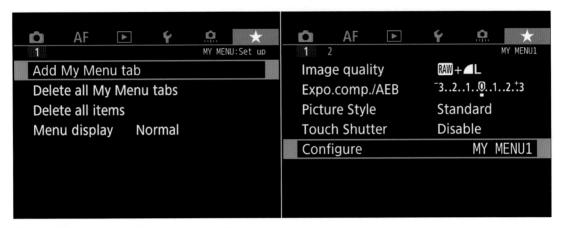

Figure 13.4 Create your My Menu tabs (left) and add entries to them (right).

Because you have just added a My Menu tab, My Menu will have two screens. The second screen will contain the options shown in Figure 13.4, left. You can use those entries to:

- Add Another My Menu Tab. Each time you do, you must use Configure to add at least one entry to the new menu. Your new menus will be assigned names, like MY MENU1, MY MENU2, etc. The original MY MENU: Set up tab will move to the farthest position in the tab lineup. You can have a maximum of five new tabs, plus the sixth Set up tab.
- Delete All My Menu Tabs. If you want to start over, you can delete all your tabs.
- **Delete All Items.** This deletes all the registered items on all the tabs you have added. The options in the MY MENU: Set up tab remain. When you delete all items, each will still contain a Configure choice, which allows you to register more entries. The tabs themselves are not removed.
- **Menu Display.** This determines which menu screen appears first when the MENU button is pressed. You can choose:
 - **Normal Display (default).** Shows the *most recently displayed* menu tab from the Shooting, AF, Playback, Set-up, Custom Settings, and My Menu choices. You'd want this if you prefer to jump back to whichever menu you were working with recently.
 - **Display From My Menu Tab.** Shows the My Menu tab only. Use this if you want to bypass the conventional menus and make your menu choices only from your custom My Menu tabs. The other menu tabs are still shown and can be selected.
 - **Display Only My Menu Tab.** Only the My Menu tabs are available. The others are hidden. Use this only if you do not need to use the conventional menus as you work. You can return to this entry and restore Normal display at any time.

In addition to registering menu items, you can fine-tune each individual tab after you have registered some items by selecting Configure. The screen shown in Figure 13.5 appears with these options:

- Sort Registered Items. Choose this entry to reorder the items in each My Menu tab. Select the menu item and press the SET button. Rotate the Quick Control Dial to move the item up and down within the menu list. When you've placed it where you'd like it, press the MENU button to lock in your selection and return to the previous screen. When finished, press MENU again to exit.
- Delete Selected Items, Delete All Items on Tab, Delete Tab. Use these to remove an individual menu item or all menu items on a tab, or to delete the entire tab itself.
- Rename Tab. You're not stuck with the MY MENU1, MY MENU2... monikers. This entry allows you to apply a new name for a tab with up to 16 characters. For example, if you created customized Shooting or Autofocus settings, you could name them My Shooting and My Autofocus, respectively. As with any of the 6D Mark II's text-entry screens, this is one example of when the touch screen is highly preferable.

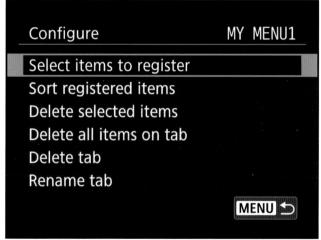

Using Live View

The Canon EOS 6D Mark II has a gorgeous 3.0-inch LCD that can be viewed under a variety of lighting conditions and from wide-ranging angles, so you don't have to be exactly behind the display to see its live view image clearly while shooting stills or video. If you want to use automatic focus the Dual Pixel CMOS AF system provides the best live view autofocus Canon has offered. You still must avoid pointing your 6D Mark II at bright light sources (especially the sun) when using live view, but the real-time preview can be used for fairly long periods without frying the sensor. (Image quality can degrade, but the camera issues a warning when the sensor starts to overheat.)

You need to take some steps before using live view. This workflow prevents you from accidentally using live view when you don't mean to, thus potentially losing a shot, and it also helps ensure that you've made all the settings necessary to successfully use the feature efficiently.

Figure 14.1
Live View settings can be found in the Shooting 5 menu when live view is active.

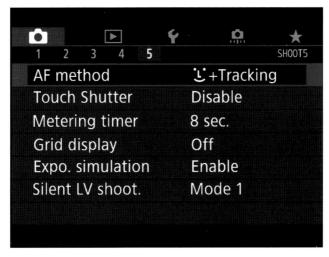

Here are the steps to follow:

- 1. **Choose a shooting mode.** Live view works with any exposure mode, including Scene Intelligent Auto, Scene modes, and Creative Auto. You can even switch from one Basic Zone mode to another or from one Creative Zone mode to another while live view is activated. (If you change from Basic to Creative, or vice versa while live view is on, it will be deactivated and must be restarted.)
- 2. **Enable live view.** You'll need to activate live view by the choosing Live View Shoot. setting from the Shooting 4 menu (when the Mode Dial is set to a Creative Zone mode); if you're using a Basic Zone mode and are not currently using live view, you have only the Shooting 1 menu available. The last entry in that menu can enable or disable live view. Press SET and use the up/down directional buttons to select Enable and press the SET button again to exit.

TIP

Note that even if you've disabled live view, you can still flip the On/Off/Movie switch to Movie and shoot video.

- 3. **Choose other live view functions.** When you're *using* live view, the MENU button summons other live view options, found in a Shooting 5 menu tab not available when not in live view mode. I'll describe these in the next section.
- 4. **Select live view or movie shooting.** Press the Live View/Movie button on the right side of the viewfinder to begin or end live view, or rotate the On/Off/Movie switch to the Movie position if you want to shoot video instead of stills. There are additional options for movie shooting, which I'll describe in Chapter 15.

Shooting Menu Options

The Shooting 5 menu, available when using live view, includes six options. Here's a quick overview for reference, with additional detail to follow later in the chapter.

AF Method

Options: Face Detection+Tracking, Smooth Zone, Live 1-Point AF

My preference: Smooth Zone

Here you can select the autofocus mode, Face Detection+Tracking, Smooth Zone, and Live 1-Point AF, which are AF methods that include face recognition, manual focus zone selection, or single focus area selection. See "Focusing in Live View" for my recommendations on choosing an AF method and other autofocus options.

Touch Shutter

Options: Enable (default), Disable

My preference: N/A

In live view modes, when Touch Shutter is enabled, you can tap the subject on the screen to initiate focus on that subject and take a picture. The focus point will turn green and the image will be captured. If the 6D Mark II is unable to achieve focus, the point where you tapped will turn orange and the picture will not be taken. Tap the subject once more to try again. If you don't want to use this menu entry, the Touch Shutter can be enabled/disabled by tapping the Touch Shutter icon in the lower-left corner of the touch screen. If you don't see the icon on the screen, press the INFO. button until it appears.

Metering Timer

Options: 4 sec., 8 sec. (default), 16 sec., 30 sec., 1 min., 10 min., 30 min.

My preference: 8 sec. most of the time; I switch to 10 min. when shooting sports

This option allows you to specify how long the EOS 6D Mark II's metering system will remain active before switching off. Tap the shutter release to start the timer again after it switches off. This choice is not available when using a Basic Zone mode.

Grid Display

Options: Off, 3×3 , 6×4 , 3×3 +Diagonal

My preference: Off

When enabled, this setting overlays one of three different grids on the screen to help you compose your image and align vertical and horizontal lines. You can choose a 3×3 cell "rule of thirds" grid, or one which consists of four rows of six boxes, which allows finer control over placement of images in your frame. A third grid uses the 3×3 layout, but adds diagonal lines.

Exposure Simulation

Options: Enable (default), During DOF Preview, Disable

My preference: During DOF Preview

This option allows you to choose whether the live view image mimics the exposure level of the final image, or whether the screen displays a bright image (dependent on the LCD Brightness setting you've specified in the Set-up 2 menu) that may be easier to view under high ambient lighting conditions.

Your choices are as follows:

- Enable. The live view image on the screen corresponds to the brightness level of the actual image based on the current exposure settings, including any exposure compensation you've specified. Use this option when you want to be able to roughly (but not precisely) monitor the effects of your exposure settings in live view.
- **During DOF Preview.** The live view image is displayed at standard brightness, but will be adjusted to simulate your exposure settings when you press the depth-of-field preview button. This is your best option when you might want to check exposure from time to time during a shooting session. It's the setting I use most often, because I can compose with a big, bright screen, but still stop down to the aperture that will be used and view the effects.
- **Disable.** The 6D Mark II ignores any exposure settings and compensation, and shows the live view image at standard brightness. This setting is useful outdoors in full sunlight, because any exposure simulation (dimmed LCD) will be difficult to interpret under high ambient lighting anyway.

SIMULATED EXPOSURE

When Exp. Sim. is displayed in white on the live view screen, it indicates that the LCD screen image brightness is an approximation of the brightness of the image that will be captured. If the Exp. Sim. display is blinking, it shows that the screen image does *not* represent the appearance of the final image because the light level is too dim or too bright. The icon is grayed out when using Night Portrait or Handheld HDR, Multi Shot Noise Reduction, flash, or Bulb exposures, because the LCD image cannot accurately reflect the image you are going to capture.

For Final Image Simulation, the 6D Mark II applies any active Picture Style settings to the LCD image, so you can have a rough representation of the image as it will appear when modified. Sharpness, contrast, color saturation, and color tone will all be applied. In addition, the camera applies the following parameters to the live view image shown: White balance/white balance correction; Shoot by ambience/lighting/scene choices; Auto lighting optimization; Peripheral illumination/ Chromatic aberration correction; Color tone; Metering mode; Highlight Tone Priority; Aspect ratio; and Depth-of-field when the DOF button is pressed.

Silent LV Shooting

Options: Mode 1 (default), Mode 2, Disable

My preference: Mode 1

Although it's not possible to completely silence the 6D Mark II's shutter noise, Canon gives you two options for making the *ker-clunk* a bit less intrusive. Because Live View mode eliminates the noisy mirror-flap action, silent live view shooting *is* fairly quiet. Silent shooting is not available when using an electronic flash, and you'll end up with inconsistent exposures if you use either Mode 1 or Mode 2 with a lens mounted on an extension tube, or if you are working with a Canon tilt-shift (TS-E) lens other than the TS-E17mm f/4L or TSE-E24mm f/3.5L II lenses. (**Note:** the new TS-E 50mm F2.8L Macro, TS-E 90mm F2.8L Macro, and TS-E 135mm F4L Macro lenses were all introduced just as this book was going to press and not available for testing, and Canon has not indicated whether they are compatible with Silent LV shooting.)

Your options are as follows:

- Mode 1. This mode produces a quieter shooting sound level in Live View mode, but allows continuous shooting.
- Mode 2. This mode, technically, isn't any quieter, but it separates the *ker* from the *clunk* sounds. Press the shutter release all the way, and the camera emits a small click as the picture is taken, and then camera operation is suspended as long as you hold the shutter button down. If you like, you can wait a moment or two before releasing the button to the halfway position or completely, which produces a second quiet click. It's a tiny bit less intrusive than Mode 1, and with enough ambient sound around you, is the closest you'll get to silent shooting with a digital SLR. Continuous shooting can be specified, but is disabled in this mode. Only a single picture will be exposed. The camera ignores this setting if you're using a remote control, and defaults to Mode 1.
- **Disable.** Turns off the silent shooting feature, although the resulting noises are roughly the same as Mode 1.

Shooting in Live View

Once you've enabled live view for later use and made your menu adjustments, you have the choice of taking pictures normally through the 6D Mark II's viewfinder or in live view. When you're ready to activate live view, make sure the Live view/Movie switch is rotated to the camera icon position, and press the Start/Stop button on the back of the camera. The mirror will flip up, and the sensor image will appear on the LCD. Press the INFO. button to cycle among a display that is blank (except for the image), one that contains basic shooting information, a full display with settings, and one that adds a live histogram. (See Figure 14.2 for the view with histogram.) Note that icons surrounded by a box can be tapped to make an adjustment for that value.

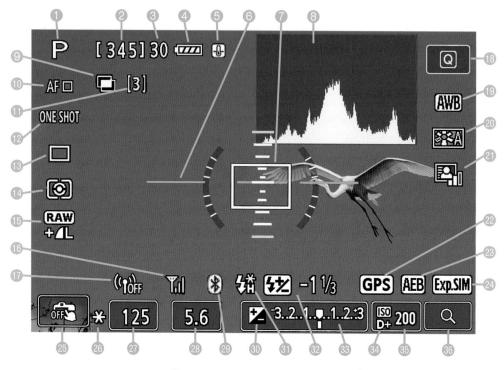

- Shooting mode
- Possible shots
- Maximum burst
- 4 Battery level
- Temperature warning
- 6 Electronic level
- AF point
- 8 Histogram
- (1) HDR shooting/Multiple exposures/Multi Shot noise reduction
- MAF method
- 1 Number of remaining multiple exposures
- 12 AF operation

- 1 Drive mode
- Metering mode
- 115 Image recording quality
- 16 Wi-Fi signal strength/ Eye-Fi transmission
- Wi-Fi function
- 1 Quick Control
- 19 White balance
- 2 Picture Style
- 21 Auto Lighting Optimizer
- @ GPS connection
- Exposure/Flash exposure bracketing/Multi Shot Noise Reduction
- Exposure simulation

- 25 Touch shutter
- 26 AE lock
- 2 Shutter speed
- Aperture
- Bluetooth function
- 30 Exposure compensation
- 31 Flash ready/Off/High-speed sync
- 32 Flash exposure compensation
- Exposure level indicator/ exposure bracketing range
- ³⁴ Highlight tone priority
- 35 ISO speed
- 36 Magnified view

Figure 14.2 The Live View screen.

Changing the Live View Display

Not all the icons shown appear at one time. Indeed, you can specify, to a certain extent, which information is displayed during live view (and movie) shooting as you cycle through the screens using the INFO. button. This section will show you how to customize your live view/movie displays. First, an overview:

- Four possible screens. The screens cycle among a minimum of one to a maximum of four different displays when you press the INFO. button. That is, if Screen 1 is shown, pressing the button takes you to Screen 2, Screen 3, Screen 4, and thence wrapping around back to Screen 1.
- Enable/Disable screens. You can specify which of the four screens are enabled by placing a check mark next to that screen's label, as seen in Figure 14.3, left. At least one screen must be active; if you unmark all of them, then Screen 1 will be enabled by default.
- **Specify information for each screen.** You can choose any or all of five different types of information for *each* screen, including basic and detailed shooting information, on-screen buttons, a histogram, and electronic level. I'll show you how to set up these screens next.

To enable/disable and define up to four screens, just follow these steps:

- 1. **Enter live view.** You must be using Live View mode to make the INFO. Button LV Display Options menu entry available. Press the Start/Stop button, then the MENU button, and navigate to the Set-up 4 menu, and choose the second entry from bottom. Press SET.
- 2. **Select switch settings.** When the next screen appears, choose Live View Info Switch Setting and press SET. The screen shown at left in Figure 14.3 appears.

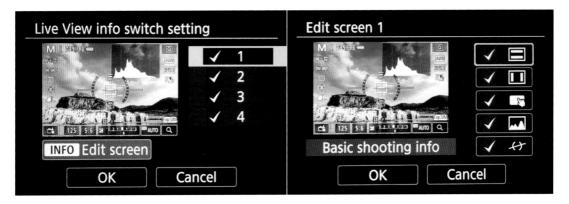

Figure 14.3 Enable/Disable individual screens (left); specify types of information (right).

- 3. **Enable/Disable screens 1–4.** To use the default screen settings, highlight any or all of the numbers at right and press SET to place or remove a check mark next to that number. You cannot deselect all four; at least one screen has to be enabled.
- 4. **Customize each screen.** You can add or remove information types from each screen if you do not want to use the default values. Highlight the screen number and press the INFO. button. The Edit Screen, shown at right in Figure 14.3, appears.
- 5. **Enable/disable each of five informational options** by highlighting the entry and pressing SET to add/remove a check mark. You can enable or disable any or all (which leaves just a blank screen) of these five (top to bottom):
 - **Basic Shooting Information.** Shows information such as shooting mode, exposures remaining, battery status, shutter speed, aperture, exposure, and ISO.
 - **Detailed Shooting Information.** Adds columns at left and right of the screen with autofocus, metering mode, image quality, white balance, and other information.
 - On-screen buttons. Adds touch-sensitive buttons to the screen to access the Quick Control Screen and Zoom level.
 - **Histogram Display.** Inserts a brightness or RGB histogram in the upper-right corner of the screen. You can choose which type of histogram to show and whether it appears in large or small size from the screen you viewed in Step 2.
 - **Electronic Level.** Adds the electronic level, which will appear if you are using Smooth Zone AF or Live 1-Point AF (it is disabled when working with Face Detection+Tracking).
- 6. **Confirm and Exit.** When you have made your settings, highlight/tap the OK option at the bottom of each screen and exit.

You can reset the Live View Button Display Options to their defaults by selecting Reset from the initial screen. Those values are as follows:

- Screen 1: Basic Shooting Info, On-Screen Buttons
- Screen 2: Basic Shooting Info, Detailed Shooting Info, On-Screen Buttons
- Screen 3: Basic Shooting Info, Detailed Shooting Info, On-Screen Buttons, Histogram, Electronic Level
- Screen 4: No information

Quick Control

You can access the Quick Control screen in Live View. Just press the Q button or tap the Q icon at the upper right of the touch screen while using a Creative Zone mode when On-Screen Buttons is enabled (as described above). Then, you can adjust any of the values shown in the left and right columns. These include AF mode, Drive mode, White Balance, Picture Style, Auto Lighting Optimizer settings, Image quality settings, and Creative filters. Figure 14.4 shows the focus mode adjustment screen that appears. If you're using a Basic Zone mode, you can change AF mode, Drive mode, and several other settings, depending on the Basic Zone mode you are using.

Figure 14.4 Focus mode adjustment screen.

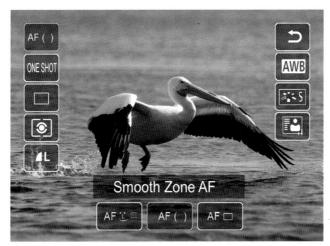

Focusing in Live View

Press the shutter button halfway to activate autofocus using the currently set live view autofocus mode. You can choose AF method: Face Detection+Tracking, Smooth Zone AF, or Live 1-Point AF. These determine how the 6D Mark II selects an area to focus on. You can also select AF operation: One-Shot or Servo, which control *when* focus is locked. Manual focus is also available if you prefer to set focus yourself.

To change the focus mode while using live view, you can access the Quick Control menu with the Q button or by tapping the Q icon on the touch screen, and navigating to the AF Method and AF operation options on the Quick Control menu. (See Figure 14.4.) AF Method is also available from the Shooting 5 menu when live view is active. I'll describe each of these separately.

Selecting an AF Method

As I mentioned, there are three AF methods: Face Detection+Tracking, Smooth Zone AF, or Live 1-Point AF. The last two are different from those found in earlier Canon Rebel models, replacing FlexiZone-Multi and FlexiZone-Single. The three current methods are described in the next section.

Face Detection+Tracking Mode

The 6D Mark II will search the frame for a human face and attempt to focus on the face. Note that when using this mode, a magnified view of your image is not possible. To autofocus using Face Detection+Tracking mode, follow these steps:

- 1. **Set lens to autofocus.** Make sure the focus switch on the lens is set to AF.
- 2. **Activate live view.** Press the Start/Stop button. Select Face Detection+Tracking from the Quick Control menu or the live view Shooting 5 menu.
- 3. Face detection. A frame will appear around a face found in the image. If only one face is detected, the frame will be green; if more than one face is found, the frame will be white and have left/right triangles flanking it. (See Figure 14.5, left.) In that case, use the directional controls to move the frame to the face you want to use for focus. If no face is detected, the AF focus frame will be displayed and focus will be locked into the center.

Figure 14.5 If multiple faces are found (left), the bracket can be moved among them. When focus is achieved (right), the bracket turns green.

- 4. **Focus.** Press the shutter button halfway to focus the camera on the face within the positioned Face Detection frame. When focus is locked in, the AF frame will turn green and the beeper, if activated, will chime. (See Figure 14.5, right.) If focus cannot be achieved, the AF frame will turn orange.
- 5. **Press and hold the shutter release to take the picture.** Press the shutter release all the way down to take the picture.

Smooth Zone AF

This mode allows focusing over a wide area, using a zone that's roughly 9 percent of the total sensor area, and which can be moved around the frame to cover all but the outer edges of frame, as shown in Figure 14.6. You can use the directional buttons to move the frame to a zone you select, but it's much faster to just tap the touch screen. Follow these steps:

- 1. **Set lens to autofocus.** Make sure the focus switch on the lens is set to AF.
- 2. Activate live view. Press the Live View/Movie button.
- 3. **Select subject.** Compose the image on the LCD.
- 4. **Set zone.** Use the directional buttons to move the zone to your subject (the AF area is 52 "clicks" wide and 32 "clicks" high), or tap the touch screen on the area you want to focus on. To return the zone to the center of the frame, press SET or the Trash button.
- 5. **Press the shutter release button halfway.** When focus is achieved, the AF frame turns green, and you'll hear a beep. If the 6D Mark II is unable to focus, the AF point turns orange instead.
- 6. Take picture. Press the shutter release all the way down to take the picture.

Figure 14.6 Choose your focus zone.

Live 1-Point AF

This method uses a much smaller "zone." (Canon calls it "1-point," but it's larger than what we'd think of as a focus point.) The focus area size is shown in Figure 14.7. When using Movie Servo AF (discussed later), the area is larger. Just follow these steps:

- 1. **Set lens to autofocus.** Make sure the focus switch on the lens is set to AF.
- 2. Activate live view. Press the Start/Stop button.
- 3. **Choose AF point.** A focus point box will appear (as I noted, when using Movie Servo AF, the box will be larger). Use the directional controls to move the AF point anywhere you like on the screen, except for the edges. As always, it's usually faster to just tap the touch screen on the area you want to focus. Press the SET or Trash button to move it back to the center of the screen.
- 4. **Select the subject.** Compose the image on the LCD so the selected focus point is on the subject.
- 5. **Press the shutter release button halfway.** When focus is achieved, the AF frame turns green, and you'll hear a beep. If the 6D Mark II is unable to focus, the AF point turns orange instead.
- 6. **Take the picture.** Press the shutter release all the way down to take the picture.

Figure 14.7
You can choose a focus area anywhere within the frame except the edges.

Magnified View

In Smooth Zone, Live 1-Point, or Manual Focus modes, you can see a magnified view that will help you determine focus. Magnified View is not available when using Face Detection. (To focus manually, you'll have to move the focus switch on the lens to the M position.) Focusing on an LCD screen isn't as difficult as you might think, but Canon has made the process even easier by providing this magnified view.

Just follow these steps:

- 1. Press the Magnify button or (when screen buttons are displayed) tap the Magnify icon at lower right on the touch screen. Initially, a 1X magnification appears, showing the whole frame. Press/Tap again to enlarge by 5X, and another time to increase to 10X. If the Magnify icon, shown earlier in Figure 14.2, does not appear, press the INFO. button until it is visible, and make sure you have enabled On-Screen Buttons for one of the displays, as described earlier in the chapter. Another press will return you to the full-frame view.
- 2. **Move magnifying frame.** Use the directional controls to move the focus frame that's superimposed on the screen to the location where you want to focus, or tap the touch screen. You can press the SET or Trash button to center the focus frame in the middle of the screen. A reference box at lower right shows the relative position of the zoomed area to the full frame. (See Figure 14.8.)
- 3. **Focus.** If you're focusing manually, rotate the focus ring on the lens. The enlarged area is artificially sharpened to make it easier for you to see the contrast changes, and simplify focusing. In Smooth Zone and Live 1-Point AF, press the shutter release halfway to focus. If Servo AF (described next) is active, pressing the shutter release halfway in magnified view returns the camera to normal view for focusing.

Figure 14.8 You can use autofocus or manual focus when zoomed 5X or 10X.

Focus Operation

Live view has two of the three focus operation modes available in still shooting: One-Shot and Servo (the equivalent of AI Servo). AI AF, which switches between One-Shot and AI Servo automatically in still mode, is not available when shooting with live view. Here's a recap to remind you of how these modes work.

One-Shot AF

In this mode, the 6D Mark II focuses once, and does not change focus until after you've depressed the shutter release all the way and taken a picture, or until you release the shutter button without taking a shot. It's great for shots without much action or subject movement. However, you might not be able to take a picture at all while the camera is seeking focus; you're locked out until the autofocus mechanism locks in. One-Shot AF is sometimes referred to as *focus priority* for that reason. Because of the small delay while the camera zeroes in on correct focus, you might experience slightly more shutter lag. This mode uses less battery power, which can be important in live view, which uses a lot of juice to power the LCD monitor all the time.

By keeping the shutter button depressed halfway, you'll find you can reframe the image while retaining the focus (and exposure) that's been set. You can also use the AE Lock button to retain the exposure calculated from the center AF point while reframing.

Servo AF

This mode, also known as *continuous autofocus*, is the mode to use for sports and other fast-moving subjects. In this mode, once the shutter release is partially depressed, the camera sets the focus but continues to monitor the subject, so that if it moves or you move, the lens will be refocused to suit the new composition. *Servo AF does not track your subject like Face Detection+Tracking*. Focus and exposure aren't really locked until you press the shutter release down all the way to take the picture. You'll often see continuous autofocus referred to as *release priority*. If you press the shutter release down all the way while the system is refining focus, the camera will go ahead and take a picture, even if the image is slightly out of focus. You'll find that Servo AF produces the least amount of shutter lag of any autofocus mode: press the button and the camera fires. It also uses the most battery power, because the autofocus system operates as long as the shutter release button is partially depressed.

Using the Touch Shutter

In Live View mode, you can activate/deactivate the Touch Shutter feature, which allows you to set focus and take a picture by tapping on your subject on the LCD monitor. It's a convenient way of activating focus and capturing an image with one gesture.

Touch Shutter can be enabled or disabled using the Touch Control entry in the live view Shooting 5 menu, available when live view is enabled. That enables using touch controls with the LCD monitor. You can activate or deactivate the Touch Shutter feature by tapping the touch shutter icon at the lower-left corner of the touch screen.

When Touch Shutter is disabled, if Touch Controls are enabled, you can still tap on the touch screen to specify where you want to focus, but you'll need to press the shutter release to actually take a picture. When touch shutter is enabled, all you need to do is tap your subject on the screen (most often, this will be a person's face). The 6D Mark II will focus using Face Detection+Tracking or Live 1-Point AF if you've selected either of those modes. If you've chosen Smooth Zone, the 6D Mark II switches to 1-Point Live instead. One-Shot AF is always used when Touch Shutter takes a picture, even if you've chosen Servo AF.

When your subject is focused, the AF point will turn green and a picture will be taken automatically. If the camera was unable to focus, the AF point turns orange. In that case, try tapping again. You can press the SET or Trash buttons to move the focus point to the center of the frame and relocate it manually with the directional buttons, if you like, but I find that a screen tap works well. When Touch Shutter is active, Single Shooting is used even if Continuous Shooting has been selected. The Touch Shutter does not work in magnified view.

Bulb Exposures

With the camera set to Bulb, you can tap the screen to start the exposure, and tap it again to stop the exposure. However, I don't recommend this technique. Unless you are very careful, these taps will cause the camera to vibrate, which can spoil your picture even if the camera is mounted on a tripod. Oddly enough, the effects are worst for "shorter" bulb exposures. For exposures longer than 15 seconds, the vibration is likely to subside within the first second or two, and have little effect on your final image.

Shooting Movies

The 6D Mark II can shoot full HDTV movies with stereo sound using the built-in microphones or an external unit at 1920×1080 resolution, or Standard HD video at 1280×720 resolution.

In some ways, the camera's Movie mode is closely related to the 6D Mark II's Live View still mode. In fact, the 6D Mark II uses live-view-type imaging to show you the video clip on the LCD as it is captured. Many of the functions and setting options are the same, so the information in the previous chapter will serve you well as you branch out into shooting movies with your camera.

To shoot in Movie mode, just rotate the Live View/Movie switch to the Movie position. If Scene Intelligent Auto, Creative Auto, P, Tv, Av, or B exposure modes are selected, the 6D Mark II will activate automatic exposure control. If the Mode Dial is set to SCN, the camera switches to HDR movie shooting (you cannot select any of the other Scene modes). I'll explain your exposure options later in this chapter.

The movie shooting screen will look something like the one shown in Figure 14.9. The figure does not show every possible indicator. For example, a red dot appears in the upper-right corner when you are actually recording, and other icons appear only when relevant or a feature is activated. Press the Start/Stop button to begin/end capture.

Movie Shooting Menus

Shooting video is quite simple, but there are some additional things you need to keep in mind before you start. This section will show you everything you need to know before you begin capturing video in earnest. We'll start with the Shooting menu movie screens that become visible when the LV selector switch is rotated to the Movie camera icon. In that mode, five new menus appear when using M, Av, Tv, P, or B exposure modes. Only three are available in Scene Intelligent Auto, Creative Auto, and Scene modes. Some of the entries have counterparts for still shooting and were explained earlier. I won't duplicate here the description provided in detail in Chapter 11. Others are new, and I'll explain them in more detail later as we go along.

Movie Shooting 1

There are five settings in the Movie Shooting 1 menu (see Figure 14.10).

- Movie Recording Size. If you want full HD video (1920 × 1080 pixels) you can choose 60/50, 30/25 (in both Standard and Light quality modes), or 24 frame-per-second rates. Standard HD (1280 × 720 pixels) is available at 60/50 Standard quality and 30/25 Light quality, using either MOV or MP4 compression methods. I'll explain frame rates and other options later in the chapter so you'll understand the array of choices.
- Image Quality. Here you can select the RAW and JPEG specifications for still photos you take while in Movie mode. This entry was explained in Chapter 11.

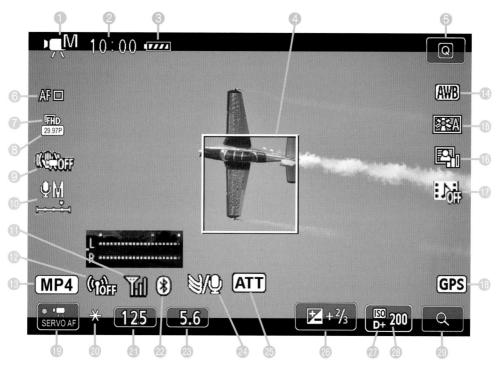

- Movie Shooting mode
- Movie shooting remaining time/ Elapsed time
- Battery level
- AF point
- 6 Quick control
- AF method
- Movie recording size
- B Frame rate
- Movie digital IS
- Mecording level (Manual)

- Wi-Fi signal strength/Eye-Fi card transmission status
- Wi-Fi function
- ¹⁸ Movie-recording format
- White balance
- 1 Picture Style
- 116 Auto Lighting Optimizer
- Wideo snapshot
- GPS connection
- 1 Movie Servo AF
- 2 AE lock

- (2) Shutter speed
- 2 Bluetooth
- ⁽²³⁾ Aperture
- Wind filter
- 25 Attenuator
- 26 Exposure compensation
- Mighlight Tone Priority
- **38** ISO speed
- ²⁹ Magnify/Digital Zoom

Figure 14.9 Movie Shooting screen.

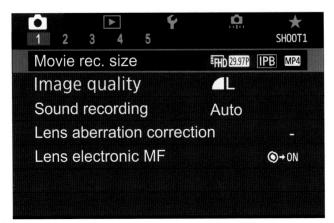

Figure 14.10
The Movie
Shooting 1 menu

- Sound Recording. Choose Auto, Manual, or Disable; plus enable or disable wind filter and/or attenuation. In Basic Zone modes, your only choices are On or Off; when On is chosen, the recording level will be Auto, you cannot change the balance between left and right channels, and the wind filter (described shortly) will be automatically activated.
 - Auto. The 6D Mark II sets the audio level for you.
 - Manual. Choose from 64 different sound levels. Select Rec Level and rotate the QCD while viewing the decibel meter at the bottom of the screen to choose a level that averages –12 dB for the loudest sounds.
 - **Disable.** Shoot silently, and add voice over, narration, music, or other sound later in your movie-editing software.
 - You can use your 6D Mark II's built-in microphones or plug in a stereo microphone into the 3.5mm jack on the side of the camera. An external microphone is a good idea because the built-in microphone can easily pick up camera operation, such as the autofocus motor in a lens.
 - Wind filter/Attenuator. Set Wind Filter to Auto to reduce the effects of wind noise and the lowest bass sounds. This also reduces low tones in the sound recording. If wind is not a problem, you'll get better quality audio by selecting Disable instead. An even better option is to use an external microphone with a wind shield. The Attenuator feature suppresses loud noises that aren't handled by Auto or Manual sound recording settings.
- Lens aberration correction. Two of the four corrections—Peripheral Illumination Correction and Chromatic Aberration Correction—can be used when using movie mode. Those options were described in Chapter 11.
- Lens electronic MF. This feature was described in Chapter 11 and won't be repeated here.

Movie Shooting 2

You'll find six entries in the Movie Shooting 2 menu, which are for the most part the same as their still photography counterparts described in Chapter 11. (See Figure 14.11.)

- Exposure compensation. Operates the same in movie mode as in still photography mode, except that bracketing cannot be used.
- Movie ISO speed settings. Similar to the still photo version; however, ISO settings cannot be manually specified, *except when using Manual exposure*. The 6D Mark II automatically chooses an appropriate ISO speed when using P, Tv, Av, and B exposure modes. Note that the L ISO setting (ISO 50 equivalent) is not used in video capture.
 - Speed Range. You can set the ISO speed range Minimum (100–12800) and Maximum (200–H2). If Highlight Tone Priority is enabled, the minimum is 200 and maximum is 25600.
 - **ISO Auto.** You can limit the highest ISO speed that will be selected to ISO 6400–H2.
 - Time-lapse ISO Auto. If you use the 6D Mark II's Time-Lapse feature (as described later in this chapter), you can separately specify the highest ISO setting that will be applied, between ISO 400 and ISO 12600.
- Auto Lighting Optimizer. The Auto Lighting Optimizer functions as described in Chapter 11. It is disabled in Manual or Bulb exposure modes.
- White balance. Operates the same as in still photography mode.
- **Custom White Balance.** Operates the same as in still photography mode.
- White Balance correction. Operates the same as in still photography mode.

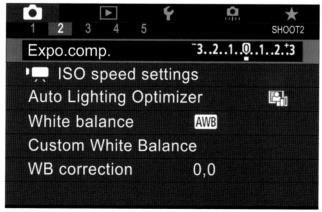

Movie Shooting 3

There are just three entries in the Movie Shooting 3 menu. (See Figure 14.12.) They are Picture Style, High ISO Speed Noise Reduction, and Highlight Tone Priority. All three function exactly as described for still photography mode, and explained in Chapter 11.

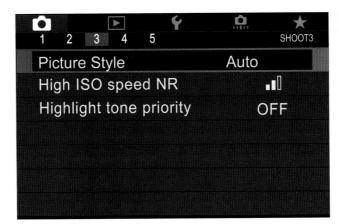

Figure 14.12
The Movie
Shooting 3 menu.

Movie Shooting 4

Seven entries make up the Movie Shooting 4 menu. (See Figure 14.13.)

- Movie Servo AF. You can enable or disable this feature, which enables the 6D Mark II to focus on the subject continuously during movie shooting—even if the shutter button is not held down halfway. It's a battery hog, and the constant refocusing may be undesirable if the noise is picked up by the camera's built-in microphone. To temporarily disable Movie Servo AF, tap the Servo AF icon in the lower-left corner of the LCD monitor screen, or press the Flash button, or a button you have defined for that function using Custom Controls in the Custom Function 4 menu. After resuming movie shooting and pressing the MENU or Playback button, or changing the AF method (described next), Movie Servo AF will resume automatically. If you've disabled Movie Servo, press the shutter button or AF-ON button halfway to initiate autofocus.
 - You can control the Movie Servo AF speed and tracking sensitivity using two entries at the bottom of the Shooting 4 (Movie) menu, described later in this list.
- **AF Method.** These are the same AF modes available in live view: Face Detection+Tracking, Smooth Zone, and Live 1 Point AF, as described earlier in this chapter.

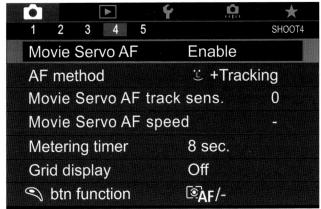

- Movie Servo AF Track Sensitivity. This entry and the next are available only when Live 1 Point AF (above) is enabled. Allows adjusting the 6D Mark II's tracking sensitivity from one of five levels, from Locked On (–3 to –1) to Responsive (+1 to +3). Use this setting to tell the camera whether it should immediately track a new subject or remain on the original subject. I explain when and how to use tracking sensitivity in Chapter 5.
- Movie Servo AF speed. This entry is available only when Live 1 Point AF is enabled. You can choose when Movie Servo AF is active, either *always* on or *only* during shooting (which preserves battery power), specifying an AF Speed, from fast (+2) to standard (0) to Slow (-7). Some lenses, such as those with STM motors, support slow focus transitions for smoother refocusing during a shot.
- Metering Timer. Specify how long the metering system remains active before switching off. You can select 4, 16, or 30 seconds, plus 1, 10, or 30 minutes. Tap the shutter release to restart the timer.
- **Grid Display.** The same options are available as described under Live View settings.
- Shutter button function. Allows you to specify the behaviors of the shutter button during movie shooting (see Table 14.1). The optional Remote Switch RS-80N3, Timer Remote Controller TC80N3, and Wireless Remote Control BR-E1 can also be used to start/stop movie capture. Note that any settings you have set for the shutter button for still photography using C.Fn III-4 Custom Controls are overridden by these options when in movie mode.

Table 14.1 Shutter Button Function			
Setting	Shutter Pressed Halfway	Shutter Pressed Completely	Remote (RC-6, BR-E1)
Metering/AF/ Camera Icon	Metering and AF	No function	No function
Metering/ Camera Icon	Metering Only	No Function	No function
Metering/AF/ Movie Camera Icon	Metering and AF	Starts/Stops Movie Capture	Starts/Stops Movie Capture
Metering/ Movie Camera Icon	Metering Only	Starts/Stops Movie Capture	Starts/Stops Movie Capture

Movie Shooting 5

There are four entries in the Movie Shooting 5 menu. (See Figure 14.14.)

- Video Snapshot. Enables/disables video snapshots, described later in this chapter.
- **Time-lapse movie.** Enables/disables time-lapse movies, described earlier in Chapter 6.
- Movie Digital IS. Enables/disables electronic image stabilization, which I'll explain next.
- Remote control. Enables starting or stopping movie capture using the optional Remote Controller RC-6, and Wireless Remote Control BR-E1.

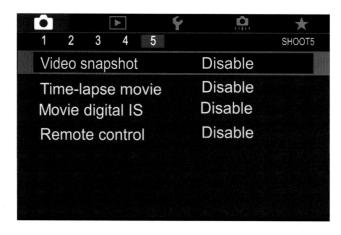

Figure 14.14 Movie Shooting 5 menu.

Movie Digital IS

Many of your lenses may have image stabilization (IS) built-in, which deploys tiny mechanisms to move lens elements to compensate for camera shake, giving you the vibration-blocking features of a higher shutter speed *but only to counter movement of the camera/lens—not your subject.* You may gain two to four "stops," with the same hand-held sharpness at 1/60th second that you might expect from a shutter speed of 1/250th or 1/500th second.

Movie digital IS is an electronic type of image stabilization that does not depend on components of the lens, so it adds image stabilization even to non-IS optics (although, if your lens has IS, it must be switched on for this feature to operate). This electronic IS functions by shifting the sensor image slightly (instead of lens elements) in response to camera movement, so that the non-moving objects in successive frames align. That reduces blur caused by camera/lens shake, and is especially helpful in video capture, which typically uses shutter speeds in the 1/60th–1/30th second range. To allow for the frame shift, the 6D Mark II crops the image slightly, trimming off areas that have been moved outside the original frame, slightly magnifying the image. The magnification may increase the visual noise or other artifacts.

You can set this feature to Disable, Enable, or Enhanced, which counters stronger camera shake and magnifies the image even more. Digital IS does not function with lenses longer than 800mm (indeed, it works best with wide angle lenses), nor in SCN (HDR movie) or Time-Lapse modes. Canon recommends disabling the feature when the camera is on a tripod, or when you are using a TS-E shift/tilt lens, a fish-eye lens, or any non-Canon optic.

Exposure Options

When shooting movies, you can use fully automatic exposure, elect to specify exposure in Manual exposure mode, or choose a shutter speed or aperture setting that you prefer for creative reasons. The 6D Mark II will select an ISO speed for you automatically in all cases except Manual exposure mode. Exposure can be locked with the * button, and cancelled with the AF point selection button located to the right of the * button. Here are your options:

- Fully automatic exposure. The 6D Mark II will automatically select an appropriate exposure for you if the Mode Dial is set to Basic Zone modes, such as Scene Intelligent Auto or Scene modes. If the Mode Dial is set to P (program auto exposure), Tv (Shutter-priority), Av (Aperture-priority), or B (bulb exposure), exposure will be set as if you had selected P. Note that B will not produce a bulb or time exposure; the camera defaults to P when you use the B position. The idea is to prevent you from losing video capture capabilities if you accidentally select B by mistake.
- Exposure compensation. When using Creative Zone modes, flip the Lock switch to the down position, and you can rotate the Quick Control Dial to specify exposure compensation.

- Speedlite movie light. In exposure modes other than M (Manual), if you have a Canon Speedlite with a built-in movie LED light mounted and powered on (such as the Speedlite 320EX), the 6D Mark II will automatically activate the lamp under low-light conditions.
- **Manual exposure.** Choose M on the Mode Dial and you can specify ISO speed, shutter speed, and aperture.
 - ISO. Press the ISO Compensation button on top of the camera to view the ISO speed setting screen. Adjust with the Main Dial. Choose Auto and the camera will select an appropriate ISO based on the shutter speed and aperture you have selected. During Manual exposure, the * button locks ISO at its current setting if you have selected Auto.
 - **Shutter speed.** Use the Main Dial to select a shutter speed, within the limitations described under Shutter-priority AE earlier.
 - Aperture. Use the Quick Control Dial to adjust aperture.

More on Shutter Speeds

You might think that setting your camera to a faster shutter speed will help give you sharper video frames. But the choice of a shutter speed for movie making is a bit more complicated than that. As you might guess, it's almost always best to leave the shutter speed at 1/30th or 1/60th second, and allow the overall exposure to be adjusted by varying the aperture and/or ISO sensitivity. We don't normally stare at a video frame for longer than 1/30th or 1/24th second, so while the shakiness of the *camera* can be disruptive (and often corrected by your camera's in-lens and in-body image stabilization), if there is a bit of blur in our *subjects* from movement, we tend not to notice. Each frame flashes by in the blink of an eye, so to speak, so a shutter speed of 1/30th or 1/60th second works a lot better in video than it does when shooting stills. Even shots with lots of movement are often sufficiently sharp at 1/60th second.

Higher shutter speeds introduce problems of their own. If you shoot a video frame using a shutter speed of 1/250th second, the actual moment in time that's captured represents only about 12 percent of the 1/30th second of elapsed time in that frame. Yet, when played back, that frame occupies the full 1/30th of a second, with 88 percent of that time filled by stretching the original image to fill it. The result is often a choppy/jumpy image, and one that may appear to be *too* sharp.

The reason for that is more social imprinting than scientific: we've all grown up accustomed to seeing the look of Hollywood productions that, by convention, were shot using a shutter speed that's half the reciprocal of the frame rate (that is, 1/48th second for a 24 fps movie). Professional movie cameras use a rotary shutter (achieving that 1/48th-second exposure by using a 180-degree shutter "angle"), but the effect on our visual expectations is the same. For the most "film-like" appearance, use 24 fps and 1/60th second shutter speed.

Faster shutter speeds do have some specialized uses for motion analysis, especially where individual frames are studied. The rest of the time, 1/30th or 1/60th of a second will suffice. If the reason you needed a higher shutter speed was to obtain the correct exposure, use a slower ISO setting, or a neutral-density filter to cut down on the amount of light passing through the lens. A good rule of thumb is to use 1/60th second or slower when shooting at 24 fps; 1/60th second or slower at 30 fps; and 1/125th second or slower at 60 fps.

Formats, Compression, Resolution, and Frame Rates

Even intermediate movie shooters can be confused by the number of different choices for format, compression, resolution, and frame rates. This section will help clarify things for you by explaining what each of these terms mean, and what options are available to you.

MP4 Formats/Compression

The 6D Mark II uses MP4 format, an industry standard, for video. MOV, which is common on Macs, is not available, but most video editors can translate your MP4 files into MOV as long as the same codec (video encoder, such as H.264) was used for both. The actual compression methods used by MP4 formats are easy to understand. The 6D Mark II stores files using the standard H.264/MPEG-4 codec ("coder-decoder") using IPB (I-frame/P-frame/B-frame) Standard and Light.

IPB is a compression method used with MP4 format. It employs *interframe* compression; that is, only certain "key" frames are saved, with other frames "simulated" or interpolated from information contained in the frames that precede and succeed them. I-frames are the complete frames or *intraframes*; P-frames are "predicted picture" frames, which record *only the pixel changes* from the previous frame (say, a runner traveling across a fixed background); B-frames are "bi-predictive picture" frames, created by using the differences from the preceding *and* following frames. This interpolation produces image quality that is a bit lower and which requires more of your camera's DIGIC 7 processing power, but file sizes are smaller.

Video encoded using IPB must be converted, or transcoded, to a format compatible with your video-editing software. The compression scheme can produce more artifacts, particularly in frames with lots of motion throughout the frame. I use this method only when the ability to shoot longer is very important. The 6D Mark II offers both the Standard version, which compresses multiple frames simultaneously for greater efficiency and smaller file sizes; and a Light version that records at a slower bit transfer rate than Standard, producing a smaller file size and greater compatibility with more playback systems.

Each movie clip can last no longer than 29 minutes and 59 seconds, and file size with SD/SDHC memory cards (those 32GB or smaller) is limited to no more than 4GB.

Here is a listing of some of the limitations you'll run up against:

■ 4GB Limit with SD/SDHC cards. If you're shooting a video clip and the file size reaches 4GB, if your memory card is *larger* than 4GB, you can continue shooting. Roughly 30 seconds before the 4GB file size is reached, the elapsed shooting time displayed on the LCD will begin blinking. If you continue past 4GB, a new movie file will be created automatically. This process continues until you've reached the maximum shooting time of 29 minutes, 59 seconds. However, you'll have to play each movie file individually, or combine them in a movie-editing program.

With SDXC memory cards (those larger than 32GB), you can shoot clips larger than 4GB; the movie will be saved as a single file. However, the camera will stop recording when the 29:59 limit is reached (described next). Note that movie files larger than 4GB must be transferred to your computer using the EOS Utility or a memory card reader; you cannot transfer them using other tools, including the 6D Mark II's wireless capabilities.

- 29:59 Limit. This limitation was reportedly established because some jurisdictions classify equipment that can capture more than 30 minutes as "camcorders" at higher tax rates. When the maximum shooting time is reached, movie capture *stops* and does not resume automatically. You'll need to press the Start/Stop button again to start a new movie file.
- MP4 Format: Full HD. In MP4 format, you can record 8 minutes to 17 minutes using IPB compression before reaching the 4GB limitation, while the 29:59 limit hits you when using IPB Light.
- MP4 Format: Standard HD. You can record from 20 to 29:59 minutes using IPB Standard and IPB Light, respectively.
- **HDR Movie Shooting.** You'll reach the 4GB limit at about 17 minutes when shooting HDR movies.

Resolution/Movie Recording Size

Resolution (Movie Recording Size) choices are a little less techie:

■ 1920 × 1080 (1080p). Canon calls this resolution "Full HD" and is the maximum resolution displayed when using the HDTV format. (The 6D Mark II cannot record video in the higher resolution 4K format.) Many monitors and most HD televisions can display this resolution, and you'll have the best image quality when you use it. Use this resolution for your "professional" productions, especially those you'll be editing and converting to nifty-looking DVDs. However, the top-of-the-line resolution requires the most storage space. Select Movie Recording Quality using the entry in the Movie Shooting 1 menu. Depending on your frame rate (described next), Full HD uses transfer rates of 216–431 MB/min to write to your memory card, so a fast Class 10 card is recommended.

- 1280 × 720 (720p). Canon refers to this resolution as "HD" but "Standard HD" or "SHD" is commonly used. It provides less resolution, and can be displayed on any monitor or television that claims HDTV compatibility. If your production will appear only on computer monitors with 1280 × 720 resolution, or on HDTVs that max out at 720p, this resolution will be fine. This resolution won't necessarily stretch your memory cards; with IPB compression it uses a 60/50 fps transfer rate of 184 MB/min.
- HDR Movie Shooting. This option is used automatically when the Mode Dial is set to Scene mode. You can choose 60/50 fps in either IPB (Standard) or IPB (Light) quality modes. HDR video improves highlight details in bright areas of a scene, improving the dynamic range.

Frame Rate

In the 6D Mark II world, in which all video is shot using *progressive scan* with no *interlaced scan* option, frame rates are easy to choose. (Interlacing is a capture method in which even/odd numbered lines of each frame are captured alternately; with progressive scan, all the lines in a frame are captured consecutively.) Fortunately, one seemingly confusing set of alternatives can be dispensed with quickly: The 50/25 fps and 60/30 fps options can be considered as pairs of *video*-oriented frame rates. The 60/30 fps rates are used only where the NTSC television standard is in place, such as North America, Japan, Korea, Mexico, and a few other places. The 50/25 frame rates are used where the PAL standard reigns, such as Europe, Russia, China, Africa, Australia, and other places. For simplicity, I'll refer just to the 60/30 frame rates in this section; if you're reading this in India, just convert to 50/25.

The third possibility is 24 fps, which is a standard frame rate used for motion pictures. Keep in mind that the rates are *nominal*. A 24 fps setting actually yields 23.976 frames per second; 30 fps gives you 29.97 actual "frames" per second.

The difference lies in the two "worlds" of motion images—film, and video. The standard frame rate for motion picture film is 24 fps, while the video rate, at least in the United States, Japan, and those other places using the NTSC standard, is 30 fps. Computer-editing software can handle either type, and convert between them. The choice between 24 fps and 30 fps is determined by what you plan to do with your video.

The short explanation is that shooting at 24 fps gives your movie a "film" look, excellent for showing fine detail. However, if your clip has moving subjects, or you pan the camera, 24 fps can produce a jerky effect called "judder." A 30 or 60 fps rate produces a home-video look that some feel is less desirable, but which is smoother and less jittery when displayed on an electronic monitor. I suggest you try both and use the frame rate that best suits your tastes and video-editing software.

Quick Control

As in still shooting, you can press the Q button to access a Quick Control screen. In Creative Zone modes, you can specify AF Method, Movie Recording Size, Movie Digital Image Stabilization, White Balance, Picture Style, Auto Lighting Optimizer, and parameters for Video Snapshot (described next). Sound level can be changed only when you've specified Manual adjustment.

Video Snapshots

Video snapshots are movie clips, all the same length, assembled into video albums as a single movie. You can choose a fixed length of 2, 4, or 8 seconds for all clips in a particular album. I use the 2-second length to compile mini-movies of fast-moving events, such as parades, giving me a lively album of clips that show all the things going on without lingering too long on a single scene. The 8-second length is ideal for landscapes and many travel clips, because the longer scenes give you time to absorb all the interesting things to see in such environments. The 4-second clips are an excellent way to show details of a single subject, such as a cathedral or monument when traveling, or an overview of the action at a sports event.

First, activate the video snapshot feature in the Movie Shooting 5 menu:

- 1. **Activate.** Select Video Snapshot from the Movie Shooting 5 menu. The screen shown in Figure 14.15 will appear.
- 2. **Enable Snapshots.** Highlight the Video Snapshot entry, press SET, select Enable, then press SET again to confirm.
- 3. **Select Album.** Next, highlight Album Settings and choose either Create a New Album or Add to Existing Album.

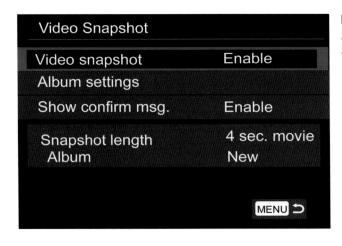

Figure 14.15Select Video
Snapshot options.

- 4. **Specify Snapshot Length.** If you choose to Create a New Album, a screen appears with the message "The next video snapshot will be added to a new album" along with the option to choose Snapshot Length. Highlight that option, press SET, and choose 2 Sec. Movie, 4 Sec. Movie, or 8 Sec. Movie. Press SET to confirm your choice.
- Confirm settings. You'll be taken back to the previous screen. Highlight OK and tap OK or press SET.
- 6. **Enable/Disable Confirm Msg.** When enabled, a message will appear on the screen inviting you to Add to Album, Save As a New Album, Playback Video Snapshot, or Delete Without Saving to Album. If you select Disable, the camera *skips* this step, automatically saves your video snapshot, and is then ready to capture another. You'd want to disable the confirmation message if you planned to shoot several video snapshots one after the other and not have to respond to the confirmation message each time.
- 7. **Exit.** Press/Tap MENU to exit Video Snapshot setup. The next section will show you how to use the feature in a little more detail.

When Video Snapshot is enabled, conventional movie shooting is *disabled*. Instead, every time you press the Start/Stop button, the 6D Mark II captures a clip of the length you've specified. The procedure goes something like this:

1. **Capture Video Snapshot.** In Movie mode, press the Start/Stop button. The 6D Mark II will begin shooting a clip, and a blue bar appears showing you how much time remains before shooting stops automatically. (See Figure 14.16.)

Figure 14.16 Recording a video snapshot.

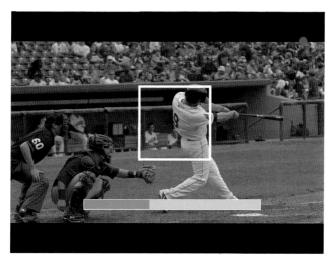

- 2. Save your clip as a video snapshot album. If you've disabled the confirmation message, the clip will be saved to the current album, and you'll be returned to the screen shown in Figure 14.16, ready to capture another snapshot. Note that the confirmation message is overlaid on whichever Playback screen you've specified using the INFO. button. The figure illustrates the display when No Information is shown on playback.
- 3. **Choose confirmation option.** The screen shown in Figure 14.17 appears. You can use the left/ right multi-controller directional buttons or touch screen to select Save As Album/Add To Album (depending on whether this is the first clip for an album, or an additional clip), Save to New Album, Playback Video Snapshot (that you just took), or Do Not Save to Album/Delete Without Saving to Album (exit without adding to an album).
- 4. Press SET. Your first clip will be saved as the start of a new album.

album/ Add

to album

new album

- 5. **Shoot additional clips.** Press the Movie button to shoot more clips of the length you have chosen, and indicated by the blue bars at the bottom of the frame. At the end of the specified time, the confirmation screen will appear again.
- 6. Add to album or create new album. Select the left-most icon again if you want to add the most recent clip to the album you just started. Alternatively, you can press the left/right multi-controller directional buttons to choose the second icon from the left, Save as a New Album. That will complete your previous album, and start a new one with the most recent clip.
 - Or, if you'd like to review the most recent clip first to make sure it's worth adding to an album, select the Playback Video Snapshot icon (second from the right) and review the clip you just shot. You can then Add to Album, Create New Album, or Delete the Clip.

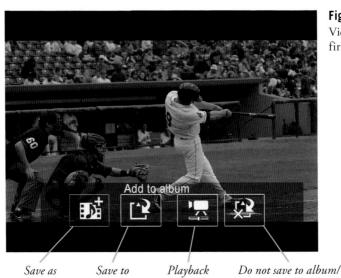

video snapshot

Delete without saving

to album

Figure 14.17Video snapshot confirmation screen.

- 7. **Delete most recent clip.** If you decide the most recent clip is not one you'd like to add to your current album, you can select Do Not Save to Album/Delete without Saving to Album (the right-most icon).
- 8. **Switch from Video Snapshots to conventional movie clips.** If you want to stop shooting video snapshots and resume shooting regular movie clips (of a variable length), navigate to the Movie Shooting 5 menu again, and disable Video Snapshot.

Note: Once you've set up the Video Snapshot feature, you can quickly enable or disable it using the Quick Control menu, which is illustrated later in this chapter. The Video Snapshot icon is the bottom icon in the left row of the Quick Control menu.

Shooting HDR Movies

Your 6D Mark II has one last trick up its sleeve, HDR Movies. The chief limitation is that this mode works *only* when you have selected the SCN position on the Mode Dial. When enabled, the 6D Mark II shoots movies at Full HD (1920×1080) when the camera is set to MP4 format and 30/25p frame rates. The feature reduces washed-out highlights in bright scenes, even if they are relatively high in contrast, using the camera's HDR Movies mode. The 6D Mark II merges multiple frames to achieve the HDR look, so a tripod is recommended to reduce (but not eliminate) noise and other artifacts caused by this additional processing. Remember that HDR Movies can be shot only in SCN mode, and are not available if you're using Video Snapshot.

Playback and Editing

As a movie is being played back, a screen of options appears at the bottom of the screen, as shown in Figure 14.18. When the icons are shown, use the left/right directional buttons to highlight one, and then press the SET button to activate that function:

- MENU. Exits playback mode.
- **Playback.** Begins playback of the movie or album. To pause playback, press the SET button again. That restores the row of icons so you can choose a function.
- **Slow motion.** Displays the video in slow motion.
- First frame. Jumps to the first frame of the video, or the first scene of an album's first video snapshot.
- **Previous frame.** Press SET to view previous frame; hold down SET to rewind movie.
- **Next frame.** Press SET to view next frame; hold down SET to fast forward movie.
- Last frame. Jumps to last frame of the video, or the last scene of the album's last video snapshot.
- Edit. Summons an editing screen (see Figure 14.19).
- Background music/volume. Select to turn background music on/off. Rotate the Main Dial to adjust the volume of the background music.

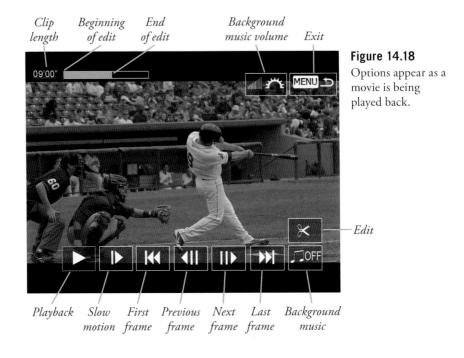

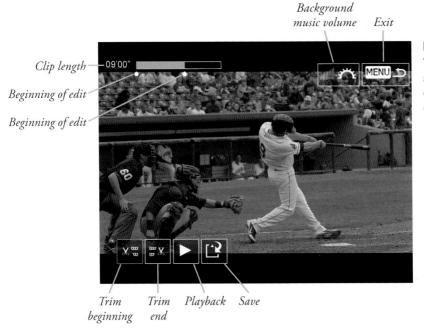

Figure 14.19
The editing screen allows you to snip off the beginning or end of a video clip.

While reviewing your video, you can trim from the beginning or end of your video clip by selecting the scissors symbol. The icons that appear have the following functions:

- Cut beginning. Trims off all video prior to the current point.
- Cut end. Removes video after the current point.
- Play video. Play back your video to reach the point where you want to trim the beginning or end.
- Save. Saves your video to the memory card. A screen appears offering to save the clip as a New File, or to Overwrite the existing movie with your edited clip.
- **Exit.** Exits editing mode.
- Adjust volume. Modifies the volume of the background music.

Tips for Shooting Better Movies

Producing high-quality movies can be a real challenge for amateur photographers. After all, by comparison we're used to watching the best productions that television, video, and motion pictures can offer. Whether it's fair or not, our efforts are compared to what we're used to seeing produced by experts. While this chapter can't make you into a pro videographer, it can help you improve your efforts.

Plan Ahead

There are several things to consider when planning a video shoot, and when possible, a shooting script and storyboard can help you produce a higher-quality video. I cover the use of lenses with the 6D Mark II in more detail in Chapter 7, but a discussion of lens selection, zooming, and other tools may be useful at this point. In the video world, not all lenses are created equal. I'll also discuss storytelling, lighting, and audio.

Depth-of-Field and Video

From an optical standpoint, the two most important considerations are depth-of-field, or the beneficial lack thereof, and zooming. I'll address each of these separately. Have you wondered why professional videographers have gone nuts over still cameras that can also shoot video? As I mentioned, the producers of *Saturday Night Live* could afford to have Alex Buono, their director of photography, use the niftiest, most expensive high-resolution video cameras to shoot the opening

sequences of the program. Instead, Buono opted for a pair of digital SLR cameras. One thing that makes digital still cameras so attractive for video is that they have relatively large sensors, which provides improved low-light performance and results in the attractive reduced depth-of-field, compared with most professional video cameras.

The roughly 26 million pixels used to *capture* the image are processed to create the 2,073,600 pixels of the final video frame. That's why the 6D Mark II gives you such great video quality, and why your video images retain roughly the same field of view and exact same depth-of-field you get with full-frame still images.

A larger sensor calls for the use of longer focal lengths to produce the same field of view, so, in effect, a larger sensor has reduced depth-of-field. And *that's* what makes cameras like the 6D Mark II attractive from a creative standpoint. Less depth-of-field means greater control over the range of what's in focus. Your 6D Mark II, with its larger sensor, has a distinct advantage over consumer camcorders in this regard, and even does a better job than many professional video cameras.

Zooming and Video

When shooting still photos, a zoom is a zoom. The key considerations for a zoom lens used only for still photography are the maximum aperture available at each focal length ("How *fast* is this lens?), the zoom range ("How far can I zoom in or out?"), and its sharpness at any given f/stop ("Do I lose sharpness when I shoot wide open?").

When shooting video, the priorities may change, and there are two additional parameters to consider. The first two I listed, lens speed and zoom range, have roughly the same importance in both still and video photography. Zoom range gains a bit of importance in videography, because you can always/usually move closer to shoot a still photograph, but when you're zooming during a shot most of us don't have that option (or the funds to buy/rent a dolly to smoothly move the camera during capture). But, oddly enough, overall sharpness may have slightly less importance under certain conditions when shooting video. That's because the image changes in some way many times per second, so any given frame doesn't hang around long enough for our eyes to pick out every single detail. You want a sharp image, of course, but your standards don't need to be quite as high when shooting video.

Here are the remaining considerations:

■ Zoom lens maximum aperture. The speed of the lens matters in several ways. A zoom with a relatively large maximum aperture lets you shoot in lower light levels, and a big f/stop allows you to minimize depth-of-field for selective focus. Keep in mind that the maximum aperture may change during zooming. A lens that offers an f/3.5 maximum aperture at its widest focal length may provide only f/5.6 worth of light at the telephoto position.

- Zoom range. Use of zoom during actual capture should not be an everyday thing, unless you're shooting a kung-fu movie. However, there are effective uses for a zoom shot, particularly if it's a "long" one from extreme wide angle to extreme close-up (or vice versa). Most of the time, you'll use the zoom range to adjust the perspective of the camera *between* shots, and a longer zoom range can mean less trotting back and forth to adjust the field of view. Zoom range also comes into play when you're working with selective focus (longer focal lengths have less depth-of-field), or want to expand or compress the apparent distance between foreground and background subjects. A longer range gives you more flexibility.
- Linearity. Interchangeable lenses may have some drawbacks, as many photographers who have been using the video features of their digital SLRs have discovered. That's because, unless a lens is optimized for video shooting, zooming with a particular lens may not necessarily be linear. Rotating the zoom collar manually at a constant speed doesn't always produce a smooth zoom. There may be "jumps" as the elements of the lens shift around during the zoom. Keep that in mind if you plan to zoom during a shot, and are using a lens that has proved, from experience, to provide a non-linear zoom. (Unfortunately, there's no easy way to tell ahead of time whether you own a lens that is well suited for zooming during a shot.)

Keeping Things Stable and on the Level

Camera shake's enough of a problem with still photography, but it becomes even more of a nuisance when you're shooting video. The image-stabilization feature found in many lenses (and some third-party optics) can help minimize this. That's why these lenses make an excellent choice for video shooting if you're planning on going for the handheld cinema verité look.

Just realize that while handheld camera shots—even image stabilized—may be perfect if you're shooting a documentary or video that intentionally mimics traditional home movie-making, in other contexts it can be disconcerting or annoying. And even IS can't work miracles. As I'll point out in the next section, it's the camera movement itself that is distracting—not necessarily any blur in our subject matter.

If you want your video to look professional, putting the 6D Mark II on a tripod will give you smoother, steadier video clips to work with. It will be easier to intercut shots taken from different angles (or even at different times) if everything was shot on a tripod. Cutting from a tripod shot to a handheld shot, or even from one handheld shot to another one that has noticeably more (or less) camera movement can call attention to what otherwise might have been a smooth cut or transition.

Remember that telephoto lenses and telephoto zoom focal lengths magnify any camera shake, even with IS, so when you're using a longer focal length, that tripod becomes an even better idea. Tripods are essential if you want to pan from side to side during a shot, dolly in and out, or track from side to side (say, you want to shoot with the camera in your kid's coaster wagon). A tripod and (for panning) a fluid head built especially for smooth video movements can add a lot of production value to your movies.

Shooting Script

A shooting script is nothing more than a coordinated plan that covers both audio and video and provides order and structure for your video when you're in planned, storytelling mode. A detailed script will cover what types of shots you're going after, what dialogue you're going to use, audio effects, transitions, and graphics. A good script needn't constrain you: as the director, you are free to make changes on the spot during actual capture. But, before you change the route to your destination, it's good to know where you were headed, and how you originally planned to get there.

When putting together your shooting script, plan for lots and lots of different shots, even if you don't think you'll need them. Only amateurish videos consist of a bunch of long, tedious shots. You'll want to vary the pace of your production by cutting among lots of different views, angles, and perspectives, so jot down your ideas for these variations when you put together your script.

If you're shooting a documentary rather than telling a story that's already been completely mapped out, the idea of using a shooting script needs to be applied more flexibly. Documentary filmmakers often have no shooting script at all. They go out, do their interviews, capture video of people, places, and events as they find them, and allow the structure of the story to take shape as they learn more about the subject of their documentary. In such cases, the movie is typically "created" during editing, as bits and pieces are assembled into the finished piece.

Storyboards

A storyboard makes a great adjunct to a detailed shooting script. It is a series of panels providing visuals of what each scene should look like. While the storyboards produced by Hollywood are generally of very high quality, there's nothing that says drawing skills are important for this step. Stick figures work just fine if that's the best you can do. The storyboard just helps you visualize locations, placement of actors/actresses, props and furniture, and also helps everyone involved get an idea of what you're trying to show. It also helps show how you want to frame or compose a shot. You can even shoot a series of still photos and transform them into a "storyboard" if you want, such as in Figure 15.1.

Figure 15.1 A storyboard is a series of simple sketches or photos to help visualize a segment of video.

Storytelling in Video

Today's audience is used to fast-paced, short-scene storytelling. To produce interesting video for such viewers, it's important to view video storytelling as a kind of shorthand code for the more leisurely efforts print media offers. Audio and video should always be advancing the story. While it's okay to let the camera linger from time to time, it should only be for a compelling reason and only briefly.

It only takes a second or two for an establishing shot to impart the necessary information. For example, many of the scenes for a video documenting a model being photographed in a Rock and Roll music setting might be close-ups and talking heads, but an establishing shot showing the studio where the video was captured helps set the scene.

Provide variety too. If you put your shooting script together correctly, you'll be changing camera angles and perspectives often and never leave a static scene on the screen for a long period. (You can record a static scene for a reasonably long period and then edit in other shots that cut away and back to the longer scene with close-ups that show each person talking.)

When editing, keep transitions basic! I can't stress this one enough. Watch a television program or movie. The action "jumps" from one scene or person to the next. Fancy transitions that involve exotic "wipes," dissolves, or cross fades take too long for the average viewer and make your video ponderous.

Composition

In movie shooting, several factors restrict your composition, and impose requirements you just don't always have in still photography (although other rules of good composition do apply). Here are some of the key differences to keep in mind when composing movie frames:

- Horizontal compositions only. Some subjects, such as basketball players and tall buildings, just lend themselves to vertical compositions. But movies are shown in horizontal format only. So, if you're interviewing a local basketball star, you can end up with a worst-case situation like the one shown in Figure 15.2. If you want to show how tall your subject is, it's often impractical to move back far enough to show him full-length. You really can't capture a vertical composition. Tricks like getting down on the floor and shooting up at your subject can exaggerate the perspective, but aren't a perfect solution.
- Wasted space at the sides. Moving in to frame the basketball player as outlined by the yellow box in Figure 15.2 means that you're still forced to leave a lot of empty space on either side. (Of course, you can fill that space with other people and/or interesting stuff, but that defeats your intent of concentrating on your main subject.) So, when faced with some types of subjects in a horizontal frame, you can be creative, or move in *really* tight. For example, if I was willing to give up the "height" aspect of my composition, I could have framed the shot as shown by the green box in the figure, and wasted less of the image area at either side.

Figure 15.2 Movie shooting requires you to fit all your subjects into a horizontally oriented frame.

- Seamless (or seamed) transitions. Unless you're telling a picture story with a photo essay, still pictures often stand alone. But with movies, each of your compositions must relate to the shot that preceded it, and the one that follows. It can be jarring to jump from a long shot to a tight close-up unless the director—you—is very creative. Another common error is the "jump cut" in which successive shots vary only slightly in camera angle, making it appear that the main subject has "jumped" from one place to another. (Although everyone from French New Wave director Jean-Luc Goddard to Guy Ritchie—Madonna's ex—have used jump cuts effectively in their films.) The rule of thumb is to vary the camera angle by at least 30 degrees between shots to make it appear to be seamless. Unless you prefer that your images flaunt convention and appear to be "seamy."
- The time dimension. Unlike still photography, with motion pictures there's a lot more emphasis on using a series of images to build on each other to tell a story. Static shots where the camera is mounted on a tripod and everything is shot from the same distance are a recipe for dull videos. Watch a television program sometime and notice how often camera shots change distances and directions. Viewers are used to this variety and have come to expect it. Professional video productions are often done with multiple cameras shooting from different angles and positions. But many professional productions are shot with just one camera and careful planning, and you can do just fine with your 6D Mark II.

Here's a look at the different types of commonly used compositional tools:

- Establishing shot. Much like it sounds, this type of composition, as shown in Figure 15.3, upper left, establishes the scene and tells the viewer where the action is taking place. Let's say you're shooting a video of your offspring's move to college; the establishing shot could be a wide shot of the campus with a sign welcoming you to the school in the foreground. Another example would be for a child's birthday party; the establishing shot could be the front of the house decorated with birthday signs and streamers or a shot of the dining room table decked out with party favors and a candle-covered birthday cake. Or, in Figure 15.3, upper left, I wanted to show the studio where the video was shot.
- Medium shot. This shot is composed from about waist to head room (some space above the subject's head). It's useful for providing variety from a series of close-ups and also makes for a useful first look at a speaker. (See Figure 15.3, upper right.)
- Close-up. The close-up, usually described as "from shirt pocket to head room," provides a good composition for someone talking directly to the camera. Although it's common to have your talking head centered in the shot, that's not a requirement. In Figure 15.3, center left, the subject was offset to the right. This would allow other images, especially graphics or titles, to be superimposed in the frame in a "real" (professional) production. But the compositional technique can be used with 6D Mark II videos, too, even if special effects are not going to be added.

■ Extreme close-up. When I went through broadcast training, this shot was described as the "big talking face" shot and we were actively discouraged from employing it. Styles and tastes change over the years and now the big talking face is much more commonly used (maybe people are better looking these days?) and so this view may be appropriate. Just remember, the 6D Mark II is capable of shooting in high-definition video and you may be playing the video on a high-def TV; be careful that you use this composition on a face that can stand up to high definition. (See Figure 15.3, center right.)

Figure 15.3 Mix your shots to help tell your story.

- "Two" shot. A two shot shows a pair of subjects in one frame. They can be side by side or one in the foreground and one in the background. (See Figure 15.3, lower left.) This does not have to be a head-to-ground composition. Subjects can be standing or seated. A "three shot" is the same principle except that three people are in the frame.
- Over-the-shoulder shot. Long a composition of interview programs, the "over-the-shoulder shot" uses the rear of one person's head and shoulder to serve as a frame for the other person. This puts the viewer's perspective as that of the person facing away from the camera. (See Figure 15.3, lower right.)

Lighting for Video

Much like in still photography, how you handle light pretty much can make or break your videography. Lighting for video can be more complicated than lighting for still photography, since both subject and camera movement is often part of the process.

Lighting for video presents several concerns. First off, you want enough illumination to create a useable video. Beyond that, you want to use light to help tell your story or increase drama. Let's take a better look at both.

Illumination

You can significantly improve the quality of your video by increasing the light falling in the scene. This is true indoors or out, by the way. While it may seem like sunlight is more than enough, it depends on how much contrast you're dealing with. If your subject is in shadow (which can help them from squinting) or wearing a ball cap, a video light can help make them look a lot better.

Lighting choices for amateur videographers are a lot better these days than they were a decade or two ago. An inexpensive incandescent video light, which will easily fit in a camera bag, can be found for \$15 or \$20. You can even get a good-quality LED video light for less than \$100. Work lights sold at many home improvement stores can also serve as video lights since you can set the camera's white balance to correct for any color casts. You'll need to mount these lights on a tripod or other support, or, perhaps, to a bracket that fastens to the tripod socket on the bottom of the camera.

Much of the challenge depends upon whether you're just trying to add some fill light on your subject versus trying to boost the light on an entire scene. A small video light will do just fine for the former. It won't handle the latter. Note that the Canon Speedlite 320EX has its own built-in video light.

Creative Lighting

While ramping up the light intensity will produce better technical quality in your video, it won't necessarily improve the artistic quality of it. Whether we're outdoors or indoors, we're used to seeing light come from above. Videographers need to consider how they position their lights to provide even illumination while up high enough to angle shadows down low and out of sight of the camera.

When considering lighting for video, there are several factors. One is the quality of the light. It can either be hard (direct) or soft (diffused). Hard light is good for showing detail, but can also be very harsh and unforgiving. "Softening" the light, but diffusing it somehow, can reduce the intensity of the light but make for a kinder, gentler light as well.

While mixing light sources isn't always a good idea, one approach is to combine window light with supplemental lighting. Position your subject with the window to one side and bring in either a supplemental light or a reflector to the other side for reasonably even lighting.

Lighting Styles

Some lighting styles are more heavily used than others. Some forms are used for special effects, while others are designed to be invisible. At its most basic, lighting just illuminates the scene, but when used properly it can also create drama. Let's look at some types of lighting styles:

■ Three-point lighting. This is a basic lighting setup for one person. A main light illuminates the strong side of a person's face, while a fill light lights up the other side. A third light is then positioned above and behind the subject to light the back of the head and shoulders. (See Figure 15.4, left.)

Figure 15.4 With three-point lighting (left); flat lighting is another approach for creating even illumination, where lights can be bounced off a white ceiling and walls to fill in shadows as much as possible (right).

- Flat lighting. Use this type of lighting to provide illumination and nothing more. It calls for a variety of lights and diffusers set to raise the light level in a space enough for good video reproduction, but not to create a particular mood or emphasize a particular scene or individual. With flat lighting, you're trying to create even lighting levels throughout the video space and minimize any shadows. Generally, the lights are placed up high and angled downward (or possibly pointed straight up to bounce off a white ceiling). (See Figure 15.4, right.)
- "Ghoul lighting." This is the style of lighting used for old horror movies. The idea is to position the light down low, pointed upward. It's such an unnatural style of lighting that it makes its targets seem weird and "ghoulish."
- Outdoor lighting. While shooting outdoors may seem easier because the sun provides more light, it also presents its own problems. As a rule, keep the sun behind you when you're shooting video outdoors, except when shooting faces (anything from a medium shot and closer) since the viewer won't want to see a squinting subject. When shooting another human this way, put the sun behind her and use a video light to balance light levels between the foreground and background. If the sun is simply too bright, position the subject in the shade and use the video light for your main illumination. Using reflectors (white board panels or aluminum foil—covered cardboard panels are cheap options) can also help balance light effectively.

Audio

When it comes to making a successful video, audio quality is one of those things that separates the professionals from the amateurs. We're used to watching top-quality productions on television and in the movies, yet the average person has no idea how much effort goes in to producing what seems to be "natural" sound. Much of the sound you hear in such productions is recorded on carefully controlled sound stages and "sweetened" with a variety of sound effects and other recordings of "natural" sound.

Tips for Better Audio

Since recording high-quality audio is such a challenge, it's a good idea to do everything possible to maximize recording quality. Here are some ideas for improving the quality of the audio your camera records:

■ Get the camera and its microphone close to the speaker. The farther the microphone is from the audio source, the less effective it will be in picking up that sound. While having to position the camera and its built-in microphone closer to the subject affects your lens choices and lens perspective options, it will make the most of your audio source. Of course, if you're using a very wide-angle lens, getting too close to your subject can have unflattering results, so don't take this advice too far. It's important to think carefully about what sounds you want to capture. If you're shooting video of an acoustic combo that's not using a PA system, you'll want the microphone close to them, but not so close that, say, only the lead singer or instrumentalist is picked up, while the players at either side fade off into the background.

■ Use an external microphone. You'll recall the description of the camera's external microphone port in Chapter 3. As noted, this port accepts a stereo mini-plug from a standard external microphone, allowing you to achieve considerably higher audio quality for your movies than is possible with the camera's built-in microphones (which are disabled when an external mic is plugged in). An external microphone reduces the amount of camera-induced noise that is picked up and recorded on your audio track. (The action of the lens as it focuses can be audible when the built-in microphones are active.)

The external microphone port can provide plug-in power for microphones that can take their power from this sort of outlet rather than from a battery in the microphone. You may find suitable microphones from companies such as Shure and Audio-Technica.

- Hide the microphone. Combine the first few tips by using an external mic, and getting it as close to your subject as possible. If you're capturing a single person, you can always use a lapel microphone (described in the next section). But if you want a single mic to capture sound from multiple sources, your best bet may be to hide it somewhere in the shot. Put it behind a vase, using duct tape to fasten the microphone and fix the mic cable out of sight (if you're not using a wireless microphone).
- Turn off any sound makers you can. Little things like fans and air handling units aren't obvious to the human ear, but will be picked up by the microphone. Turn off any machinery or devices that you can plus make sure cell phones are set to silent mode. Also, do what you can to minimize sounds such as wind, radio, television, or people talking in the background.
- Make sure to record some "natural" sound. If you're shooting video at an event of some kind, make sure you get some background sound that you can add to your audio as desired in postproduction.
- Consider recording audio separately. Lip-syncing is probably beyond most of the people you're going to be shooting, but there's nothing that says you can't record narration separately and add it later. It's relatively easy if you learn how to use simple software video-editing programs like iMovie (for the Macintosh) or Windows Movie Maker (for Windows PCs). Any time the speaker is off-camera, you can work with separately recorded narration rather than recording the speaker on-camera. This can produce much cleaner sound.

External Microphones

The single-most important thing you can do to improve your audio quality is to use an external microphone. The 6D Mark II's internal stereo microphones mounted on the front of the camera will do a decent job, but have some significant drawbacks, partially spelled out in the previous section.

These drawbacks include:

- Camera noise. There are plenty of noise sources emanating from the camera, including your own breathing and rustling around as the camera shifts in your hand. Manual zooming is bound to affect your sound, and your fingers will fall directly in front of the built-in mics as you change focal lengths. An external microphone isolates the sound recording from camera noise.
- **Distance.** Anytime your 6D Mark II is located more than 6 to 8 feet from your subjects or sound source, the audio will suffer. An external unit allows you to place the mic right next to your subject.
- Improved quality. Obviously, Canon couldn't install a super-expensive, super-high-quality microphone. Not all owners of the 6D Mark II would be willing to pay the premium, especially if they didn't plan to shoot much video themselves. An external microphone will almost always be of better quality.
- Directionality. The 6D Mark II's internal microphones generally record only sounds directly in front of them. An external microphone can be either of the directional type or omnidirectional, depending on whether you want to "shotgun" your sound or record more ambient sound.

You can choose from several different types of microphones, each of which has its own advantages and disadvantages. If you're serious about movie making with your 6D Mark II, you might want to own more than one. Common configurations include:

■ **Shotgun microphones.** These can be mounted directly on your 6D Mark II. I prefer to use a bracket, which further isolates the microphone from any camera noise. One thing to keep in mind is that while the shotgun mic will generally ignore any sound coming from *behind* it, it will pick up any sound it is pointed at, even *behind* your subject. You may be capturing video and audio of someone you're interviewing in a restaurant, and not realize you're picking up the lunchtime conversation of the diners seated in the table behind your subject. Outdoors, you may record your speaker, as well as the traffic on a busy street or freeway in the background.

WIND NOISE REDUCTION

Your 6D Mark II has a wind cutoff option for the internal microphones. However, most microphones come with their own windscreen. Always use the windscreen provided with an external microphone to reduce the effect of noise produced by even light breezes blowing over the microphone. Many mics include a low-cut filter to further reduce wind noise. However, these can also affect other sounds. External mics often have their own low-cut filter switch.

- Lapel microphones. Also called *lavalieres*, these microphones attach to the subject's clothing and pick up their voice with the best quality. You'll need a long enough cord or a wireless mic (described later). These are especially good for video interviews, so whether you're producing a documentary or grilling relatives for a family history, you'll want one of these.
- Handheld microphones. If you're capturing a singer crooning a tune, or want your subject to mimic famed faux newscaster Wally Ballou, a handheld mic may be your best choice. They serve much the same purpose as a lapel microphone, and they're more intrusive—but that may be the point. A handheld microphone can make a great prop for your fake newscast! The speaker can talk right into the microphone, point it at another person, or use it to record ambient sound. If your narrator is not going to appear on-camera, one of these can be an inexpensive way to improve sound.
- Wired and wireless external microphones. This option is the most expensive, but you get a receiver and a transmitter (both battery-powered, so you'll need to make sure you have enough batteries). The transmitter is connected to the microphone, and the receiver is connected to your 6D Mark II. In addition to being less klutzy and enabling you to avoid having wires on view in your scene, wireless mics let you record sounds that are physically located some distance from your camera. Of course, you need to keep in mind the range of your device, and be aware of possible signal interference from other electronic components in the vicinity.

Index

A	motor drives, 1//
A+ (full auto), 12	phase detection, 109–111
AC Adapter Kit ACK-E6, 4, 6	preferences, 128–129
Accelerate/Decelerate Tracking, 125	setting, 16
access lamp, 30	AF area selection
access points, connecting to, 162	button, 36–37
action, freezing, 143–144, 185–186, 211	default settings, 48
adapter rings, using with lenses, 174	displaying, 31
Adobe RGB color space, 268–271. See also	modes, 18-19, 120-123, 128
RGB-IR metering sensor	AF button, 37
AE lock	AF custom functions
button, 30, 342	Accelerate/Decelerate Tracking, 125
displaying, 31	AF Area Selection Method, 128
Live View screen, 352	AF Microadjustment, 132, 137
Movie Shooting screen, 363	AF Point Auto Switching, 125
AE lock/AE bracketing in progress, in	AF Point Display During Focus, 131
viewfinder, 41	AF Point Selection Movement, 130
AE lock/FE lock button, 30. See also Exposure	AF-Assist Beam Firing, 127
Metering Mode, AE Locked After Focus	AI Servo 1st Image Priority, 125–126
options	AI Servo 2nd Image Priority, 126
AEB (automatic exposure bracketing),	Auto AF Point Selection, 130
259–260	Initial AF Point, Auto Selection, AI Servo AF
AE/FE (autoexposure/flash exposure) lock, 34	129–130
AF (autofocus). See also back-button focus;	Lens Drive when AF Impossible, 127
Dual Pixel CMOS AF system; focus	Orientation Linked AF Point, 128–129
modes	Select AF Area Selection Mode, 128
contrast detection, 108-109	Tracking Sensitivity, 124–125
cross-type focus point, 112–116	using, 123–124
fine-tuning lenses, 132–138	VF Display Illumination, 131
versus manual focus, 107–108	

AF modes	AF-ON button, 30, 34, 342
AI Focus AF, 120	AI Focus AF, 16-17, 120
AI Servo AF, 119–120	AI Servo 1st Image Priority, 125-126
Live View screen, 352	AI Servo 2nd Image Priority, 126
Live View Shooting defaults, 49	AI Servo AF, 16-17, 119-120
M (Manual) focus, 120	Android connections, 163
Movie Settings defaults, 50	Angle Finder C right-angle viewer, 4
Movie Shooting screen, 363	Anti-Flicker Shooting options, 290. See also
One-Shot AF, 119	flicker detection
options, 348	aperture
selecting in Live View, 356-359	displaying, 31
AF operation	exposure triangle, 56
AF method selection button, 37	of lenses, 176
default settings, 48	Live View screen, 352
displaying, 31	Movie Shooting screen, 363
Live View screen, 352	readout, 39
Live View Shooting defaults, 49	in viewfinder, 41
options, 15	aspect ratio options, 48, 292
readout, 39	attenuator, Movie Shooting screen, 363
in viewfinder, 41	audio tips, 391–394. See also Sound recording
AF point in viewfinder, 41	options
AF Point Auto Switching, 125	Auto AF Point Selection, 130
AF Point Display options	Auto cleaning, displaying, 31
default, 49	Auto Lighting Optimizer. See also lighting
options, 131, 308	default settings, 48
AF point selection	displaying, 31
button, 30, 34	Live View screen, 352
displaying, 31, 39	Movie Shooting screen, 363
movement, 130	options, 262–263
in viewfinder, 41	Auto Picture Style, 274
AF points	Auto Power Off
and lens groups, 114–116	default, 49
Live View screen, 352	options, 315
Movie Shooting screen, 363	Auto Rotate options, 313-314. See also Rotate
AF sensors, design, 107	Image options
AF with Color Tracking, 123	Auto Selection options, 129
AF-Assist Beam Firing, 127	Autofocus switch, 28
AFD (Arc-form drive), 177	autofocus tables, 51
AF/MF switch, 29, 116	autofocus wide-angle telephoto zoom lenses, 172

Autofocus/Manual focus switch, 39-40	body cap, 2
automatic and semi-automatic modes, 12-13	bottom of camera, 42
Automatic Selection AF mode, 17, 19	bracketed shots, number of, 337
Av (Aperture-priority) mode	bracketing
electronic flash, 202	Auto Cancel options, 336
equivalent exposure, 61	Sequence options, 336–337
menu tabs, 244	white balance, 267
using, 12, 68–70	brightening images, 262–263
	brightness histogram, 32
В	Bulb exposures
_	features, 361
B (Bulb exposure) setting, 12	long exposures, 147–148
back focus, 133, 138	menu tabs, 244
back of camera, 29–36	readout, 39
back-button focus, 138–140. See also AF	shooting modes, 12
(autofocus)	in viewfinder, 41
Basic Zone modes, 14, 270	Bulb Timer options, 289
batteries, stretching longevity, 316	Bulb/interval shooting, 39
battery chargers, 2, 5	burst
Battery Compartment latch, 42	displaying, 31
Battery Grip BG-E21, 6	Live View screen, 352
Battery Info. options, 322–324	in viewfinder, 41
battery level	buttons and controls, assigning, 341-342
displaying, 31, 39	
Live View screen, 352	С
Movie Shooting screen, 363	_
in viewfinder, 41	CA (Creative Auto) mode, 12, 14
battery pack LP-E6N	cables
in box, 2–3	HDMI HTC-100, 4
charging, 5	IFC-400PCU, 3
registering, 324–325	camera
battery power, saving, 118, 139	in box, 2
Beep options, 322	recommendations, 50–54
Bluetooth function	resetting, 47–50
default, 49	tilt and rotation, 35
displaying, 31	camera back, 29–36
enabling, 162–163	camera bottom, 42
Live View screen, 352	camera front, 26–29
Movie Shooting screen, 363	camera settings. See also default settings
readout, 39	adjusting, 11, 44
blur, adding and reducing, 71–72, 149–150	clearing, 330
	defaults, 49

camera shake, vanquishing, 146	Close-up mode, 14
camera top, 36–38	close-up photography, Av mode, 70
Candlelight mode, 14	close-ups
Canon iMage Gateway, 161–162	composing, 387–388
capacitive versus resistive, 43	manual flash settings, 211
Car Battery Cable CBC-E6, 5	CMOS AF system, 108, 112
Card error warning, 39, 41	color balance bracketing, 267
Card full, 39, 41. See also memory cards	color gamuts, 268
card reader, using, 24	color management, 271
card slot cover, 30	Color Rendering Index, 192
Center-weighted metering, 15–16, 66–67	Color Space options, 33, 268-271
Certification Logo Display options, 331	color temperature, 188–190
C.Fn entries and screens, 333, 335-343	Color tone effect parameter, using with
channels, choosing for wireless flash, 229,	Picture Styles, 274
237–238	composition in movies, 386-389
charging batteries, 5-6	computers, transferring photos, 23-24
choosing	concerts, Tv (Shutter-priority), 72
AF method in Live View, 356–359	continuous autofocus, 16-17, 120
exposure methods, 67–76	continuous lighting. See also lighting
flash modes, 210-216	color temperature, 188–190
focus modes, 16–17	daylight, 190–191
focus points, 17–19	versus electronic flash, 183-188
f/stops, 75	fluorescent light, 191-192
functions, 44	incandescent/tungsten light, 191
lenses, 169-170	white balance bracketing, 190
metering modes, 15-16, 64-67	continuous shooting, 141-143
shooting modes, 12-15	contrast
shutter speed, 75	detection, 108-109
chromatic aberration, 254	information, 33
CIPA (Camera & Imaging Products	parameter for Picture Styles, 273
Association), 5	providing, 127
circles of confusion, 117-118	Control over HDMI default, 49
cleaning, Shooting Information/Quick	controls. See also Custom Controls
Control screen, 31	assigning, 341–342
Cleaning image sensor, 39	displaying, 31
Clear All Camera Settings options, 330	touch versus physical, 12
Clear All Custom Func. (C.Fn) options, 343	Copyright Information options, 330
Clear flash settings, 259	Creative filters, Live View screen, 352
Clear settings option, 259	Cropping options, 302-303
close-up lites, 224	cross-type focus point, 112-116

Ctrl over HDMI options, 309	Diffraction correction, 255-256
Custom Controls. See also controls	digital/USB port, 28–29
displaying, 31	diopter correction, 6-8, 30, 34
options, 341–342	directional buttons
Custom Functions	default, 342
adjusting, 334	locating, 30
AF (autofocus), 123–124	for navigation, 245
Bracketing Auto Cancel, 336	Distortion correction, 253-254
Bracketing Sequence, 336–337	DOF (depth-of-field)
Clear All Custom Func. (C.Fn), 343	and f/stops, 56
clearing, 343	Preview button, default, 342
Custom Controls, 341–342	P (Program) mode, 60
Dial Direction During Tv/Av, 341	DPOF print order, creating, 297–299
Exposure comp. Auto Cancel, 339	DRIVE button, 19–20, 37
Exposure Level Increments, 335	Drive mode
Exposure Metering Mode, AE Locked After	default settings, 48
Focus, 339–340	displaying, 31, 39
ISO Speed Setting Increments, 336	Live View screen, 352
Number of Bracketed Shots, 337	in viewfinder, 41
overview, 333	Dual Pixel CMOS AF system, 112. See also
Retract Lens on Power Off, 341	AF (autofocus)
Safety Shift, 337–338	Dust Delete Data options, 284
user settings, 328	1
Warnings in Viewfinder, 340	E
Custom Shooting Mode (C1-C2) options,	
326-329. See also shooting modes	Edgerton, Harold, 143
Custom White Balance options, 266	EF lenses, 27, 171, 173–175, 178–179. See also lenses
.	EF-S lenses, prohibition of use, 6
D	electrical contacts, 27–28, 40
date and time, setting, 10–11	electronic flash. See also flash; Speedlites
Date/Time/Zone options, 317–318	close-up lites, 224
daylight, 190–191	versus continuous lighting, 183–188
DC coupler cord access cover, 26–27	exposure modes, 201
default settings, recommendations, 47–50. See	FE lock, 202–204
also settings	first-curtain sync, 194, 196–197
delay, setting, 19	flash exposure compensation, 202-204
delayed exposures, 150-155. See also	flash range, 204–205
exposures	ghost images, 196–198
lepth-of-field preview button, 27	HSS (high-speed sync), 199
Dial Direction During Tv/Av options, 341	overview, 194, 196
liffraction, 56	second-curtain sync, 194, 196–197
	sync speed, 198–199

electronic level	exposure options, Movie Shooting menus,
Live View screen, 352	369-371
using, 35	exposure settings, 60
in viewfinder, 41	Exposure Simulation options, 349–352
Electronic Manual Focus options, 256. See	exposure triangle, 56
also M (Manual) focus	exposures. See also delayed exposures; light
e-mail default settings, 53–54	and exposure; long exposures; multiple
EOS Digital Solution Disc CD, 3	exposures; short exposures
EOS Utility	adding and subtracting, 72–73
Picture Styles, 279–280	calculation, 61–63, 185
Wi-Fi function, 159–160	determining, 200
equivalent exposures, 60–61	external meters, 63
Erase button, 30, 34	GN (guide numbers), 200–201
Erase Images options, 21, 296	impact, 57
E-TTL II	ISO settings, 76–79
flash mode, 211	Live View screen, 352
metering, 257	locking, 65
Evaluative metering, 15–16, 65	options, 143–144
ExpoDisc, 189, 265-266. See also white	exposures remaining. See also multiple
balance	exposures
exposure bracketing range, Live View screen,	12 to 18 percent reflectance, 61–63
352	displaying, 31
Exposure comp. Auto Cancel options, 339	limit, 9
exposure comp./AEB, default settings, 48	Live View screen, 352
exposure compensation	readout, 39
amount, 39	in viewfinder, 41
displaying, 31, 39	external electronic flash. See Speedlites
Live View screen, 352	external meters, 63
Movie Shooting screen, 363	External Speedlite control. See also Speedlite
in viewfinder, 41	Clear Flash Settings, 209
Exposure Compensation/Automatic Exposure	E-TTL II Meter, 206
Bracketing options, 259–260	flash C.Fn settings, 209
exposure level	flash firing, 205
increments, 335	Flash function settings, 207-209
Live View screen, 352	Flash Sync Speed in Av Mode, 206
readout, 31, 39	options, 256–259
in viewfinder, 41	eyecup, 2, 30
Exposure Metering Mode, AE Locked After	Eye-Fi card
Focus options, 339-340. See also AE	displaying, 31
lock/FE lock button	options, 314–315
exposure modes, explained, 64	transmissions, 352, 363

†	flash settings
Face Detection+Tracking Mode, 356–357	clearing, 259
Faithful Picture Style, 274	disabling flash firing, 210
FE lock	E-TTL II, 211
button, 30	flash modes, 210–216
and flash exposure compensation, 202–204	High-speed sync, 214–216
in viewfinder, 41	manual flash, 211
Feature Guide options, 321	MULTI flash, 213–214
FEC (flash exposure compensation)	flash sync
default settings, 48	in Av mode, 257–258
displaying, 31	contacts, 36–37
and FE lock, 202–204	flash units
readout, 41	controlling, 227–228
field sports, lens recommendation, 180	linking, 216–217
File Numbering options, 312–313	power ratio, 240
fill flash, 194, 211, 215	flashing status light, 6
fill light and key light, 226, 240–242	flat lighting, 391
Filter effect parameter, using with Picture	flicker detection, 41. See also Anti-Flicker
Styles, 274	Shooting options
filter thread, 39–40	fluorescent light, 191–192
filtering vs. toning, 277	focus, evaluating, 134–136
Fine Detail Picture Style, 274	focus assist beam, 127
Firmware Version options, 331	focus indicator, in viewfinder, 41
first-curtain sync, 194, 196–197	focus modes. See also AF (autofocus)
fisheye lenses, 180, 253	choosing, 16–17
flash, M (Manual) exposure, 76. See also	circles of confusion, 117–118
electronic flash; wireless flash	overview, 116
Flash Custom Function settings, 259	focus points, selecting, 17-19
flash exposure bracketing, 41, 352	focus priority, 119
flash exposure compensation, Live View	focus ring, 39-40
screen, 352	focus scale, 39–40
flash exposure lock, 39, 41	focus test chart, 134-135
flash firing, 210, 257	focusing, in Live View, 355-360
Flash function settings, 242, 258–259	folders, creating, 310-312
flash modes, choosing, 210-216	Food mode, 14
flash range, 204–205	Format Card options, 314
Flash ready/Improper flash exposure lock	formatting memory cards, 9-10
warning, in viewfinder, 41	frame rate
Flash ready/Off/High-speed sync, Live View	Movie Shooting menus, 373
screen, 352	Movie Shooting screen, 363

freezing action, 143–144, 185–186, 211	Н
front focus, 133	hand grip, 27
front of camera, 26–29	Handheld Night Scene mode, 15
f/stops	HDMI cable, controlling playback operation
and DOF (depth-of-field), 56	309
explained, 59	HDMI cable HTC-100, 4
selecting, 75	HDMI mini c port, 29
and shutter speeds, 60	HDMI Out port, 28
functions	HDR (High Dynamic Range), 31, 57
accessing, 22, 44	HDR Backlight Control, 15
locking, 326	HDR default settings, 52–53
waking up, 25	HDR Mode options, 288
G	HDR Movies mode, Movie Shooting menus, 377
-	HDR shooting, Live View screen, 352
Gateway services, 161–162 geotagging, 165–168	HDR warning, 340
"Ghoul lighting," 391	Help Text Size options, 321
GN (guide numbers), 200–201	Hertz measurement, explained, 214
GPS acquisition/Logging, 31, 39	High ISO Speed Noise Reduction, 282–283.
GPS antenna location, 37–38	See also ISO speed; noise reduction
GPS connection	Highlight Alert options, 49, 308
Live View screen, 352	Highlight Tone Priority
Movie Shooting screen, 363	displaying, 31
GPS receiver, activating, 165–168	Live View screen, 352
GPS Settings options, 319–320	Movie Shooting screen, 363
gray cards, 61, 64	options, 283
grid	readout, 39
display options, 349	in viewfinder, 41
superimposing on images, 308	highlights, capturing detail, 57–58
in viewfinder, 41	Histogram Disp. options, 309
Group photo mode, 14	Histogram display default, 49
groups, using with wireless flash, 229–230,	histograms, 32–33
238–242	Live View screen, 352
Groups A-H lenses, 116	hot shoe/flash sync contacts, 36-37
1	HSS (high-speed sync)
	Live View screen, 352
	using, 199, 214-216
	in viewfinder, 41
	hues, availability, 268–269

Index views, 22–23
Index/Magnify/Reduce button, 21, 30, 33
INFO. button, 15, 21-22, 30, 325
infrared adjustment indicator, 40
Initial AF Point, Auto Selection, AI Servo AF
129–130
inserting memory cards, 8
interface cable IFC-400PCU, 3
interval photography, 151–155
Interval Timer options, 289
iOS connections, 163
IR (infrared) transmitters, 217, 228
ISO button, 37
ISO settings
adjusting, 76–79
defaults, 48
exposure triangle, 56
ISO speed. See also High ISO Speed Noise
Reduction
displaying, 31
Live View screen, 352
Movie Shooting screen, 363
readout, 39
settings, 261, 336
in viewfinder, 41
J
JPEG, RAW options, 41, 247-250
• • •
K
key light and fill light, 240–242
Kids mode, 14
KODAK Gray Cards, 64

incandescent/tungsten light, 191

L	lenses
Landscape mode, 14, 53–54	adapter rings, 174
landscape photography	aperture, 170, 176
Av mode, 70	autofocus motor drives, 177
hand-held, 72	autofocus type, 176
Landscape Picture Style, 274	autofocus wide-angle telephoto zoom, 172
Language options, 318	choosing, 169–170
lapel microphones, 394	compatibility, 173–175
Large Zone AF mode, 17, 19, 121	components, 39–40
LCD Brightness options, 49, 316	cost, 170
LCD illuminator button, 37	designations, 176
LCD monitor	EF series, 27, 171–179
electronic level, 35	filter size, 176
features, 29–30	fine-tuning autofocus, 132–138
protecting, 46	fisheye zoom, 180
LCD Off/On Button options, 49, 317	focal length, 176
LCD panel, 37–39	focusing, 170
LCD touch screen. See also touch controls	image quality, 170
disabling, 321	image stabilization, 178
mastering, 43–46	image-stabilized autofocus wide-angle
LC-E6 battery chargers, 5	telephoto zoom, 172
LED illumination, 192	L-series, 171–172
lens aberration correction, 48, 252-256, 364	macro, 181
Lens AF stop button, default, 342	"The Magic Three," 178–179
lens correction information, 33	mounting, 6
Lens Drive when AF Impossible, 127	overview, 169–170
lens electronic manual focus, default settings,	recommendations, 171–173, 180–182
48	retracting, 341 series, 176
lens groups, and AF points, 114–116	shake correction, 181
lens hood bayonet mount, 39-40	size, 170
lens lock pin, 27	STM, 172–173
lens mount bayonet, 40	telephoto, 179, 182
lens mounting index mark, 28-29	telephoto zoom, 172
lens release button, 27	third-party options, 171
	tilt-shift, 181
	types, 176
	USM, 171–172
	wide-angle, 171, 178
	zoom, 179
	zoom range, 170
	zoom wide-angle-telephoto, 171–172
	20011 mae angle telephoto, 1/1 1/2

light and exposure, 56–58, 61. See also	long exposures, 147–150. See also exposures
continuous lighting; exposure	L-series lenses, 171-172
light meters, 63, 76	Lume Cube, 190
light sources, 185–186, 191–192	
light trails, producing, 148	M
lighting. See also Auto Lighting Optimizer;	
continuous lighting	M (Manual) modes
evenness of, 185	exposure, 12–13, 74–76
for video, 389-391	focus, 116, 120
lighting ratios, setting, 240–242	menu tabs, 244
lithium-ion battery pack	macro default settings, 53–54
in box, 2–3	macro lenses, 181
charging, 5	macro lites, 224
registering, 324–325	macro photography, Av mode, 70
Live 1-Point AF, 358	"The Magic Three" lenses, 178–179
Live View. See also Movie Shooting menus	Magnification (apx) options, 49, 309
bulb exposures, 361	Magnified View, 352, 359
changing display, 353-354	Magnify button, 30, 33
enabling, 348	Magnify/Digital Zoom, Movie Shooting
focusing in, 355–360	screen, 363
screen, 352	magnifying images, 45–46
settings, 347	Main Dial
Shooting 5 menu, 348–351	default, 342
shooting in, 351–355	description and location, 26–27, 37–38
shooting movies, 362	Dial Direction During Tv/Av, 341
shooting options, 292	image jump options, 307
Touch shutter, 361	menu navigation, 245
Live View/Movie Shooting mode, 30, 32, 34,	options, 16
49	Manual flash setting, 211
LOCK switch, 30. See also Multi-function	Manual focus lens switch, 28
lock switch	Manual/Software URL options, 331
locking	Map Utility, 168
exposure, 65	master flash, 226, 230-236
flash exposure, 202–204	maximum burst
functions, 326	displaying, 31
Logging function, displaying, 31	Live View screen, 352
long exposure default settings, 52–53	in viewfinder, 41
Long Exposure Noise Reduction, 280–282.	M/B modes, electronic flash, 202
See also noise reduction	

memory cards. See also Card full; Release	Movie Digital IS, 363, 369
shutter without card	Movie ISO speed settings, 50
access lamp, 34	Movie mode, menu tabs, 244
card slot cover, 30	Movie recording size, Movie Shooting screen,
formatting, 9–10, 314	363
inserting, 8	Movie Servo AF
no card warning, 39	Movie Shooting screen, 363
recommendation, 3	speed defaults, 50
transferring images from, 24	track sensitivity, 50
MENU button, 30	movie settings defaults, 50
menus. See also My Menu	Movie Shooting 1, 362–364
accessing, 50-51, 243-245	Movie Shooting 2, 365
creating, 343–345	Movie Shooting 3-4, 366–368
highlighting entries, 245	Movie Shooting 5, 368–369
modes and tabs, 244	Movie Shooting menus. See also Live View;
navigating, 245–246	time-lapse movie
metering modes	exposure options, 369–371
choosing, 15–16, 64–67	frame rate, 373
default settings, 48	HDR Movies mode, 377
displaying, 31, 37	MP4 Formats/Compression, 371–372
Live View screen, 352	Playback and Editing, 378–379
readout, 39	Q (Quick Control) button, 374
in viewfinder, 41	Resolution/Movie Recording Size, 372-373
metering system, M (Manual) exposure, 76	screen, 363
metering timer, Live View Shooting defaults,	shutter button functions, 368
49	shutter speed, 370-371
Metering Timer options, 349	Video Snapshots, 374–377
microphones	Movie shooting remaining time/Elapsed time,
description and location, 27-28	363
In port, 28–29	movie tips
using with movies, 391–394	audio, 391–394
Mirror Lockup options, 290-291	close-ups, 387–388
MM (Micrometer) motor drive, 177	composition, 386–389
Mode Dial	depth-of-field and video, 381-382
lock release, 36	establishing shot, 387–388
settings, 12–13	image stabilization, 383–384
Mode Guide options, 321	lighting for video, 389–391
modes, semi-automatic/manual, 12-13	medium shot, 387–388
Monochrome Picture Style, 275, 340	shooting scripts, 384
motor drives, 177	storyboards, 384–385
mounting lenses, 6	storytelling in video, 385
	zooming and video, 382–383

Movie-recording format, Movie Shooting screen, 363	0
MP4 Formats/Compression, Movie Shooting	One-Shot AF mode, 16–17, 119, 360
menus, 371–372	On/Off switch, 12–13, 36
MULTI flash setting, 213-214	optical slave units, 228
Multi Function Lock options, 326	Orientation Linked AF Point, 128–129
Multi Shot noise reduction, Live View screen,	outdoor lighting, 391
352	over shoulder shots, 388–389
Multi-controller/directional buttons, 30, 34,	overexposure, 62, 73
342	overriding selections, 337–338
Multi-function lock switch, 35, 39, 41. See	_
also LOCK switch	P
multiple exposures. See also exposures	P (Program) mode
default settings, 48	DOF (depth-of-field), 60
displaying, 31, 39	electronic flash, 201
Live View screen, 352	menu tabs, 244
options, 284–288	setting, 12–13
Multishot noise reduction	using, 72–73
displaying, 31	pairing devices, 163
warning, 340	PAL/NTSC options, 320
My Menu, creating, 343–345. See also menus	Panning mode, 14
••	Partial metering, 15–16, 66
N	Peripheral Illumination Correction, 253
neck strap mount, 28–29	phase detection, 109–111
Neutral Picture Style, 274	Photobook Set-up options, 300
NFC (Near Field Communications)	photos. See pictures
Connect Station, 159	Picture Styles
mark, 28–29	contrast information, 33
using, 164	default settings, 48
Night Portrait mode, 15	displaying, 31
No card warning, 39, 41	Live View screen, 352
noise reduction, 31, 33. See also High ISO	Movie Shooting screen, 363
Speed Noise Reduction; Long Exposure	options, 271–280
Noise Reduction	sharpness information, 33
NTSC/PAL options, 320	pictures
Number of Bracketed Shots options, 337	advancing through, 21
numbering files, 312-313	brightening, 262–263
	checking, 22
	areating tolders 310 317
	creating folders, 310–312
	erasing, 21, 296

jumping ahead or back, 21-22	port covers, 28
magnifying and reducing, 45	Portrait mode, 14, 52-53
navigating, 33	portrait photography
protecting, 294–295	Av mode, 70
rating, 304	lens recommendation, 181
remaining to record, 39	Portrait Picture Style, 274
reviewing, 21–23	possible shots, displaying, 31
rotating, 295–296	power options, 5-6, 316
scrolling around, 21–22, 45	powering off, 315
searching, 297, 306	pressing and tapping, 25
taking, 20	Print Order options, 297–299
transferring to computers, 23-24	printer, Wi-Fi connection, 160–161
zooming in on, 22	ProPhoto RGB, 268–269
pincushion distortion, 254	Protect Images options, 294-295
Playback and Editing, Movie Shooting menus,	
378–379	Q
Playback button, 30, 32-33	
Playback Grid options, 49, 308	Q (Quick Control) button, 34, 374
Playback image button, 21	QCD (Quick Control Dial), 34
Playback menu options	date/time/zone settings, 317–318
AF Point Disp., 308	default, 342
Cropping, 302–303	Dial Direction During Tv/Av, 341
Ctrl over HDMI, 309	identifying, 11
Erase Images, 296	Index views, 22
Highlight Alert, 308	menu navigation, 245
Histogram Disp., 309	self-timer, 19
Image Jump with Main Dial, 307	time and date, 10–11
Magnification (apx), 309	QR code, displaying, 331
Photobook Set-up, 300	Quick control
Playback Grid, 308	button, 30
Print Order, 297–299	dial, 30
Protect Images, 294–295	icon, 31
Rating, 304	Live View screen, 352
RAW Image Processing, 300–301	Movie Shooting screen, 363
Resize, 303	Quick Control screen
Rotate Image, 295–296	displaying, 31
Set Image Search Conditions, 306	flash exposure compensation, 203
Slide Show, 305–306	Live View, 355
user settings, 328	producing, 22, 31
, 020	using, 36

R	S
radio control, using with wireless flash,	Safety Shift options, 337–338
240–242	Saturation parameter, using with Picture
radio masters, Speedlites as, 235–236	Styles, 274
radio transmitters, 217, 228	saving battery power, 118, 139
Rating options, 304	scales, adjusting, 45
RAW	Scene Intelligent Auto
options, 247-250, 300-301	electronic flash, 201
and white balance, 189	Full Auto, 14, 68
rechargeable batteries, 5	menu tabs, 244
recording level, Movie Shooting screen, 363	options, 73–74
reducing images, 30, 33, 45–46	SCN (scene) modes, 12, 14-15
registration and warranty card, 2	screens, six-second rule, 19
release priority, 119	scrolling through images, 21-22, 45-46
Release shutter without card. See also memory	searching images, 297, 306
cards; shutter release	second-curtain sync, 194, 196–197
default, 49	SEL [], displaying, 121
options, 251	Select AF Area Selection Mode, 128
remote control	Select Folder options, 310-312
port and cover, 27–28	selecting
sensor, 26–27	AF method in Live View, 356–359
Resize options, 303	exposure methods, 67–76
Resolution option, 247	flash modes, 210-216
Resolution/Movie Recording Size, Movie	focus modes, 16–17
Shooting menus, 372–373	focus points, 17–19
Retract Lens on Power Off options, 341	f/stops, 75
reviewing images, 21–23	functions, 44
RF-3 body cap, 2	lenses, 169–170
RGB histogram, 32	metering modes, 15–16, 64–67
RGB-IR metering sensor, 61. See also Adobe	shooting modes, 12–15
RGB color space	shutter speed, 75
right-angle viewer, 4	selections, overriding, 337-338
ring lites, 224	self-timer
ring ultrasonic motor (USM) drives, 177	countdown, 39
Rotate Image options, 295–296. See also Auto	delayed exposures, 150-151
Rotate	lamp, 26-27
rotation and tilt, checking, 35	shots, 39, 41
•	using, 19–20
	semi-automatic and automatic modes, 12–13
	Sensor Cleaning options, 325
	sensor focal plane, 36. See also image sensor

Servo AF mode, 360

SET button, 11, 30, 35, 342 Shooting Information screen, 31 Set Image Search Conditions options, 306 Shooting menu options Anti-Flicker Shooting, 290 settings. See also default settings adjusting, 11, 44 Aspect Ratio, 292 Auto Lighting Optimizer, 262–263 clearing, 330 Bulb Timer, 289 defaults, 49 Color Space, 268–271 Set-up menu options Auto Power Off, 315 Custom White Balance, 266 Dust Delete Data, 284 Auto Rotate, 313-314 Battery Info., 322-324 Electronic Manual Focus, 256 Exposure Compensation/Automatic Exposure Beep, 322 Bracketing, 259–260 Certification Logo Display, 331 External Speedlite control, 256–259 Clear All Camera Settings, 330 HDR Mode, 288 Copyright Information, 330 High ISO Speed Noise Reduction, 282–283 Custom Shooting Mode (C1-C2), 326-329 Highlight Tone Priority, 283 Date/Time/Zone, 317-318 Image Quality, 247-250 Eye-Fi Settings, 314–315 Image Review, 251 Feature Guide, 321 Interval Timer, 289 File Numbering, 312–313 ISO Speed Settings, 261 Firmware Version, 331 Lens Aberration Correction, 252–256 Format Card, 314 Live View Shooting, 292 GPS Settings, 319-320 Long Exposure Noise Reduction, 280–282 Help Text Size, 321 Mirror Lockup, 290–291 INFO. Button Display Options, 325 Multiple Exposure, 284–288 Language, 318 LCD Brightness, 316 Picture Style, 271–280 Release Shutter without Card, 251 LCD Off/On Button, 317 Manual/Software URL, 331 user settings, 327–328 White Balance, 263-266 Mode Guide, 321 White Balance Shift/Bracketing, 267–268 Multi Function Lock, 326 shooting modes. See also Custom Shooting Select Folder, 310–312 Mode (C1-C2) Sensor Cleaning, 325 displaying, 31 Touch Control, 321-322 Live View screen, 352 user settings, 328 selecting, 12–15 Video System, 320 in viewfinder, 41 Viewfinder Display, 318–319 shooting scripts, using with movies, 384 Wireless Communication Settings, 315 shooting settings, defaults, 48 shadows, capturing detail, 57–58 short exposures, 144-146. See also exposures sharpness shotgun microphones, 393 Av mode, 70 shots possible, 39, 352 information, 33 parameter for Picture Styles, 273

shots remaining	speaker, 29
12 to 18 percent reflectance, 61-63	Speedlites. See also electronic flash; External
displaying, 31	Speedlite control
limit, 9	270EX II, 223, 231, 237
Live View screen, 352	320EX, 223, 231, 237
readout, 39	430EX III-RT, 222, 231, 235–237
in viewfinder, 41	580EX II, 221–222, 231–233, 236
Shutter button, default, 342	600EX-RT/600EX I-RT, 218-220, 231-232
shutter release. See also Release shutter	235–236
without card default	flash capabilities, 231
button, 26–27	master flash, 230
defaults, 49	optical masters, 232-233
shutter speed	powering, 218
displaying, 31	radio masters, 235–236
exposure triangle, 56	recommendation, 4
and f/stops, 60	side mounting, 218
Live View screen, 352	slave units, 230
Movie Shooting menus, 370–371	Transmitter (ST-E2), 233-234, 239
Movie Shooting screen, 363	Sports mode, 14, 51–52
readout, 39	Spot AF point, in viewfinder, 41
selecting, 75	Spot metering, 15–16, 41, 66–67
in viewfinder, 41	spreading/pinching fingers, 45–46
Shutter-priority (Tv) mode	sRGB color space, 268-271
electronic flash, 202	stage performances
equivalent exposure, 61	default settings, 52–53
menu tabs, 244	Tv (Shutter-priority), 72
settings, 12	Standard Picture Style, 274
using, 71–72	Start/Stop button, 30, 34
Silent LV Shooting options, 351	Still shooting mode, 31
single autofocus, 16–17, 119, 360	STM (stepper motor)
Single-point AF mode, 17, 19, 120	drives, 177
Single-point Spot AF mode, 17, 19, 120	lenses, 172–173
six-second rule, 19	stopping action, 143-144, 185-186, 211
slave connection, using with flash, 217	storyboards, using with movies, 384–385
slave flash, setting up, 236–237	strap, 2
slave units, 228, 230	strap mount, 28–29
Slide Show options, 305–306	streaks, creating, 148
smartphone, connecting to, 162–165	strobes, linking to camera, 216–217
Smooth Zone, 357	stroboscope, 143
software in box, 3	studio flash default settings, 53–54
Sound recording options, 50, 364. See also	studio work, M (Manual) exposure, 76
audio tips	•

swiping	Trash button, 11
functions, 44	travel default settings, 53-54
scales, 45	tripod socket, 42
sync speed problems, avoiding, 198–199	tungsten light, 191
	Tv (Shutter-priority) mode
T	electronic flash, 202
	equivalent exposure, 61
tablets, connecting to, 162–165	menu tabs, 244
tabs, jumping between, 245	settings, 12
tapping and pressing touch screen, 25, 44	using, 71–72
telephoto lenses, 179, 182	two shots, using in movies, 388–389
telephoto zoom lenses, 172	C
television, viewing on, 320	U
temperature warning, Live View screen, 352	
text, resizing, 321	underexposure, 62–63, 73
three-point lighting, 390	USB port, locating, 24, 28–29
thumbnail images	user settings
scrolling among, 46	Custom Functions, 328
viewing, 22–23	Playback menu, 328
tilt and rotation, checking, 35	Set-up menu, 328
tilt-shift lenses, 181	Shooting menu, 327–328
time and date, setting, 10–11, 317–318	Shooting modes, 12
time exposures, 147–148	user's manuals, 2
time lapse photography, 151–155	USM (micromotor ultrasonic motor)
timed exposures, 147	drive, 177
time-lapse movie, 39, 153–155. <i>See also</i> Movie Shooting menus	lenses, 171–172, 178–179
Toning effect parameter, using with Picture	V
Styles, 274	V
toning vs. filtering, 277	Vertical image auto rotation default, 49
top of camera, 36-38	VF Display Illumination, 131
touch controls, 12, 321-322. See also LCD	Video Snapshots
touch screen	Movie Shooting menus, 374–377
touch screen	Movie Shooting screen, 363
disabling, 321	Video System options, 320
mastering, 43-46	viewfinder
Touch Shutter	display options, 318–319
activating, 361	electronic level, 35
Live View screen, 352	eyepiece with eyecup, 29-30
Live View Shooting defaults, 49	icons, 41
options, 349	warnings, 340
Tracking Sensitivity, 124–125	vignetting, 253–254
transferring photos to computers, 23-24	

W	Wi-Fi signal strength
warning icon, 39, 41, 340	displaying, 31
warranty and registration card, 2	Live View screen, 352
WB bracketing, 190	Movie Shooting screen, 363
WB Correction warning, 340	wildlife, lens recommendation, 180
web services, connecting to, 161–162	wind filter, Movie Shooting screen, 363
white balance. See also ExpoDisc	wind noise reduction, 393
bracketing, 31, 190	Wireless Communication Settings options,
correction, 31	315
	wireless flash. See also flash
customizing, 267	channel controls, 229
data, 32	channel selection, 237–238
default settings, 48	combinations, 226–227
displaying, 31	controlling units, 227-228
Live View screen, 352	groups, 230, 238-239
Movie Shooting screen, 363	master, 226, 232-234
options, 263–266	options, 230–231
RAW, 189	overview, 225–226
White Balance Shift/Bracketing options,	radio master, 235–236
267–268	ratio control, 240–242
wide-angle lenses, 171, 178	slave, 236–237
Wi-Fi function	using, 228–229
access points, 162	
camera connection, 158	Z
Connect Station, 159	_
connections, 155	zone, setting, 317–318
default, 49	Zone AF mode, 17, 19, 120
displaying, 31	zoom lenses, 179
enabling, 156–157	zoom ring, 39–40
EOS utility, 159–160	zoom scale, 39–40
guidelines, 155–156	zoom wide-angle-telephoto lenses, 171–172
Live View screen, 352	
Movie Shooting screen, 363	
printer connection, 160–161	
readout, 39	
smartphone, 162–165	

tablets, 162–165 web services, 161–162